Modern Art in Detail
75 MASTERPIECES

Modern Art in Detail

75 MASTERPIECES

 Thames & Hudson

SUSIE HODGE

WILLARD LIBRARY, BATTLE CREEK, MI

Contents

Late 20th century

248

21st century

298

Introduction

For many, art since the late 19th century has become increasingly bewildering. Some consider much of it to be incomprehensible, while others see it as more expressive than art of previous centuries. Many maintain that art should be a vehicle for technical skills, and that it should also be beautiful, pleasing and coherent. However, a great deal of modern and contemporary art is less about beauty or technical abilities, and more about expressing ideas and philosophies. In addition, many contemporary artworks are not permanent, not as well known as some more traditional art, and often address difficult subjects. For this reason, much modern and contemporary art is better understood with some background knowledge; some insight into the artist's intentions, emotions and circumstances.

So this book has been written as an accessible guide to give you close access to seventy-five modern and contemporary works of art to enjoy at your leisure. It explains underlying meanings and messages and explores why and how the art was made, who made it, who or what influenced it, and much more. It's like having your own personal art guide pointing out things you may not have noticed or were not aware of, drawing comparisons and demonstrating influences and inspirations. It is an invigorating, thought-provoking consideration of a wide range of art, made from the late 19th to the 21st centuries, exploring individuality and the broader context of modern and contemporary art, encompassing how some of the artists fit in with specific art movements, schools of thought, or even just particular places and moments in time.

Modern and contemporary art is not always serious, and unlike a great deal of art of the past, much of it was not made to be revered. It is often intentionally absurd, or disturbing, witty or transient. Additionally, people's views of it will always be coloured by their experiences, perceptions and expectations. So knowing something of the artists' intentions can be exceptionally helpful. Furthermore, while this book will help you to understand specific works of art, by knowing what to look for and consider, it also provides you with tools to enable you to analyse and discover more about other works of modern and contemporary art.

The seventy-five featured works include paintings, prints, sculpture, installations, collage and constructions, made by male and female artists of various nationalities and ages, born in different time periods, with diverse outlooks, beliefs and reasons for making their art, and at different stages in their careers. The main purpose of the book is to help make sense of the numerous changes, outlooks, approaches and outcomes that have emerged in modern art. It does not judge, but aims to give each work a chance to be viewed and appreciated in context.

The details

The book explores each work of art on two double-page spreads. On the first spread, the art being discussed is shown fully with a brief background about the artist and the work's historical and contextual framework . Then on the next two pages, several key aspects are identified and discussed in greater depth in numbered close-ups. Depending on the art

> *"The artist is a receptacle for emotions that come from all over the place: from the sky, from the earth, from a scrap of paper, from a passing shape, from a spider's web."*
>
> – Pablo Picasso

itself, these details may include information about the artist or a relevant art movement's ideology, any symbolism or allegorical information, a closer consideration of techniques and methods, the artist's choice and use of materials, inspiration and influences, philosophies and reasons for producing the work. In this way, layers of information about each work are uncovered. Alongside, there are also one or two images that have a particular bearing on the main artwork. These show some of the cross-fertilization of ideas, illustrating how various other factors have augmented and influenced the main work, including such things as paintings, sculpture, buildings, poems or people, or a photograph of a contemporary event or significant object.

Modern, postmodern and contemporary art

Art is not a linear development, but a flexible, changeable evolution that expands in different directions often at the same time, and like many art movements that are named in hindsight, there is no one consensus of opinion that agrees on a definition for modern, postmodern and contemporary art. They are all loose descriptions of periods in time where certain values emerged in a wider range of artistic production. Modern art, or modernism, is an umbrella term used for art and often more specifically for design and architecture, a succession of art and design developments, styles and movements, all characterized by a deliberate rejection of art styles of the past, especially realistic depictions. It concentrated on innovation and experimentation with form, materials, techniques and processes to create art that reflected modern society and

various social and political agendas. Many modernists had a utopian view of life and a belief in society's progress, and for this reason, modern art is commonly described as beginning in around 1850 with the development of Realism, although some art historians consider modern art to have started with Impressionism in the 1870s and 1880s, and others describe it as beginning at the turn of the 20th century. It is usually described as ending after Pop art in the late 1960s with the beginnings of Conceptual art. So the description is flexible.

By the late 1960s, as with nearly all art movements and schools of thought, a reaction against it occurred. The term 'postmodernism' was first used around 1970, but like modernism, there is no one postmodern style or theory, and many art historians and galleries do not make any distinctions between modernism and postmodernism. Those who do recognize postmodernism, see it as being a wide variety of approaches that specifically tend to erase distinctions between high culture and mass or popular culture, and also between art and everyday life. It is often an eclectic mixing of different artistic styles using a range of media, and encompasses art movements such as Conceptual art, Neo-Expressionism, Feminist art and the YBAs, or Young British Artists. While modernism was based on idealism and reason, postmodernism was more sceptical. In addition, while modernists championed clarity and simplicity; postmodernists embraced complex and often contradictory layers of meaning. Postmodernism can be confrontational and controversial, challenging the boundaries of taste, or it can be amusing or self-effacing. Postmodernists often openly borrow from past styles, but imbue them with

new ideas. Finally, in another elastic term, contemporary art is usually defined as any art that has been produced over the last twenty-five years.

How and why art changed

From the earliest times to the late 19th century, artists were largely commissioned by wealthy individual patrons or institutions such as the Church. Most art was created to help viewers understand things like religious beliefs or morals, to recognize who was in charge, or to celebrate success. Each era had its goals and aspirations, and art was always made to assist these, such as humanism and Catholicism during the Renaissance and Baroque periods, the light-hearted extravagances of the Rococo style, and the articulation of heroism and patriotism in Neoclassicism. Yet whatever the style, or the ambitions of artists and their patrons, one common characteristic of nearly all art from the Renaissance to Realism was idealization of the subject.

From the 18th to the 19th centuries, the Industrial Revolution with its rapid developments in manufacturing, transport and technology profoundly affected social, economic and cultural conditions, firstly in western Europe, then in north America and eventually across the world. By the mid 19th century, large machine-powered factories dominated numerous skylines, and many people migrated from the country to towns and cities to find work. As the urban centres prospered and the pace of life changed, artists began expressing the transformations around them with novel approaches.

Photography and portable paint

One of the catalysts for change in art was the invention of photography in 1839. As photographic technology advanced, it became more accessible to the public and a serious threat to artistic traditions and artists' livelihoods. Photography was precise and accurate and could be produced faster than painting, so artists sought new modes of expression, some moved away from realistic accuracy, others used photography as preparation for works of art, memory prompts and as a means of creating original compositional ideas.

In 1841, US painter John Goffe Rand (1801–73) invented and patented the first collapsible paint tube made of tin with a screw cap that allowed remaining oil paint to be stored and used later without drying out. Previously, artists had kept their paint in pig's bladders sealed with a tack. This was smelly, messy and leftover paint dried out. After Rand's invention, it became easier for artists to paint outdoors, as his collapsible tubes did not smell or leak and the paint inside could be used whenever needed. Like photography, this invention instigated diverse reactions and responses among artists, but most notably, it gave them more freedom and choice.

Different directions

In the mid 19th century, artists began portraying ordinary, often poor people and everyday situations. In depicting such mediocre, unremarkable subjects, including imperfections rather than idealizing their subjects, and applying paint with sketchy rather than precise brushstrokes, these artists caused instant controversy. Their radical approach became labelled 'Realism'. Yet while they represented the ordinary world objectively, others went in different directions. Some artists emphasized the visual sensations of their surroundings rather than focusing on naturalism, producing paintings that bordered on abstraction. Although their approaches were individual, these artists defied artistic convention as well, painting in dabs, flecks and washes of paint, capturing perpetual changes of light and its effects. These ideas in turn influenced ensuing artists, and as the 19th century moved into the 20th century, artistic changes gathered momentum and occurred more often. Those artists who chose not to adhere to tradition but to experiment with ideas and methods – the avant-garde – continued to portray their contemporary worlds.

In venturing beyond acceptable notions of fine art of the time, many of the artists established themselves as independent thinkers, presenting subject matter that was often perceived as lewd, controversial, nonsensical or just plain ugly, and many of them were initially shunned or ridiculed for their work. Eventually however, most of the artists in this book became significantly influential to subsequent generations.

Whether modern or ancient, art is never produced in a void. All art is shaped by various influences such as the artist's personal situation, background, language, training, location, available materials, religion, morals and beliefs, cultures, traditions, patronage and financial constraints. Even among concordant groups of artists, these factors vary enormously, and so art's appearance, function, meaning and development is frequently variable. Timing is also critical; what might be hailed as great art in some instances can be seen as abhorrent or outrageous in others.

Art movements

For clarity, Western art is usually categorized into art movements. Some movements are formed consciously by the artists themselves. These artists often write manifestos or work or exhibit together. Other movements are labelled retrospectively, on consideration of the artists' common approaches, ideals, styles, principles, methods and time periods. There is no fixed rule that determines what constitutes an art movement, and no formula for naming them; their names may be serious or sarcastic, flattering or insulting. During the 20th century, there was a greater number of styles and changes in approach than ever before – and so a larger number of art movements than at any other period in the history of art.

Yet since the 21st century, artists have become more diverse in their approach and use of materials and there is greater freedom in what is acceptable. So it is becoming increasingly difficult to group them into art movements. Additionally, classifying avant-garde artists into movements is often neither accurate nor even appropriate. Which is why many of the artists in this book have not been categorized into a specific art movement, while some are described as being in more than one. As time passes, this may change. For instance, the Renaissance was not named until the 19th century, and the Post-Impressionists were only grouped together under that term after they were all dead.

Every artist featured in this book contested accepted forms of art in some way in order to most accurately convey their experiences of life. Every artwork has challenged, probed and often shocked, compelling viewers to reconsider their own attitudes and feelings, and the world around them. Some of the works here may be familiar, others may be more obscure, but all express innovative, usually groundbreaking ideas for the times in which they were created, confronting preconceptions.

Innovation and ideas

The book begins with a painting produced in 1890 by a painter whose work was derided during his life but who is now one of the most revered artists in the world, Vincent van Gogh (1853–90). At the time, he broke dramatically with accepted painting styles and methods. Other artworks here anticipate world wars, some include materials and methods used for the first time in fine art. Several explore spirituality or the subconscious and some consider colour or materials. Some continue to create illusions while others make a point of stressing that their work is art and not trying to be anything else. There are small artworks and monumental, religious and secular, colourful and monochrome.

The book continues chronologically and ends with art produced in the 21st century, made of materials that would never have been considered by artists featured at the beginning of the book. Every artist included has attempted to make sense of his or her time and place in the world, to express culture and society in personal and often perceptive ways.

Broad range

So the book represents an overview of artistic expression and endeavour across approximately 120 years of change and developments. While not all the artists can be categorized into art movements, those movements that are covered include Post-Impressionism, Secessionism, Fauvism, Cubism, Futurism, Pop art, Expressionism, Orphism, Dada, Surrealism, Abstract Expressionism, De Stijl, Constructivism, Suprematism, Kinetic and Land art, Fluxus, Conceptual art and Neo-Expressionism. It is a definitive guide to some of the most important and influential concepts in modern art, a close-up exploration of seventy-five cutting-edge artists' thinking and expression.

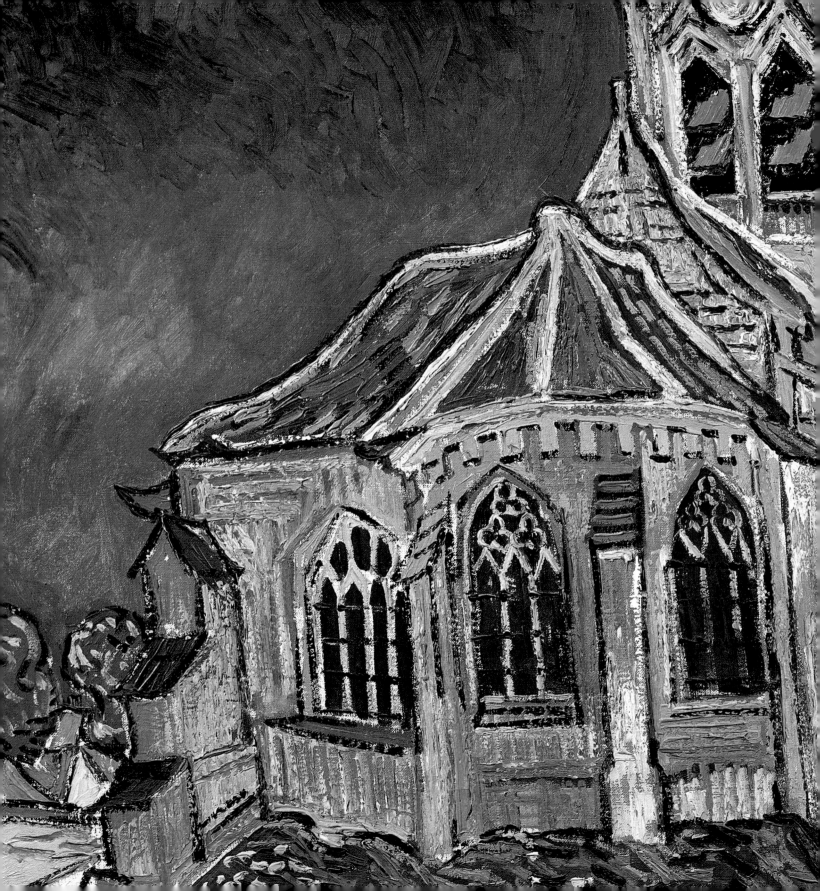

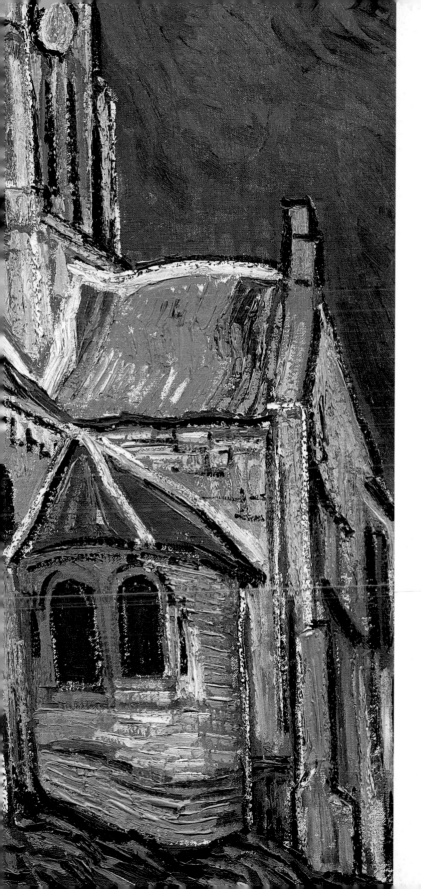

LATE 19TH CENTURY

IN REACTION TO THE strict academic conventions that had been adhered to by artists for centuries, the last decades of the 19th century witnessed the development of numerous new art forms and styles. Realism featuring ordinary people, loose brushwork or rough surfaces and avoiding exaggeration or idealization heralded Impressionism, closely followed by Neo- and Post-Impressionism, which were a diverse range of art styles and approaches, frequently utilizing modern synthetic pigments and focusing on brilliant colour. Similarly, but in different ways, Symbolist and Art Nouveau artists also represented *La Belle Époque* (Beautiful Era), which was an optimistic, economically prosperous and peaceful time when the arts flourished that is considered to have lasted from the end of the Franco-Prussian War in 1871 to the outbreak of World War I in 1914.

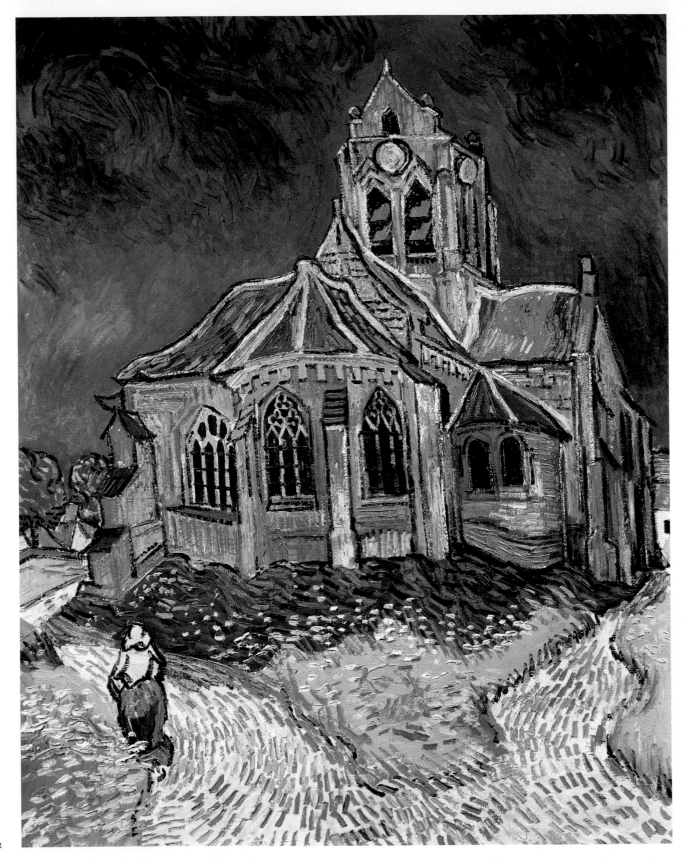

THE CHURCH IN AUVERS-SUR-OISE

VINCENT VAN GOGH

1890

oil on canvas
94 x 74 cm (37 x 29 in.)
Musée d'Orsay, Paris, France

FAMED NOW FOR HIS TRAGIC LIFE as much as for his expressive and emotive art, Vincent van Gogh (1853–90) tried several careers before becoming an artist only ten years before his death at the age of thirty-seven. During that time, he produced more than 2,000 works of art, and yet remained unappreciated until his death.

The eldest of six siblings, born in the southern Netherlands to a Protestant pastor father, Van Gogh was apprenticed at the age of sixteen to the art dealers Goupil & Cie, which had branches in the Hague, London and Paris. After he lost his position, he tried teaching in England and working as an evangelical preacher in the Borinage mining district of Belgium, but both jobs ended unhappily. In 1881, he took art lessons with Anton Mauve (1838–88), and was influenced by the work of Frans Hals (c. 1582–1666), Rembrandt van Rijn (1606–69) and Jean-François Millet (1814–75). He later discovered the paintings of Peter Paul Rubens (1577–1640) and Japanese *ukiyo-e* prints, which he started collecting. In 1886, he joined his brother Theo in Paris, where for a short time he studied with the painter Fernand Cormon (1845–1924). He became acquainted with the Impressionists who inspired him to lighten his palette and shorten his brushstrokes. Two years later, he moved to Arles in the south of France, inviting Parisian artists to join him to form an artists' colony, but Paul Gauguin (1848–1903) was the only one who did. The two men argued almost constantly, and Van Gogh's already fragile mental health deteriorated. After one huge row, Gauguin left and Van Gogh cut off part of his left earlobe. While in an asylum being treated for this and other health problems, his work became even more dramatic and intense. In May 1890, he moved to Auvers-sur-Oise on the outskirts of Paris, but within two months, he shot himself and died two days later.

This is one of the eighty paintings that Van Gogh produced in the last two months of his life while living in the village of Auvers-sur-Oise. It depicts the 13th-century church there, and it demonstrates his unique approach in blending Japanese-style undulating, contrasting contours, as well as impasto paint and vibrant colours.

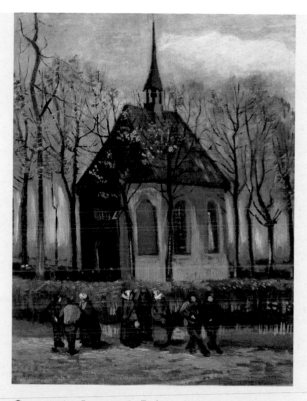

Congregation Leaving the Reformed Church at Nuenen, Vincent van Gogh, 1884–85, oil on canvas, 41.5 x 32 cm (16 ¼ x 12 ½ in.), Van Gogh Museum, Amsterdam, Netherlands

In 1885, Van Gogh's father, Theodorus, died. Van Gogh had already painted his father's church in Nuenen while staying with his parents at the vicarage in 1884, but in 1885, he added some mourners leaving the church as a mark of respect. He painted this soon after he had made the decision to become a professional artist but before being inspired by the Impressionists and Japanese art, so his colours and brushmarks still follow the influence of traditional Dutch painting.

1 PERSPECTIVE

Although this shows the influence of the one-point perspective used by Utagawa Hiroshige (1797–1858), Van Gogh distorted the architecture of the Auvers church. Depicted on a low horizon, with waving contour lines, viewers are forced to look up at it. While in perspective, it is not the mathematical formula that had been adhered to by artists since the Renaissance, but his interpretation of what he was seeing. Viewers are forced to look up at it, and into the deep blue of the sky. The two paths dramatically narrow as they divide and recede around the church.

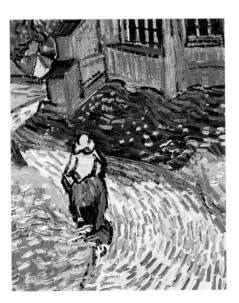

2 COLOUR

After he moved to France, Van Gogh used vivid colour for its expressiveness. Ultramarine predominates in the shadows and sky, whereas the vibrant orange-red roof contrasts with the blue areas and the green of the grass.

3 INFLUENCES

The thick dark outlines and the flat swathes of colour on the roof and background can be traced to *ukiyo-e* prints. The effects of light and emphasis on choppy brushstrokes show how Van Gogh learned from the Impressionists.

4 SPIRITUALITY

Van Gogh believed that true spirituality is found in nature, not in man-made buildings. The church looms above the woman walking up the path and viewers, creating a powerful image of a house of worship that has stood for centuries.

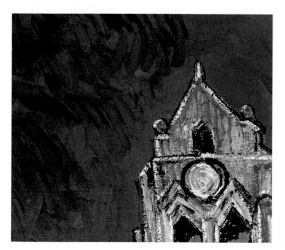

⑤ DYNAMISM

With undulating lines and flowing brushwork, the monumental building appears distorted, portrayed as if it is moving. It suggests Van Gogh's mental disquiet. The curving roof, hatched marks and angled brushwork in the sky create an agitated effect, emphasized by the impasto paint, which contrasts with the smooth effects of the Japanese prints he admired.

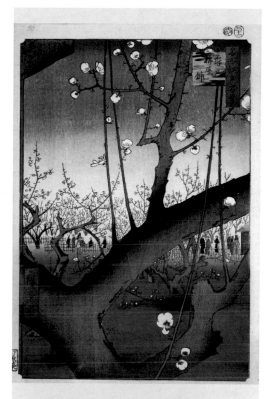

TECHNIQUES

Van Gogh created this painting during the last months of his life. He had started using the technique of applying thick or impasto application in his earliest paintings, but it became exaggerated. Here, the paint is almost smeared on with brushes and a palette knife.

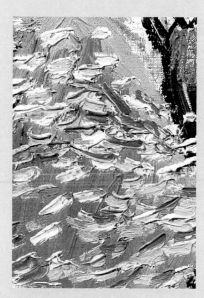

⑥ METHOD

Van Gogh applied thin opaque paint, allowing the canvas texture to show through in places. Then, with a wet-in-wet technique, he added more paint, in some places thickly, such as in the grass.

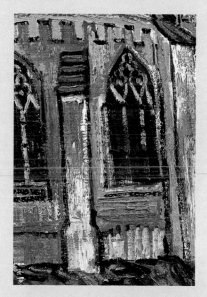

⑦ OUTLINES

Dark outlines became a feature of Van Gogh's paintings. Unlike Japanese prints, which had uniform black outlines, Van Gogh's contour lines were often in a softer colour and created with broken marks.

***Plum Park in Kameido*, Utagawa Hiroshige, 1857, woodblock print, 34 x 22.5 cm (13 ⅜ x 8 ⅞ in.), Rijksmuseum, Amsterdam, Netherlands**

From the series *One Hundred Famous Views of Edo* (1856–59), this depicts the 'Sleeping Dragon Plum', the most famous tree in Edo (modern Tokyo), recognized for its pure white double blossoms and snaking branches that stretch across the ground like a dragon. The series was commissioned soon after the earthquake in Edo in 1855 and featured locations in the city. Van Gogh began collecting Japanese prints after his first encounter with them in Antwerp in 1885, and this was one of a few he copied. He particularly admired Hiroshige's exaggerated one-point perspective, cropped compositions, calligraphic contours and luminous colours.

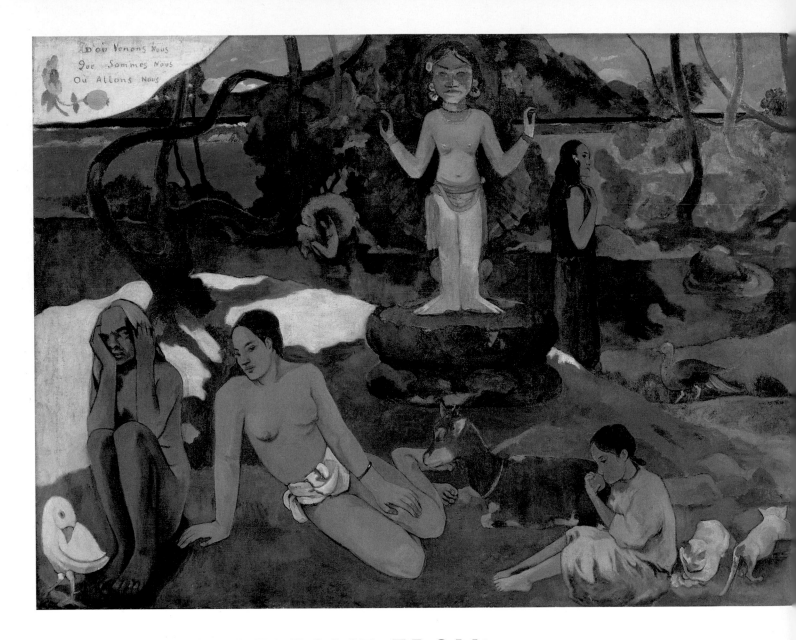

WHERE DO WE COME FROM?
WHAT ARE WE?
WHERE ARE WE GOING?

PAUL GAUGUIN

1897–98

oil on canvas
139 x 374.5 cm (54 ¾ x 147 ½ in.)
Museum of Fine Arts, Boston, USA

IN HIS LATE THIRTIES, Eugène Henri Paul Gauguin (1848–1903) left his wife, their five children and his career as a stockbroker, to pursue his dream of becoming an artist.

He then went to Pont-Aven in Brittany where there was a thriving art community. There he began developing a flat, colourful painting style, focusing on simplified lines and his own form of symbolism. In 1888, he stayed with Van Gogh in Arles for nine weeks, but after a huge row, he then moved to Tahiti, where he developed his painting approach even further. However, plagued by illness, depression and financial worries, he died in poverty at the age of fifty-four.

Gauguin struggled against popular opinion to develop his flat-looking, boldly coloured style of painting. *Where Do We Come From?* is his largest painting, executed on rough, heavy sackcloth, which was all he could afford. Painted while he was living in Tahiti, this is what he believed to be his greatest painting. He created it at a time of great personal crisis to summarize his thoughts. Redolent with symbolism, it presents a Tahitian landscape, but expresses universal human concerns. The baby on the right of the painting represents the *Where Do We Come From?* part of the work. It has been suggested that the dog represents Gauguin himself.

② THE BEGINNING

In a letter to his friend Georges Daniel de Monfried, Gauguin explained that the painting should be read from right to left, beginning with the baby. Three crouching young women watch over the innocent child. The baby represents the beginning of life and the women symbolize the biblical Eve.

① SPIRITUAL BELIEF

An exotic-looking idol is an emblem of spiritual belief. It represents what Gauguin described as 'The Beyond'. Animals are traditionally believed to have a sixth sense or a spirituality that humans have lost, so here Gauguin painted a goat, a cat and kittens. Nothing is in correct proportion, deliberately promoting the idea that they are not part of Earth's gravitational pull.

③ DESTINY AND DESIRE

In the centre of the painting, Gauguin explores human destiny, ambition and the desire to seek more in life. A Tahitian youth is seen stretching up and plucking the fruit of experience, while nearby a child eats the fruit he has picked. A large figure sits behind, perhaps watching the women behind him. The women are in the shadows, clothed and walking arm in arm.

④ THE END OF LIFE

On the left of the painting, a young woman reflects on life, and an old woman prepares to die, indicated by her pose, grey hair and the strange white bird in front of her; the lizard in its claws represents futility.

⑤ BACKGROUND

Set in the tropical surroundings of Tahiti, Gauguin painted a small river running through woods, the sparkling blue sea in the distance, and beyond that, the misty volcanic mountains of another island.

Gauguin's flat-looking forms with dark outlines gave rise to his style being termed 'Cloisonnism' after an enamelling technique. It is also called Synthetism for its expression of his feelings.

⑥ COLOUR

Shades of blue elicit a melancholy atmosphere; even the trees in the background and the idol are blue, whereas yellow has been used to resemble the opulent gold leaf in ancient religious works of art. Gauguin's palette for this included Prussian blue, cobalt blue, cadmium yellow, chrome yellow and red ochre.

⑦ OUTLINES

Gauguin developed Cloisonnism with French painter Émile Bernard (1868–1941). The name refers to the *cloisons* (compartments) separated by metal wires used in the creation of enamel objects. Thin, dark contour lines characterize the style. The dark outlines heighten the perceived intensity of the other colours.

Detail from *Apple Harvest*, Camille Pissarro, 1888, oil on canvas, 61 x 74 cm (24 x 29⅛ in.), Dallas Museum of Art, Texas, USA

After several years of using the broken brushmarks of Impressionism, Camille Pissarro (1830–1903) began experimenting with pointillism. Here, he painted peasants picking apples in the French countryside with carefully placed dots of vibrant colours to create the effects of the dazzling afternoon sunlight. Closely juxtaposed, the pure colours of Pissarro's dots blend in the eyes of viewers rather than being premixed on a palette as in traditional oil painting. Pissarro's work and his advice were influential on Gauguin and the composition of *Where Do We Come From?* can be seen to derive from this canvas and the colour theories that inspired Pissarro.

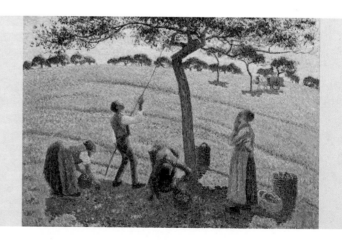

THE WATER-LILY POND

CLAUDE MONET

1899

oil on canvas
88.5 x 93 cm (34 ¾ x 36 ¾ in.)
National Gallery, London, UK

BORN IN PARIS, OSCAR-CLAUDE MONET (1840–1926) grew up in Normandy, and was introduced to painting *en plein air* (out of doors) by Eugène Boudin (1824–98). Another landscape painter, Johan Barthold Jongkind (1819–91) also advised him, and in 1862 he entered the Parisian studio of Charles Gleyre (1806–74) where he met Pierre-Auguste Renoir (1841–1919), Alfred Sisley (1839–99) and Frédéric Bazille (1841–70). Inspired by the Barbizon painters and Édouard Manet (1832–83) in France and John Constable (1776–1837) and J. M. W. Turner (1775–1851) in England, Monet exhibited at the Paris Salons of 1865 and 1866, but afterwards his work was rejected. In 1874, he helped form the independent group of artists who became known as the Impressionists, who captured light and fleeting moments with short brushmarks and vibrant colour. His painting, *Impression, Sunrise* (1872), inspired the group's originally derogatory name. He adhered to Impressionistic principles throughout his life.

In 1883, Monet and his family moved to Giverny in the north of France, where he created a magnificent garden with a huge pond that he filled with water lilies imported from Japan and adorned with a curved Japanese-style footbridge. By 1899, when the pond was completed and the water lilies were blooming, he created twelve paintings of it from the same viewpoint under differing light conditions. This is one of them. Other versions of this work that Monet painted during the same year are called *The Japanese Bridge* in recognition of the focal point: the graceful bridge. Monet was one of several artists working at the time who began collecting Japanese *ukiyo-e* woodblock prints from the 1860s and taking ideas from them. Several of the prints he acquired featured images of bridges. With some dappled light and texture, this painting demonstrates his *plein air* approach to painting, in which he expresses his sensations as well as his observations. Shadows beneath the lily pads cover the reflections and serve to give the image a sense of depth and reality. Two years after he completed this work, Monet admitted to having an obsession with painting his water garden, and it became his main motif for the rest of his life.

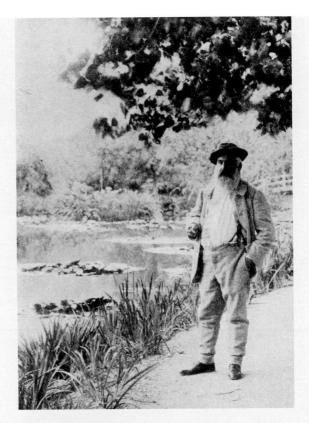

Monet and his pond

Here Monet stands in front of his pond, abundant with foliage, and the elegant Japanese bridge. He had employed six gardeners to construct the pond and one constantly maintained the flowers as Monet wanted to suit his painting. He was fifty-nine when the pond was completed and he painted it and the garden almost incessantly for the remaining twenty-seven years of his life. Most of *The Water-Lily Pond* was painted *en plein air* so he could capture the momentary effects of light and colour, but he completed it in his studio.

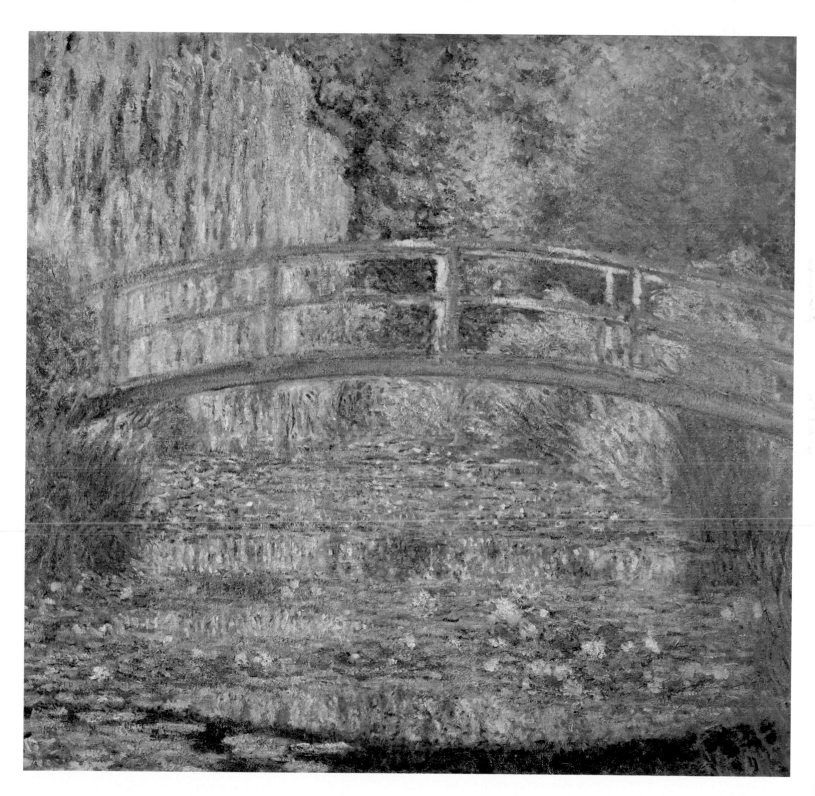

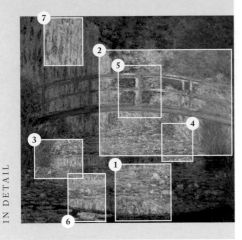

② COMPOSITION

With its gentle curve over the pond, the bridge commands the composition. All is harmonious, from the bridge itself, to the curving shapes of the lilies on the water's surface and the cascading willow leaves. The concordant colours and balanced arrangement combine to convey a sense of calm stillness.

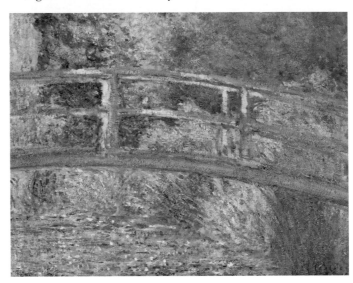

③ PALETTE

Monet's palette for this work probably comprised lead white, cadmium yellow, vermilion, deep madder, cobalt blue, cobalt violet, viridian, emerald green and French ultramarine. Although the colours harmonize, they also contrast in tone, making depth apparent through the deeper colours, such as the dark greens.

① BRUSHSTROKES

Rather than apply thin glazes in the traditional method of oil painting, Monet used thick paint in short, flat strokes and dabs, known as '*taches*' – French for 'blots' or 'stains'. He achieved this technique with a flat, square ferrule paintbrush, which had been recently invented and became the Impressionists' preferred brush. Before this, paintbrushes were mainly round in shape and *taches* were more difficult to achieve. The technique was one of several groundbreaking painting ideas that the Impressionists invented.

4 PLEIN AIR

Monet painted this outdoors, *en plein air*. He applied thicker paint with a palette knife in some areas, as well as using a ferrule brush. He did so for speed, trying to capture his sensations and create textures on the canvas.

5 JAPONISM

Monet's water garden became known locally as the 'Japanese garden'. At the end of the 19th century in Paris, the Japanese style was so fashionable that the term 'Japonism' was used to describe the phenomenon.

6 REFLECTIONS

The curving arch of the bridge can be seen as a reflection at the bottom of the canvas. The only sky that can be detected is shown as reflections in the water and these are wavy lines between reflections of the willow tree leaves.

7 OBSESSION

Monet visited his garden at least three times a day to study the light, making visual notes of colours and shadows in his sketchbooks. He continued to paint the pond until he died, creating larger and looser images as time passed.

Inside Kameido Tenjin Shrine, Utagawa Hiroshige, 1856, woodblock print, 34 x 22 cm (13 ½ x 8 ¾ in.), Brooklyn Museum, New York, USA

When Japan began trading with the Western world in 1858 after over 200 years of isolation, Japanese goods such as furniture and ornaments began arriving in Europe, wrapped in *ukiyo-e* prints that were cheap in Japan. Yet the prints gripped the West. Art such as this had rarely been seen in Europe and the United States and it captured artists' imaginations. Monet collected the prints from the 1860s. He admired their emphasis on flatness, pared-down colours and compositions, as well as the idea of producing a series of images on a theme. Hiroshige's composition with its arched bridge and cascading wisteria influenced Monet's bridge design in his garden. He added a wisteria trellis over his pond and as Hiroshige's wisteria frames this image, so Monet's willow leaves frame his painting.

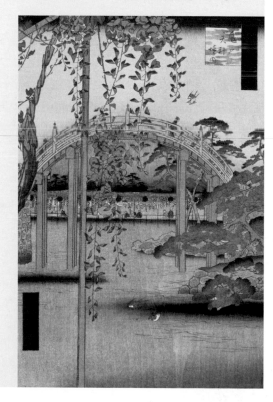

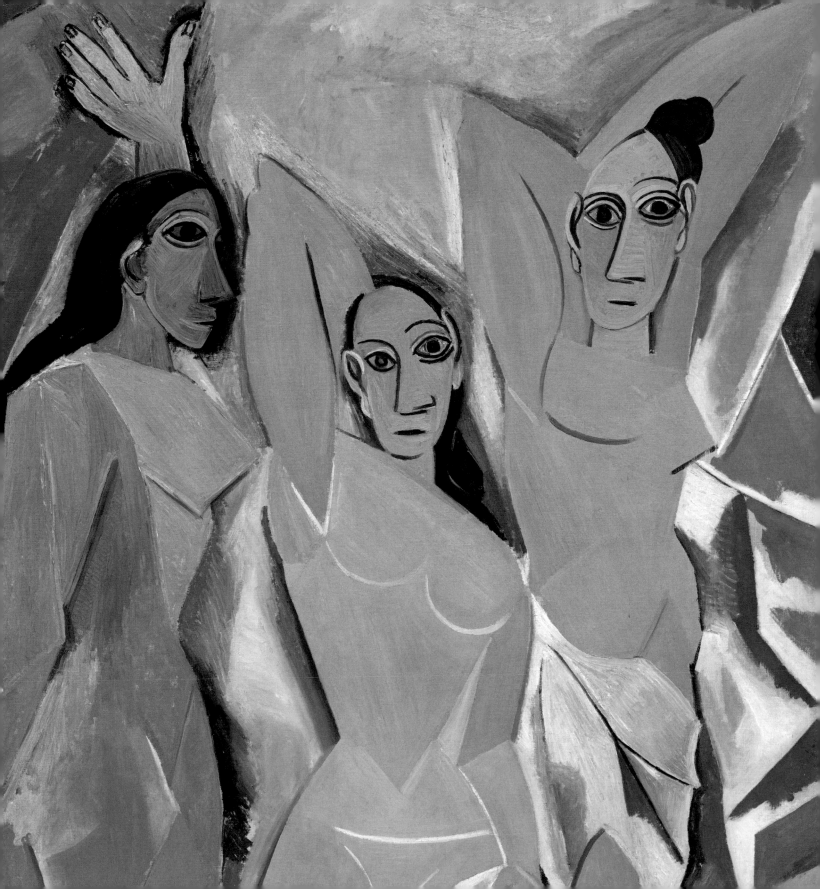

EARLY 20TH CENTURY

FOLLOWING ON FROM THE new artistic directions of the 19th century, by the early 20th century, innovative technologies and discoveries emerged with even greater momentum. Avant-garde artists in France, Italy, Britain, Germany, the United States and beyond continued to reject the traditions and rigidity of academic art, and developed styles that challenged accepted artistic conventions even more frequently. As these fresh approaches appeared in rapid succession, they influenced and inspired each other. Expressionism, Cubism, Fauvism and Futurism began in Germany, France and Italy, while in Russia, the Suprematists and Constructivists rejected references to nature and focused on geometric forms. For the first time, art moved away from being purely figurative, and once the first abstract works were produced, many more artists began exploring the concept.

MONT SAINTE-VICTOIRE

PAUL CÉZANNE

1902–04

oil on canvas
73 x 92 cm (28 ¾ x 36 ⅛ in.)
Philadelphia Museum of Art, Pennsylvania, USA

SCORNED AND RIDICULED DURING his lifetime for his unusual approach to painting, after his death Paul Cézanne (1839–1906) became one of the most influential artists of the 20th century. He inspired artists such as Monet, Edgar Degas (1834–1917), Matisse and Picasso, and was hugely important in the development of Cubism.

Born in Aix-en-Provence in the south of France, Cézanne came from a middle-class family. His father, a wealthy banker, persuaded him to study law, but soon after, Cézanne convinced his father to let him study art in Paris, where he met Camille Pissarro and other artists who became known as the 'Impressionists'. Pissarro encouraged him to paint outdoors observing nature, and to use lighter colours and small brushstrokes. After rejection from the official Paris exhibitions – the Salon – in 1874 and 1877, he exhibited with the Impressionists. Then in 1878, he returned to Provence and pursued his own artistic path. While most of the Impressionists sought to capture the effects of light, Cézanne was more interested in exploring underlying structure, so his brushstrokes became angled and descriptive.

This is one of some sixty views of Mont Sainte-Victoire in Provence, painted by Cézanne using oils and watercolour. He used colour more than tone to portray depth and structure.

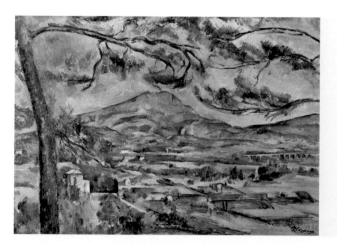

Mont Sainte-Victoire with Large Pine, Paul Cézanne, *c.* 1887, oil on canvas, 67 x 92 cm (26 ⅜ x 36 ¼ in.), Courtauld Gallery, London, UK

This is one of Cézanne's earliest paintings of Mont Sainte-Victoire. It demonstrates his original experimentation with form and colour. He used small patches of colour from his limited palette and outlined his main forms in dark blue. His angled paint patches create a fragmented appearance.

1 UNDERDRAWING

Since the Renaissance, painters had been encouraged to hide any underdrawing and underpainting, and to cover their canvases completely with smooth paint using imperceptible brushstrokes. Cézanne did not follow this convention. Here, the canvas can be seen in places and the paint is often thin. He allows his first marks, or underpainting, to show as part of the completed work. This is one of the first modern paintings to stress that it is an artwork rather than pretending to portray reality.

2 PALETTE

From 1878 Cézanne retained roughly the same palette. His subtle mixtures create harmony across the composition. He used lead and zinc white, ivory black, chrome yellow, yellow ochre, red earth, vermilion, cobalt blue, French ultramarine, emerald green, viridian, and possibly Naples yellow, Prussian blue and chrome green.

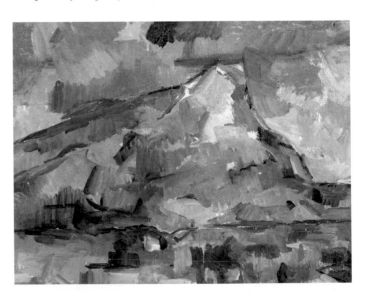

3 SYMBOLIC

Mont Sainte-Victoire dominates the landscape to the east of Aix-en-Provence. Since ancient Roman times, it had been associated with victory in battle. In Cézanne's lifetime, a cross was erected at its peak to celebrate Provence being spared from invasion during the Franco-Prussian War of 1870 to 1871.

Despite the spontaneous appearance of this work, Cézanne used a slow and deliberate technique to build up a complex and subtle image. He applied his two-dimensional brushwork carefully and created subtle nuances with mixtures of colour.

④ COLOUR

Cézanne chose his colours to describe mass as well as atmosphere. He exploited the contrasting effects of warm and cool colours. The mountain is predominantly cool blue, whereas the landscape in the foreground is made up of vibrant, intense colours, including bright greens, yellows and reds.

⑥ COMPOSITION

The composition is divided into three horizontal sections. The top section of contrasting blues, violets and greys forms the mountain and the main part of the work. The middle section is the brightest, with a patchwork of yellow ochre, emerald green and viridian green. Patches of green invigorate the lowest section.

⑤ RHYTHM

The directional brushstrokes that Cézanne evolved can be seen clearly. The angled marks are methodical and rhythmic, and the colours are light and dark, alternated across the canvas. Although the Impressionists depicted changing light, he was focused on the underlying structure of the elements.

⑦ EN PLEIN AIR

Cézanne preferred to work outdoors where he could see Mont Sainte-Victoire in clear light. He painted it in various weather conditions and at different times, including bright sunlight, after storms, early in the day and towards dusk. Such lighting conditions allowed him to see colours at their most intense.

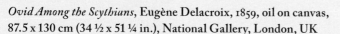

Ovid Among the Scythians, **Eugène Delacroix, 1859, oil on canvas, 87.5 x 130 cm (34 ½ x 51 ¼ in.), National Gallery, London, UK**

Cézanne was inspired by the fluid, dramatic and colourful paintings of Eugène Delacroix (1798–1863) and his free, painterly application. Delacroix was a Romantic painter, and although this painting clearly articulates a story, it can be compared with Cézanne's apparently objective landscape in its composition. Delacroix was depicting the poet Ovid in exile after being banished from Rome in AD 8 to the Black Sea port of Tomis in south-east Romania. The most obvious influence for Cézanne in this work is the way in which Delacroix portrayed the mountainous background. Although Delacroix's brushmarks are softer and blended more than Cézanne's, both artists were conveying the mystical grandeur of the distant mountains.

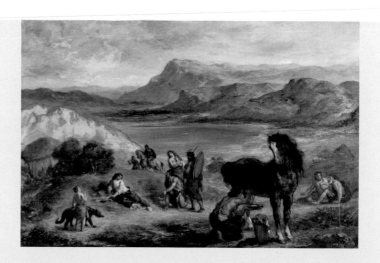

ROSEBUSHES UNDER THE TREES

GUSTAV KLIMT

c. 1905

oil on canvas
110 x 110 cm (43 ¼ x 43 ¼ in.)
Musée d'Orsay, Paris, France

ONE OF THE FOUNDERS of the Vienna Secession and considered the greatest painter of the Art Nouveau period, Gustav Klimt (1862–1918) began his career painting large murals in public buildings. His more decorative, sensuous style came later, when he amalgamated the shapes and colours of Symbolism with his notions of aesthetics, frequently painting women, allegorical scenes, flowers and landscapes.

Klimt grew up in Baumgarten, south-west of Vienna, with six siblings in a poor family. At fourteen years old, he entered the Viennese School of Arts and Crafts. There he studied architectural painting and was inspired by Hans Makart (1840–84), the foremost contemporary Viennese historical painter. Klimt followed Makart's classical style and emphasis on decorative elements as he worked with his brother Ernst (1864–92) and their friend Franz Matsch (1861–1942) on commissions, calling themselves the 'Company of Artists'. They produced large paintings for public buildings, noticeable for their striking light effects. In 1888, Klimt received the Golden Order of Merit from Emperor Franz Joseph I of Austria for his contributions to art, and was made an honorary member of the universities of Munich and Vienna. Then in 1892, tragically, both his father and brother Ernst died, and he assumed financial responsibility for his mother, sisters, sister-in-law and niece.

In 1897, after becoming disillusioned with the inflexible stance of the official Viennese artists' association, Klimt co-founded the Vienna Secession avant-garde group. During his time with the Secessionists, which lasted until 1908, Klimt produced some of his most notable paintings, especially during his Golden Phase from 1899 to 1910. Many of these paintings use gold and silver leaf, and feature coils and spirals reminiscent of Mycenaean patterns and Byzantine mosaics. In 1891, Klimt met Emilie Flöge, who became his companion and muse. Every summer, he holidayed on the shores of Lake Attersee with her family, where he painted many landscapes, including this work, *Rosebushes under the Trees*, which he painted from direct observation of the location.

The Sunflower, Gustav Klimt, 1906–07, oil on canvas, 110 x 100 cm (43 ⅜ x 43 ⅜ in.), private collection

Painted during the summer after he completed *Rosebushes Under the Trees*, this work is uncharacteristic of Klimt's style in its naturalism. Following in the footsteps of Van Gogh, Klimt seems to have depicted the flower as a symbol of something else. Its shapes and composition has led to conjecture that the sunflower represents his muse Emilie Flöge or the lovers in his painting *The Kiss* (1907–08). It was painted in Litzlberg on Lake Attersee in a garden where Emilie posed for Klimt among the flowers for paintings and fashion photography. Klimt exhibited the work in 1908 in Vienna.

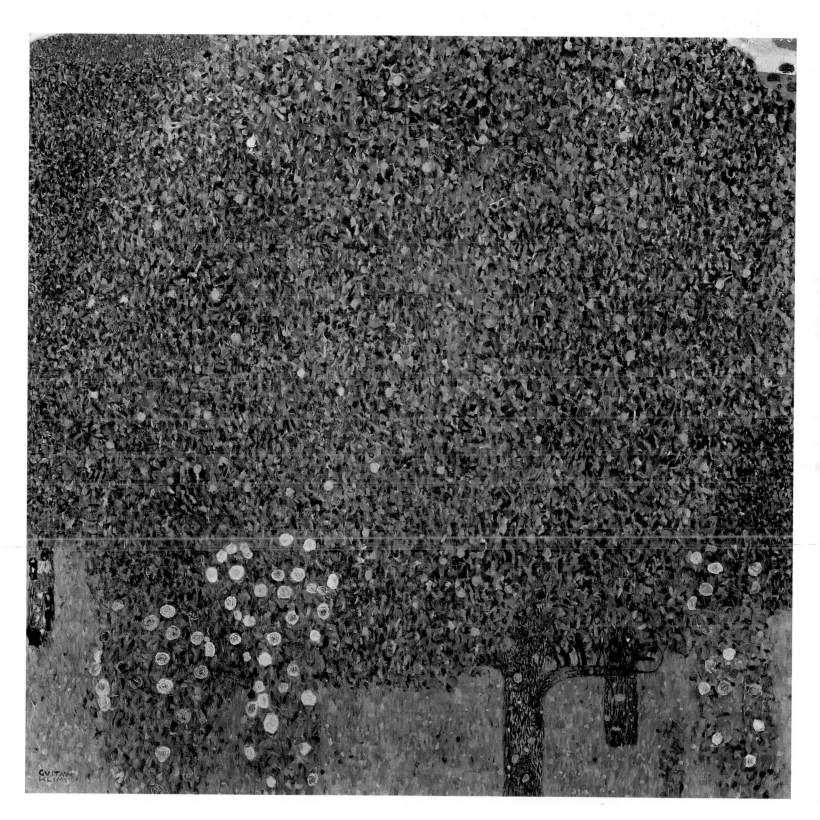

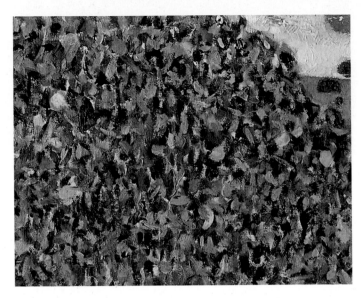

❶ LOCATION

For more than twenty years, from the time Klimt met Emilie, he took summer holidays with her and her family in Litzlberg on Lake Attersee, a large, picturesque lake in the Salzkammergut area of Austria. While there, Klimt often visited a small island castle, and painted the trees, bushes and flowers. A soft easterly wind known as the 'Rosenwind' (breeze of roses) crosses the castle's rose garden and fills the air over the lake with the smell of roses. It was Klimt's inspiration for this painting.

❷ JAPANESE INFLUENCE

Like many of his contemporaries, Klimt was inspired by Japanese art and design. With no horizon line and only the tiniest glimpse of sky, the flattened space and curving contours of this large work reflect the oriental compositional skills he so admired and that were being utilized in many aspects of Art Nouveau at the time.

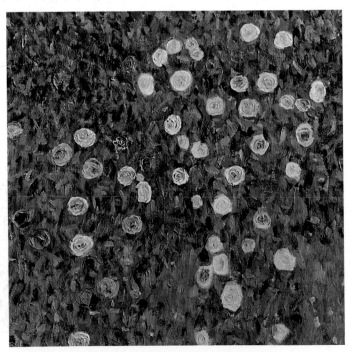

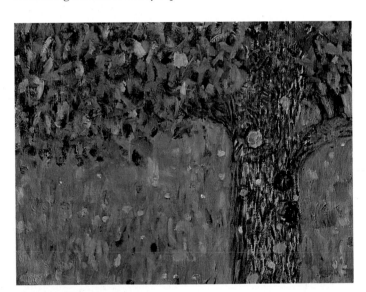

❸ FOLIAGE

Above a narrow band of meadow, the foliage here forms the main part of the painting. Klimt creates a network of dabs of paint ranging from bright blues, yellows, pale pinks, mauves and browns across the image, predominantly built up with angled, short marks of variegated greens.

While this work was painted during Klimt's Golden Phase, he has not used gold or silver leaf. However, his method still recalls the intricacy of medieval manuscripts and Byzantine mosaics as he did in his other Golden Phase paintings.

4 PALETTE

Klimt's painting method and luminous palette created the canvas's shimmering surface. His palette included zinc white, lemon yellow, light red, vermilion and alizarin crimson.

5 APPLICATION

Klimt coated the canvas with a cool, pale blue using a wide, flat brush. Then he covered the canvas with short, intense dots and dabs and small brushstrokes in a decorative, fluent style.

6 LIGHT

Klimt's intensely painted scene glows with rich light. His mass of flecks makes the leaves and blossoms seem to dissolve into each other, while the lighter leaves and flowers shimmer.

7 ABSTRACTION

If not for the tree trunks and grass, the work would appear abstract. Yet Klimt was not interested in creating abstract images and was compelled to cover his canvases densely.

Detail from *The White Rose and The Red Rose*, Margaret Macdonald Mackintosh, 1902, gesso set with glass beads and shell on hessian, 99 x 101.5 cm (39 x 40 in.), Hunterian Art Gallery, University of Glasgow, Scotland, UK

In Turin in 1902, the British artists and designers Margaret Macdonald Mackintosh (1864–1933) and Charles Rennie Mackintosh (1868–1928) showed some of their designs at a large international exhibition. This gesso panel was part of the couple's display called 'The Rose Boudoir'. They often featured roses in their designs as a feminine encapsulation of the grandness and abundance of nature. Two years earlier, Margaret exhibited at the Vienna Secession and her elongated, ornamental style influenced Klimt. In this work, the broad background swirls, fine lines and sensual, rhythmic compositional patterns can be seen to have had an effect on Klimt's theme of roses.

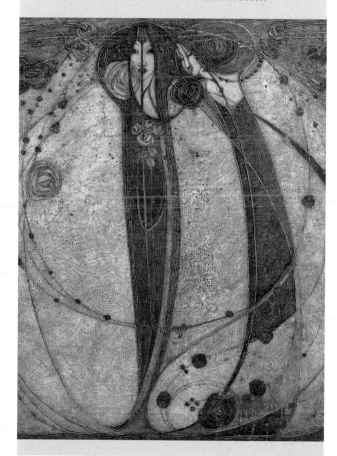

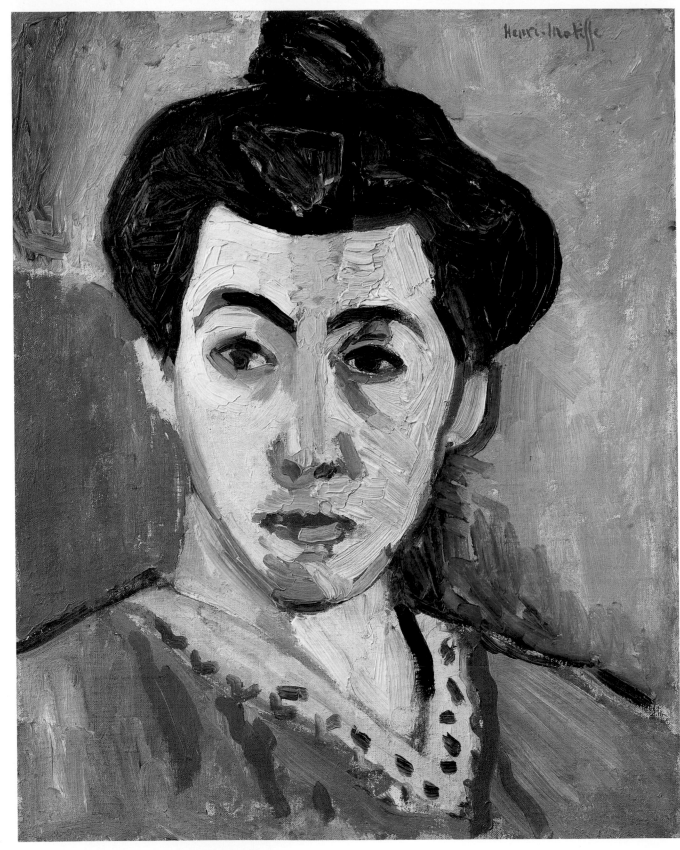

MADAME MATISSE, THE GREEN STRIPE

HENRI MATISSE

1905

oil on canvas
40.5 x 32.5 cm (16 x 12 ¾ in.)
Statens Museum for Kunst, Copenhagen, Denmark

OF ALL 20TH-CENTURY ARTISTS, Henri Matisse (1869–1954) is one of the most famous and influential, usually ranked alongside Pablo Picasso (1881–1973). With his expressive and balanced compositions, bold and sensual use of colour and skilful draughtsmanship, his art is among the most iconic of the period.

Born in northern France close to the Belgian border, Matisse began studying law in Paris at the age of twenty and passed his exams with distinction. In 1889, while recovering from appendicitis, his mother gave him a box of paints. 'From the moment I held the box of colours in my hands, I knew this was my life,' he recalled. In 1891, he returned to Paris, where he studied art at the Académie Julian and the École des Beaux-Arts. Inspired by the Impressionists and Van Gogh, he began experimenting with bolder colours and looser paint application. Other important influences included Cézanne, Gauguin, Paul Signac (1863–1935) and Japanese art, while visits to Corsica and the south of France intensified his interest in capturing light and colour. In 1905, he painted this portrait of his wife Amélie Parayre, which is unlike any other he had done. He had been hurt by the criticisms of a portrait of Amélie wearing a hat he had exhibited in the recent Salon d'Automne, and so created another portrait of her, saying that he only wished to express his feelings in his art.

The Salon d'Automne had been organized by Matisse and his friends in 1903 as an alternative to the conservative annual Paris Salon. In 1905, the vibrantly coloured, freely painted images that they exhibited there inspired the art critic Louis Vauxcelles to describe them as '*fauves*' (wild beasts). The ensuing scandal catapulted them from obscurity and the term 'Fauvism' stuck. Matisse was seen as the leader of the movement, and although it did not last long, Fauvism had an extensive impact on the development of modern art.

In contrast with the more flowing portrait of *Madame Matisse in a Hat* (1905), this portrait was structured and ordered. Matisse simplified her face, hair and clothes, and used impasto paint in large areas, few colours and tones.

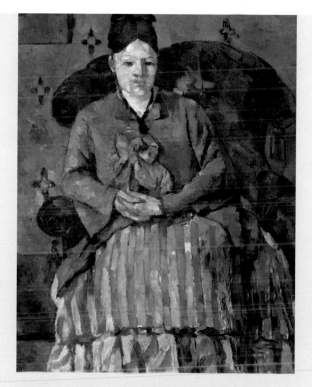

Madame Cézanne in a Red Armchair, **Paul Cézanne, c. 1877, oil on canvas, 72.5 x 56 cm (28 ½ x 22 in.), Museum of Fine Arts, Boston, USA**

Cézanne broke with traditional methods of perspective and paint application by using angled paint marks to visually describe structure and solidity. His wife, Hortense Fiquet sat for him twenty-seven times. In 1895, the art dealer Ambroise Vollard, who represented him as well as Matisse, exhibited this work in his gallery where Matisse saw it. The subtle variations of colour and tone are Cézanne's attempts at capturing three-dimensional structure on a flat surface, and Matisse's portrait of his wife Amélie in 1905 is a direct response to it.

IN DETAIL

1 STRUCTURE

Matisse uses colour to convey uplifting feelings and vivacity. Strong, sinuous brushstrokes and relatively unmodulated colour create emotional impact rather than verisimilitude. Much of the painting's strength and sense of solidity is created by the structure of the brushwork and the colour combinations. Planes of colour suggest three-dimensional structure rather than subtle colour contrasts to create effects of light and shadow.

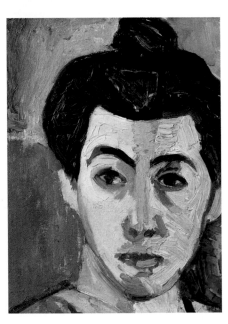

2 COLOUR

After spending the summer in the fishing village of Collioure with painter André Derain (1880–1954), Matisse was painting using a new method of vibrant colours and broad brushmarks, aiming to capture the sensation of sunlight rather than realistic details. The colour contrasts of this work are a continuation of that approach when he returned to Paris.

3 GREEN STRIPE

The green stripe down the centre of Amélie's face acts as an artificial shadow line and divides the face in the conventional portraiture style, with a light and a dark side, but Matisse does this chromatically more than tonally. The green stripe also anchors the portrait and conveys a sense of solidity. The highly visible brushstrokes create artistic drama.

4 COMPOSITION

The face takes up most of the canvas, and the background is divided into patches of mauve, orange, blue and green. The space across the composition is two-dimensional, with a hint of depth suggested by the dark area of shading above Amélie's left shoulder. The portrait is cut off at the top of the canvas, the face is frontal with the torso angled left.

❺ EMOTION

Matisse used colour to illustrate the emotions he felt for his wife as well as aspects of her personality. The yellow on the left of the painting suggests liveliness and laughter, while the pink implies warmth and kindness. Matisse and Amélie married in 1898. When he was still a struggling artist, she worked as a milliner to support them.

Colour wheel

German writer Johann Wolfgang von Goethe wrote poetry, dramas, memoirs, novels and treatises on botany, anatomy and colour. By 1800, he had written theories about colour interaction, simultaneous contrast and complementary colour effects. He also wrote about colour evoking emotions. In 1839, French chemist Michel-Eugène Chevreul expanded on these ideas in *De la loi du contraste simultané des couleurs* (*The Law of Simultaneous Contrast of Colours*), describing how colours appear to brighten when juxtaposed with their opposite on the colour wheel. Matisse's use of bright colour formed part of an expressive mood in the arts across Europe at the time that was indebted to Goethe.

Matisse sought to convey emotional power in his use of strong, sinuous brushstrokes, bright colour, flattened pictorial space and bold simplifications.

❻ LIGHT

Both sides of Amélie's face are illuminated with bright colours. It suggests at least two light sources, possibly one from her left and another from her front. The green stripe is a shadow, which suggests solidity and a direct source of light. Overall, the light is ambiguous.

❼ LINE

While colour, thick paint, flattened pictorial space and simplification express uplifting emotions, Matisse also used line expressively, like calligraphy. In some places it is thicker, then thinner, fluid and broken, so it forms organic shapes and divides colours.

❽ METHOD

Before painting, Matisse evenly covered a fine-grained canvas with a ground of chalk, oil, size (weak glue) and flake white oil paint. Next, he created the outlines with French ultramarine. Finally, he built up the work with thick layers of oil paint.

LES DEMOISELLES D'AVIGNON

PABLO PICASSO

1907

oil on canvas
244 x 233.5 cm (96 x 92 in.)
Museum of Modern Art, New York, USA

ONE OF THE MOST INFLUENTIAL ARTISTS of the 20th century, Pablo Picasso (1881–1973) was a painter, draughtsman, sculptor and ceramicist. During a career that lasted more than seventy-five years, he produced more than 20,000 works and changed the course of art. His originality, versatility, inventiveness and prolific achievement have left an unrivalled legacy. During his life, his revolutionary creations brought him widespread recognition and prosperity.

Born in southern Spain at the end of the 19th century, Picasso showed his artistic genius from an early age. He grew up admiring the work of El Greco (*c.* 1541–1614), Diego Velázquez (1599–1660) and Francisco de Goya (1746–1828). At the age of fourteen, he was accepted at the Llotja art academy in Barcelona, where he painted in a realistic and technically accomplished style. After moving to Paris in 1900, he became inspired by Manet, Degas, Henri de Toulouse-Lautrec (1864–1901) and Cézanne, as well as by African and Oceanic art. From that time, he experimented with numerous ideas, techniques and theories. Although many of his later styles have not been labelled, the earliest include his Blue Period (1900–04), Rose Period (1904–06), African Period (1907–09), Analytical Cubism (1909–12), Synthetic Cubism (1912–19), Neoclassical Period (1920–30) and Surrealism (1926 onwards).

After settling in Paris, Picasso broke with academic convention with his Blue and Rose Period paintings. Then in May or June 1907, he visited the Musée d'Ethnographie du Trocadéro (now the Musée de l'Homme) and later that year, he saw a Cézanne retrospective at the Salon d'Automne. Both experiences had an effect on him, and after producing hundreds of preparatory paintings and drawings, he painted *Les Demoiselles d'Avignon*. Overall, it reflected his responses to Cézanne's structured depiction of objects and figures, his own fascination with African, Iberian and Oceanic masks, as well as his complex relationships with women. This monumental work has frequently been described as the most important painting of the 20th century and the work that instigated Cubism. Yet initially it was viewed with shock and horror, and Picasso subsequently kept it hidden in his studio for nine years.

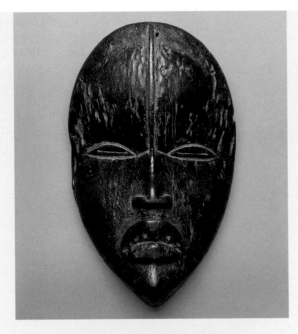

***Dean Gle Mask*, artist unknown, late 19th to early 20th century, wood and pigment, 9 ¾ x 6 x 3 in. (25 x 15 x 7.5 cm), Brooklyn Museum, New York, USA**

After visiting the Ethnography Museum in Paris, where he saw masks such as the one pictured, Picasso experienced a 'revelation'. His friend Matisse wrote that he was 'struck' by the purity of line of the African sculpture in the shop of Père Sauvage on the Rue de Rennes. He wrote: 'It was as fine as Egyptian art. So I bought one and showed it to Gertrude Stein… And then Picasso arrived. He took to it immediately.' The poet Max Jacob recalled visiting Matisse with Picasso and seeing it: 'Picasso held it in his hands all evening. The next morning, when I came to his studio, the floor was strewn with sheets of drawing paper. Each sheet had virtually the same drawing on it, a big woman's face with a single eye, a nose too long that merged into the mouth, a lock of hair on the shoulder.'

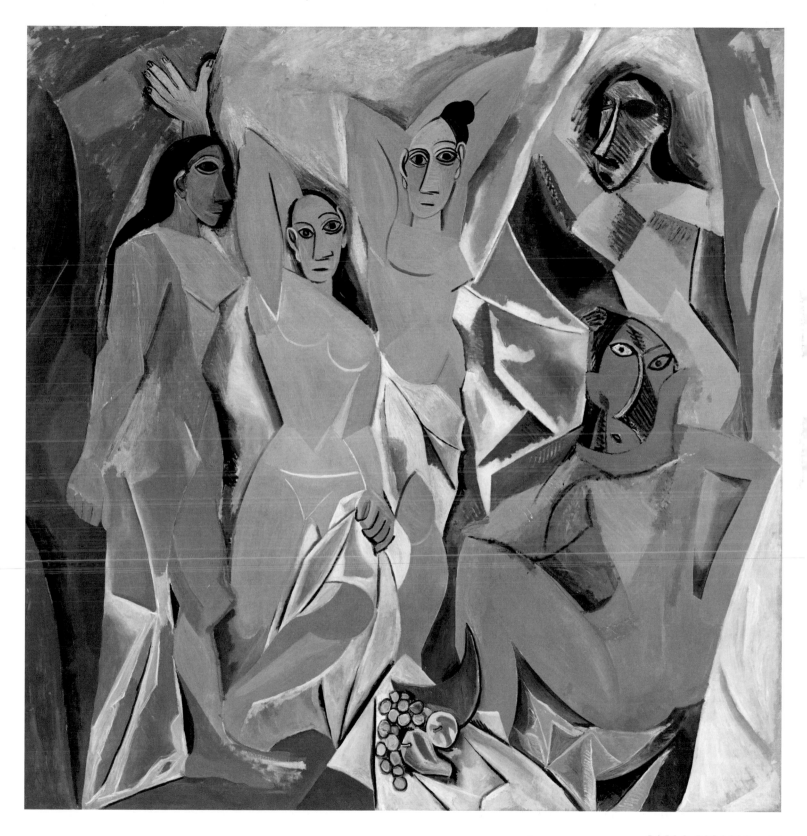

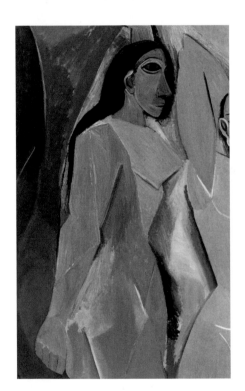

<div style="writing-mode: vertical">IN DETAIL</div>

1 IBERIAN FACES

Three masklike faces with enormous, almond-shaped eyes show the influence of ancient Iberian sculpture that Picasso had seen in the Louvre in 1906. By the time he painted this, he owned several Iberian statue heads that had been stolen from the Louvre. But in 1911, the 'affaire des statuettes' made headlines and he returned them. Here, the head in profile draws back a curtain to reveal two others staring out at viewers.

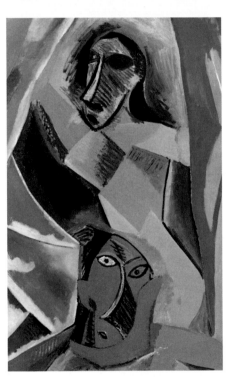

2 FEMALE/MALE

Five prostitutes from a brothel on a street named Avignon in the red-light district of Barcelona fill the canvas. Preparatory studies reveal that Picasso initially intended this figure to be a male medical student, warning of the consequences of dallying with prostitutes. The hand pulling back the curtain remains male.

3 AFRICAN MASKS

The heads of these two women resemble the African masks that Picasso saw in the Ethnography Museum in Paris. He said: 'The masks weren't just like any other pieces of sculpture… They were weapons… Spirits, the unconscious… emotion… *Les Demoiselles d'Avignon* must have come to me that very day….'

4 FRAGMENTATION

The angular figures are radically simplified with flat, geometric planes. Faces seen from the front have noses in profile. In turning objects and figures into fragmented forms and shapes, and spurning traditional tonal contrast or linear perspective, Picasso attacked the ideals of European art to initiate Cubism.

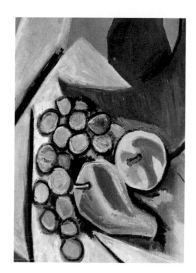

⑤ STILL LIFE

At the bottom of the canvas on a dramatically tilting tabletop is a small arrangement of fruit, with a scythelike wedge of watermelon behind a bunch of blue grapes, an apple and one or two pears. They are sharp and angular like the women's bodies. Fruit is a traditional symbol of sexuality and this grouping is deliberately sexual. It also pays homage to Cézanne.

⑦ DISTORTION

Despite the horror with which this painting was first received, it ushered in a new way of painting. Breaking traditional rules, Picasso replaced a fixed point of view and harmonious proportions, with multiple perspectives and distortion. He abandoned the Renaissance illusions of three-dimensionality. His rebelliousness paved the way for a freedom to create rather than imitate.

⑥ DRAPERY

Originally, Picasso painted a sailor in uniform in the centre of this composition. He represented lust, but like the medical student, Picasso chose to paint over him. So only women emerge from brown, white and blue curtains that resemble shattered glass. The apparent lack of depth creates ambiguity – are the figures in front or entwined in the curtains and sheets?

⑧ METHOD

Much of this is painted as if seen from several points of view at once. The picture plane is flattened and broken up into spiky shards. Picasso used an off-white ground on a fine-grained canvas and chose flat, pinky-peach paint for the flesh. He juxtaposed blue and orange to create the brightest effects. The work looks spontaneous but he did nearly one hundred preparatory sketches.

Detail from *Still Life*, Paul Cézanne, 1892–94, oil on canvas, 73 x 92.5 cm (28 ¾ x 36 ⅜ in.), Barnes Foundation, Pennsylvania, USA

The still life in *Les Demoiselles d'Avignon* is a homage to Cézanne, who revived the theme of still life and painted from different angles on one canvas. Cézanne was preoccupied with still life, and painted the same objects over and again. This concentrated study of familiar items enabled him to develop a new way of capturing his visual sensations. He believed that conventional perspective, which uses a single viewpoint, did not accurately reflect the way that people perceive the world. This powerful idea had huge repercussions on art that followed, and particularly on Picasso. The fusion of figures and background in *Les Demoiselles d'Avignon* was also inspired by Cézanne's painting *Bathers* (1898–1905).

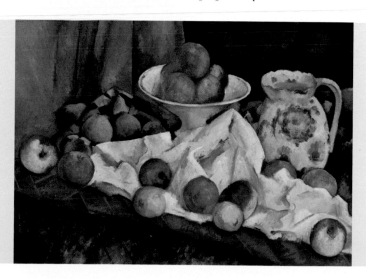

THE CITY RISES

UMBERTO BOCCIONI

1910

oil on canvas
199.5 x 301 cm (78 ½ x 118 ½ in.)
Museum of Modern Art, New York, USA

A PAINTER AND SCULPTOR, Umberto Boccioni (1882–1916) was one of the principal figures of the Futurist movement. Highly influential, he had a unique approach to the dynamism of form and the deconstruction of solid mass.

Born on the southern tip of Italy, Boccioni's family moved frequently, eventually settling in Catania, Sicily in 1897. At nineteen years old, he relocated to Rome and enrolled at the Accademia di Belle Arti where he met Gino Severini (1883–1966) and studied under Giacomo Balla (1871–1958) who promoted the Divisionist method of painting, using separate strokes of pure colour.

In 1907, he moved to Milan where in early 1910, he met Symbolist poet and theorist Filippo Marinetti, who had published his Futurist manifesto the previous year. In February 1910, under Boccioni's leadership, Balla, Severini, Carlo Carrà (1881–1966) and Luigi Russolo (1885–1947) signed the 'Manifesto of Futurist Painters'. It declared that Italy's classical past was a hindrance to the country's development as a forward-thinking, modern power.

Considered the first truly Futurist painting, *The City Rises* depicts a city being built, capturing the Futurists' admiration of dynamism and development. A large horse dominates the foreground while several figures struggle to gain control of it. They are blurred, communicating rapid movement, while the buildings in the background are rendered more realistically.

Antibes, the Pink Cloud, Paul Signac, 1916, oil on canvas, 71 x 91.5 cm (28 x 36 in.), Museum of Fine Arts, Boston, USA

Boccioni was inspired by Paul Signac (1863–1935). He admired his vivid palette and sense of dynamism expressed through short, dotlike brushmarks.

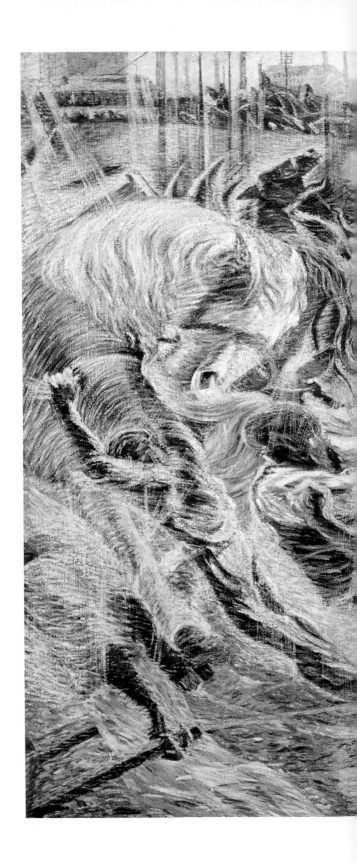

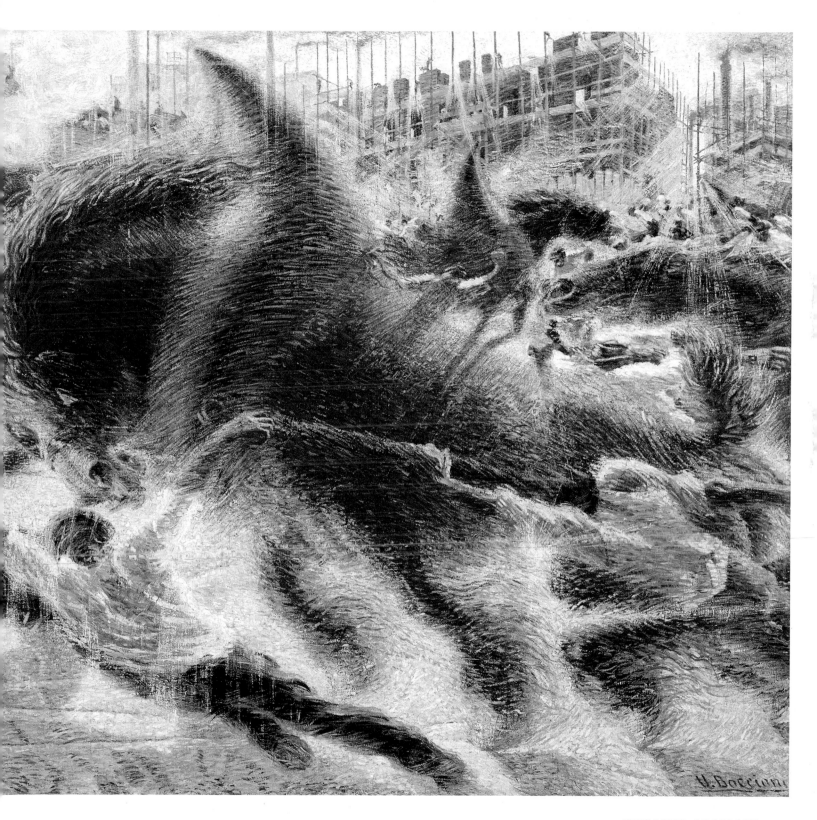

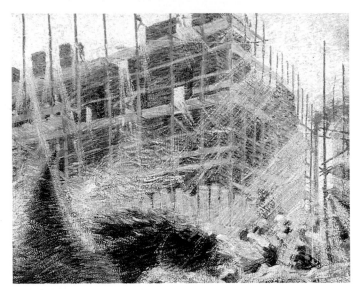

② BUILDINGS

Contrasting with the energy, strength and dynamism in the foreground, these buildings convey a stable serenity. The smooth, straight lines contrast with the fluid, curves of the action elsewhere. This is a growing city, indicated by the scaffolding surrounding the buildings.

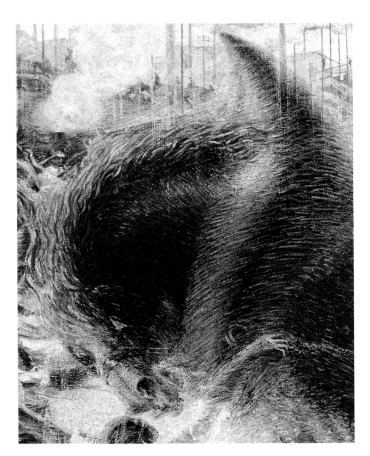

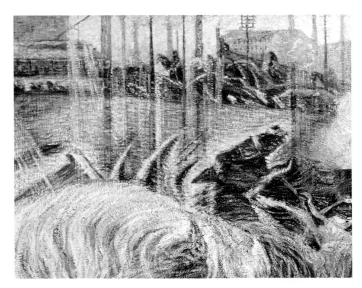

① HORSE

With apparent dynamism, this powerful horse turns its blinkered head. The strong, fast movement is conveyed with short, delicate, splinterlike brushmarks that create a blurring effect. The horse symbolizes work and speed in the building of a modern city. It represents movement, power and noise as the city is constructed.

③ MILAN V. VENICE

This depicts the urban area of Milan, which was perceived as progressive and ideally industrial by the Futurists. Many of them were disappointed with Italian cities such as Venice and Florence, that were steeped in history and celebrated for that. The Futurists believed that this preoccupation with the past was stifling.

④ COLOUR

With only small touches of other colours, this is predominantly painted in primary colours. Boccioni's palette for this comprised flake white, lemon yellow, cadmium yellow, light red, raw sienna, raw umber, vermilion, emerald green, ultramarine and ivory black.

⑤ PAINT APPLICATION

In illustrating dynamism and speed, this was not only the first Futurist painting – Futurism had been a literary movement for the first year of its existence – but an exemplary one. The wild energy of the horses and the dramatic angles of the figures are rhythmical and suggest machinelike uniformity, strength and speed.

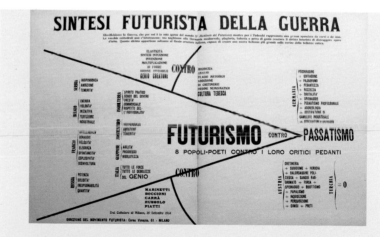

⑥ WORKERS

These men are working with enormous effort, their powerful bodies leaning at impossible angles as they exert themselves. Their activities celebrate a shared cause, masculinity and Boccioni's view of who will shape the future – the men who are in control of the world through physical strength.

The Futurists and war

In 1914, five years after Marinetti had published *The Manifesto of Futurism*, and four years after Boccioni's *Manifesto of Futurist Painters*, Marinetti produced another provocative manifesto *Futurist Synthesis of the War*. Signed by the main Futurists including Boccioni, it focused on their strong support for the glorification of war and its ability to annihilate Italy's classical heritage. At this point in history, they fervently believed that war was 'the world's only hygiene'.

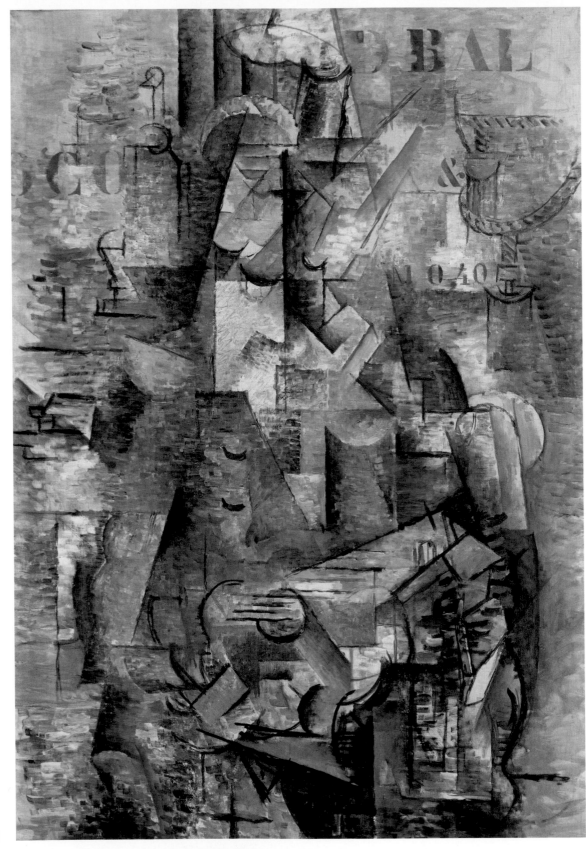

THE PORTUGUESE (THE EMIGRANT)

GEORGES BRAQUE

1911

oil on canvas
116.5 x 81.5 cm (46 x 32 in.)
Kunstmuseum Basel, Switzerland

STARTING HIS CAREER AS A MEMBER of the Fauvist movement, Georges Braque (1882–1963) developed Cubism after meeting Picasso in 1907. As the men collaborated, their paintings shared many similarities in palette, style and subject matter. After World War I, Braque developed a more personal style, using brilliant colours and textural effects.

Braque was born in the Parisian suburb of Argenteuil but grew up in Le Havre. Like his father and grandfather he trained as a house decorator, but he studied drawing and painting in the evenings at the École des Beaux-Arts in Le Havre. In 1902, he moved to Paris with his friends Raoul Dufy (1877–1953) and Othon Friesz (1879–1949). There he studied at the Académie Humbert and the École des Beaux-Arts, and was struck by the paintings of Matisse and André Derain (1880–1954) in 1905 at the Salon d'Automne where Fauvism emerged. Working closely with Dufy and Friesz, he painted flat, decorative compositions with intense colours, and after visiting Antwerp and the fishing village of L'Estaque near Marseille, he showed some of his Fauvist paintings at the Salon des Indépendants in 1906. In September 1907, he went to the Cézanne retrospective exhibition, and was one of the few who saw Picasso's *Les Demoiselles d'Avignon* in his studio later that year. Soon after, he and Picasso began working together and in 1908, he exhibited his painting *Houses at L'Estaque* that art critic Louis Vauxcelles described as being 'full of little cubes'. In 1912 with Picasso, Braque invented the *papier collé* collage technique in which they glued paper, cut-up advertisements and other materials to their canvases to add descriptive elements to their paintings. This was the first time that collage had been used in fine art and evolved from Braque's interest in creating effects from his training as a decorator. Braque and Picasso developed a painting style of intersecting, overlapping planes – not necessarily cubes – that was a groundbreaking method of depicting the world. It became one of the most important art movements of the 20th century. Braque's painting of a guitarist sitting in the window of a cafe-bar is one of his most sophisticated Cubist works, and exemplifies his Analytical Cubism phase.

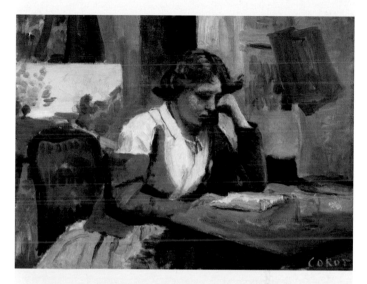

Young Girl Reading, Jean-Baptiste-Camille Corot, c. 1868, oil on paperboard on wood, 32.5 x 41 cm (12 ¾ x 16 ¼ in.), National Gallery of Art, Washington, DC, USA

French artist Jean-Baptiste-Camille Corot (1796–1875) painted landscapes, figures and portraits. His restrained palette here of soft greys, ochre, umber, greens and pink creates a contemplative atmosphere and contrasts with the vivid hues of the Impressionists, even though he influenced them and many others including Braque. This sombre palette was inspirational for Braque, along with his approach, which Corot explained: 'What there is to see in painting, or rather what I am looking for, is the form, the whole, the value of the tones... That is why for me the colour comes after, because I love more than anything else the overall effect, the harmony of the tones, while colour gives you a kind of shock that I don't like. Perhaps it is the excess of this principle that makes people say I have leaden tones.'

② FACE

This is a man's face – visual clues are provided, but the face is not described in detail as in most portraits. With Cubism, for the first time, viewers had to try to decipher and determine what they were seeing. The image has long been held to be of a Portuguese musician that Braque had seen in a bar in Marseille years earlier, although some research suggests the painting may depict a musician on a boat.

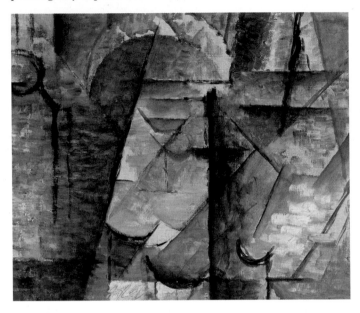

③ ROPE

This rope has long been considered to be a curtain cord, holding back the heavy, draping curtain behind the figure. The other, more recent suggestion that this is a musician on a boat, would suggest that this is a heavy rope tied to a bollard to secure the vessel.

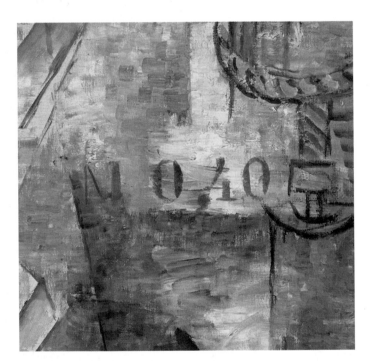

① NUMBERS

To provide clues about the subject and emphasize the flatness of the canvas, Braque added stencilled numbers and letters to the painting. He wrote: 'As part of a desire to come as close as possible to a certain kind of reality, in 1911 I introduced letters into my paintings… They were forms which could not be distorted because, being quite flat, [they] existed outside space and their presence in the painting, by contrast, enabled one to distinguish between objects situated in space and those outside it.'

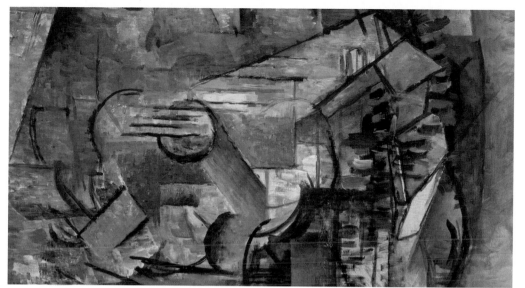

④ GUITAR

Cubism moved away from the pictorial illusionism that had dominated Western art for centuries, which made images more difficult to comprehend, so Braque gives certain clues. In the centre of the painting, diagonal lines and intersecting shapes allude to a guitar. Tonal shading creates a sense of solidity, but then disappears. Additionally, the diagonal pyramidal shape seems to be present, then disappears. This forming and reforming was part of the Cubist approach, inviting viewers to investigate visually.

Braque learned decorative paint effects from observing his father. Here he stencilled letters and numbers. In other works, he blended pigments with sand. His faceted lines and planes border on abstraction as he expresses the essence and structure of his subjects rather than directly representing them.

⑤ STENCILLED LETTERS

The letters indicate which way up the painting should hang. The 'D' is possibly the last letter in the word 'grand' for 'Le Grand Bal' and suggests a dance-hall poster, so helping to convey atmosphere. Stencilled letters in Braque's paintings were one stage further towards adding collage materials to his paintings.

⑥ COLOUR AND LIGHT

Braque used limited, subdued hues; here solely brown tones, in order to focus viewers' attention on form. Light and dark areas suggest chiaroscuro and transparent planes that allow viewers to see through the image, from one level to another. In other places, transparent planes reveal lines and shapes beneath.

⑦ SPACE

The image is shown from several angles; there is no one fixed viewpoint. Instead, fragmented and splintered facets are layered in flat intersecting planes. Braque was exploring the structure of all he viewed. In dissecting the figure and objects around him, the lines and planes interact dynamically with the space around it.

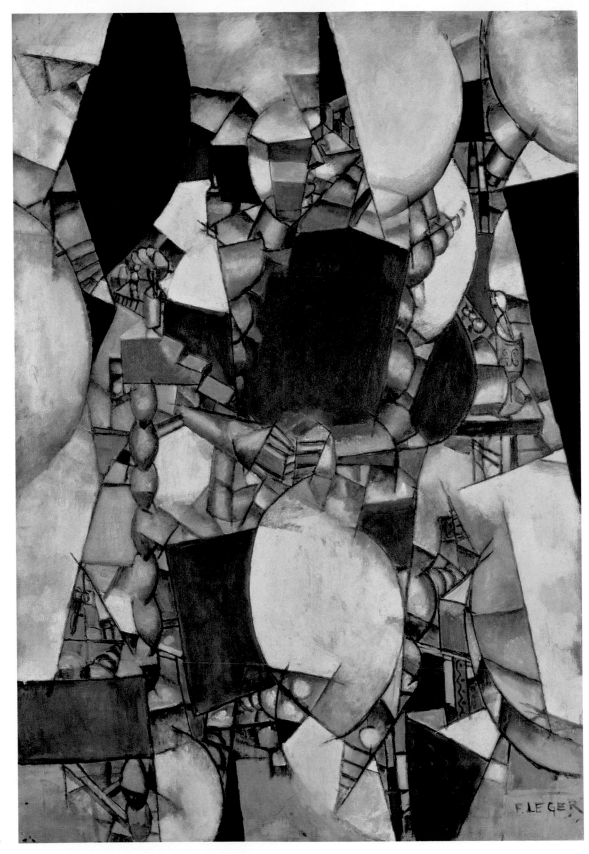

THE WOMAN IN BLUE

FERNAND LÉGER

1912

oil on canvas
193.5 x 129 cm (76 ⅛ x 50 ⅞ in.)
Kunstmuseum Basel, Switzerland

EIGHT YEARS AFTER PAINTING this Cubist work, Fernand Léger (1881–1955) became friends with the pioneering Swiss architect Le Corbusier and socialized with his friends and colleagues who, like him, were fascinated by machinery, speed and movement. Before becoming a painter, Léger was apprenticed to an architect and some years later, while studying in Paris at the École des Arts Décoratifs and the Académie Julian, he supported himself working as an architectural draughtsman. Architecture and machines always had a powerful influence on his work.

Born in Normandy, Léger trained as an architect, and moved to Paris in 1900. He did military service from 1902 to 1903 and then studied art. He finally began working as an artist in 1906. After seeing the Cézanne retrospective at the Salon d'Automne in 1907, his Impressionist-style of painting was replaced by an angular approach. While he remained a painter, he also produced ceramics, films, set designs, stained glass, prints and illustrations. His paintings feature geometric shapes, illusions of three-dimensional forms and primary colours.

In 1909, Léger moved to the artists' residence La Ruche in Montparnasse. There, he befriended artists including Braque, Picasso, Robert Delaunay (1885–1941) and Marc Chagall (1887–1985), and the writer Guillaume Apollinaire. In 1910, he and Delaunay visited the Galerie Kahnweiler, where they saw Cubist paintings. The following year, Léger exhibited paintings at the Salon des Indépendants that led to his recognition as a Cubist. He continued to exhibit at the Indépendants and the Salon d'Automne until he was drafted into the army in 1914. After being gassed, he was released from the army in 1917.

By the time he painted this work, Léger was living and working in a loft studio in the Rue de l'Ancienne Comédie on the Left Bank. His Cubist style and interest in machines and other modern industrial objects are apparent. This is an abstraction, in that it represents a woman, but it is a distorted interpretation. Contrasts of colour, juxtapositions of curved and straight lines, and solid- and flat-looking planes create a powerful effect that Léger believed expressed modern life.

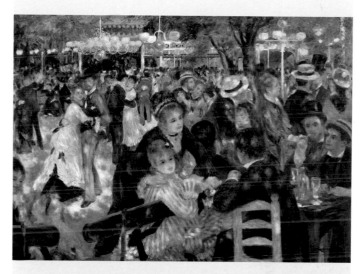

Dance at Moulin de la Galette, Pierre-Auguste Renoir, 1876, oil on canvas, 131.5 x 176.5 cm (51 ¾ x 69 ½ in.) Musée d'Orsay, Paris, France

Renoir's aim here was to convey the vivacious and joyful atmosphere of this popular dance garden in Montmartre. His depiction of the moving crowd, dappled in both natural and artificial light, is painted with vibrant colours and lively brushstrokes. Some of his friends feature in the work but overall the painting was about exuberance, Parisian life and light. Léger maintained that he and the other Cubists were primarily inspired by Impressionism. His *Woman in Blue* was influenced by Renoir's palette – that included lead white, cobalt blue, viridian, chrome yellow, chrome orange, vermilion, red lake and French ultramarine – and apparent breaking up of forms across the composition. In a lecture, he explained: '…the realistic value of a work of art is completely independent of any imitative character… The Impressionists were the first to reject the absolute value of the subject….'

② SHAPES

Broken shapes are distributed across the canvas. The seemingly abstract deep blue shapes appear to float, but can also be seen as the figure of a woman. Her blue dress, in both curving and trapezoid shapes, dominates the composition, set against large white and creamy lemon semicircular shapes and smaller circles, squares, trapezoids and cylindrical shapes.

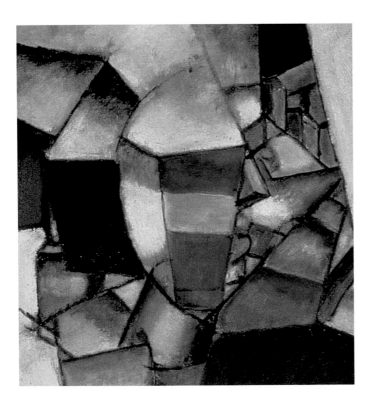

③ CUBISM

This is Léger's personal form of Cubism. He achieved a sense of rhythm across the surface of the composition by breaking his figures and background into splintered, curving and overlapping planes. Made up of geometric forms, this is either the woman's white blouse, fragments of a tablecloth, or parts of a cloud. The small geometric shapes indicate other elements of furniture behind her.

① COLOUR

This is the woman's profile. Léger intensified the colours of his main objects, stressing colour and using a restricted palette, only slightly modifying the pure colour. His palette included flake white, ivory black, French ultramarine, cadmium yellow and deep madder. To preserve what he called 'a very red red, and a very blue blue', he defined each coloured area with black outlines.

4 MACHINES

Created to look machinelike and mechanical, these are the woman's arms and hands. They are angular, grey and shaded as if made of metal to appear almost robotic. Like most Cubist paintings, this entire work can be confusing and quite difficult to decipher. Nevertheless, Léger maintained that art should be accessible to everyone.

5 SIDE TABLE

Within a few months, Léger produced three major interpretations of this theme of a woman in blue as his style shifted towards abstraction. This is the second and largest. The woman is sitting at a table sewing, her elbow leaning on it, a cup with a spoon next to her. It is a traditional subject, handled in a nontraditional fashion.

6 SMOKE

White shapes across the canvas describe clouds or puffs of smoke. Some emerge from distant chimneys, some are from cigar smoke in the foreground. The contorted, complicated shapes are barely decipherable – one of the issues with Cubism as a whole. For instance, this twisted vertical object is a chair leg with another chair back in front of it. The blue is the skirt of the woman's dress.

Sainte-Chapelle, Paris, France

Built in the 13th century, the Sainte-Chapelle (Holy Chapel) is a Gothic-style royal chapel on the Île de la Cité in the centre of Paris, that was close to Léger's loft studio in the Rue de l'Ancienne Comédie, where he painted *The Woman in Blue*. The most famous features of the chapel are its stained-glass windows. Familiar with these windows, Léger was clearly inspired by their colours, shapes and defining black outlines.

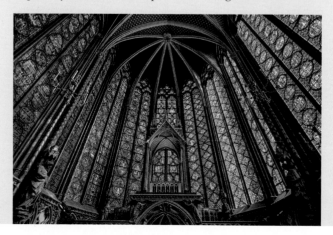

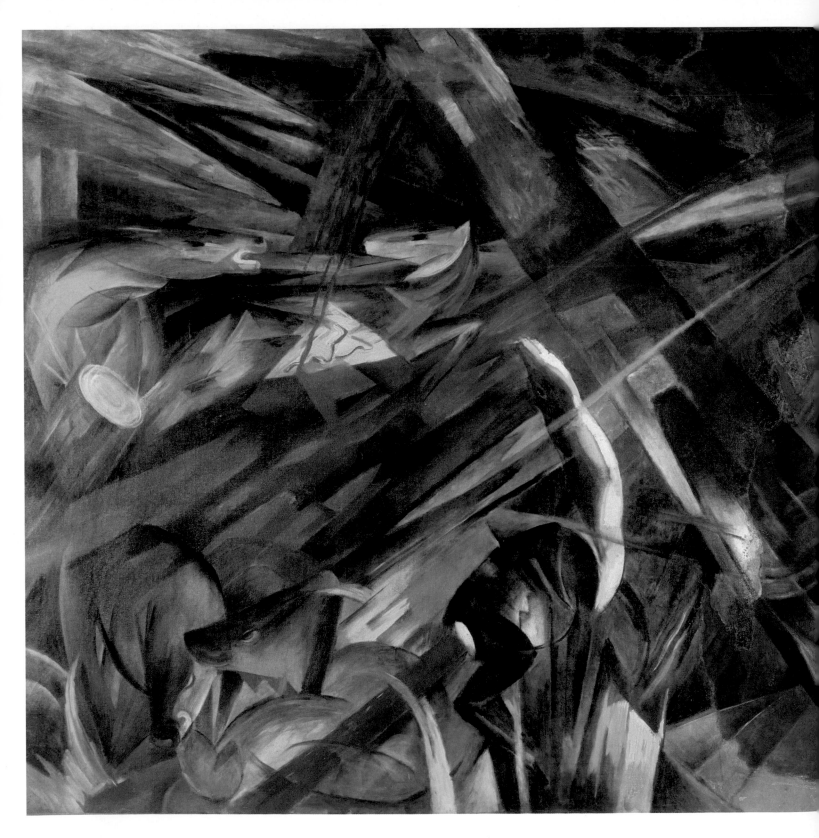

THE FATE OF THE ANIMALS

FRANZ MARC

1913

oil on canvas
194.5 x 263.5 cm (76 ⅝ x 103 ¾ in.)
Kunstmuseum Basel, Switzerland

A PIONEER OF GERMAN EXPRESSIONISM, Franz Marc (1880–1916) was interested in spirituality and primitivism, and for most of his life believed that animals were innocent victims. He depicted the world seen through their eyes.

Born in Munich, Marc studied philosophy and then enrolled at Munich's Academy of Fine Arts in 1900. Soon, the contemporary styles of Jugendstil inspired him to move away from the realism taught at the Academy and he began working with bold colours and angular shapes. In 1903 and 1907, Marc spent time in Paris and studied the work of the Impressionists and Post-Impressionists. In 1905, he met the Swiss artist Jean-Bloe Niestlé (1884–1942), whose animal paintings influenced him. He was also inspired by Van Gogh, the vibrant colours of the Fauves and the multiple viewpoints of Cubism and Futurism. In 1911, he and Wassily Kandinsky (1866–1944) founded *Der Blaue Reiter* (The Blue Rider), a journal and artists' group. After meeting Robert Delaunay, he began experimenting with simultaneous colour contrasts.

Painted in 1913, *The Fate of the Animals* was Marc's premonition of World War I. Vivid colours and jagged forms depict man's destruction of the natural world.

Windows Open Simultaneously, Robert Delaunay, 1912, oil on canvas, 45.5 x 37.5 cm (18 x 14 ¾ in.), Tate, Liverpool, UK

Robert Delaunay (1885–1941) painted several images of the Eiffel Tower. Influenced by Cubism, he depicted the tower from multiple viewpoints, yet unlike the muted colours employed by Braque and Picasso, he used bright colours. The poet Apollinaire described Delaunay's bright, angular style as Orphism or Orphic Cubism. The brilliant colours and fragmented forms express optimism for the future, whereas Marc's work is foreboding.

② COLOUR THEORY

By late 1910, Marc had formed his personal *farbentheorie* (colour theory). Blue was masculine, representing austerity, durability and spirituality. Yellow was feminine: gentle, happy and sensual. Red represented the material world, brutal and, as he wrote: 'always the colour to be opposed and overcome by the other two'.

① DEER

Two years after painting this work, Marc wrote about his reasons for depicting animals: 'The ungodly people around me (particularly the men) did not arouse my true feelings, whereas the undefiled vitality of animals called forth everything good in me… I found people "ugly" very early on; animals seemed to me more beautiful, more pure….' Central to the composition, the deer curves its neck to look at a tree about to fall. As the deer twists away from the falling tree, it expresses ideas about sacrifice.

③ PALETTE

Van Gogh and Delaunay's use of the law of simultaneous contrast probably had the most effect on Marc's palette. Here it consisted of flake white, zinc white, lemon yellow, red earth, vermilion, alizarin crimson, emerald green, viridian, French ultramarine, cobalt violet and ivory black.

Marc built on the idea of colour symbolism that had been pioneered by Van Gogh. He used unnatural colours to represent emotion in images of the natural world.

TECHNIQUES

④ RED BOARS

Painted in alizarin crimson and touches of white, with French ultramarine for the darkest tones, these are two boars about to be engulfed by the flames.

⑤ GREEN HORSES

Swordlike flames are about to kill two green horses. The coloured shafts are arranged around the composition and they fall in a green splintered shape.

⑥ BROWN FOXES

The right of the painting is depicted in brownish tones. It is not clear why, but the four foxes here are the only animals that are not in harm's way.

⑦ LINES

Originally this painting was called *The Trees Showed Their Rings, the Animals Their Veins*, and lines predominate. However, none are horizontal or vertical, and the diagonal shafts create tension. The animals appear on these diagonals that resemble long sharp splinters, pointed flames or daggerlike sparks.

⑧ FIRE

The fate of the animals is a man-made disaster. It is a forest fire that creates terror, suffering and destruction. Sparks of the fire emerge from an unknown source and are spreading. Red and yellow diagonal lines cut across the green of the forest towards the animals, and notably behind the deer.

The Red Dog (Arearea), **Paul Gauguin, 1892, oil on canvas, 75 x 94 cm (29 ½ x 37 in.), Musée d'Orsay, Paris, France**

The Post-Impressionists had a strong impact on Marc, especially Gauguin, Cézanne and Van Gogh. Gauguin's colours and focus on simplifying the natural world enthused him. Gauguin painted this in Tahiti soon after arriving there in 1891. An imaginary scene, it blends dreams and reality, with two women sitting on the ground, a blue tree behind them and a red dog in the foreground. Vividly coloured organic shapes make up the landscape, while deeper in the background some women worship a statue. He believed that the painting was one of his best works. Through it, he aimed to impress those back in Europe with the beauty and exoticism of Tahiti, even though in reality, it was fairly modernized.

FIVE WOMEN ON THE STREET

ERNST LUDWIG KIRCHNER

1913

oil on canvas
120 x 90 cm (47 ¼ x 35 ⅜ in.)
Museum Ludwig, Cologne, Germany

ONE OF GERMANY'S MOST influential Expressionist painters, Ernst Ludwig Kirchner (1880–1938) was born in Bavaria and studied architecture at Dresden Technical High School from the age of twenty-one. After finishing his studies, however, he decided to become a painter. Drawing inspiration from Albrecht Dürer (1471–1528), Van Gogh, Gauguin, medieval and primitive art and Neo-Impressionism, from the start, he renounced conventional approaches. In 1905, he and three fellow architectural students, Fritz Bleyl (1880–1966), Karl Schmidt-Rottluff (1884–1976) and Erich Heckel (1883–1970), founded *Die Brücke* (The Bridge). It was an artists' group that rejected traditional academic art, but sought to form a bridge between classical art and contemporary ideas.

Motivated by angst about the state of the world in the early 20th century, Kirchner produced distorted paintings, woodblock prints and sculpture, focusing on the human figure and aiming to create emotional effects. Fascinated by Dürer's woodcuts, he tried to emulate and modernize them with his style of pared-down lines and dynamic compositions. In painting he worked with coarse brushmarks, unnatural and discordant colours, and contorted shapes.

In 1911, Kirchner moved to Berlin, where he discovered new inspiration in and around the city. From 1913 to 1915, he painted *Strassenszenen* (street scenes) of Berlin – a series consisting of eleven paintings, thirty-two sketchbook pages, fifteen ink-brush drawings, seventeen chalk pastel drawings, fourteen woodcuts, fourteen etchings and eight lithographs. Often featuring prostitutes, the street scenes show how Berlin was developing into a metropolis. The series became a key part of German Expressionism, and Kirchner's painting, *Five Women on the Street*, was the first of the series. Five prostitutes are walking along a Berlin street; their plumage-type collars and hats and the pointed elements of their clothes suggest birds of paradise or perhaps even birds of prey. The scene is deliberately threatening and uncomfortable. The fractured, spiky figures embody the feelings of foreboding pervading Germany and much of Europe at the time.

Landauer Altarpiece: Adoration of the Trinity, **Albrecht Dürer, 1511, oil on panel, 135 x 123.5 cm (53 x 48 ⅝ in.), Kunsthistorisches Museum, Vienna, Austria**

This altarpiece by Dürer depicts God the Father holding the cross on which Jesus is suspended, moments before his death. Above, in a ray of golden light, is the Holy Spirit in the form of a dove. With great skill, Dürer painted a crowd of saints and ordinary mortals. Throughout his career, Kirchner admired Dürer and maintained: 'Albrecht Dürer is the greatest German master... the new German art will find its father in him.'

② COLOUR

Although green and black dominate the composition, various colours have been used, including raw umber, vermilion and ivory black. Pale and deep blue-greens appear with more sickly yellow-greens, plus blue-black, indigo and golden yellow.

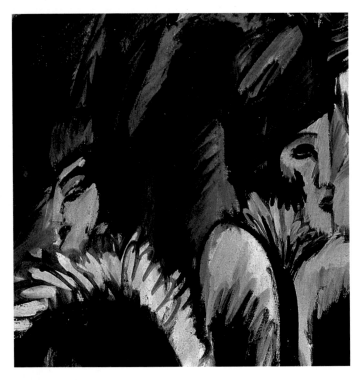

① BIRDLIKE

The women's collars and hats cascade with their feathery plumage, suggesting birds, but with menacing rather than exotic connotations. These two fashionable women, with their angular, haughty and heavily made-up faces, and fur or feathered collars should be glamorous, but instead appear hostile, even witchlike. Intentionally ominous, they could be models on a catwalk or even distortions in a warped mirror.

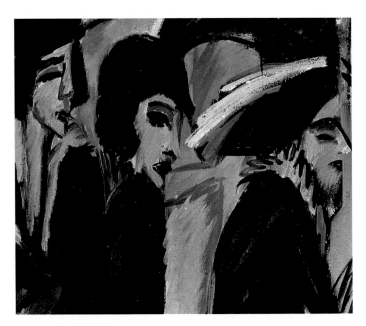

③ THREE WOMEN

These three women with their chilling, masklike faces appear to be looking in a shop window. Some of the ghastly sap green that reflects on them is the light from the display that is holding their attention. Hatched lines indicate reflections on the glass.

④ CAR

A green car has pulled up beside the women. The unseen driver appears to be about to approach the prostitutes. Kirchner was implying the corrupt morals of German society. At the time in Berlin, prostitutes were a dichotomy. Often taken as escorts to important events, they were also held in contempt. The women are wearing hobble skirts, a fashion of the period designed by couturier Paul Poiret.

⑤ SPACE

The five women appear to be on a stage, almost as if they are about to perform. There is little to be seen around them, even the car and shop window are only suggested. They are confined within the image, just as they are restricted by their profession; their environment closes around them.

⑥ LES DEMOISELLES

The composition with the five prostitutes recalls Picasso's *Les Demoiselles d'Avignon*. These five prostitutes are also distorted. Kirchner uses them to question conventions of aesthetics and art, and of the female form.

⑦ HANDS

This woman's hands epitomize the painting. Like the feathery, furry plumage that adorns the women's upper bodies and heads, the hands appear boneless and shapeless.

Evening dress, Muguette Buhler, 1922–24, pencil and gouache on paper, 30 x 22 cm (11 ¾ x 8 ¾ in.), private collection

Fashion illustrator Muguette Buhler (1905–72) worked for many couturiers during the early to mid 20th century. This is her example of an evening gown of the period designed by Paul Poiret. The silhouetted, clinging fabrics and feathers were in vogue, and most saw them as soft and feminine. Although many onlookers admired the loss of petticoats and corsets as a positive move into the modern age, Kirchner recognized ominous underlying elements. In emphasizing extreme thinness and sharp-angled outfits, and exaggerating the contrast of green and black, he used these new fashions to enhance the threatening and malevolent atmosphere.

VIOLIN AND GUITAR

JUAN GRIS

1913

oil on canvas
100.5 x 65.5 cm (39 ½ x 25 ¾ in.)
private collection

JUAN GRIS (1887–1927) WAS born in Madrid and moved to Paris as a teenager. Growing up in Madrid, Gris had been educated at the Escuela de Artes y Manufacturas (School of Art and Manufacturing) from 1902 to 1904, in mathematics, physics and mechanical drawing. Yet he found it confining, and changed to study art. From 1904, he studied painting with José Moreno Carbonero (1860–1942), a successful artist who had also taught Salvador Dalí (1904–89) and Picasso. In 1906, he moved to Paris, where he lived in the Bateau-Lavoir studios in Montmartre artists' quarter. There he met Picasso, Braque, Matisse and the US writer Gertrude Stein, who became a collector of his work. Initially working as an illustrator and satirical cartoonist for magazines and periodicals, he also painted, and became influenced by Picasso and Braque's new style of painting. He soon began experimenting with a reduced palette, breaking down his subjects into geometric planes.

While retaining the fragmented forms and shapes of Picasso and Braque, Gris began developing his own bold, graphic approach with bright colours and smooth tonal gradations. Occasionally incorporating fairly large pieces of newsprint and advertisements into his work, he became a precursor of Dada and Pop art. Later, like Picasso, Gris designed costumes for the Ballets Russes ballet company based in Paris. In 1913, he signed a contract with the German art dealer Daniel-Henry Kahnweiler, giving him the exclusive right to sell his work. Kahnweiler had similar arrangements with Picasso and Braque. It is unclear why, but Picasso resented him. In her memoir, *The Autobiography of Alice B. Toklas* (1933), Stein wrote: 'Juan Gris was the only person whom Picasso wished away.'

In mid August 1913, Gris travelled to Céret, a small town in the Pyrénées-Orientales region, near the Spanish border where a small community of young avant-garde artists were staying, including Picasso, Braque and Matisse. It was Gris's first trip away from Paris since 1906, and as close as he would ever go to his homeland because he had evaded compulsory Spanish military service and would have been prosecuted if he returned. He remained in Céret until the end of October, painting profusely. *Violin and Guitar* is one of twenty still lifes of musical instruments that he produced there.

Still life with Musical Instruments, Books and Sculpture,
Evaristo Baschenis, *c.* 1650, oil on canvas, 94 x 124 cm (37 x 48 ¾ in.),
Museum Boijmans Van Beuningen, Rotterdam, Netherlands

Descending from a family of artists, the Italian Baroque painter Evaristo Baschenis (1617–77) is best known for his still lifes of musical instruments. For the purpose, he became friendly with a family of violin makers from Cremona. Although still lifes were common in the Dutch Republic during the 17th century, they were unusual among Italian artists. Coupled with his close scrutiny of forms, shapes, shadows, textures and highlights, rather than dramatic Baroque-style religious or mythological stories, Baschenis was unique. His style was directly inspired by fellow Italian painter Caravaggio (1571–1610), in much the same way that Gris was inspired by Picasso.

② RHYTHM

This is built on a series of rhythmical lines, shapes and angles that follow the mathematical ratio known as the Golden Section, which has been used in art for thousands of years. However, Gris did not adhere to this precisely, but created a harmonious and ordered rhythm through juxtapositions of geometric shapes and colours.

① WOOD EFFECT

Many historians describe 1913 as the beginning of Gris's mature phase of painting. Despite Picasso's ambivalent feelings towards Gris, he admired *Violin and Guitar* and praised it to Kahnweiler. This painting demonstrates Gris's skill in depicting textures such as wood. Although it does not contain a collage, the layering of painted shapes and planes are like a collage, combining representation with fantasy.

③ VIOLIN

As Picasso, Braque and Cézanne used traditional elements within their paintings, so did Gris. Violins suggest both high and low art. Overall, the curving contours of the violin appealed to Gris's sense of design.

Planning for Gris was a lengthier process than for other Cubists. He measured and calculated exactly where he would place each line, what shapes would align with others, where each colour and tone would be situated. The whole became an interlocking arrangement that was devoid of any superfluous decoration or detail. He usually executed a meticulously rendered drawing in preparation for each painting, drawing the lines with compasses and a ruler.

④ COMPOSITION

Gris flattens his composition into a grid of overlapping planes. Within the grid, he offset and balanced light and dark. The instruments have been disassembled into angled planes, overlapping into a cluster that is an aesthetically pleasing design.

⑤ PALETTE

In 1913, Gris began to enrich the colour and forms of his paintings as demonstrated here with his contrasts of soft, warm colours with cool blue and turquoise. His use of colour strengthens his composition. Employing the most varied, contrasting chromatic harmonies he could devise, Gris carefully calculated the tonal ambience of his subject and setting.

⑥ BRUSHWORK

Some elements are painted realistically, in order to be recognizable as tangible objects, such as the violin, guitar, wooden floorboards and patterned wallpaper. These are created with contrasting brushstrokes, like the fine waving lines and the purple violin case with its softly graduating tones. The plain, less lifelike geometric shapes are depicted with flat, even brushmarks.

⑦ LAYERING

The flattened planes, representation of wood grain, and the striped and scrolled pattern of wallpaper are layered to emulate Braque and Picasso's *papiers collés* of late 1912 and early 1913 that had fascinated Gris before he left for Céret. The volume that characterized his early works has disappeared in favour of a direct fragmentation of space, attained by means of horizontal and vertical lines, and by layering shapes, lines, colours and paint.

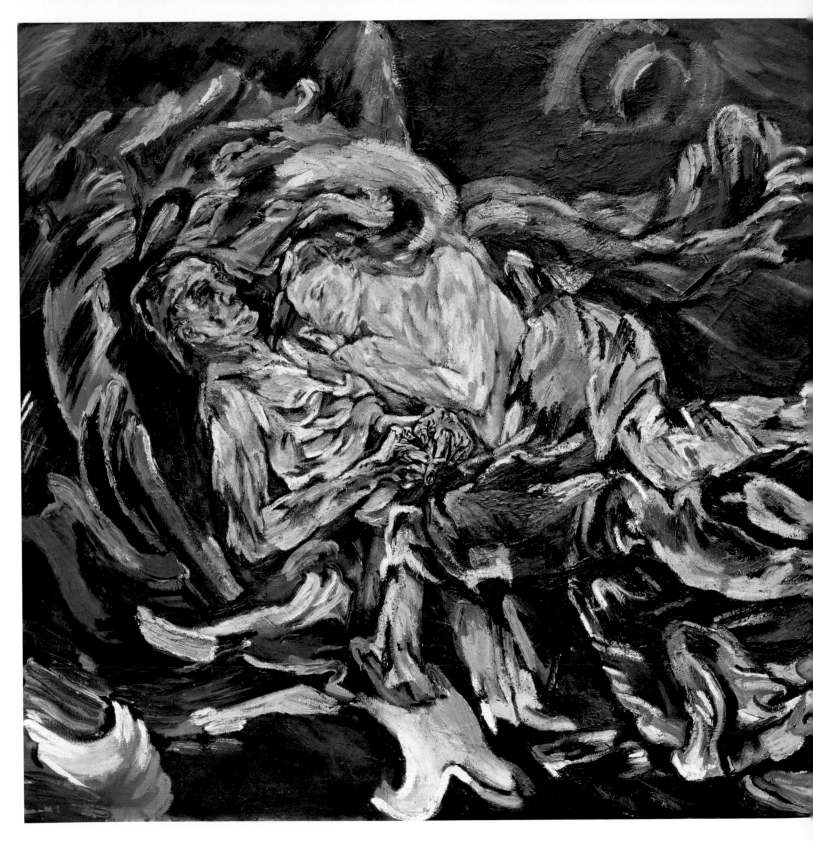

THE BRIDE OF THE WIND

OSKAR KOKOSCHKA

1913

oil on canvas
180.5 x 220 cm (71 x 86 ¾ in.)
Kunstmuseum Basel, Switzerland

ONE OF THE LEADING exponents of Expressionism,
Oskar Kokoschka (1886–1980) was born in Pöchlarn in
Austria, but after his father went bankrupt in a financial crash
in 1889, the family moved to Vienna, where Kokoschka's father
worked as a travelling salesman. After being inspired by the
stained-glass windows and Baroque frescoes of the Church
of the Piarist Order where he sang in the choir, Kokoschka
won a scholarship to study at the School of Arts and Crafts
in Vienna, where he learned drawing, lithography and
bookbinding. In 1907, he became a member of the Vienna
Crafts Studio, producing work influenced by Art Nouveau.
The following year, he met the Viennese architect Adolf Loos,
who helped to launch his artistic career. At the same time,
Kokoschka composed plays for the new Expressionist theatre,
in which he conveyed his humanist philosophy. He also
painted portraits, using delicate, agitated lines, colour
and exaggerations of features and gestures to express his
sitters' psychological states.

This is Kokoschka's most famous work, also known as *The
Tempest*. It is a self-portrait of Kokoschka with his lover Alma
Mahler (1879–1964), the widow of composer Gustav Mahler.

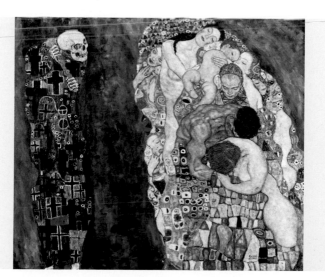

Death and Life, Gustav Klimt, 1915,
oil on canvas, 178 x 198 cm (70 ⅛ x 78 in.),
Leopold Museum, Vienna, Austria

Klimt began this in 1908, the same
year as the 'Kunstschau Vienna' show
he helped stage. Klimt recommended
that Kokoschka should be one
of the exhibiting artists. The style
and composition of this painting is
comparable to Kokoschka's *Bride*. Early
in his career, Kokoschka was extremely
influenced by Klimt's style and themes
of women, life and death.

IN DETAIL

① ALMA

A composer, sculptor and writer, Alma Schindler had affairs with some of the most eminent men in Vienna. However once she was married, her husband, the composer Gustav Mahler, forbade her from composing. After nine years of marriage, Gustav died. Alma was aged thirty-one, still beautiful, vivacious and intelligent. Once again, she was much courted, and she and Kokoschka had a passionate romance. Kokoschka loved her for the rest of his life.

② PAINTING STYLE

Kokoschka began his career as a commercial artist for the Wiener Werkstätte, an esteemed Viennese crafts workshop, and his first paintings were influenced by Impressionism and Art Nouveau. By the time he painted this, however, he was using graphic, gestural brushmarks that lean towards Expressionism.

③ AGITATED BRUSHWORK

After he exhibited at 'Kunstschau Vienna' in 1908, Kokoschka developed a method of applying his oil paints thinly, in agitated marks, sometimes even scratched on with his paintbrush handle dipped into wet paint. These multicoloured – almost knotted – lines convey movement and a sense of the unreal.

④ PSYCHOLOGICAL PENETRATION

Kokoschka's relationship with Alma was extreme and enduring on his side, but she wearied of him. This work, painted just before they broke up, shows her sleeping peacefully beside him, while he lies awake, staring out, looking disturbed and anxious. He later wrote: 'In my *Bride of the Wind*, we are united for eternity.'

⑤ DEPTH PERCEPTION

Kokoschka wrote about the need for artists to develop their ability to see depth – to perceive and portray distances as well as depicting the depths of their sitters' thoughts. This is a small vessel in the midst of a turbulent ocean, buffeted by the wind, with depth and distance suggested through colour placement.

⑥ MOVEMENT

With large, loose strokes of colour, Kokoschka paints a swirling vortex around the two figures. In 1962, he said: 'Painting… isn't based on three dimensions, but on four. The fourth dimension is a projection of myself….' He believed that using intuition, all artists should capture a sense of movement and emotion.

⑦ THE TEMPEST

Also called *The Tempest*, this painting depicts the couple's tempestuous relationship. Kokoschka and Alma are alone. In the background, purple mountains are illuminated by the moon, and eclipsed by a black sun over the crashing waves. As well as personal distress, this expresses the political turmoil prior to World War I.

The Starry Night, **Vincent van Gogh, 1889, oil on canvas, 73.5 x 92 cm (29 x 36 ¼ in.), Museum of Modern Art, New York, USA**

'This morning I saw the countryside from my window a long time before sunrise, with nothing but the morning star, which looked very big,' wrote Vincent van Gogh to his brother Theo in 1889, describing his inspiration for this painting. It was one of a number of powerful influences on Kokoschka, who like Van Gogh, sought to convey emotion and humanistic ideals. With its impasto, swirling paint marks, the painting was Van Gogh's search for eternal truths, showing a whirling night sky over a village, but also expressing Van Gogh's loneliness. Like *The Starry Night*, *The Bride of the Wind* is painted with colourful, thick, directional paint marks and points to the artist's inner problems and fears.

PRISMES ÉLECTRIQUES (ELECTRIC PRISMS)

SONIA DELAUNAY

1914

oil on canvas
250 x 250 cm (98 ⅜ x 98 ⅜ in.)
Musée National d'Art Moderne,
Centre Georges Pompidou, Paris, France

A PIONEER OF ORPHISM OR ORPHIC CUBISM,
Sonia Delaunay (1885–1979) was a multidisciplinary artist.
She painted, designed textiles, clothing and stage sets,
and ran shops and a textile company.

Although born into a poor family in the Ukraine, Sonia
had a privileged upbringing as at the age of five, she was sent
to live with her prosperous uncle and aunt in St Petersburg.
Despite never being officially adopted by them, she took their
name, becoming 'Sofia Terk', but using 'Sonia' as a nickname.
From the age of eighteen, she studied painting at the Academy
of Fine Arts in Karlsruhe, Germany. In 1905, she moved to
Paris and enrolled at the Académie de La Palette, where she
became inspired by Post-Impressionism and Fauvism. During
her first year in Paris Sonia met and married her friend
Wilhelm Uhde, an art dealer, collector and critic, so that she
could remain in Paris and help to disguise Uhde's homosexual
lifestyle. Uhde organized her first solo exhibition, where
she showed vividly coloured figurative paintings. He also
introduced her to significant artists and writers living in Paris,
including in 1909, Robert Delaunay, which led to Sonia and
Uhde divorcing amicably so that she and Robert could marry.

Early in her marriage, Sonia made a patchwork quilt for
her newborn son. She used differently coloured swatches
of fabric resembling textiles she had seen in Ukraine.
Meanwhile, Robert was exploring Chevreul's colour theories,
and the couple produced vibrant works based on simultaneous
colour contrasts blended with Cubist ideas that they called
Simultanism, but that their friend Apollinaire dubbed
'Orphism'. She also collaborated with poets, including
Apollinaire, Blaise Cendrars and Tristan Tzara, stating:
'Painting is a form of poetry, colours are words, their relations
rhythms, the completed painting a completed poem.'

Prismes électriques (*Electric Prisms*) forms part of a series
of the same name she created from 1913 to 1914. This painting
represents the optical effects created by electric lamps on
the streets of Paris. She said that the phenomenon of colour
simultaneity appeared everywhere in cities, created by electric
and natural light.

Colour Study, Square with Concentric Circles, **Wassily
Kandinsky, 1913, watercolour, gouache and crayon on
paper, 24 × 31.5 cm (9 ⅜ × 12 ⅜ in.), Städtische Galerie
im Lenbachhaus, Munich, Germany**

Painted just a few months before Sonia painted *Electric
Prisms*, this small study was Wassily Kandinsky's
exploration into ways in which different colour
combinations are perceived by others. Kandinsky was
interested in the general perception of colour, whereas
Sonia investigated ways in which colour appears through
weather and light effects, especially with electric lighting.
Both artists were intent on capturing ways that colours
interact with each other and with viewers. Featuring
twelve concentric circles confined inside a grid, all
different, made up of overlapping, contrasting colours,
including bright reds, warm golds, soft pinks, deep
greens and cool, vivid blues, this does not try to represent
anything but visual effects; an objective visual reality that
was innovative at the time.

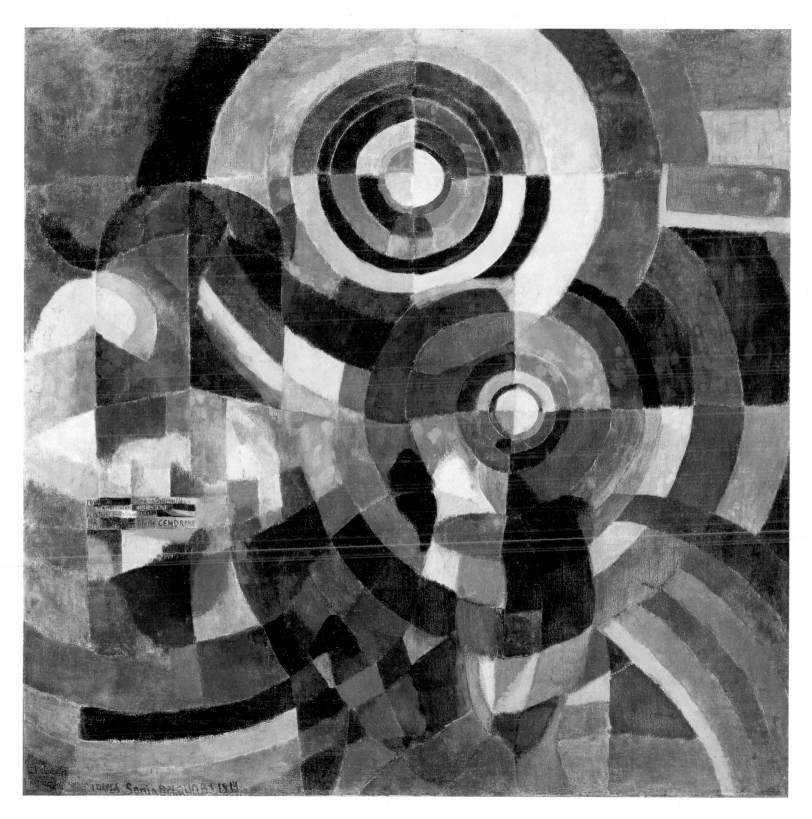

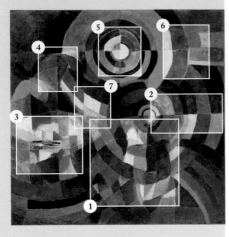

② FOURTH DIMENSION

Several artists were fascinated by the possibility of a fourth dimension, and Sonia, with her overlapping colours and shapes that follow the theory of simultaneity, was trying to explore this extra dimension here. As different spheres and circle sections appear to overlap, they intentionally depict the dynamic movement of electricity.

① ABSTRACT CREATION

Sonia was always comfortable producing both figurative and abstract artwork. In her *Electric Prisms* series she took ideas from the patchwork quilt she had made for her son in 1911, creating geometrically inspired shapes and bold colours that emphasize moods. However, the image also suggests the busy Boulevard Saint-Michel in Paris, and while most of the image is abstract, two figures can be discerned here.

③ TEXT

In 1913, Sonia collaborated with Cendrars, illustrating an experimental colour-poem '*La Prose du Transsibérien et de la Petite Jehanne de France*' ('*Prose on the Trans-Siberian Railway and of Little Jehanne of France*'). It was her first attempt at interpreting relationships between words and colour. Several words have been added to this painting, including 'Blaise', 'Cendrars', 'Prose', 'Jehanne', 'de', 'France', 'Terk', 'Peinture' and 'Representation'.

Combining a love of colour with a fascination for light, Cubism, Fauvism, childhood recollections of Russia, and theories of metaphysics, Sonia created an original approach to art. Here she used thinly applied, transparent swathes of paint in pure, vibrant mixtures and fragmented shapes.

④ MOVEMENT

In dispensing with form and so deliberately creating flatness, Sonia created a sense of movement and depth through her overlapping patches of vibrant hues. The concentric circles seem to swirl. Some colours appear heavy, creating momentum through their proximity to the lighter colours.

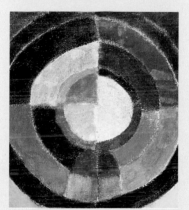

⑤ COLOUR

Orphism dispensed with recognizable subject matter, relying on form and colour to convey meaning. The variations of light from the light bulbs and ways in which the eye sees them appeared to Sonia as prisms of colour. She contorted them, placing warm yellows and magenta against cool lilacs and greens.

⑥ LIGHT

Based on studies of lighting along the Boulevard Saint-Michel, this suggests the optical effects of dazzling electric street lights. The multicoloured swirls of transparent colour translate as light energy falling on the street, refracting into coloured discs, and animated by contrasts of shapes and colour.

⑦ COMPOSITION

Inspired by her patchwork quilt with its interlocking strips of coloured fabric, Sonia created a composition filled with giant slabs of colour, discarding any attempt to show perspective or depth. She explained: 'For me, there was no gap between my painting and what is called my "decorative" work.'

Detail from *Boats at Collioure*, André Derain, 1905, oil on canvas, 60 x 73 cm (23 ⅝ x 28 ⅞ in.), Kunstsammlung Nordrhein-Westfalen, Dusseldorf, Germany

In the summer of 1905 Derain spent two months travelling with his friend Matisse, in search of suitable sights to paint. They settled in the small fishing town of Collioure, on the south-west coast of France near the Spanish border. Much as the Delaunays did later, Derain and Matisse discussed the latest art theories and painted vividly coloured, exuberant canvases, often with broken brushwork and fragmented images. When Sonia arrived in Paris, she became enthralled by their Fauvist paintings and altered her own painting style accordingly. The notion of creating flat images in the brightest colours became the overriding characteristic of her work.

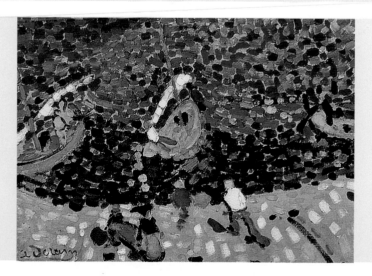

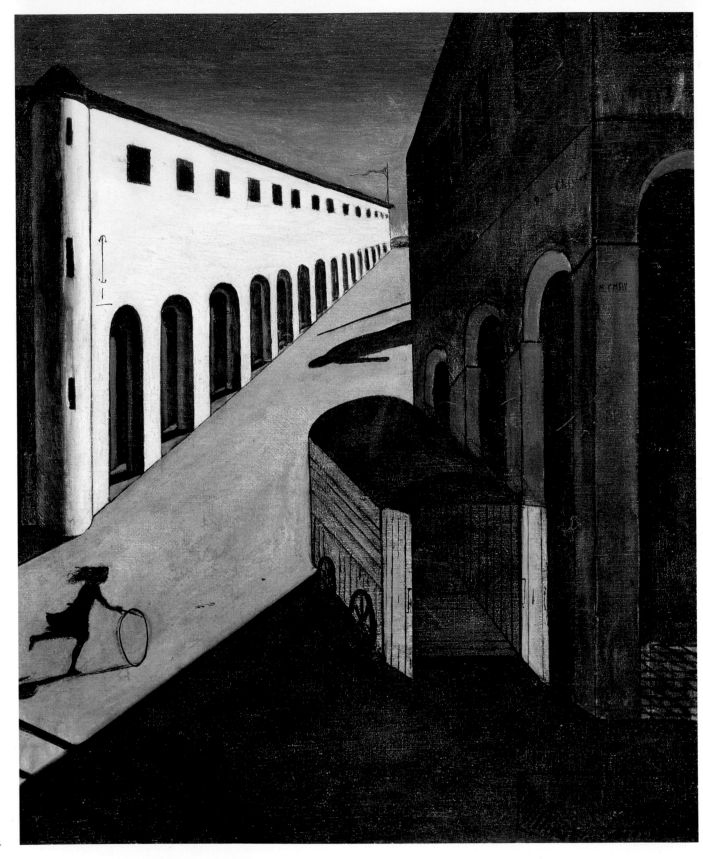

MYSTERY AND MELANCHOLY OF A STREET

GIORGIO DE CHIRICO

1914

oil on canvas
85 x 69 cm (33 ½ x 27 ⅛ in.)
private collection

BEFORE AND DURING WORLD WAR I, Giorgio de Chirico (1888–1978) developed *Pittura metafisica* (Metaphysical Painting), which features mysterious images including dramatic perspectives, deep shadows and unexpected objects in strange places. After 1919, he began working in a Neoclassical style, while often revisiting metaphysical themes.

Growing up in Greece with Italian parents, De Chirico became fascinated by art, architecture and Greek mythology. From 1903 to 1905, he studied art in Athens at the Higher School of Fine Arts. After the death of his father in 1906, he enrolled at the Academy of Fine Arts in Munich, where he began painting the *Metaphysical Town Square* (1910–17) series, that aimed to uncover the truths he believed were hidden beneath the surfaces of things. In 1909, he spent six months in Munich with his family and then stayed in Florence for more than a year. In July 1911, while travelling through Turin, he became inspired by its Baroque architecture. He lived in Paris for three years, where he befriended Apollinaire and Picasso and participated in exhibitions, including at the Salon des Indépendants and the Salon d'Automne. He gained critical renown, painting dramatic scenes featuring darkly shadowed piazzas and arcades with incongruous elements such as tailors' dummies and faceless statues shown in steep perspective. His art influenced the subsequent Surrealist movement.

With the outbreak of World War I, he returned to Italy where he enlisted in the army, but was deemed unfit to serve because of a nervous condition and was reassigned to a military hospital. There he met Italian painter Carlo Carrà who worked with him in establishing the *Scuola metafisica* (Metaphysical School), and his paintings became even more brooding. Later in the 1920s, he began painting in a classical style, and the Surrealists renounced him.

With its incongruous objects, *Mystery and Melancholy of a Street*, painted at the start of World War I, represents what lies beyond the physical world. Long shadows emit a sinister, desolate air and the atmosphere is oppressive and threatening. Overall, although enigmatic, the image conveys a sense of anguish, fear and foreboding.

Island of the Dead, Arnold Böcklin, 1880,
oil on wood, 111 x 156.5 cm (43 ⅝ x 61 ⅝ in.),
Kunstmuseum Basel, Switzerland

After painting this on commission in 1880, Swiss painter Arnold Böcklin (1827–1901) executed four more versions of the same image over the next six years. He never gave an explanation of its meaning, but all renditions depict a remote rocky promontory across an expanse of water. An oarsman manoeuvres a small rowing boat from the stern. In front of him in the stern is a figure shrouded in white standing in front of an object draped in white that is usually interpreted as a coffin. The islet is home to a grove of tall, dark cypress trees, which are traditionally associated with cemeteries and mourning. A strange light adds to the sense of discomfort. Böcklin was a Symbolist, influenced by Romanticism, who aimed to express his feelings through images that include mythological and fantastical figures in classical settings. His work directly inspired De Chirico.

② ARCHITECTURE

The painting's buildings and space were inspired by the Baroque architecture of Turin, with its piazzas, arcades and archways. Here, two facades enclose a deserted public space, creating an eerie atmosphere. This empty street appears gloomy and desolate.

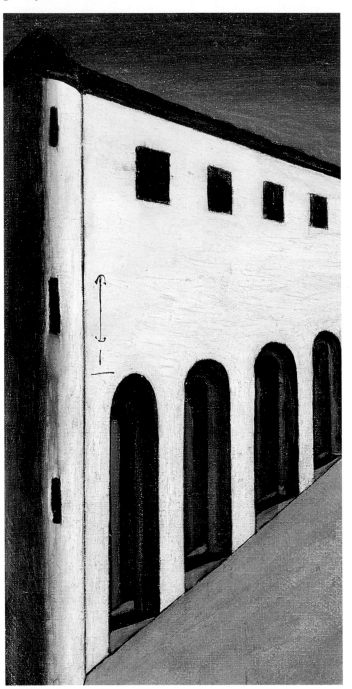

① CHILD

In 1532, German painter Lucas Cranach the Elder (1472–1553) executed a painting entitled *Melancholy*. In it, three nude children try to pass a large ball through a hoop using sticks. A winged woman sitting near them making another hoop, personifies melancholy. In a poem dedicated to his dead daughter, the 17th-century Dutch poet, Joost van den Vondel wrote:

> She drove, followed by a zealous troop
> The clanging hoop
> Through the streets

This silhouetted figure of a child with a hoop may have derived from either or both of those works.

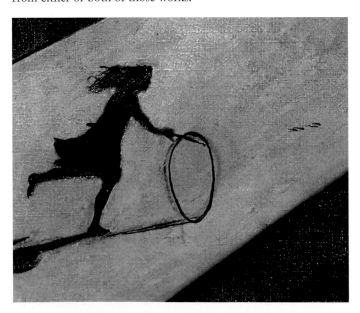

③ SHADOW

The girl appears to be running directly towards this elongated shadow looming in the background. Unexplained, it could be a figure, although it is more likely to be a statue just around the corner. All the elements in De Chirico's paintings had particular meanings for him, but viewers have to work them out for themselves, which leaves this somewhat ominous shadow an unexplained mystery.

Influenced by the Symbolists, De Chirico created visual enigmas that make viewers question reality. Intrigued by the philosopher Friedrich Nietzsche, he featured Nietzschean themes of classicism and melancholy in his paintings and placed incongruous objects in them to indicate the absence of truth in life.

④ PERSPECTIVE

The use of exaggerated perspective enhances the disturbing, mysterious appearance of commonplace things. While the perspective makes the architecture completely illogical, it creates a threatening impression. Long, dark, flat shadows add to the overall sense of unease.

⑤ LIGHT

Just as the perspective represents dramatic extremes, so the light is distorted. A source of bright light appears to be coming from behind the building on the right of the painting and brilliantly illuminates the arcades on the left. The angle of light suggests late afternoon.

⑥ COLOUR

The street that stretches diagonally between the buildings is painted in yellow ochre, glowing brightly against the white wall. De Chirico did not buy manufactured oil paints, but mixed his own, using dry pigments and oil binders to achieve his palette.

⑦ FORMS

The horsebox is a rectangular form, with a curved end that is echoed in the surrounding arches, while circles appear in the wheels and girl's hoop. De Chirico believed that geometrical shapes, including the arch and circle, projected emotions such as nostalgia, anticipation and uncertainty.

IMPROVISATION GORGE

WASSILY KANDINSKY

1914

oil on canvas
110 x 110.cm (43 ¼ x 43 ¼ in.)
Städtische Galerie im Lenbachhaus, Munich, Germany

IN A RESPONSE TO the teachings of Theosophy, Wassily Kandinsky (1866–1944) painted what words could not say, exploring spirituality and mysticism through pioneering abstract and abstracted paintings, lithography and wood engravings. He also taught and wrote about his theories.

After graduating from Grekov Odessa Art school, Kandinsky took law and economics at the University of Moscow and became a lawyer. He then moved to Munich and studied art with Anton Azbé (1862–1905) and Franz von Stuck (1863–1928). There he became a member of the artists' group Phalanx. From 1906 to 1908, he travelled around Europe, and was inspired by Fauvism and Expressionism, painting with vivid colour contrasts and distorting representational elements. Two early influences were the folk art and fairy tales of the Vologda region and Monet's paintings. He finally settled in Murnau in Bavaria. In 1909, he joined the Theosophical Society and it had a powerful effect on his art. In 1911 he co-founded the Expressionist artists' group *Der Blaue Reiter* (The Blue Rider), encouraging a spiritual approach to art. That year, he attended a concert which featured music by Austrian composer and painter Arnold Schoenberg (1874–1951). It prompted Kandinsky to write to Schoenberg and they became friends. Kandinsky began painting colours and forms that corresponded to music. In 1912, his book *Concerning the Spiritual in Art* was published, defining three types of painting that he called *Impressions*, *Improvisations* and *Compositions*. *Impressions* are based on external realities while *Improvisations* and *Compositions* stem from the unconscious.

As a Russian, Kandinsky was forced to leave Germany at the start of World War I. He remained in Russia until 1921, when he went back to Germany where he taught design, painting and theory at the Bauhaus. *Improvisation Gorge* is one of approximately thirty-five *Improvisations* that Kandinsky painted between 1909 and 1914 in Germany. The works in the *Improvisations* series were his most spontaneous and imaginative, featuring vibrant colours and distorted objects. This is not completely abstract, but has some figurative elements. It represents a ravine or gorge in Bavaria.

Haystacks, (Effects of Snow and Sun), Claude Monet, 1891, oil on canvas, 65.5 x 92 cm (25 ¾ x 36 ¼ in.), Metropolitan Museum of Art, New York, USA

Between 1890 and 1891, Monet produced a series of paintings of haystacks in a field near his home in Giverny, France capturing the effects of changing light and weather conditions. In 1896, Kandinsky saw at least one of these paintings at an exhibition in Moscow. Because of the broken brushwork and brilliant colours, he did not immediately recognize the subject, but he was transfixed by the painting. He wrote: 'I noticed with surprise and confusion that the picture not only gripped me, but impressed itself ineradicably on my memory.' It was then that he determined to become an artist. At a similar time, he attended a performance of Richard Wagner's opera *Lohengrin* (1850), which became another influence. For the rest of his career, he aimed to emulate ways that music and colour can appeal to the emotions, without having to represent recognizable subjects.

② PAINT APPLICATION

Over white priming, Kandinsky applied opaque and translucent paint, leaving visible marks, as here in the waterfall. After drawing his initial shapes across the surface, he painted colours in certain areas, then created dark contours with fine brushstrokes. He used a precise painting process, including careful glazing.

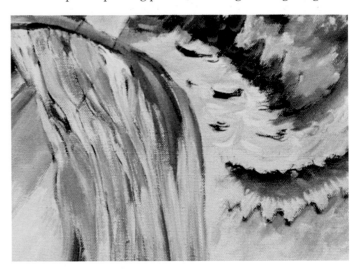

③ FIGURATIVE ELEMENTS

Although this painting appears completely abstract, there are figurative references. This is a couple in traditional Bavarian peasant costume, on a boat landing that leads viewers' eyes into the rest of the painting. Two boats with four oars are moored beside the landing.

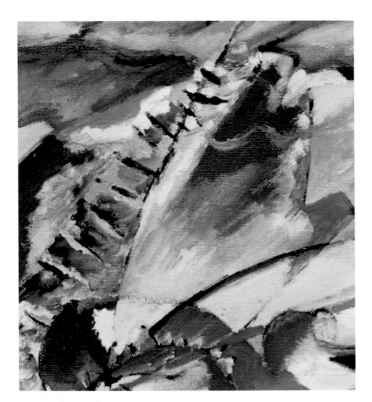

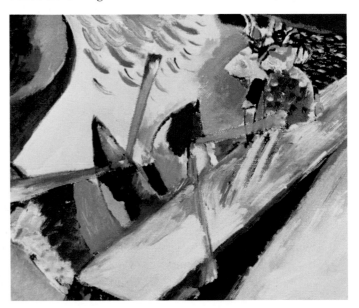

① COLOUR

Kandinsky modulated hues of primary colours, transforming them into colours including orange, violet, green and turquoise. Some colour changes are achieved through additions of white and black, but more often, they are created with unusual colour blends that create brilliant effects. Here, adhering to the law of simultaneous contrast, red is adjacent to various greens, while orange is beside vivid blue.

4 DYNAMISM

The shapes, objects and forms in this image appear caught in a swirling, unrestrained motion. The short lines that Kandinsky uses for the lake and waterfall, and longer lines describing the boat landing, the ground beneath the houses and the lake edges, convey the sounds of the location.

5 COMPOSITION

The square format allowed Kandinsky to create linear elements that point into the centre of the composition, where circular, curving shapes create a vortex or maelstrom. Additionally, the composition seems to be divided into diagonal thirds, with the waterway cutting through the middle of the canvas.

6 DISTANT MOUNTAINS

The silhouette of a fir tree is near to a line of mountains. The dark, ladderlike objects could be iron gangways and railings, steps, railway tracks or motifs that visually connect the water, mountains and sky to convey a sense of the height of the gorge.

7 IMPROVISATION AND SYNESTHESIA

For Kandinsky, an improvisation was an expression of inner processes that occur spontaneously. He is thought to have had synesthesia, a condition that combines the senses so he saw colours in his mind when he heard sounds. The colours relate to sounds.

Dancers, Franz von Stuck, 1896, oil on canvas, 52.5 x 87 cm (20 ⅝ x 34 ¼ in.), private collection

An influential German Symbolist and Art Nouveau painter, sculptor, engraver and architect who became an important figure in the Munich art world in the early 20th century, Franz von Stuck (1863–1928) primarily produced portraits to commission and expressed mythological and symbolic themes in an eloquent, fluid style, as well as figurative sculptures. At thirty-two years old, he was appointed professor at the Munich Academy where he taught Kandinsky, Paul Klee (1879–1940) and Josef Albers (1888–1976). This painting demonstrates his expressive Art Nouveau style.

BIRTHDAY

MARC CHAGALL

1915

oil on cardboard
80.5 x 99.5 cm (31 ¾ x 39 ¼ in.)
Museum of Modern Art, New York, USA

OVER HIS LONG LIFE, Marc Chagall (1887–1985) produced paintings, book illustrations, stained glass, stage sets, ceramics, tapestries and prints, based on his memories and emotional associations. Although he has been linked with several art movements and was influenced by Fauvism, Cubism and Russian folk art, his bright, figurative style was original.

The eldest of nine children, Chagall was born to a poor family near Vitebsk (now in Belarus). For some months in 1906, he studied art with Russian portraitist Yehuda Pen (1854–1937), then moved to St Petersburg and studied at the Imperial Academy for the Protection of the Fine Arts and the Zvantseva School of Drawing and Painting, where among others, he was taught by Léon Bakst (1866–1924), who produced exotic, colourful sets and costumes for the Ballets Russes. In 1911, Chagall moved to France just as Cubism was emerging as the leading art movement. He enrolled at a small art academy, socialized with Apollinaire, Robert Delaunay, Léger, Amedeo Modigliani (1884–1920) and André Lhote (1885–1962), and began creating his evocative paintings.

At the start of World War I, he returned to Russia where he married Bella Rosenfeld who had a profound effect on his work. He produced *Birthday,* sometimes called *Anniversary,* just before they married; it is a visual expression of their love.

A Street, **Iosif Solomonovich Shkolnik,** ***c.*** **1910, oil on canvas, 49 x 64 cm (19 ¼ x 25 ¼ in.), Kaluga Museum of Fine Arts, Russia**

Iosif Solomonovich Shkolnik (1883–1926) was born in Balta (now in Ukraine), and studied at the Odessa Art School and then, like Chagall, at the St Petersburg academy. He became involved with avant-garde artist groups in Russia, and it is likely that Chagall met him. His naive style was inspired by Russian folk art.

② FLOATING

Chagall painted the figures' feet floating in the air, as if hovering in their love-filled bliss above the bright red carpet. This expresses the power of their love. Chagall loved Bella from the moment they met but her parents were against the relationship. Both families came from Vitebsk, but the Rosenfelds were wealthy, whereas the Chagalls were poor.

③ TABLE

The table is laden with objects. These include a purse – perhaps alluding to the issue between the two families regarding money, and Chagall's opinion that it did not matter because of his love for Bella. There is also a ring of bread with a knife. Chagall's parents worked hard to ensure that there was bread on the table for their children. Here, it symbolizes that he will provide for his future wife.

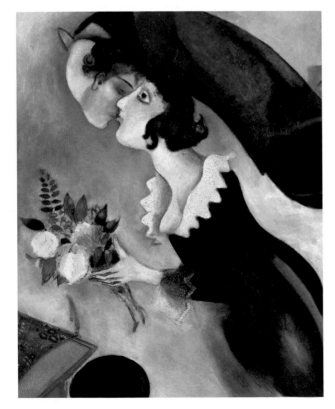

① BELLA

Chagall met Bella Rosenfeld in 1909 before he moved to Paris, and maintained that he fell in love with her at first sight. Wearing a black dress with white lace collar, Bella rushes towards the window, holding flowers that Chagall has given her. In his autobiography, he wrote of Bella: 'It is as if she knows everything about my childhood, my present, my future, as if she can see right through me.'

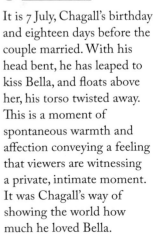

④ THE KISS

It is 7 July, Chagall's birthday and eighteen days before the couple married. With his head bent, he has leaped to kiss Bella, and floats above her, his torso twisted away. This is a moment of spontaneous warmth and affection conveying a feeling that viewers are witnessing a private, intimate moment. It was Chagall's way of showing the world how much he loved Bella.

5 PERSPECTIVE

Although over the course of his long career, Chagall's style and approach often changed, he continued to disregard conventional linear perspective. In this room, the rules of perspective and gravity do not apply. For example, the top of this stool and side view of its legs can be seen together, which would be impossible. It is a stylistic element taken from the Cubists.

6 PALETTE

The predominant colours in this painting are red, black, white and green, which are the main colours used by Kazimir Malevich and the Suprematists who were creating avant-garde paintings in Russia. Chagall's palette here likely included: lead white, charcoal black, Prussian blue, cerulean blue, ultramarine, cobalt blue, red iron oxide, green earth, lead yellow and cadmium yellow.

7 STYLE

Later in his career, Chagall created theatre sets, stained glass and book illustrations as well as paintings. He always retained fond memories of his homeland and childhood. He continued to express his fascination for the crafts, art and other creative traditions of his country whatever medium he worked in. This paisley shawl is part of the colourful folk art that inspired him as a child.

Costume for L'Après-midi d'un faune, Léon Bakst, 1912, graphite, tempera and gold paint on laid charcoal paper, 31.5 x 24.5 cm (12 ½ x 9 ⅝ in.), Wadsworth Atheneum Museum of Art, Connecticut, USA

Bakst was a Russian painter and set and costume designer. He taught painting at the Zvantseva School of Drawing and Painting in St Petersburg where in 1907, Chagall won a scholarship to attend. Bakst encouraged him to express himself fluidly. From 1908, Bakst began working with Russian art critic, ballet impresario and founder of the Ballets Russes, Sergei Diaghilev, producing scenery and costume designs. Bakst became the artistic director of the Ballets Russes, and he and Diaghilev created ballets that appealed to the general public rather than only the aristocracy. The striking costumes and sets inspired many artists who had been part of the Fauvist movement. This is one of Bakst's designs for a principal dancer in the production of *L'Après-midi d'un faune* (*The Afternoon of a Faun*) in 1912. The exoticism, flowing style and lavishness entranced audiences and created new crazes in fashion.

DYNAMIC SUPREMATISM

KAZIMIR MALEVICH

c. 1915–16

oil on canvas
80.5 x 80 cm (31 ⅝ x 31 ½ in.)
Tate, London, UK

KAZIMIR MALEVICH (1878–1935) WAS born near Kiev to Polish parents. During his childhood, the family frequently moved around Ukraine where he became familiar with peasant art and embroidery, and his first paintings were in the peasant style. In 1898, he studied at the Kiev School of Art. After his marriage and the death of his father, he went to Moscow and took classes in the studio of painter Fedor Rerberg (1865–1938), and in 1907, he moved to Moscow with his mother, wife and children. There, he became acquainted with avant-garde artists including Kandinsky, Natalia Goncharova (1881–1962) and Mikhail Larionov (1881–1964). In both Moscow and St Petersburg, he joined a number of art groups, including the Jack of Diamonds, Donkey's Tail, Target and Union of Youth. In 1913, he visited an exhibition in Moscow of the paintings of Russian avant-garde artist Aristarkh Lentulov (1882–1943) that considerably affected his work, inspiring him to develop Suprematism. That year he designed groundbreaking bright geometrical costumes and a black square backdrop for the Futurist opera *Victory Over the Sun*.

From December 1915 to January 1916, an exhibition was held in Petrograd (now St Petersburg) called '0.10: The Last Futurist Exhibition'. Until then, Russian avant-garde artists had appeared to follow European art. The exhibition demonstrated that Malevich was at the forefront of new ideas. Abandoning all references to the visual world, he was painting simplified, coloured or monochrome geometric shapes on white backgrounds. In 1916, he published his manifesto, *From Cubism to Suprematism* which explained that art should express pure sensation and be devoid of any illusory or representational tricks. Although his experiments were suppressed in post-revolutionary Russia, his ideas influenced the evolution of modern art.

Painted in either 1915 or 1916, *Dynamic Suprematism* was an important work in the development of Suprematism. Never before had art sought to discard all the techniques and traditions of the past. Malevich declared that Suprematism was based on 'the supremacy of pure artistic feeling', rather than an attempt to recreate images of the world.

***Ballet*, Aristarkh Lentulov, *c.* 1910–12, oil on canvas, 162 x 180 cm (63 ¾ x 70 ⅞ in.), National Gallery, Prague, Czech Republic**

Lentulov studied at Penza Art College and the Kiev School of Art. His paintings focus on Russian folk art and the effects of light through colour. From 1910 to 1911, he studied in Paris under Henri Le Fauconnier (1881–1946) and at the Académie de La Palette. There, he was inspired by Orphism, Fauvism and Cubism. After his return to Russia in 1912, he was significant in the development of Cubo-Futurism, and he and Malevich helped found an artists' group, *Segodnyashnii Lubok* (Today's Lubok). His show in Moscow in 1913 had a similar effect on Russian artists as Cézanne's retrospective had on French avant-garde artists.

② WEIGHTLESSNESS

While the large triangle in the background appears to be weighted and stable, the smaller shapes in the front of it seem to be active, even weightless. They appear to move randomly. It is unclear how they are animated, whether they are blowing on a breeze or floating in water, but their lightness adds to Malevich's concept of not linking anything he painted to the visible world.

③ LIGHT

Malevich adhered to a set palette during his Suprematist period. Declaring 'colour is light', he created the effect of different planes of light through various blends of pigment. Although several of his canvases were monochrome, his basic palette was derived from the scientific findings of Scottish scientist James Clerk Maxwell and US physicist Ogden N. Rood regarding light.

① LAYERS

The geometric shapes appear to float in a white space. Some seem to be in front of others, as the space appears to consist of two layers; one containing the large triangle, and the other with smaller shapes. The smaller shapes could actually be on several layers. The shapes themselves seem flat, but apparently float in a three-dimensional space.

4 PALETTE

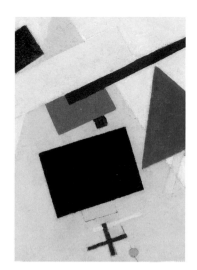

In his quest to paint light, Malevich used a particular palette for this work of zinc white, vermilion, cadmium yellow, chrome yellow, emerald green, cobalt blue, ultramarine and carbon black. In some places he used the paint without blending, such as the black, cobalt blue and yellow shapes. In other areas he diluted the colours to make hues that appear to illuminate the surface.

5 FEELING

Malevich wrote that the aim of Suprematism was to discard 'art ideas, concepts and images' in order to reach a 'desert in which nothing can be perceived but feeling'. He believed that concepts of the conscious mind are worthless, elements that simply clutter the everyday and that beyond the world of consciousness, there was something that he described as 'non-objective feeling'.

6 APPLICATION

Also called *Supremus 57*, this painting draws on all Malevich learned through studying Cubism, Futurism and Primitivism. He creates visual tension by putting the shapes on diagonal axes. He used cardboard as a guide for his brush as he painted the edges of his shapes to ensure they were straight. Paint is applied to each shape in uniform layers, directly on to the canvas.

7 METHOD

Malevich primed this canvas with white paint rather than colour. This helped him to convey the effects of light because when the white shows through the painted shapes, they appear radiant. Once the initial white layer was dry, he drew the outlines of the shapes freehand and extremely lightly with the tip of a pencil. Next, he applied fluid layers of smooth paint.

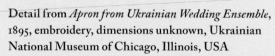

Detail from *Apron from Ukrainian Wedding Ensemble*, 1895, embroidery, dimensions unknown, Ukrainian National Museum of Chicago, Illinois, USA

Before Malevich was even aware of professional artists and the fine art of museums, he was surrounded by Ukrainian folk art like this piece of embroidery. The embroidery and decorated tiles, walls and stoves were part of his culture, and his first forays into art emulated their bold, brightly coloured, simplified pictures and patterns. Although he saw examples of such folk art all around him, he also had the opportunity to visit the National Folk Decorative Art Museum in Kiev, which had a collection that was established in 1899.

PORTRAIT OF TRISTAN TZARA

JEAN ARP

1916–17

wood
40 x 32.5 x 9.5 cm (15 ¾ x 12 ¾ x 3 ¾ in.)
Kunsthaus Zurich, Switzerland

JEAN ARP (1886–1966) WAS A DADAIST and a Surrealist
who lived and worked in Germany, France and Switzerland.
With a German father and French mother, he had been
named Hans, which he was known by in Germany, but
when in France, he was known as Jean. Born in Alsace,
which was then part of Germany, he studied art in Strasbourg,
Weimar and later in Paris. By the age of twenty-five, he had
co-founded the first modern artists group in Switzerland,
Der Moderne Bund (The Modern Alliance). He also worked
for a short time in Munich with Kandinsky and the group
Der Blaue Reiter (The Blue Rider). Returning to Paris, he
socialized with Modigliani, Picasso, Sonia and Robert
Delaunay, and the writers Guillaume Apollinaire and Max
Jacob, sharing ideas on creativity and the future of art.

In 1915, Arp escaped from the atrocities of World War I to
neutral Zurich. There, with other artists and writers, including
Hugo Ball (1886–1927), Emmy Hennings (1885–1948), Tristan
Tzara (1896–1963), Hans Richter (1888–1976) and his future
wife, Sophie Taeuber (1889–1943), he discussed art and put
on performances in the Cabaret Voltaire, a nightclub in
Zurich founded by Ball and Hennings in 1916. Together they
established the Dada movement, which was a protest against
the horrors of war. Interdisciplinary and intentionally
irreverent, Dadaism spread internationally.

As well as performing at Cabaret Voltaire, Arp made
'chance collages' by dropping scraps of paper on to larger sheets
of paper and pasting them where they landed. He also created
tapestries, and crafted wooden reliefs with layered biomorphic
forms as in this work, which is a portrait of Tzara, who was
a poet, playwright, journalist, art critic, performer, composer
and film director.

At the end of the war, Arp returned to Germany. In
Berlin in 1918, he inspired other artists, including Hannah
Höch (1889–1978), Raoul Hausmann (1886–1971) and Kurt
Schwitters (1887–1948), to create a branch of the Dada
movement. He later wrote articles for various magazines,
and in 1925 he was among the co-founders of Surrealism.
In 1926, he became a French citizen.

Cabaret Voltaire

In partnership, Arp, Taeuber, Tzara, Ball and Hennings
opened the Cabaret Voltaire in Zurich as an arts and
literary venue. It became critical in establishing Dada.
This poster for the nightclub reads: 'Voltaire artists'
club. Every evening, with the exception of Friday. Music
lectures and recitations. Opening Saturday 5 February
in the Meierei Hall, Spiegelgasse 1.'

② CONSTRUCTION

Arp used wood of different thicknesses, cut out and painted in pink, black and grey, and then assembled with the screws left visible, to imply that this is not a traditional relief, but an irregular construction of shapes and curving contours. Although it is an evocation of a head, there are no obvious facial features.

③ PAINT APPLICATION

In his varied shapes and paint application, including flat, smooth areas and white splatters on grey, Arp expressed Tzara's personality. Intellectual and passionate, Tzara organized violent, disruptive performances at the Café Voltaire, intended to shock and upset his audiences, as well as calmer literary gatherings. He also wrote poems that expressed his anguish about the human condition.

① ORGANIC SHAPES

At a time when artists were experimenting with unusual materials – the Cubists were using collage for instance – Arp used his imagination. He became known for creating biomorphic, organic sculptural forms based on nature, as he aimed to simplify and reduce nature to its essence. Although the work is not realistic, here the wavy lines suggest plants, birds, butterflies, body parts and other natural motifs.

④ SPONTANEITY

While paint can be employed quickly and spontaneously, it takes careful thought to carve and cut wood. Yet Arp created this as spontaneously as he could, following the Dadaist desire to create a new language of art. The restricted palette was his way of keeping the image uncomplicated.

⑤ ASSEMBLAGE

Arp was one of the first artists to use randomness as part of his process. It was a forerunner to automatism, later used by the Surrealists and Abstract Expressionists. He was not the first to make assemblages, Picasso was in 1912, but Picasso's assemblages were made of found or ready-made elements, whereas Arp's were of fresh materials.

⑥ ENIGMATIC

Rather than beginning with a subject in the traditional way, Arp created his form first, and then gave his work a title, which is unusual for fine art. It was Arp's way of reducing the involvement of his conscious mind. So this work remains mysterious as it was not meant to be obvious and realistic.

⑦ APPEARANCE

Despite Arp's ideas about refusing to conform, this portrait adheres to one traditional aspect of portraiture. It expresses Tzara's underlying personality rather than his outward appearance. Before Dada, Tzara was a poet, and the lilting, lyrical contours can be seen as a fairly sensitive depiction rather than a faithful likeness.

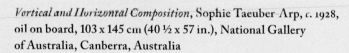

Vertical and Horizontal Composition, Sophie Taeuber-Arp, *c.* 1928, oil on board, 103 x 145 cm (40 ½ x 57 in.), National Gallery of Australia, Canberra, Australia

This panel was part of Taeuber-Arp's decorative scheme for the interior of the Café de l'Aubette in Strasbourg, commissioned in 1926 by the architect brothers Paul and André Horn. It echoes the designs she made for stained glass-windows in the cafe that included a patisserie, bars, function rooms, a ballroom, a cellar nightclub and a cinema. She may have made the panel as a way of preserving the design in durable form. Arp and their friend, Dutch artist Theo van Doesburg (1883–1931), worked on the project with her although she remained responsible for most of the decoration. Sadly, the designs were too modern for the clients' taste, so it was changed and by 1940, nothing of Taeuber-Arp's modernist designs remained there.

METROPOLIS

GEORGE GROSZ

1916–17

oil on canvas
100 x 102 cm (39 ⅜ x 40 ⅛ in.)
Museo Thyssen-Bornemisza, Madrid, Spain

GEORGE GROSZ (1893–1959) BECAME one of the principal artists associated with the *Neue Sachlichkeit* (New Objectivity) movement along with his friends and fellow artists Otto Dix (1891–1969) and Max Beckmann (1884–1950). After observing the horrors of World War I at first-hand, his artwork became his social commentary.

Grosz was born Georg Ehrenfried Gross in Berlin but after the death of his father in 1901, he and his mother moved to Pomerania. Following early signs of creativity, he began attending a weekly drawing class. From 1909 to 1911, he studied at the Dresden Academy of Fine Arts and then took a course in graphic art at the Berlin College of Arts and Crafts. In 1913, he spent several months in Paris at the Académie Colarossi, where he learned to make rapid sketches of life models, which became extremely useful later when he made quick sketches of people on the busy streets of Berlin.

After World War I broke out Grosz registered for military service in November 1914, but he was discharged six months later on health grounds. By January 1917, he was conscripted. Within a short time, he suffered a nervous breakdown, was admitted to an infirmary and discharged as unfit. He remained in Berlin for the rest of the war working as an illustrator and cartoonist. There he met authors, artists and intellectuals with whom he founded the Berlin branch of Dada in 1918. Disillusioned over the human predisposition for violence that he had observed during the war years, he expressed his shock and disgust in works depicting scenes of crime and murder, and themes of cities and circuses.

Inspired by the political and social satirists William Hogarth (1697–1764) and Honoré Daumier (1808–79), Grosz's paintings censured what he saw as the depravity surrounding him. He became involved in pacifist activity, publishing drawings in satirical publications and participating in social and political protests. He painted *Metropolis* between December 1916 and August 1917. It is one of his most prominent expressions of distress about the war and of government oppression. He later wrote: 'My drawings expressed my despair, hate and disillusionment....'

Wayside Railway Station, Honoré Daumier, 1865–66, crayon and watercolour with pen and ink on paper, 28 x 34 cm (11 x 13 ⅜ in.), Victoria & Albert Museum, London, UK

This work forms part of a series of drawings, paintings and lithographs showing everyday life in France, especially in and around trains and railway stations that Daumier executed in the 1860s. It shows four people sitting on a bench at a railway station. The older woman appears to be getting something out of her basket for a dog that stands in front of her. The man leans on his stick, apparently asleep, and the child leans on his mother. The painting is an example of Daumier's observation of the general public. He did a series of sketches featuring various categories including musicians and rustic life. Daumier's astute depictions of society fascinated Grosz, who followed the tradition, albeit more caustically.

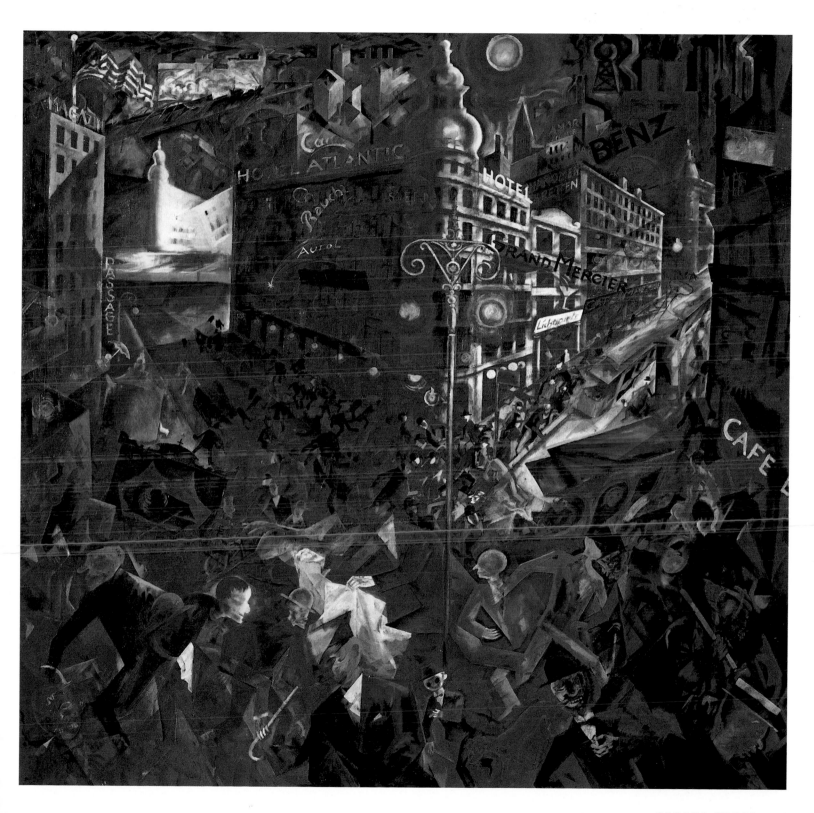

② COLOUR

Dominated by its shades of fiery red and orange, incandescent blue and deep purple, the painting is intentionally claustrophobic. The dark, rich colours express violence and vice, tumult, heat and blood. Among other colours in the work, Grosz used alizarin, cadmium red, yellow ochre, Prussian blue and emerald green.

③ COMPOSITION

Grosz completed *Metropolis* after his mental breakdown. He presents the city as a place that is as dangerous as a battlefield. Tilted on a dramatic diagonal, the composition conveys the social upheavals of the time. Multiple perspectives create a disorienting space and collapse distinctions between inside and outside.

① THE CITY

Grosz began painting this in December 1916. In early January 1917, he returned to the army, but after his breakdown, he entered an asylum, where he continued painting his apocalyptic vision, completing it in August 1917. The city itself is unidentified. It appears a generic metropolis; a lonely, corrupt and aggressive urban area, in which buildings and people jostle for space.

④ INFLUENCES

The forceful diagonal lines expressing dynamism developed from a Futurist influence and Grosz saw many Futurist paintings at Berlin's Der Sturm Gallery. However, the overlapping geometrical planes of the buildings are inspired by Cubism, the aggressive illustration of Grosz's feelings are Expressionist, and the irrationality is Dadaist.

⑤ LIGHT

Buildings rise up behind those in the foreground, brightly lit from below. The various light sources cast gloomy shadows; lights hang under the arches, or are suspended over the streets along with illuminated signs for hotels, bars, cafes and theatres. Faces reflect the glow of the street lamps, but they lack features, stressing their self-involved attitudes.

⑥ LINES

Diagonal lines guide viewers' eyes towards the vertical axis of the building in the centre of the painting, accentuated by the street lamp. The dramatic lines of perspective have the effect of pointing like a dart towards the mass of figures in the foreground, where moral order has broken down.

⑦ FIGURES

People move quickly, crossing each other's paths. Some are well dressed, others not so. None stop to converse; they collide as they pass, all intent on their own lives. Grosz said: 'I drew and painted from a spirit of contradiction and attempted in my work to convince the world that this world is ugly, sick and mendacious.'

RECLINING WOMAN WITH GREEN STOCKINGS

EGON SCHIELE

1917

gouache and black crayon on cream paper
29.5 x 46 cm (11 ⅝ x 18 ⅛ in.)
private collection

WITH HIS LINEAR GRAPHIC STYLE, the Austrian painter Egon Schiele (1890–1918) produced paintings of intense, raw sexuality. Exceptionally prolific during his brief career, his life was marked by notoriety and a tragically early death aged twenty-eight, three days after that of his pregnant wife from the Spanish flu.

Born near Vienna, Schiele was sixteen years old when he was accepted at the School of Arts and Crafts in Vienna. Within a few months however, he transferred to the Academy of Fine Arts in Vienna, where he studied painting and drawing. In 1907, he contacted Gustav Klimt whom he had long admired, and for several years, Klimt advised Schiele on his drawing and painting, and introduced him to patrons, models and the work of other artists, including Van Gogh, Edvard Munch (1863–1944) and Jan Toorop (1858–1928). Klimt also introduced Schiele to the Wiener Werkstätte, the arts and crafts workshops of the Vienna Secession. In 1909, Schiele left the academy and formed the *Neukunstgruppe* (New Art Group). In his painterly explorations, Schiele was moderately successful, and he participated in several exhibitions with the Vienna Secession and *Der Blaue Reiter* (The Blue Rider) group. In 1915, he married, which seemed to have a maturing effect on his work. This painting emphasizes female sexuality in his characteristically controversial style.

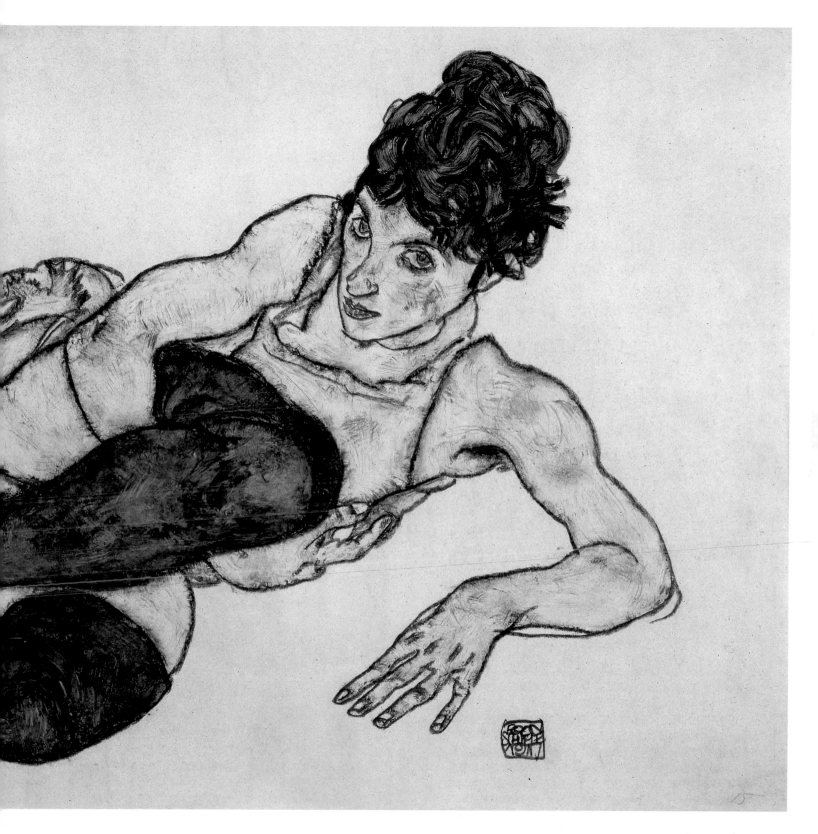

② FACE

Schiele uses the minimum of lines to describe his model's face. Although fine black outlines are drawn around each feature, which should create a flat appearance, the patches of colour on each cheek and the lights and darks in the lips, eyes and hair, create tonal contrast and texture. The model appears on an equal level with the male artist, which was unusual for the time.

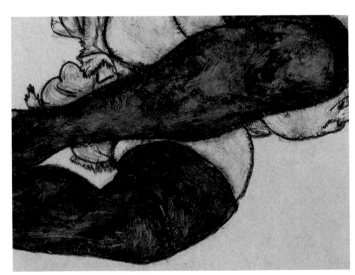

① SITTER

Schiele caused controversy with his nonconformist life and paintings. Two sisters, Adele and Edith Harms, lived opposite his studio. In 1915, he married the elder sister, Edith. She was reserved and embarrassed to pose in some of the more provocative stances Schiele requested. Yet she did not want him to use other models. Two years after their marriage, she had gained some weight and no longer met her husband's preferred slender frame, so other women, including her sister Adele modelled once again. This is probably Adele.

③ STYLE AND GREEN STOCKINGS

By this time in Schiele's life, his work had become quite realistic, but the style of this painting is still energetic and subjective. The green paint here is applied with sketchy, agitated marks. He applied underpainting in patches to show raised areas, such as around the knees, and then applied thin green paint for the stockings in directional marks.

Schiele's empty backgrounds create negative spaces that isolate his subjects, forcing viewers to focus on them. His linear treatment conveys a sense of spontaneity and energy.

4 METHOD

Colour always followed Schiele's initial lines, and this began with him defining main volumes with glazes of ochre or brown. Over this he applied short dabs of brightly coloured gouache, to capture contours on flesh and drapery. He applied longer, more fluid strokes for hair and stockings.

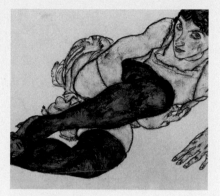

5 RHYTHM

Schiele's art often expresses sinuous rhythms. Here, an 'S' curve begins at his model's face, and continues down her right upper arm, from the elbow to her right buttock, round her left thigh and down her shin to her shoe. The lower part of her right arm forms a rhythmic line with her torso.

6 LINE

Schiele's draughtsmanship was sure and he broke some of his lines to express immediacy. Around the petticoat, zigzag lines describe movement and the texture of the fabric, and the curved lines convey the softness of the cloth and flesh and the roundness of the figure.

7 PERSPECTIVE

Schiele's elevated perspective forces viewers to look down on the model. He has foreshortened and distorted her proportions. Her bare slender arms, underwear and the hair under her arms are elements that would normally be hidden from strangers, so it adds a voyeuristic element.

Mermaids, Gustav Klimt, *c.* 1899, oil on canvas, 82 x 52 cm (32 ¼ x 20 ½ in.), Zentralsparkasse, Vienna, Austria

As a teenager, Schiele admired Klimt's work. Klimt's underlying sensuality appealed to him more than the decorative, embellished aspects of his style. Painted when Schiele was still a child, *Mermaids* focuses on the sensuality of the female body. The mermaids' sinuous dark hair that appears to extend below the picture echoes the shapes of their lithe figures. The colouring of this painting and Schiele's *Green Stockings* are broadly comparable. However, there is a sense of menace in the mermaids' faces that recalls the boldness of Schiele's female subject, especially the emphasis on their eyes, eyebrows and mouths. This was a period when women were expected to be modest and were dominated by men. Both artists outraged Viennese society.

PORTRAIT OF THE ARTIST'S WIFE, JEANNE HÉBUTERNE

AMEDEO MODIGLIANI

1918

oil on canvas
101 x 65.5 cm (39 ¾ x 25 ⅞ in.)
Norton Simon Art Museum, California, USA

THE FOURTH CHILD OF AN Italian Jewish family, Amedeo Modigliani (1884–1920) was born in Livorno, Tuscany, just as his father's business collapsed. His birth, however, saved the family from ruin, as according to an ancient law, creditors could not seize the bed of a pregnant woman or a mother with a newborn child. As bailiffs entered the family home, Modigliani's mother went into labour, and the family piled their most valuable assets on to her bed.

As a child Modigliani suffered with pleurisy and typhoid fever. At fifteen years old, he began studying in the studio of the Italian artist Guglielmo Micheli (1866–1926), and after being diagnosed with tuberculosis in 1901, his mother took him on a tour of Italy to recuperate. They visited Naples, Rome, Florence and Venice, where he became familiar with classical Italian art. Soon after, he moved to Florence and studied figure drawing at the Scuola Libera di Nudo. He then lived in Pietrasanta where he studied sculpture but he left as he was not strong enough for the strenuous and time-consuming stone-carving process. In Florence, he was inspired by the paintings of Duccio di Buoninsegna (d. *c.* 1319), Simone Martini (*c.* 1285–1344) and Sandro Botticelli (*c.* 1445–1510), and in 1905, he discovered the work of Toulouse-Lautrec at the Venice Biennale. A few years later, he left Italy for Paris where he set up a studio in Montmartre and mixed with artists including Picasso, Constantin Brancusi (1876–1957), Severini and Derain. Under Brancusi's influence, in 1910, he produced almost thirty carved stone heads in the elongated style he had been developing in his painting. However, he preferred painting portraits, and his work became dominated by images of his mistress, Jeanne Hébuterne (1898–1920), an art student whom he had met in 1917 when she was aged nineteen and he was aged thirty-three. He painted this portrait of her in 1918 when she was probably pregnant with their child.

Modigliani's elongated figures and masklike faces do not fit into any art movement. Although in his distinctive elongated style, this portrait of Jeanne resembles a Renaissance Madonna, but also shows other influences, including Cubism and ancient Egyptian art.

In the Salon of the Rue des Moulins, Henri de Toulouse-Lautrec, *c.* 1894, oil on canvas, 112 x 133 cm (44 x 52 ⅜ in.), Musée Toulouse-Lautrec, Albi, France

Influenced by the linear approach of Toulouse-Lautrec, Modigliani emulated aspects of his sketchy paint application, method of expressing light, sinuous lines, fine dark contours, seemingly casually applied patches of tonal contrast and the apparent disconnection of figures. Here, Lautrec depicted Mireille, one of the girls he knew from a Parisian brothel (that was in the Rue d'Amboise, not the Rue des Moulins as in the title). Turned to the side, her leg drawn up comfortably, Mireille sits in the salon of the brothel with other prostitutes as they wait for clients. Lautrec's use of reduced lines and minimal colours had a powerful effect on Modigliani's painting style.

Simplicity is the important element of the background. In order to focus on the sensuous lines of the figure, the background consists of two flat colours that contrast with the plain red wooden chair. Modigliani picked out Jeanne's eye colour in one of the background panels, while the unmodulated red chair omits any detail.

③ SANDRO BOTTICELLI

Modigliani's elegant, languid style shows the refined aesthetic he developed in the last years of his life, strongly influenced by Botticelli. This is markedly apparent in the slender, long neck, sloping shoulders and masked expression of his muse. It is directly comparable to Botticelli's own muse, Simonetta Vespucci.

① FACE

One of Modigliani's traits was his painting of eyes. Even though he knew Jeanne intimately, he painted her eyes a flat greyish blue with no details. Almond-shaped, piercingly bright and without pupils, they nonetheless appear to look directly out of the canvas. Her thick auburn hair forms a strong tonal and colour contrast with her eyes.

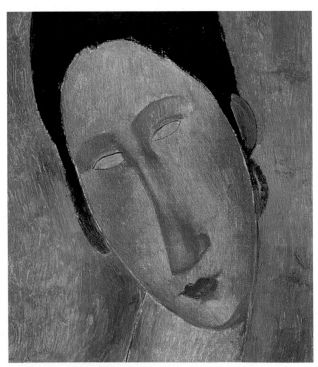

Modigliani drew on various influences. Stylistic devices of Cubism are evident, including a geometric simplification inspired by his work with sculptors Ossip Zadkine (1890–1967) and Jacques Lipchitz (1891–1973).

4 PALETTE

Modigliani creates subdued, intense tones and colours using a restricted palette with no green. Apart from the flat-looking flesh tones, the blended shades of red, blackish blue and blue-grey focus on softness.

5 LINE

The subdued colours were mixed to allow Modigliani's graceful, rhythmic line to take precedence. The S-shaped curve of Jeanne's body draws viewers' eyes in and around the image.

6 METHOD

Working on a white ground, Modigliani began this portrait by brushing on outlines of dark blue paint. He built up Jeanne's figure concurrently with the background. The few details were added last.

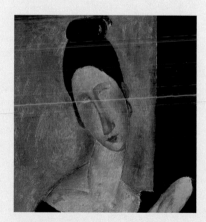

7 STYLE

Modigliani worked at a time when artists were exploring tribal art. He drew on various stylistic influences, including ancient Egyptian statuary, reflected in the shape of his sitter, like an Egyptian bust.

The Annunciation with St Margaret and St Ansanus, Simone Martini and Lippo Memmi, 1333, tempera and gold on panel, 305 x 265 cm (120 x 104 in.), Uffizi, Florence, Italy

Modigliani was inspired by the paintings of Simone Martini as is evident in this painting that Martini produced in collaboration with his brother-in-law Lippo Memmi (*c.* 1291–1356). Created for a side altar in Siena Cathedral, it forms part of a cycle of four altarpieces dedicated to the city's patron saints. This was for St Ansanus who stands on the left. In the centre, the Angel Gabriel has entered the Virgin's house to tell her that she will bear the child Jesus. Gabriel holds an olive branch, a traditional symbol of peace, while Mary, seated on a throne, is startled from her reading. Duccio's *Maestà* (*c.* 1307–11), which depicts Christ's childhood, was displayed above this painting and so the altarpiece became important in Modigliani's development as a painter. Neither this work, nor *Maestà* had any precedent. Rather than contemporary Italian altarpieces, this resembles French illuminated manuscripts of the time. The sinuous pose and elongated figure of the Virgin is echoed in Modigliani's portrait of his wife.

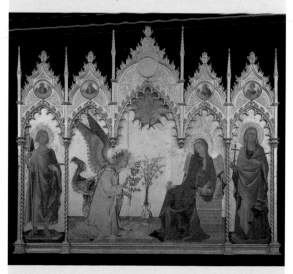

DAS UNDBILD

KURT SCHWITTERS

1919

collage of various materials, gouache, cardboard
36 x 28 cm (14 ⅛ x 11 in.)
Staatsgalerie, Stuttgart, Germany

AFFECTED ADVERSELY BY THE depressed state of Germany after World War I, and building on ideas he recognized from the Dada movement, Kurt Schwitters (1887–1948) began creating artwork out of rubbish and litter he collected randomly. The resulting collages included printed media and often had philosophical associations.

Schwitters was the only child of an affluent couple in Hanover. In 1901, aged fourteen, he had his first epileptic fit, and from then on suffered with recurring attacks that made him become introverted and insecure. From 1909 to 1914, he studied art and drawing at the Dresden Academy. On leaving, he experimented with Cubism and other aspects of Post-Impressionism. Because of his epilepsy, he was initially spared from military conscription, but as the war progressed and more men were needed, he was enlisted, and spent the last eighteen months of the conflict working as a technical draughtsman in a machine factory at Wülfen near Hanover. After the war he began creating art using refuse he found in the street. That year, he had a solo exhibition at the prestigious Der Sturm gallery in Berlin and published 'An Anna Blume' ('To Anna Flower'), a nonsensical Dadaist poem that attracted the attention of, among others, Hausmann and Arp, two of the key figures linked with the Berlin branch of Dada, with whom he became friends. He and Hausmann created Ursonate (1922–32; Ur Sonata) together, a sonata based on two of Hausmann's poems made of sounds created by letters that were connected in unexpected ways. Das Undbild followed this idea, intended to encourage viewers to make connections between the letters and shapes. He called his art 'Merz' after finding a fragment of an advertisement from 'Kommerz und Privatbank'– a local bank. Ultimately he called everything he created Merz, including collages, constructions, poetry, music, performances and installations.

In 1923, he published Merz magazine, which became an important vehicle for spreading Dadaist ideas internationally. Through the magazine, he came into contact with several leading modernist thinkers including Theo van Doesburg and El Lissitzky (1890–1941), who became his friends.

Merzbau replica, 2011, stone, 460 x 580 x 393 cm (181 x 228 ⅜ x 154 ¾ in.), Royal Academy, London, UK

Breaking down barriers between architecture and installation art, Schwitters created several buildings that he called 'Merzbau' (Merz Barn). The first was in his parents' garden in Hanover, which was destroyed in World War II, while his second, created while he was hiding from the Nazis in Norway was lost in a fire in the 1950s. When the German army invaded Norway in 1940, Schwitters escaped to Britain where he was interned as an enemy alien. There he held Dada performance evenings in an improvised studio until he was released in 1941. He planned to make a third Merzbau out of a shed he acquired in Cumbria, in north-west England, but died before he completed it. Located in a remote woodland, the building was left as it was when he died in 1948. Nearly twenty years later, it was reclaimed by restoration attempts. This is a replica, which was on display in the courtyard of London's Royal Academy in 2011.

② COLOURS

Schwitters understood how to employ the minimum colour range for impact. He used gouache in most of his collages, for their opacity and ability to be watered down. Here, as well as gouache in black and white, he used cobalt blue, French ultramarine, and yellow and brown ochre.

① LETTERS

Schwitters used words and letters in his work, and relished unexpected juxtapositions and placements. This large printed '*und*' gave him the name for the image – the title means 'The And Picture'. Since his early studies, Schwitters had been interested in linear design and typography, and by incorporating words into imagery, he explored sounds and graphics combined.

③ MULTILAYERED

The first abstract collages that Schwitters produced appeared in 1918 at the end of World War I. Influenced by some of Arp's works, this multilayered image uses words to add a sense of the absurd or a mystery. Schwitters created this in the first year of his Merz painting and collages. The diagonal composition, based around a blue triangle creates layers of imagined associations.

4 COLLAGE

Although collage was not new, the way in which Schwitters used it was innovative and crucial to art at a time when the basis of fine art was being called into question through the shocks of World War I. This is a new category of artwork, which is neither a painting, nor a construction. It enabled other artists to explore unfamiliar materials, breaking with traditions and crossing boundaries.

5 SPACE

This artwork was not concerned with creating spatial illusions as most paintings then did. Neither did it focus on the articulation of forms in space, which was the main concern of sculptors. Even Braque and Picasso's collages in their Synthetic Cubist works were about describing textures and structure, while this is only concerned with the properties of the materials in the work.

6 DIAGONALS

Despite conveying the impression that this has been created randomly, Schwitters planned it carefully in order to give a spontaneous, dynamic appearance, which highlights the nature of the discarded ephemera he used. The diagonals cut across and around the composition, resulting in an interplay of shapes, including triangles, trapezoids and rectangles, and suggestions of objects.

Still Life with Book (St Matorel), Juan Gris, 1913, oil on canvas, 46 x 30 cm (18 ⅛ x 11 ¾ in.), Musée National d'Art Moderne, Centre Georges Pompidou, Paris, France

Spanish-born Gris moved to Paris in 1906, just a few years after his fellow countryman and Cubist Picasso had settled there. The Cubist paintings produced by Gris, however, contrasted with Picasso's through their stronger colouring and firmer angles. Gris spent nearly the whole of his short career painting in his individual Cubist style, steering the movement in new directions. Here, his radically fragmented composition, bright colour contrasts, strong angles, lettering and textural effects create a bold, graphic look that can be seen to have had a direct influence on Schwitters's work—only this painting describes a still life from the real world, and Schwitters's *Das Undbild* is not intended to represent anything from the natural world.

CUT WITH THE KITCHEN KNIFE DADA THROUGH THE LAST WEIMAR BEER-BELLY CULTURAL EPOCH OF GERMANY

HANNAH HÖCH

1919–20

photomontage
collage, mixed media, 114 x 90 cm (44 ⅞ x 35 ⅜ in.)
Neue Nationalgalerie, Berlin, Germany

THE ONLY FEMALE IN the Dada movement, Hannah Höch (1889–1978) was not taken seriously by the supposedly enlightened male Dadaists. Yet in spite of this, her work – especially her photomontages – was bold and original and added to the credibility of the movement.

Born in Gotha in Thuringia, Germany, Höch left school when she was fourteen years old. In 1912, she entered the School of Applied Arts in Berlin where she studied glass design rather than fine arts to please her father, who thought that it would be more practical. Two years later, at the outbreak of World War I, she returned to Gotha to work with the Red Cross, but within a year she went back to Berlin and enrolled again at the School of Applied Arts, only this time, she studied painting and graphic design with German painter, etcher and lithographer, Emil Orlik (1870–1932). In 1915, she met Hausmann, who introduced her to the Berlin Dadaists, a group that included Grosz, Arp, and the brothers Wieland Herzfelde (1896–1988) and John Heartfield (1891–1968). Despite their declaration that they supported equal rights and opportunities for men and women, Grosz and Heartfield were reluctant to let Höch participate in the 'First International Dada Fair' in Berlin in 1920. It took a great deal of persuasion by Hausmann before they relented.

From 1916 to 1926, Höch worked part-time at Ullstein Verlag, a newspaper and magazine publishing house in Berlin. There, she wrote articles on handicrafts and designed sewing, knitting, crocheting and embroidery patterns. Although these were traditionally feminine pastimes, the job gave her a clearer understanding about relationships between words and images. In 1917, she developed her original form of photomontage.

She produced this large photomontage for the Dadaists' exhibition in Berlin in 1920. Featuring figures, buildings and portraits, it is a distinctive and irreverent statement showing elements of World War I, the political chaos in post-war Berlin, perceptions of gender, social tensions and the intrinsic sexism that was in art in general.

The Kapp Putsch

After World War I, the mood in Germany was agitated. Immediately following the Armistice of November 1918, until the signing of the Treaty in Versailles in June 1919, a naval blockade was instigated on the country. As Germany depended on imports, citizens died from starvation during that time. Kaiser Wilhelm II had abdicated and protest marchers declared that the Treaty of Versailles was too harsh. Once the peace treaty was signed, the Weimar Republic took control of the country and in March 1920, right-wing politicians led by Wolfgang Kapp attempted a coup. Putschists and crowds gathered in the government district in Berlin (above). However, large sections of the German population refused to cooperate with Kapp and joined a general strike called by the government, triggering another uprising, which was suppressed by military force.

② SATIRE

This work lambasts the political breakdown that had been taking place in Germany since the war had ended. Cutting and pasting contemporary images from newspapers and magazines, Höch summarizes the discord and dissonance between various factions, belittling problems through placement and proximity.

③ SELF-PORTRAIT

A portrait of Höch is stuck on a map that indicates the countries that had given women the vote by 1920. Surrounding her are other Berlin Dadaists, including Grosz, Hausmann, Heartfield (in the bath) and the art critic Theodore Däubler shown with a baby's body. The lettering spells out *Dadaisten* (Dadaists).

① PHOTOMONTAGE

Photomontages are collages made of photographs and photographic images from the media. Höch developed original ideas using print to reflect the contemporary world through art. Her pioneering methods of photomontage evolved through her friendship with artists including Hausmann, Schwitters and Piet Mondrian (1872–1944) among others.

④ KÄTHE KOLLWITZ

This is a popular dancer of the time, Niddy Impekoven, beneath the head of the female Expressionist, Käthe Kollwitz (1867–1945). Like Höch, she is a rare female in a man's world. Her head is also being speared by a man in front of the elephant, while Impekoven rests his foot on a giant ball bearing.

⑤ ALBERT EINSTEIN

This is Albert Einstein who is saying: '*He-he Sie Junger Mann, Dada ist keine Kunstrichtung*' ('He-he young man, Dada is not an art trend.') Horses are shown to his left and a train above his head. The text reads: 'Dada' and '*Legen Sie Ihr Geld in Dada an!*' ('Invest your money in Dada!').

⑥ MECHANICAL CONTROL

Amid the images of wrestlers, German soldiers, protest groups and political figures is General Hindenberg on top of the body of a dancer. The wheel, cog and ball bearings across the image suggest mechanical control, as if the machine will keep working, despite the absurdity of events.

⑦ KITCHEN KNIFE

Within the fractured German society, Höch expresses her position as a female within a male-dominated art movement and the male assumption of women's passivity in general and of female artists in particular. The kitchen knife in the title alludes to women's expected roles.

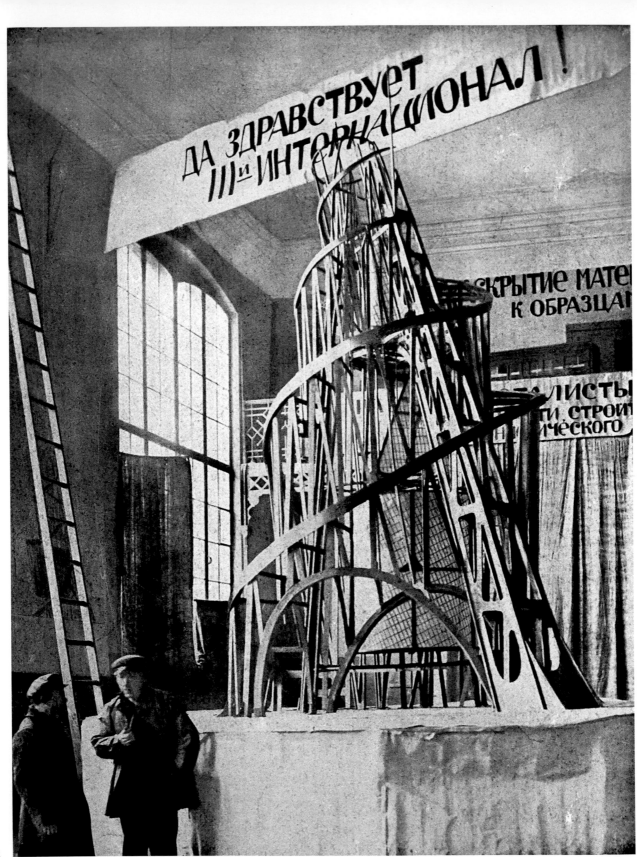

MONUMENT TO THE THIRD INTERNATIONAL

VLADIMIR TATLIN

1919–20

model wood, iron and glass
420 x 300 x 80 cm (165 ⅜ x 118 ⅛ x 31 ½ in.)

VLADIMIR TATLIN (1885–1953) WAS central to the development of Russian Constructivism. Learning from Picasso's Cubist reliefs and Russian Futurism, he created objects that amalgamate sculpture and architecture.

From a young age, Tatlin was inspired by icon painting and Russian folk art, and he began his career as an icon painter in Moscow. From 1902 to 1910, he studied at the Moscow School of Painting, Sculpture and Architecture and also the Penza School of Art south-east of Moscow. He socialized with Russian avant-garde artists and architects, including Natalia Goncharova and Mikhail Larionov, and was inspired by their art movement, Rayonism, which derived from Futurism, and fragmented objects into spatial and structural relationships.

Late in 1913, Tatlin travelled to Berlin and Paris. In Paris, he visited Picasso and discovered his process of analysing forms for three-dimensional, mixed-media constructions. Until 1915, he travelled in Europe, Turkey, Egypt and Asia Minor. On his return to Moscow, he produced constructions that he called 'painting reliefs', which he exhibited at the '0.10' Futurist exhibition held in Petrograd (now St Petersburg) in 1915 to 1916. He became the leader of a group of Moscow artists who applied engineering techniques to the construction of sculpture, that developed into Constructivism. Other Constructivists included El Lissitzky, Naum Gabo (1890–1977) and Alexander Rodchenko (1891–1956).

Amalgamating architecture and sculpture, Tatlin's creations were abstract, as he explored the natural potential of his materials and the geometrically inspired forms he could create with them. As well as their lines, shapes and forms, the negative or surrounding space is an important aspect of his creations. Tatlin and the Constructivists addressed social and political concerns of contemporary Russia in their art. From 1919 to 1920, Tatlin created a design for the Communist International headquarters in Petrograd, known as the *Monument to the Third International*. A model of the monument was exhibited and photographed (left) in the city in November 1920. Although never built, the structure became the influential example of Constructivist art.

The Eiffel Tower, Paris, France in 1889

The Eiffel Tower was constructed in Paris in 1889 to commemorate the centennial of the French Revolution. The wrought-iron lattice tower was a symbol of modernity and inspired Tatlin directly. His monument was often called *Tatlin's Tower* and was designed to use similar girder styles and cross-branching as the Eiffel Tower, but would have been far larger and asymmetrical. As Tatlin's monument honoured the new Bolshevik regime, it was also more utilitarian than the Eiffel Tower. So when it was rejected for being too modern and ambiguous, it was seen as symbolic of the failed aspirations of the Bolshevik regime.

② SPIRAL

Erected with the help of a complicated system of vertical pillars and spirals, the tower is shaped like a spring, corkscrew or helix. The spiralling nature of the design conveys dynamism and suggests the revitalizing effects of the Russian Revolution of 1917. Tatlin said: 'The spiral is the most effective symbol of the modern spirit of the age... [it] forms the purest expression of humanity set free by the Revolution'.

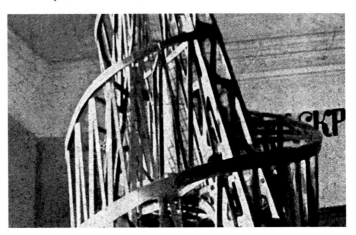

③ ROTATING GEOMETRY

The monument was to consist of three great rooms of glass, each placed on top of each other and each a rotating geometric shape: a cube on the ground floor, a cone in the middle and a cylinder on the top. Each of these units was designed to rotate.

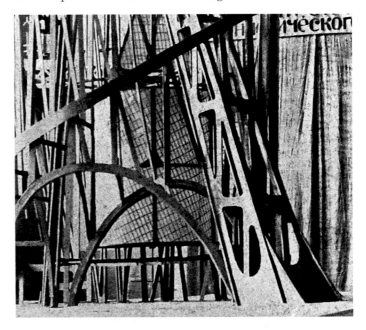

① STRUCTURE

The Constructivists believed that art should help to improve society and be useful, not just an adornment, and like Malevich and the Suprematists, they eliminated all embellishments from their designs. In addition, Tatlin embraced and celebrated the machine age by exposing the skeleton of his structures. This was a direct response to Cubism which ultimately derived from Cézanne's attempts at showing structure in his paintings.

4 FUSION

Tatlin planned to adorn the top of his massive monument with a projector that would be used to beam Communist slogans on to the clouds, which would serve as projector screens for citizens to see on the ground below. Tatlin's design was intended to fully interact with its spatial environment in every way – it was a complete fusion of art and engineering.

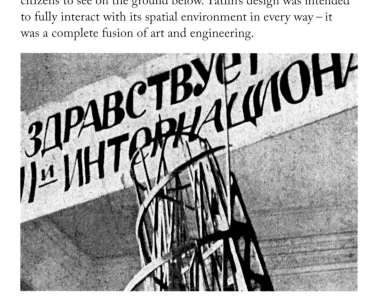

5 HEIGHT

In 1920, Tatlin unveiled his first model for the proposed monument, which at the time would have been the world's tallest structure at over 396 metres (1,299 ft). But it was never built. By the mid-1920s, the utopian visions of world revolution had diminished. Idealism in art and politics was replaced by a dictatorship under Joseph Stalin that disapproved of abstract art. The monument had a huge impact on modern architecture through its use of modern materials iron, steel and glass.

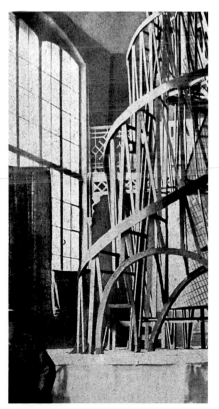

The cube, the cone and the cylinder

After the Russian Revolution, Tatlin worked for the Bolshevik leader Vladimir Lenin, implementing his campaign to remove monuments that reflected the Tsarist period from the streets and replace them with designs that proclaimed the ideas of the Soviet regime. Designed for conferences and the Party Congress, the cube, or bottom floor, was intended to revolve once a year. The central cone was to serve as the executive headquarters and would rotate monthly. The top floor, shaped like a cylinder, was to be used for communications, media and propaganda, and broadcast to Europe. It would rotate once a day. Each of the three units as seen in this replica at the State Tretyakov Gallery, Moscow, was designed to rotate at differing speeds.

RED BALLOON

PAUL KLEE

1922

oil on chalk-primed muslin gauze mounted on board
31.5 x 31 cm (12 ½ x 12 ¼ in.)
Solomon R. Guggenheim Museum, New York, USA

A PROLIFIC SWISS-BORN GERMAN ARTIST who was influenced by Cubism, Expressionism and Surrealism, Paul Klee (1879–1940) was the son of a music teacher. A talented violinist, he chose the visual arts over music as a teenager. He also inherited drawing skills and grew up unsure which way his career would evolve. Even when he eventually chose art, music remained important to him: he played his violin before beginning a painting and his art frequently referenced music.

Born near Bern, Klee moved to Munich when he was nineteen years old to enter the Academy of Fine Arts. On completing his degree, he went to Italy, visiting Rome, Florence and Naples, where he familiarized himself with the work of the Italian masters. By 1905, he had developed signature techniques, such as drawing with a needle on a blackened pane of glass, while his *Inventions* (1903–05) series of etchings became his first exhibited works. In Munich in 1911, he met Kandinsky, Marc and Macke and joined their art group *Der Blaue Reiter* (The Blue Rider). He also studied the work of other artists who were experimenting with new ideas, such as Sonia and Robert Delaunay, Picasso and Braque. These influences inspired him to experiment with abstraction. Yet he was nervous of colour and tended to draw and produce prints before painting. Then, in 1914, he visited Tunisia, and the vivid light and natural colours changed his attitude as he famously wrote: 'Colour and I are one. I am a painter.'

During World War I he served in the German army painting camouflage on aircraft. After the war, he taught at the Bauhaus in Germany, first in Weimar and then Dessau, in the bookbinding, stained-glass and mural-painting workshops.

A transcendentalist, Klee followed the philosophy that emerged from English and German Romanticism, Immanuel Kant and German Idealism. He believed that people are at their best and succeed when they are truly independent and that the visual world is only one of several other realities. Defying categorization, his diverse body of work expresses that philosophy. In *Red Balloon*, he demonstrates his recently discovered expertise as a colourist using the simplified naive and witty style that made him famous.

Hammamet with its Mosque, **Paul Klee, 1914, watercolour and graphite on paper mounted on cardboard, 24 × 22 cm (9 ⅜ x 8 ¾ in.), Metropolitan Museum of Art, New York, USA**

Klee's visit to Tunisia was life-changing experience. The light of North Africa inspired his sense of colour, which had previously evaded him. On 14 April 1914, he visited a small town to the north-west of Tunis, Hammamet, where he painted this watercolour from just outside the city walls. Blending figurative and abstract elements, it depicts the mosque flanked by two towers and gardens. The foreground comprises veils of translucent colour. This patchwork of angled, flat colour appears across the landscape, while simple shapes describe vegetation throughout the composition. Klee was particularly inspired by Robert Delaunay's use of bright colour in semigeometric shapes.

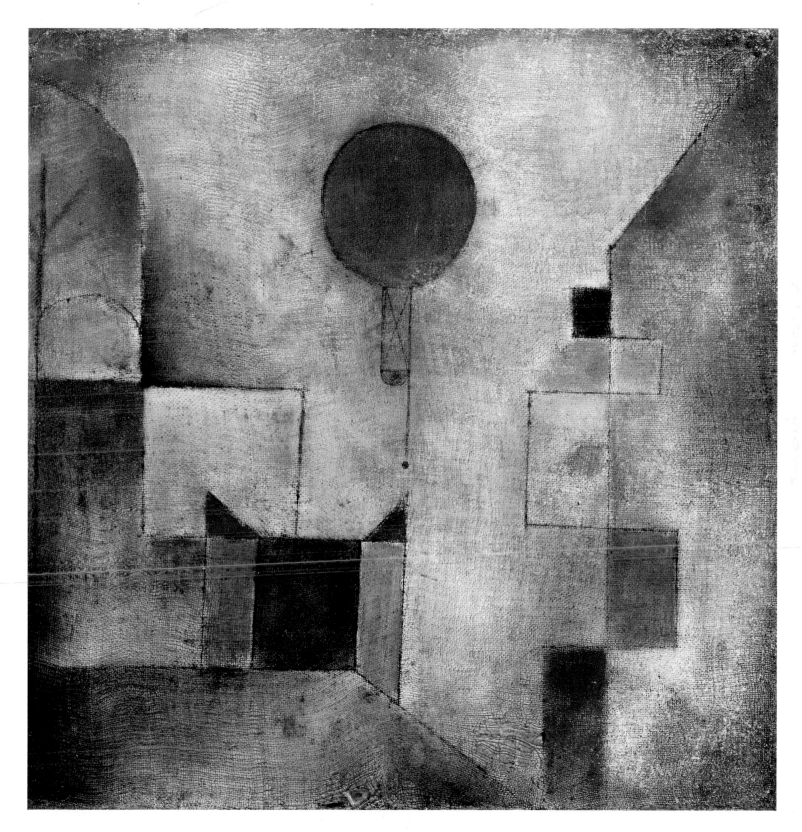

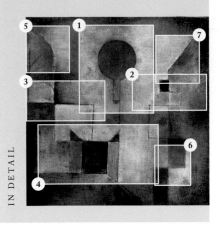

2 GEOMETRIC SHAPES

Squares, triangles, rectangles and a circle appear to float across the composition. The geometric shapes suggest buildings. With no tonal variations, the geometric shapes appear weightless.

3 NON-REPRESENTATIONAL

As the painting has a representational title, it creates an allusion to real life, although it is an abstract composition. Klee communicated associations that were more expressive than descriptive.

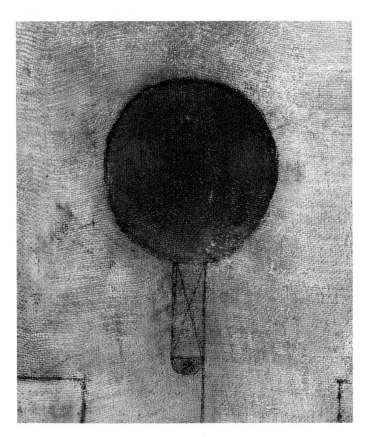

1 INNOCENCE

The red balloon evokes childhood. Klee wrote: 'I want to be as though newborn, knowing nothing, absolutely nothing about Europe… to be almost primitive.' He tried to ignore art movements and shake off any influences. He endeavoured to create his own innocent style devoid of preconceptions – and avoid being artistically categorized.

4 CITYSCAPE

Although ambiguous, this image with its deconstructed shapes and different viewpoints is intentionally suggestive of a street or cityscape. The vibrant red balloon could be interpreted as a sun.

With his passion for and scientific assessment of colour, Klee's paintings have a mystical, abstract quality, making them as he hoped, difficult to categorize. Here, it is probable that he was recalling an actual location and sight he had seen, but created his own interpretation of it.

⑤ METHOD

Klee coated a sheet of muslin with chalk. He coated a sheet of paper with black oil paint and laid a clean sheet of paper on top of it. Over the top of the clean paper, he drew the shapes and then lifted the top sheet of paper, transferring the underside image on to his muslin, like a print.

⑥ COLOURS

Chalk and oil on muslin highlight Klee's colours. Over the white and grey ground, he used blues, green, red, yellow and brown chalks, either filling the entire shapes with flat-looking colour or blending and spreading the colours to soften the edges.

⑦ LINES

Despite evading associations with any specific art movements, Klee was fascinated by Cubism, Futurism, Constructivism, Suprematism and Bauhaus ideas. This shows an influence of all those influences. The red balloon is the only round shape amid straight lines.

The Bauhaus

The Bauhaus art school was open from 1919 to 1933 and it changed the ways in which art and design is taught. The school's impact was felt across the world long after it closed. Shaped by the Arts and Crafts Movement, it was a modern, anti-academic institution that gave students practical skills. It aimed to reconcile creativity and craftsmanship with manufacturing in response to the rise of mass production, and unite art with industrial design. The school was founded in Weimar in 1919 by German architect Walter Gropius. It moved to Dessau from 1925 to 1932 and then Berlin from 1932 to 1933. Two other architects, Hannes Meyer and Ludwig Mies van der Rohe, led the school from 1928 to 1930 and from 1930 to 1933 respectively. When the Nazi Party came to power in 1933, the Bauhaus was accused of subversion, which led to its closure.

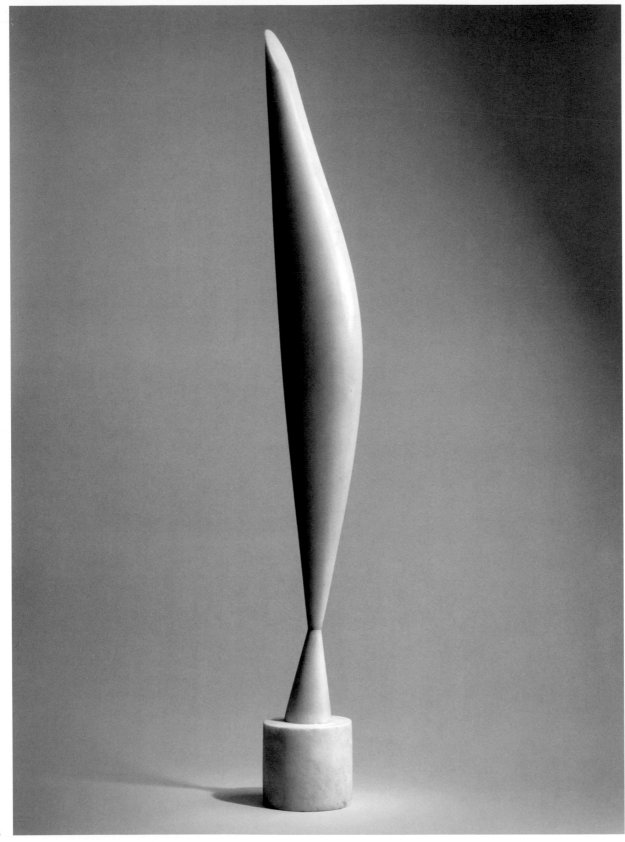

BIRD IN SPACE

CONSTANTIN BRANCUSI

1923

marble
144 x 16.5 cm (56 ¾ x 6 ½ in.)
Metropolitan Museum of Art, New York, USA

OFTEN REGARDED AS THE MOST important sculptor
of the 20th century and a great pioneer of modernism,
Constantin Brancusi (1876–1957) grew up in a village close to
Romania's Carpathian Mountains, an area recognized for its
woodcarving and other folk craft traditions. With a difficult
childhood, Brancusi left home at the age of eleven. From 1889
to 1893, he attended the School of Arts and Crafts in Craiova
part-time, while also working in various jobs. In 1894, he
enrolled at the school full-time, and graduated with honours
in 1898. He went on to study modelling and life sculpture at
Bucharest's National School of Fine Arts until 1902, where
he won several awards for his work. In 1904, he moved to
Paris, travelling most of the way on foot. Once in the capital,
he encouraged the myth that he was a peasant with an exotic
heritage; he wore rustic Romanian clothing and carved his
own furniture. From 1905 to 1907, he trained in sculpture
and modelling at the École des Beaux-Arts, and then began
working as a studio assistant to French sculptor Auguste
Rodin (1840–1917), but left after only a month, announcing
that: 'Nothing grows under the shadow of big trees.'

After leaving Rodin's studio, Brancusi formed his own style
and methods. He produced smoothly contoured sculptures in
marble and bronze, and often made several versions on one
theme in different materials. Five of his works appeared in the
Armory Show in New York in 1913 that exhibited avant-garde
European and US art. The following year US photographer
Alfred Stieglitz (1864–1946) put on Brancusi's first solo show
at his gallery, 291, in New York. Although the exhibition
was successful, and Brancusi attracted US buyers, his work was
regarded as controversial. His smooth, detail-free forms, their
lack of realism and his ideas, such as the base of his sculpture
being as important as the sculpture itself, provoked the public.
Bird in Space also caused a stir. In 1926, a US customs official
labelled a version of it as a 'miscellaneous household good',
which meant it was taxable as an import rather than a work
of art, which would be exempt from customs duties. After a
two-year-long courtroom battle, however, the judge ruled in
Brancusi's favour, establishing a precedent for all modern art.

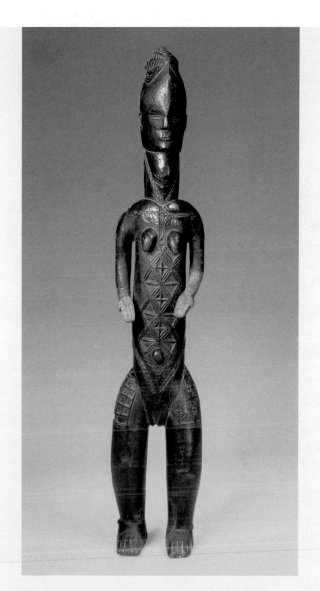

Female Bete statue, **artist unknown, 19th century,
wood, 72.5 × 14 × 13.5 cm (28 ½ x 5 ½ x 5 ⅜ in.),
Musée National, Abidjan, Ivory Coast**

This female figure comes from Africa's Ivory Coast.
It has a small head with a broad forehead and almond
eyes, short legs and arms, an elongated neck and small
bust, and stands with open hands and forward-facing
palms. Brancusi was among several European artists
during the 20th century who were inspired by African
art, particularly pared-down statues that accentuate
specific features. Like *Bird in Space,* this work emphasizes
the parts of the figure that mattered most to the artist.

② STREAMLINED FORM

Tapering to a slanting, oval plane at the top, this sculpture is stripped of all ornamentation or extraneous details. The result is a streamlined, elongated body that suggests the swift upward movement of a bird as it soars vertically into the sky.

③ DIRECT CARVING

As a child, inspired by the folk art around him, Brancusi had often carved wooden farm tools. When he grew up, he pioneered the technique of direct carving, rather than working with plaster or clay models. He wrote: 'The artist should know how to dig out the being that is within matter.'

① BIRD

The idea of a bird in flight preoccupied Brancusi for many years. Between 1923 and 1940, he produced sixteen versions of this sculpture, seeking to capture the essence of a bird and of flight, rather than the individual appearance of a particular bird, or any details of wings, feathers or beak for example.

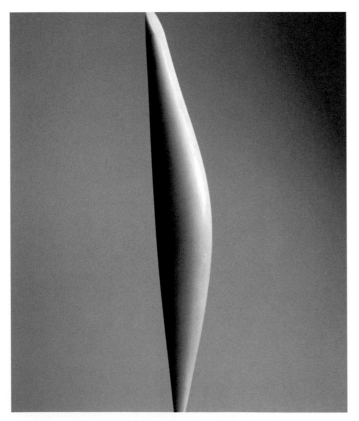

④ MARBLE

Although informed by the past, in emphasizing clean, smooth geometric lines, Brancusi created an individual blend of modernity and timelessness. The swell of the body leads viewers' eyes over the smooth mound of polished marble. This was the sculptor's first version of *Bird in Space*: he went on to carve six other versions with marble and cast nine in bronze.

⑤ FIGURATIVE

Many described Brancusi's art as abstract, but he always maintained that his work was representational, even if the reality was often concealed. By drastic simplification and the abandonment of ornamentation, he always sought to convey his subjects' meaning or essential qualities. Here, the sculpture's streamlined appearance is suggestive of a wingless bird.

⑥ INTEGRAL BASE

One of Brancusi's ideas that did not conform with sculptural history was that his bases, plinths or stands were integral parts of his artwork. They are sculptural elements in their own right. Here, the base is a discrete cylinder, attached to a slender, conical footing that continues into the body of the 'bird'. The clean, geometric lines of this stand add to the balance of the work as a whole.

Birds and Flowers, Chen Mei, 1731, album leaf, ink and colour on silk, 17 x 12 cm (6 ¾ x 4 ⅝ in.), Yale University Art Gallery, Connecticut, USA

The theme of a bird in flight preoccupied Brancusi for several years and his admiration of Eastern art's paring down of shapes inspired him. *Bird in Space* focuses on the grace of movement rather than a bird's physical attributes, eliminating details such as wings and feathers. In the 18th century, Chen Mei (*c.* 1726–42) served as a court painter in China. This delicate painting, like Brancusi's sculpture, expresses the graceful swoop of the birds, both in flight and at rest. Created for Emperor Qianlong, the painting was made as part of an album of flowers, birds, insects and other animals. Although it includes details that Brancusi eradicated, it is the essence of the curving lines of the birds and their flight that informed Brancusi's sculpture.

THE TILLED FIELD

JOAN MIRÓ

1923–24

oil on canvas
66 x 92.5 cm (26 x 36 ½ in.)
Solomon R. Guggenheim Museum, New York, USA

PAINTER, SCULPTOR AND CERAMICIST Joan Miró
(1893–1983) invented a new kind of visual language, arranging
objects from his imagination with simplified, biomorphic, but
usually recognizable forms. This radical, inventive style played
a key role in the development of Surrealism.

Miró was born in Barcelona to a family of craftsmen.
From the age of fourteen to seventeen, he trained at the
Barcelona School of Commerce. Then in 1912, he entered
the Llotja School of Industrial and Fine Arts where he studied
landscape and decorative art, and learned about modern art
movements. Inspired by the bright colours of Fauvism and
the fragmented compositions of Cubism, his early paintings
blended some of these ideas along with stylized Romanesque
Catalonian murals. In 1919, he moved to Paris, where he met
Picasso and was so poor that he later claimed he hallucinated
through hunger. He wrote down his visions in notebooks.
These hallucinations inspired his 'automatism' or unconscious
painting that he believed expressed underlying truths,
creativity and spontaneity. This work is an example of that
mixture of conscious and unconscious thought. It represents
a view of his family's farm in the village of Montroig, Catalonia.

**Detail from *The Stoning of
St Stephen*, artist unknown,
c. 1100, fresco, Church of
St Joan de Boí, Lleida, Spain**

The walls of Romanesque
churches were covered with
colourful frescoes. Miró's
inventive style took elements
from the Romanesque art he
saw around him throughout
his life. It is noticeable in his
rich colours, expressive contours
and lack of perspective.

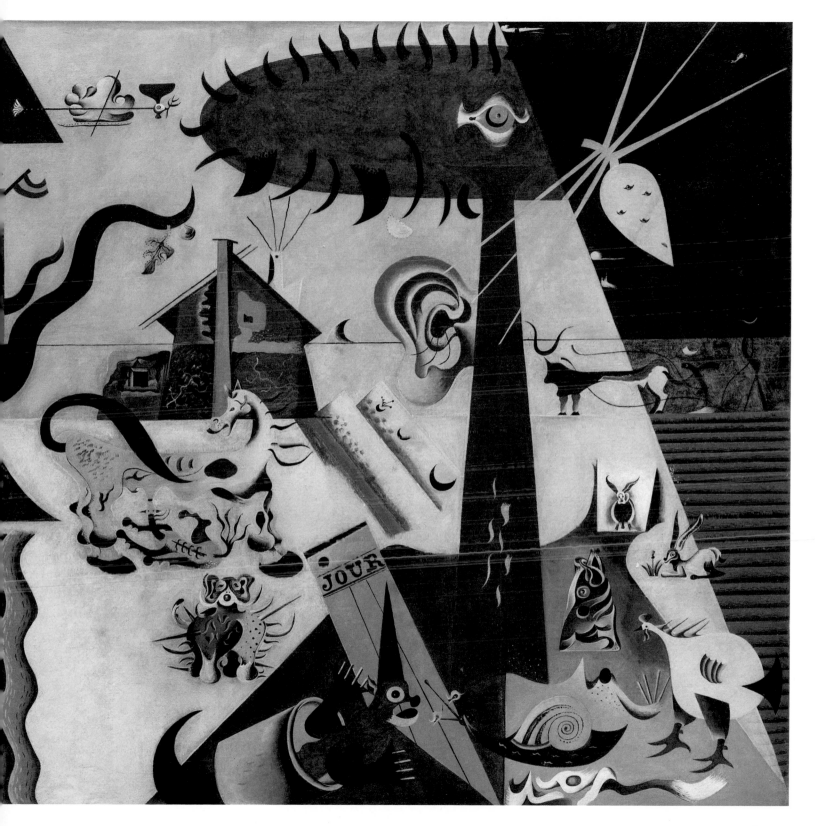

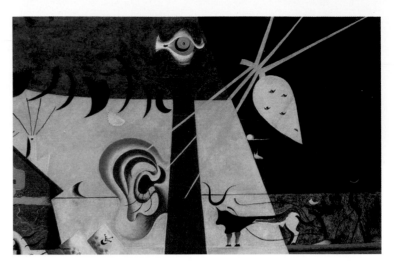

② EYE AND EAR

The eye in the pine tree and the eye-covered pine cone beneath can be traced to examples of Christian art, where angels' wings were often embellished with tiny eyes. It also suggests Miró's memory, although he denied this, claiming it was a fruit. The ear reflects his belief that every object contains a living soul. He said: 'A beautiful tree breathes and listens to you.' The figure with a cattle-drawn plough is based on the prehistoric cave paintings of Altamira in Spain, which Miró knew well.

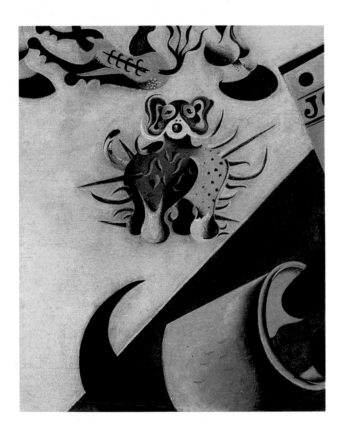

① INSPIRATION AND IMAGINATION

Inspired by medieval Spanish tapestries and *The Garden of Earthly Delights* (*c.* 1500–05) by Dutch painter Hieronymus Bosch (*c.* 1450–1516), these organic, flat-looking shapes depict a view of Miró's family's farm in Catalonia. He said: 'It was difficult to select the right colours for a summer that never happened… Art historians might realize that I simply made everything up….'

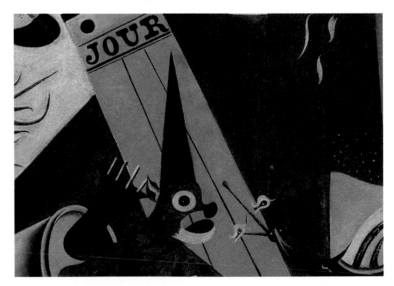

③ CUBISM

In Paris, Picasso showed Miró the Cubist method of fragmenting objects and arranging compositions on a grid, which Miró adopted. This recalls a Cubist still-life arrangement. It includes a folded Parisian newspaper with the word '*jour*' (day) and a Spanish lizard wearing a conical-shaped hat. They represent Miró's bases of Paris and Montroig.

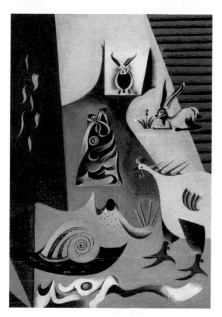

④ CREATURES

This is the first Surrealist painting by Miró. Although he never joined the Surrealist group, its founder, André Breton claimed that he was 'the most Surrealist of us all.' Throughout his career, Miró referenced his family farm, especially reproducing stylized creatures including squirrels, snails, hares and roosters, all of which appear to have been inspired by medieval Spanish tapestries and Catalan ceramics. Behind them is another recurrent stylization: a ploughed field.

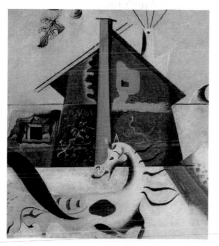

⑤ HOUSE

The Miró family farm in Montroig was a large white house in the foothills of the red mountains, close to the sea. Here, he could not 'conceive of the wrongdoings of mankind'. This is his version of the farmhouse; brown and tumbling down with a horse in front. Horses feature often in his paintings, representing timelessness and the countryside.

⑥ LANDSCAPE

The landscape is set in rural Catalonia where Miró was born. It is a region of Spain near the French border that has its own parliament, language, history and culture. He later explained: 'I have managed to escape into absolute nature, and my landscapes have nothing in common anymore with outside reality....'

⑦ FLAGS

The three flags – French, Catalan and Spanish – refer to Catalonia's attempts to split from the central Spanish government. By depicting the Catalan and French flags together, separated from the Spanish flag, Miró announced his allegiance to the Catalan cause and rejection of Spanish repression.

⑧ COLOUR AND COMPOSITION

The bright yellow landscape, flattening of objects, imaginative shapes and restricted palette create a vibrant, uplifting image. Miró later wrote: 'The yellow was sunlight, representing hope.' His palette here probably included flake white, zinc white, lemon yellow, cadmium yellow, burnt sienna and alizarin crimson.

PORTRAIT OF THE JOURNALIST SYLVIA VON HARDEN

OTTO DIX

1926

oil and tempera on wood
121 x 89 cm (47⅝ x 35 in.)
Musée National d'Art Moderne,
Centre Georges Pompidou, Paris, France

OTTO DIX (1891–1969) WAS a key member of the *Neue Sachlichkeit* (New Objectivity) movement of the mid 1920s. Haunted by his experiences as a German soldier in World War I, his first subjects were crippled soldiers, but later he painted nudes, prostitutes and often brutal portraits.

Dix was born in Untermhaus in Thuringia, Germany. Following an apprenticeship with a local painter, he entered the Dresden Academy of Applied Arts in 1910. At the outbreak of World War I in 1914, he volunteered for the German army. He was wounded several times, nearly died and became traumatized, but won the Iron Cross. He also made sketches of many of the tragic scenes he witnessed.

After the war, he resumed his art education at the Dresden and Dusseldorf art academies. He began experimenting, using elements of Futurism and Cubism integrated with Dadaist and Expressionist ideas. In 1919, he co-founded the Dresden Secession group. He painted portraits, created collages and woodcuts, and worked with mixed media. Gradually, his views emerged in his art. Angry about the treatment of wounded and crippled veterans in Germany, he produced bitterly satirical paintings. Over the next few years, this anger expanded into disturbing paintings depicting sexual violence, murder and cruelty. He exhibited in Berlin and Dresden before moving to Dusseldorf in 1922. In 1924, with other pacifist artists who had fought in the war, he participated in a travelling exhibition of paintings, '*Nie Wieder Krieg!*' ('No More War!'). He became one of the principal members of the New Objectivity movement that took its name from an exhibition in Mannheim in 1923. New Objectivity artists depicted what they saw as the corruption, frenzied pleasure-seeking and general debilitation of post-war Germany during the Weimar Republic.

Dix's portrait of German journalist and poet Sylvia von Harden is a New Objectivity image. It portrays the new type of ambitious woman who was emerging in Germany as a result of the unprecedented abominations that had occurred.

The Garden of Earthly Delights, Hieronymus Bosch, *c.* 1500–05, oil on oak panel, central panel 220 x 196 cm (86 ½ x 77 in.), each side panel 220 x 96.5 cm (86 ½ x 38 in.), Museo Nacional del Prado, Madrid, Spain

Bosch produced moralizing paintings for medieval viewers and this example shows the fate of humanity since Adam and Eve were expelled from the Garden of Eden. In the three panels of this ambitious work, Bosch presented the consequences of living a sinful life. The lack of softening of the imagery inspired Dix and other artists in post-war Germany. Although he does not cite the Bible, Dix highlighted similar human traits in his art.

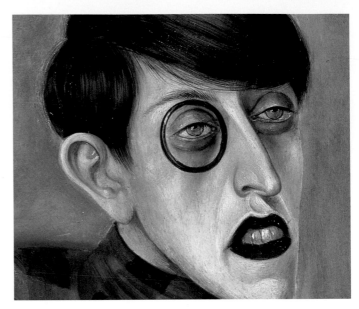

② HEAD

Von Harden has a closely cropped, mannish hairstyle. Her angular jaw, long narrow nose and hard, darkly painted lips adorn a grimacing face, and the monocle in her right eye suggests masculinity and myopia, perhaps aggravated by her writing career, indicating that she has no time to focus on other things.

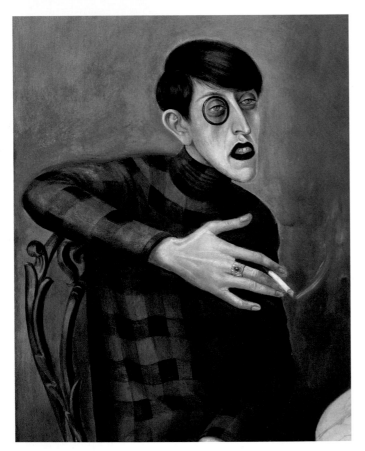

① NEUE FRAU

This image of Sylvia von Harden became iconic. Dix depicted her as the *Neue Frau* (New Woman) that was emerging in Germany, personifying general social changes. The New Woman discarded all previous conventions of femininity: she smoked, drank, had a career and did not care about marriage or having children.

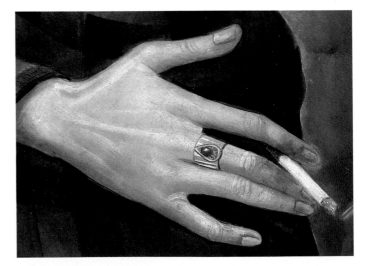

③ HAND

Although the subject wears a ring on her finger, it is one that could be worn by men or women. The cigarette and nicotine-stained fingers demonstrate that she does not care for conventional ideals of female beauty. This hand is placed over the part of her body that would, in most depictions of women, be a curving breast.

④ CAFE CORNER

Von Harden requested that Dix represented her with her legs crossed and a cigarette between her fingers. As an habitué of Berlin's well-known Romanisches Café, he placed her in a corner of the establishment, at a small, round marble-topped table with a cocktail. This signifies a modern woman who is comfortable being alone in public. Slumped on the chair wearing a red and black checked dress, her stockings are sagging, implying that she is not concerned with how she looks. There are no signs of femininity on the table – simply cigarettes, matches and an alcoholic drink.

After experimenting with Expressionism, Futurism and Dada, Dix painted in a realist manner so he could present a critical view of Weimar society. His knowledge and admiration for the Old Masters led him to base his style on a technique that revived their working methods.

⑤ CONTRASTS

The dress reveals few feminine curves. Dix presents an androgynous appearance, the body appears cylindrical, almost mechanical. These geometric shapes contrast with the ornate and delicate chair that Von Harden occupies.

⑥ METHOD

Following German Renaissance artists such as Cranach the Elder, Dix painted on wood rather than canvas and used a mixed technique of tempera and oil. In addition, he painstakingly prepared his support, then applied glazes.

⑦ REPETITION

Dix was inspired by Hans Holbein the Younger (c. 1497–1543). Here, he emulates Holbein's repetition of shapes. Rectangles are repeated in Von Harden's dress, matchbox and cigarette case, and circles are echoed in her monocle and the glass.

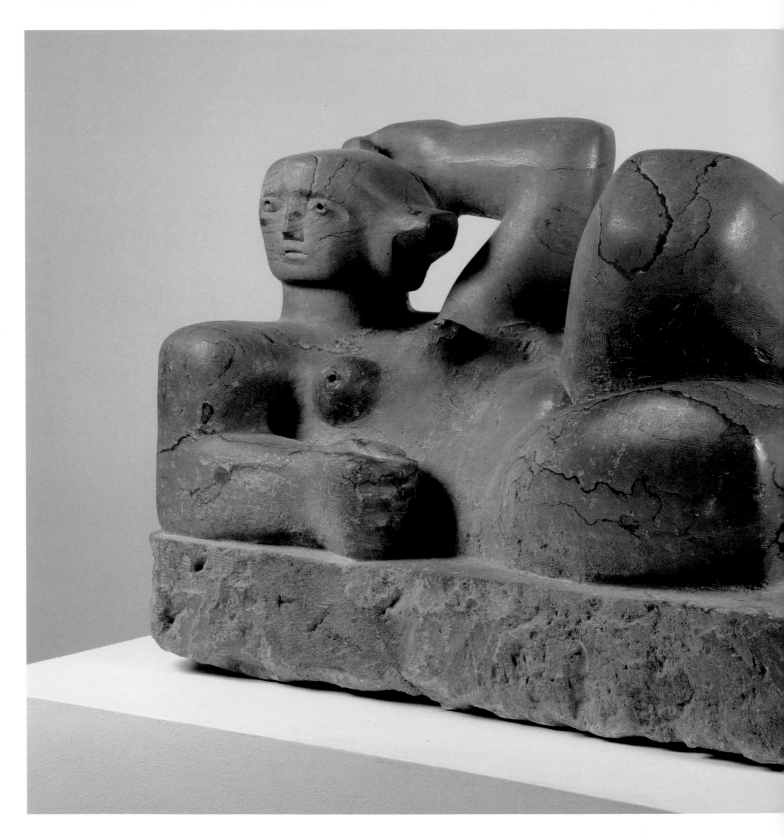

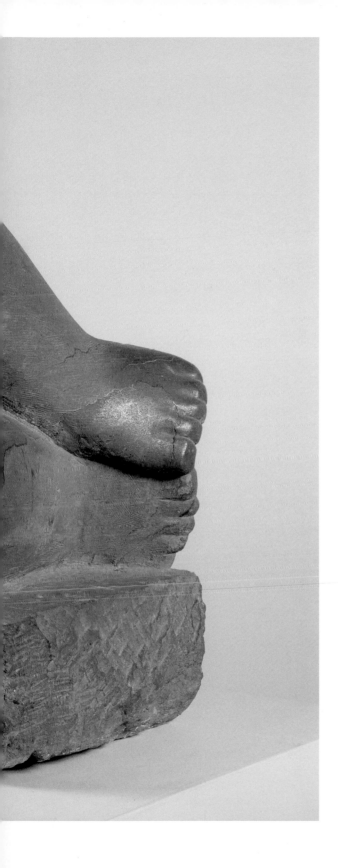

RECLINING FIGURE

HENRY MOORE

1929

brown Horton stone
57 x 84 x 38 cm (22 ½ x 33 x 15 in.)
Leeds Museums and Galleries, Yorkshire, UK

THE MOST INTERNATIONALLY CELEBRATED
sculptor of the second half of the 20th century, Henry Moore
(1898–1986) was born in Yorkshire, England, the son of a coal
miner. Best known for his semi-abstract, organically inspired
monumental sculptures, he was also a fine draughtsman, and
produced many graphic works on paper. Moore's works recall
the undulations of the natural environment. They are usually
abstractions of the human form, and often feature reclining
figures or a mother and child.

Determined that his sons would not follow him into the
mines, Moore's father ensured that they were well educated.
Moore attended the local grammar school, where he began
modelling in clay and carving in wood, later declaring that he
decided to become a sculptor at the age of eleven after learning
about Michelangelo (1475–1564) at Sunday School. However,
perceiving sculpture to be manual labour with few career
prospects, Moore's parents opposed his ambitions, and he
began his career teaching. In 1916, in the midst of World
War I, he volunteered for army service but within a year he
was injured in a gas attack. For the rest of the war he worked
as a physical training instructor. In 1918, he enrolled at Leeds
School of Art to study sculpture. There he met Barbara
Hepworth (1903–75) who strongly influenced him. In 1921,
Moore received a scholarship to continue studying at the
Royal College of Art in London. While in London, he
frequented the British Museum studying the ethnographic
collections. In 1924, he toured Italy and France for six months,
where he became enthralled by the art of Giotto di Bondone
(c. 1270–1337), Masaccio (1401–28) and Michelangelo. In Paris,
he took art classes and also studied at the Louvre and the
Musée d'Ethnographie du Trocadéro, where he saw an
Aztec Chacmool sculpture depicting a reclining figure.

On his return to London, Moore taught at the Royal
College of Art while also creating sculpture and socializing
with artists including Hepworth, Ben Nicholson (1894–1982),
Naum Gabo and Piet Mondrian. *Reclining Figure* was one
of his early works in stone and was inspired by the Chacmool
statue he had seen in Paris years earlier.

① NATURE

The natural world and the human body inspired Moore's forms. As well as figures and the landscape of his birth, he derived ideas from studying stone, shells and bones. The curves of the figure recall the rise and fall of a landscape.

② FIGURE

Non-Western art was crucial in shaping Moore's work. This stylized figure is one of the earliest examples of his exploration of the reclining figure, which was a motif that became central to his mature style.

③ BREASTS

Although it focuses on nature, much of this sculpture is unnatural, for example the figure's perfect rounded breasts. They may have derived from the influence of Michelangelo's female figures such as his sculpture *Night* (1526–31).

④ FACE

The simplified facial features are small and expressionless, conveying a universal human, with no defining nationality, age or expression. In this way, Moore has created a sense of everywoman – the epitome of an Eve-like figure or a deity.

⑤ HAND

Heavy, firm and dependable, this hand is not traditionally feminine. However, it serves to visually add weight to the sculpture and portray a sense of classicism or ancient stylization.

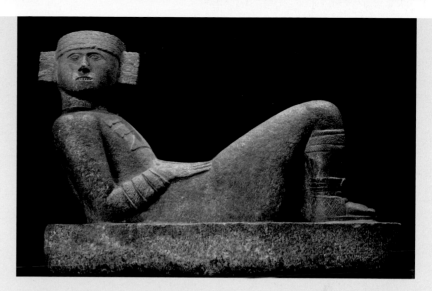

Aztec Chacmool figure, **artist unknown, c. 900–1000, stone, 155 x 115 x 80 cm (61 x 45 ¼ x 31 ½ in.), Museo Nacional de Antropología, Mexico City, Mexico**

When Moore was in Paris in 1925, he visited the Musée d'Ethnographie du Trocadéro, where he saw a cast of a Chacmool figure, a Pre-Columbian statue. It encouraged him to directly carve single figures that emphasize mass and form.

Committed to the method of direct carving, Moore continually explored how to align his sculpture with the landscape, echoing prehistoric monoliths. His particular interest in such ancient works can be seen here in the heaviness, basic materials and undulating forms.

⑥ 'TRUTH TO MATERIALS'

Moore revived the practice of direct carving that came close to the aim of 'truth to materials' – a belief that the form of a work of art should be inseparably related to the material in which it is made.

⑦ STONE

The stone-carving process appealed to Moore. Rejecting classical materials, particularly white marble, and using unusual stone gave his work a fresh appeal that echoed notions of primitive art.

⑧ ASYMMETRY

Along with the large hand, the huge thighs are also out of proportion with the figure's small head and breasts. The asymmetry creates an unexpected, flowing form, suggestive of non-Western art.

AMERICAN GOTHIC

GRANT WOOD

1930

oil on beaver board
78 x 65.5 cm (30 ¾ x 25 ¾ in.)
Art Institute of Chicago, Illinois, USA

FAMOUS FOR HIS REGIONALIST STYLE, Grant Wood (1891–1942) painted with a detailed, realistic approach that like other Regionalists, reflected the traditional old-fashioned values of small-town America.

Wood lived on a farm in rural Iowa until he was ten years old when his father died unexpectedly and the family moved to the larger town of Cedar Rapids. As a child, he was apprenticed in a local metalworking shop. After high school, he attended a summer course at the Minneapolis School of Design and Handicraft and in 1911, he passed the Iowa Teachers Exam. For a year, he taught at a small local school, then in 1913, he moved to Chicago, where he established a jewelry and fine metalwork shop. Occasionally, he took evening classes in drawing at the School of the Art Institute of Chicago, and for several years, he took correspondence and summer school courses in the decorative arts.

From 1917 until the end of World War I, Wood served in the US Army as a camouflage painter. In 1919, he returned to Cedar Rapids to support his mother and sister, teaching at a school and designing window displays for a department store. Meanwhile, he painted, completing mural and portrait commissions for several local businesses. In the summer of 1920, Wood visited Paris. Three years later, he went back to study at the Académie Julian and travel with artist friends to Sorrento, Italy. In 1927, he was commissioned to design a stained-glass window for the Veteran Memorial Building in Cedar Rapids, and was sent to Germany to oversee the window's production. During his three-month stay in Munich, he encountered early German and Flemish paintings for the first time. He abandoned his former Impressionist style, and began following the realism of the 15th- and 16th-century Flemish school of painters, adopting tighter brushstrokes and a darker palette. He went on to produce his most memorable works including *American Gothic,* which was accepted into the annual exhibition of the Art Institute of Chicago in 1930 and won prestigious accolades. The painting of a woman and a man holding a pitchfork in front of a steep-roofed building, launched Wood into the public eye.

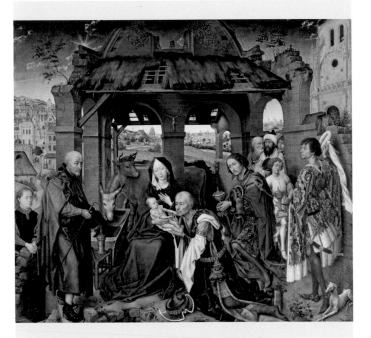

St Columba Altarpiece, **Rogier van der Weyden,** *c.* **1455, oil on oak panel, central panel 138 x 153 cm (54 ⅜ x 60 ¼ in.), Alte Pinakothek, Munich, Germany**

Between 1920 and 1928, Wood travelled to Europe four times. In Munich in 1928, he explored the city's museums and studied the paintings of artists such as Hans Memling (*c.* 1430–94) and Rogier van der Weyden (*c.* 1399–1464). Their influence was profound, and Wood became nicknamed 'the Hans Memling of the American Midwest'. While in Munich, he saw this altarpiece by Van der Weyden. This central panel illustrates the Adoration of the Magi. Van der Weyden's method of depicting pale skin, textures, strong tonal contrasts, meticulous details and a clearly conveyed sense of space inspired Wood when he painted *American Gothic.*

❶ HOUSE

In 1930, Wood was in Eldon, Iowa. When he saw this modest little house he was amused by what he saw as a structural absurdity: a Gothic-style window in a wooden house, built in the US Carpenter Gothic architectural style. He sketched it on the back of an envelope. After obtaining permission from the house owners he returned the next day and made a sketch in oil on paperboard of it, in which he exaggerated the angle of the roof and gave it a longer window.

❷ WOMAN

Wood decided to paint the house with 'the kind of people I fancied should live in that house'. This woman has been interpreted as either the man's wife or his daughter, although Wood specified that she was meant to be the farmer's daughter. The model was his younger sister, Nan Wood Graham, whom he adored. Yet the image of the pinch-mouthed, stern-faced woman inspired scathing comments. More kindly, the depiction has been seen by some as timeless and enigmatic, giving rise to the nickname of 'the American *Mona Lisa*'.

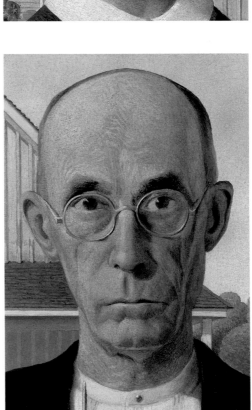

❸ MAN

Tall and grim-faced, the man was modelled by Wood's dentist, Dr Byron McKeeby. Staring resolutely ahead, he stands in front of his rural, Gothic Revival farmhouse. His long features emphasize the Gothic style that is accentuated throughout the painting. Wood painted the couple separately. He said of this painting: 'I had in mind something which I hope to convey to America – the picture of a country rich with peace; a nation infinitely worth the sacrifices necessary to its preservation.'

4 NAN'S CLOTHES

In a black dress and colonial print apron, stark white collar adorned with a plain cameo brooch, Nan's clothing evokes a sense of the US Midwestern rural community. Wood said he dressed his models as if they were 'tintypes from my old family album'. He painted *American Gothic* during the Great Depression, and the sombre colours reflect the mood of the time.

5 PITCHFORK

The farmer holds a pitchfork with the tines pointing upwardly, echoing the Gothic-style window behind. This was interpreted by some as the man representing a priest and the pitchfork indicating the Holy Trinity. The metal pitchfork echoes the stitching of the man's overalls. The realistic rendering of the textures evolved from Wood's studies of German and Flemish art.

6 REGIONALISM

Regionalism lasted from approximately 1925 to 1945. Emphasizing the small-town atmosphere and everyday life of the rural United States was an essential element, and it contrasted with the feelings of hopelessness that pervaded the Great Depression. To highlight the attitude of the movement, Wood once remarked that he 'got all his best ideas for painting while milking a cow'.

7 STYLE

While the style of this painting is influenced by European and German artists, Wood imbued it with his own ideas. He stresses vertical, horizontal and slanting lines, including in the architecture, the woman's braiding on her apron and the stripes on the man's shirt. Even this plant highlights verticality. The composition is tightly cropped, suggesting the restrictions of small-town life.

Detail from *Portrait of Anne of Cleves*, Hans Holbein the Younger, *c.* 1539, parchment mounted on canvas, 65 x 48 cm (25 ⅝ x 18 ⅞ in.), Musée du Louvre, Paris, France

A German-Swiss printmaker and painter, Holbein the Younger famously worked in England at Henry VIII's court. This is one of the paintings he produced in England and Wood probably saw it at the Louvre. The painting epitomizes all that he admired in Holbein's work. Painted with meticulous brushmarks, the colours are rich and intense. These elements fascinated Wood during visits to Europe and for the rest of his career his style remained figurative, hard-edged and realistic-looking, with figures—as in *American Gothic* and in Holbein's portrait here—appearing detached and disconnected.

PERSISTENCE OF MEMORY

SALVADOR DALÍ

1931

oil on canvas
24 x 33 cm (9 ½ x 13 in.)
Museum of Modern Art, New York, USA

SPANISH ARTIST SALVADOR DALÍ (1904–89) is the most famous Surrealist. As renowned for his flamboyant personality and self-promotion as for his creativity, he produced paintings, sculpture, prints, films, fashion and advertising designs.

Dalí was born near Barcelona to a prosperous middle-class family. Before his birth, an elder brother had died, and Dalí was often told that he was the reincarnation of that first Salvador. Images of this deceased brother and of Catalan landscapes recurred in his art. In 1922, Dalí entered the San Fernando Academy of Fine Arts in Madrid, where he experimented with Impressionist and Pointillist styles, and was influenced by the work of Raphael (1483–1520), Agnolo Bronzino (1503–72), Velázquez and Johannes Vermeer (1632–75). Dalí studied the work of Italian Renaissance painters closely and sought to emulate them. Although Vermeer was his favourite painter, and his moustache was a parody of Velázquez's, Dalí especially admired Raphael's art.

Between 1926 and 1929, he visited Paris several times, where he met Picasso, Miró and René Magritte (1898–1967) who introduced him to Surrealism. After moving to Paris, André Breton invited Dalí to join the Surrealists. He also married Gala, a Russian immigrant who left her husband for Dalí and became his muse and inspiration. Following the theory of automatism, in allowing his unconscious mind to guide him, Dalí created what he called his 'paranoiac critical' method, painting in a self-induced paranoid state, and producing what he called 'hand-painted dream photographs' in a meticulous classical style. His smooth paint application and firm contours in *Persistence of Memory* are classical and convey a sense of peace. The creature at the centre of the painting with its closed eye and long eyelashes suggests that it is dreaming and unaware of time passing, while memories may appear.

Dalí was expelled from the Surrealist group by 1939. However, he continued painting photographic likenesses of things that could never happen in reality all of his life.

① FLOPPY CLOCKS

Dalí believed that all viewers would find intuitive connections with his work. These soft melting pocket watches epitomize his exploration of softness and hardness. While hallucinating, he sensed a feeling of soft and hard, and of cold and hot. When he was asked whether his soft watches were inspired by German-born theoretical physicist Albert Einstein's theory of relativity, he said they were not, but that he had been inspired by a Camembert cheese he saw melting in the sun.

② ANTS

This orange pocket watch in the lower corner of the painting is swarming with ants. For Dalí, ants were a symbol of death and decay and he used them in several works, including the film he made with Spanish director Luis Buñuel, *Un Chien Andalou* (*An Andalusian Dog*, 1929). Because the ants are so recognizable they are even more unnerving when seen in an unfamiliar context.

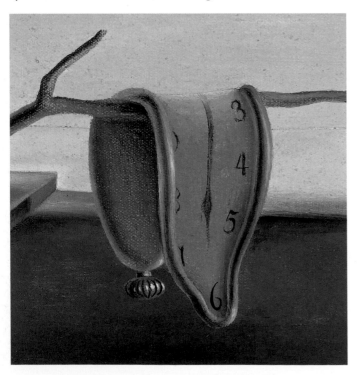

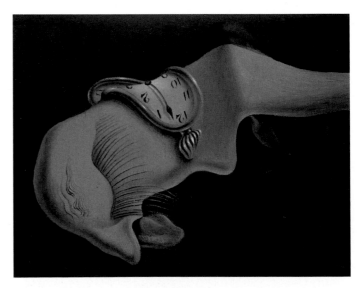

③ STRANGE FIGURE

Resembling a human figure, this strange creature with a deformed nose is a self-portrait. It is also an indefinite dreamlike figure whose form and composition are ambiguous. The eyelashes resemble insects as well as Dalí's characteristic moustache. An object akin to a tongue hangs from the nose.

④ CLIFFS

This seaside landscape bathed in clear light, with golden, craggy cliffs, is a depiction a tip of the Cap de Creus peninsula in north-eastern Catalonia where Dalí grew up. Showing his personal memories of his early years in Spain, they suggest how memories persist. Dalí painted bizarre juxtapositions in this hyperrealistic manner for the rest of his life.

Dalí used oil paints in both traditional glazes and his own invented method. His brushstrokes were particularly fluid as he mixed his paints with linseed oil to create a more liquid medium, and then created almost imperceptible brushmarks. His contours and effects of light are consequently crisp, clear and realistic-looking.

TECHNIQUES

⑤ ILLUSIONISM

A skilled draughtsman, Dalí spent his life trying to perfect the skills he saw in the work of the Old Masters, particularly Raphael, Vermeer and Velázquez. As well as 'hand-painted dream photographs', he described his method 'the usual paralysing tricks of eye-fooling'.

⑥ PREPARATION

Dalí used a small, closely woven canvas that he primed with white. Then he drew outlines in pencil and built up the image with small round sable brushes and thinly applied opaque paint, resting his painting arm on a mahl stick. For close details, he looked through a jeweller's glass.

⑦ LIGHT

The view across a landscape to the sea is bathed in early morning translucent light. The pale light appears to be coming from the right, which in Europe would be the setting sun, but the cool lemon and distant sea suggests the beginning of the day. This ambiguity is deliberate.

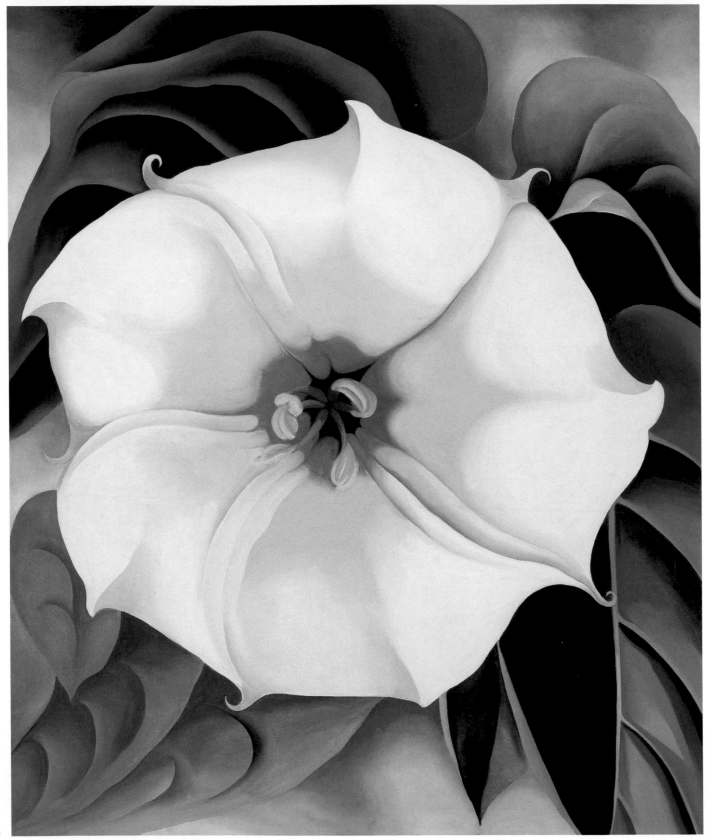

JIMSON WEED/WHITE FLOWER NO. 1

GEORGIA O'KEEFFE

1932

oil on linen
122 x 101.5 cm (48 x 40 in.)
Crystal Bridges Museum of American Art, Arkansas, USA

BOLDLY INNOVATIVE AND DETERMINED, prolific US artist Georgia O'Keeffe (1887–1986) painted enlarged flowers, dramatic New York skyscrapers, glowing New Mexico landscapes and animal bones set against deep blue desert skies.

Often called the 'Mother of American Modernism', she grew up on a farm in Wisconsin with six siblings. Unusually for the time, her mother encouraged her education, and after high school, O'Keeffe studied at the School of the Art Institute of Chicago for a year, but left when she became ill with typhoid fever. In 1907, she took classes at the Art Students League in New York, where she learned realist painting techniques from William Merritt Chase (1849–1916), F. Luis Mora (1874–1940) and Kenyon Cox (1856–1919). She worked as a commercial illustrator, and then taught art in Virginia, Texas and South Carolina. During that time, she continued to study art and was introduced to the principles and philosophies of Arthur Wesley Dow (1857–1922) and Arthur Dove (1880–1946), who emphasized a focus on individual style and interpretation of subjects, rather than objective copying. In 1915, she sent some recent abstract charcoal drawings to a friend in New York who showed them to art dealer and photographer Alfred Stieglitz (1864–1946). Without O'Keeffe's knowledge, Stieglitz exhibited ten of her drawings at his 291 Gallery in New York in 1916. When she found out, O'Keeffe confronted him, but allowed him to continue showing her work. In 1917, he presented her first solo show and a year later, she moved to New York. Stieglitz helped her financially and eventually divorced his wife, marrying O'Keeffe in 1924. That year, she began producing her large paintings of flowers at close range followed by her depictions of New York skyscrapers.

By 1927, she was very successful; a great achievement for a female in the male-dominated art world. O'Keeffe and Stieglitz lived in New York, but from 1929, she spent part of the year in New Mexico, where she was inspired by the landscape, architecture and local Navajo culture. O'Keeffe's *Jimson Weed* is one of many flower close-ups. It captures the essence of the flower rather than a botanical reproduction.

Golden Storm, Arthur Dove, 1925, oil and metallic paint on plywood panel, 47 x 52 cm (18 ½ x 20 ½ in.), Phillips Collection, Washington, DC, USA

Painted on Dove's boat on Long Island, this depicts the movement of water in various patterns and a narrow range of tonal values. Dark blues, greens and gold create an iridescent, cloudy sky illuminated by lightning. Dove was inspired by ideas about spirituality, and he influenced O'Keeffe's approach to art, especially regarding depictions of the natural world using an abstract vocabulary. She drew on his theories to develop her style and whereas Dove's painting can be seen as abstract patterns, hers of the same period could always be linked to the real world. It was only later in her career that she began painting more abstract images.

② OBSERVATION

O'Keeffe painted her flowers from careful observation. She said: 'Nobody sees a flower really, it is so small... I'll paint what I see – what the flower is to me but I'll paint it big and they will be surprised into taking time to look at it....' She strove to depict what she described as 'the wideness and wonder of the world as I live in it'.

③ NATURE

At this time in her life, O'Keeffe had not yet embarked upon the abstract paintings that she later produced, but this represents her spirit of adventure. It is indicative of her ability to capture something truly modern between reality and abstraction, while still adhering to the age-old theme of nature and the natural world.

① CROPPING

Influenced by modernist photographer and filmmaker Paul Strand (1890–1976), who closely cropped his photographs to draw viewers into the essential elements of the image, O'Keeffe was one of the first artists to render detailed close-ups in painting. Also inspired by Dove's objectifying of images, she has made this flower almost abstract.

④ PERSPECTIVE

O'Keeffe grew Jimson weed around her patio and made it the subject of many paintings, usually capturing the plant from different viewpoints or perspectives. This direct frontal perspective creates a symmetrical image, almost like a design or element of a pattern, and displays the inspiration she took from contemporary modernist photography.

⑤ NEW MEXICO

When O'Keeffe found Jimson weed near her home in Abiquiu, New Mexico its beauty stunned her. She explained: 'It is a beautiful white trumpet flower with strong veins… Some of them are a pale green in the centre – some a pale Mars violet… when I think of the delicate fragrance of the flowers, I almost feel the coolness and sweetness of the evening.'

⑥ ESSENTIALS

O'Keeffe depicts the flower with subtly modulated tones of white, yellow and green to evoke the play of light and shadow on its petals. Painting it in the Art Deco period, she abandoned details of the subject, instead rendering the blossom and leaves as simplified, circular forms. Essentially, she only used three colours: white, blue and green.

⑦ BRUSHSTROKES

In focusing on the flower's complex structure, O'Keeffe painted with a reduced palette and applied precise, fine brushstrokes of fluid paint to create firm, flowing contours, curving shapes and a smooth surface of carefully blended colours. Almost entirely filling the picture plane with velvety brushmarks, she only depicts petals, leaves and sky.

Under the Wave off Kanagawa, Katsushika Hokusai, *c.* 1830–32, polychrome woodblock print, ink and colour on paper, 25.5 x 38 cm (10 ⅛ x 14 ⅞ in.), Metropolitan Museum of Art, New York, USA

This is part of a series of *ukiyo-e* prints, *Thirty-six Views of Mount Fuji* (*c.* 1830–33), by Japanese artist Katsushika Hokusai (1760–1849). O'Keeffe was inspired by the simplicity of the composition, the smooth, flowing lines, pared-down colours and reinterpretation of nature. Here, Hokusai features Mount Fuji minimally behind the great, dramatic, curving wave. In a similar way, O'Keeffe emphasized her flower against the blue sky. Hokusai uses a reduced palette, but while his colours are clear and separated, O'Keeffe's are more blended. Both works of art are comparable for their emphasis on line and pure, bright colour and their ability to reduce forms to the minimum.

THE TWO FRIDAS

FRIDA KAHLO

1939

oil on canvas
172 x 172 cm (67 ⅝ x 67 ⅝ in.)
Museo de Arte Moderno, Mexico City, Mexico

INFLUENCED BY CHRONIC HEALTH ISSUES, personal problems and her Mexican ancestry, Frida Kahlo (1907–54) is recognized for her brooding, introspective paintings. Although she is often classed as a Surrealist, she was never part of that movement. Her art did not derive from dreams or her subconscious, but was always autobiographical. She is also often categorized as a Magic Realist.

Of German and Mexican heritage, Kahlo was born on the outskirts of Mexico City, one of six daughters. At six years old, she contracted polio and had to remain in bed for nine months. After recovery, she walked with a limp. Growing up, she became involved with aspects of Mexican culture, politics and social justice. She also took drawing classes and briefly met the famous Mexican muralist Diego Rivera (1856–1957), who was painting a mural on her school campus.

Then in September 1925, tragedy struck. Kahlo was travelling home from school when her bus collided with a tram. Impaled by an iron handrail, she sustained multiple fractures and a crushed pelvis, and bound in a plaster corset, she spent several months in hospital. During her recovery, she began painting self-portraits. In 1928, she joined the Mexican Communist Party and was reintroduced to Rivera with whom she became romantically involved. Rivera was forty-two years old, tall and overweight, and Kahlo was aged twenty-one, small and delicate. When they married in 1929, Kahlo's parents described the union as a 'marriage between an elephant and a dove'.

From that time, Kahlo began wearing traditional Tehuana costume and drew greater artistic inspiration from Mexican folk art. Yet the marriage was unhappy. Rivera's infidelities took a toll on Kahlo's fragile health. She plunged into affairs with men and women, miscarried twice, had two abortions, an appendectomy and two gangrenous toes amputated. Among his infidelities, Rivera had an affair with Kahlo's younger sister, Cristina. Despite gaining recognition for her art, her other problems were all pervading, and she and Rivera divorced in 1939 (although they remarried a year later). Her double self-portrait *The Two Fridas* expressed how she felt at that time, broken by physical and psychological pain.

Frida Kahlo and Diego Rivera, 1933

Kahlo and Rivera pose here in their apartment at the Barbizon Plaza Hotel, New York in October 1933, which was the day after Rivera had been dismissed from painting a mural in the Rockefeller Center. They first met when Kahlo was an art student hoping to get advice on her career, and Rivera was a famous muralist. After they married, their volatile tempers and numerous infidelities made for a turbulent marriage. A year after their divorce in 1939, they remarried, but that second marriage was as tumultuous as the first.

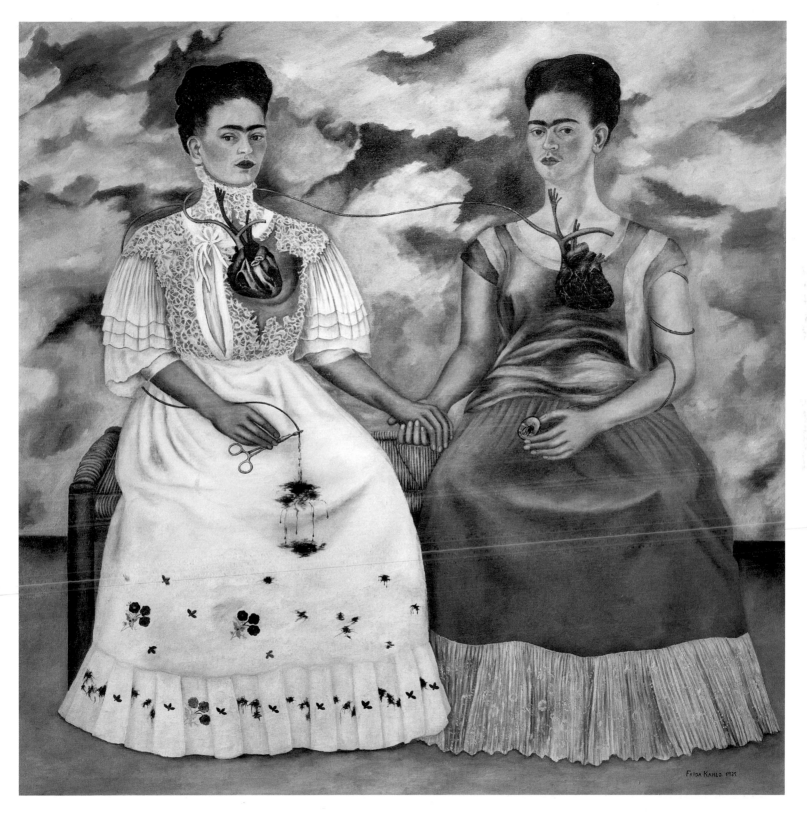

VICTORIAN

In this double self-portrait, Kahlo depicts herself wearing a white lace, stiff-collared European-style Victorian dress. The virginal whiteness of the dress draws attention to the red blood, but also represents the clothes she wore before her marriage to Rivera. This may also represent her paternal German heritage.

3 BLEEDING HEART

The more European Frida figure is weakened by an exposed heart that is torn and bleeding as she pines for her lost love. After her accident, Kahlo underwent thirty-two operations and was familiar with the sight of her own blood. A bleeding heart is a traditional symbol of Catholicism and of Aztec ritual sacrifice.

1 FRIDA'S HEAD

Kahlo always emphasized her dark hair and made her eyebrows heavier than they were. Here she looks like a doll, with no obvious expression, and nothing to reveal her feelings in the year in which she and Rivera divorced. She later admitted that this painting expressed her loneliness through being separated from him.

4 TEHUANA COSTUME

In indigenous Mexican dress, this portrays Kahlo as independent and strong, uninterested in conventions of beauty and female behaviour. This Frida also has an exposed heart, but it is whole.

5 HANDS

The two Fridas are holding hands, resilient because they are together. In her other hand, the Mexican Frida figure holds a miniature portrait of Rivera attached to a vein.

6 FORCEPS

Blood spills on to the European Frida's lap as she holds forceps that have cut a vein. While connecting the two Fridas, this also alludes to Kahlo's endurance of constant pain and frequent surgical procedures.

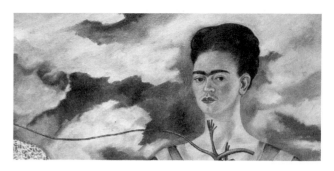

7 SKY

Kahlo once said, 'I paint myself because I am often alone and I am the subject I know best.' The stormy sky with agitated clouds symbolizes her distressing life and inner turmoil.

Detail from *The Gipsy Boy and Girl*, José Agustin Arrieta, *c.* 1854, oil on canvas, 114 x 89 cm (44 ⅞ x 35 in.), private collection

Genre painter José Agustin Arrieta (1803–74) captured the kinds of characters that Kahlo and Rivera perceived as admirably Mexican. This depicts a young Mexican couple in 19th-century Puebla. The young woman is dressed in similar costume to Kahlo's daily wear.

ARC OF PETALS

ALEXANDER CALDER

1941

painted and unpainted sheet aluminium and iron wire
240 x 220 x 90 cm (94 ½ x 86 ⅝ x 35 ½ in.)
Solomon R. Guggenheim Museum, New York, USA

ALEXANDER CALDER (1898–1976) INTRODUCED movement to sculpture, first with *Cirque Calder* (*Calder's Circus*), and then with hanging mobiles that moved with the air. Russian Constructivists had conceived kinetic art in 1920, but Calder combined his training in art and mechanical engineering to become a leading exponent of the genre. His work resonates with Dadaist ideas, Miró's automatist paintings and Mondrian's rhythmic clarity.

As a young teenager, Calder and his family moved between New York and California, and after leaving high school in San Francisco, he studied mechanical engineering at the Stevens Institute of Technology in New Jersey, excelling in mathematics. He held various jobs, including working as a hydraulic engineer and a draughtsman for the New York Edison Company, and as a mechanic on the passenger ship *H. F. Alexander* that sailed from San Francisco to New York. Later, he moved to New York and while studying at the Art Students League, he produced illustrations for the *National Police Gazette*. In 1925, one of his assignments for the paper was to spend spent two weeks sketching at the Ringling Brothers and Barnum and Bailey Circus and he then became fascinated with the lights, colours and sounds of the circus.

In 1926, he moved to Paris, and enrolled at the Académie de la Grande Chaumière. He made mechanical toys, which he submitted to the Salon des Humoristes. He created his *Cirque Calder* – a miniature, transportable circus made from wire, cloth, string, rubber, cork and other found objects – which he first performed that year. He also invented wire sculpture, or what critics called 'drawing in space'. After Calder visited Mondrian's studio in 1930, he began creating kinetic sculptures manipulated with cranks and motors, which Marcel Duchamp (1887–1968) named 'mobiles' in 1931. By 1932, Calder was creating hanging sculptures, which moved with air currents, as well as static, abstract sculptures that Arp dubbed 'stabiles'. His mobiles challenged all sculpture's previous conventions. In 1941, he created this large and delicately counterbalanced construction of hinged and weighted metal wire that moves with the slightest breath of air to respond to its environment unpredictably.

Ejiri in Suruga Province (Sunshū Ejiri) from *Thirty-six Views of Mount Fuji*, Katsushika Hokusai, c. 1830–32, woodblock print, 25.5 x 37 cm (10 x 14 ⅝ in.), Metropolitan Museum of Art, New York, USA

A sudden gust of wind catches walkers by surprise as they make their way along a winding road with Mount Fuji in the distance. As the figures are buffeted by the breeze, they hold on to their hats, but one man's hat is blown away, as well as pieces of paper from a woman's backpack. These light paper squares rise and flutter in the air and across a field. Meanwhile leaves from a tall, slender tree also whirl and dance high in the air. Ejiri was a station on the Tōkaidō Road famous for a nearby picturesque pine forest on the foothills of Mount Fuji. Calder's *Arc of Petals* echoes Hokusai's sense of movement, along with his finely balanced Japanese compositional ideas, limited palette and minimal contour lines. They had similar belief in the constant motion and changes of the universe, and the power of natural forces over the frailty of humanity.

① PETALS

Cut, shaped and individually painted metal elements, in monochromatic black and grey, these petal shapes appear to float on fragile stems. More than twenty individual petals make up the work, and appear to diminish in size, as real petals reduce in size in a flower. They evoke an organic, natural sense of dynamism.

② BALANCE

Illustrating Calder's skills as an engineer, this inventive work is a complex aerial composition, Calder used exact weighting and proportions to create a harmonious form that, while it dances and changes shape, constantly remains visually and technically balanced. Each petal acts to stabilize the mobile.

③ MOVEMENT

This construction is designed to move continuously, producing spontaneous patterns to illustrate nature's seemingly random patterns. Intended to create biomorphic shapes as it floats, sways and twirls, the mobile simulates the motion of petals floating on a breeze. As air wafts through it, the petals glide smoothly, each in turn inspiring movement in the others that surround them.

Calder described his mobiles as 'four-dimensional drawings'. In a letter to Duchamp in 1932, he wrote of his desire to make 'moving Mondrians'. He intended his sculptures to generate changing outlines, spaces, shapes and colours as air currents move round and through them.

④ MATERIALS

Calder used his sense of design and appreciation for nature to suggest living flora. His engineering background informed his innovative use of industrial materials. Aluminium and wire are lightweight and allow the discrete parts of the mobile to change shape and cast interesting shadows.

⑤ COMPOSITION

In 1932, Calder wrote: 'Why must art be static? You look at an abstraction, sculptured or painted, an intensely exciting arrangement of planes, spheres, nuclei, entirely without meaning. It would be perfect, but it is always still.' He believed his compositions represented the perpetual motion of the universe.

⑥ METHOD

Calder developed an innovative method of sculpting, bending and twisting wire to create this, recalling the methods of the Futurists and the Constructivists. He cut, bent, punctured and twisted his materials by hand. This mobile consists of flat pieces of painted metal connected by wire veins and stems.

Dances, **Arthur Bowen Davies, 1914–15, oil on canvas, 213.5 x 350.5 cm (84 x 138 in.), Detroit Institute of Arts, Michigan, USA**

US artist Arthur Bowen Davies (1862–1928) studied at the Chicago Academy of Design and the Art Students League in New York. He painted using vibrant colours and refined brushwork, inspired by Dutch landscapes and the work of Jean-Baptiste-Camille Corot (1796–1875) and Jean-François Millet (1814–75). He became highly successful and was the main organizer of the legendary Armory Show of 1913 in New York as well as a member of The Eight, a group of painters who protested against the powerful but conservative National Academy of Design. Calder was inspired by Davies's emphasis on simplification and using colour and shape to convey a sense of dynamism.

THE ANTIPOPE

MAX ERNST

1941–42

oil on canvas
161 x 127 cm (63 ¼ x 50 in.)
Solomon R. Guggenheim Museum, New York, USA

IN DRAWING IMAGERY FROM HIS UNCONSCIOUS, German-born Max Ernst (1891–1976) was one of the first artists to practise automatism and was a pioneer of both Dada and Surrealism. His paintings and collages expressed his anguish and anger about Western culture, originating from when he was a soldier in World War I.

The third of nine children, Ernst was born near Cologne, and at the age of eighteen, he enrolled at the University of Bonn, studying philosophy, art history, literature, psychology and psychiatry. While visiting asylums, he became fascinated with the art of mentally ill patients and began painting. In 1911, he befriended Auguste Macke (1887–1914) and joined his *Die Rheinischen Expressionisten* (The Rhenish Expressionisten) group of artists. The following year, after visiting an exhibition in which he saw works by Picasso, Van Gogh and Gauguin, his methods changed. Over the next couple of years, he became close friends with Arp, and he exhibited with several artists' groups. In 1914, he went to Paris, where he met Apollinaire and Robert Delaunay. That August, he was conscripted into the German army. His experiences traumatized him. In 1962, he wrote in his autobiography: 'On 1st of August 1914 M. E. [Max Ernst] died. He was resurrected on 11th November 1918.'

After World War I, Ernst met Klee and formed the Cologne Dada group with Arp and Alfred Grünwald (1892–1927). In 1922, he moved to Paris, where he became a founding member of the Surrealist movement. With no artistic training, he experimented with unusual techniques and unexpected materials. Combining these ideas with automatism, his ideas were remarkable. However, when World War II broke out, he was arrested for being a 'hostile alien' as a German in Paris. With the aid of friends he was released but soon after, when the Nazis invaded France, they decided his work was 'degenerate' and he was arrested again. With the help of US art collector Peggy Guggenheim, he escaped to the United States, and she became his third wife. Soon after he arrived in New York, Ernst produced a small oil painting on cardboard. Peggy encouraged him to make this larger version of the Surreal image that represents Ernst, Peggy and her daughter.

Two Men Contemplating the Moon, **Caspar David Friedrich**, *c.* 1825–30, oil on canvas, 35 x 44 cm (13 ¾ x 17 ¼ in.), Metropolitan Museum of Art, New York, USA

The chief advocate of German Romantic painting, Caspar David Friedrich (1774–1840) is best known for his allegorical landscapes featuring contemplative figures, often silhouetted against mists, ruins, dark or moody skies or the sea, and deliberately evoking subjective responses to the natural world. Ernst was particularly inspired by Friedrich's style that celebrated Germanic culture, customs and mythology. Here, the figures' faces cannot be seen, so viewers are watching them from a distance. The large tree cutting diagonally through the composition, the sinister-looking branches and the moon combine to project a sense of mystery. Partly because of his strong influence on Ernst, many Surrealists regarded Friedrich as a precursor to their movement.

① HORSE AND BIRD

In France, Ernst had spent hours riding with Leonora. She loved horses and Ernst was obsessed with birds. This horse-headed female wearing an owl headdress, amalgamates their two passions and so can be viewed as a direct image of the love Ernst had left behind. However, some believe it represents Peggy.

② RED FIGURE

Peggy and Ernst married soon after he arrived in New York and started this painting. However, in Europe he had been having an affair with the married, English-born Surrealist Leonora Carrington (1917–2011). It is thought that this figure may represent Leonora.

③ PINK FIGURE

This half-nude, birdlike character wearing a pink tunic is depicted in a relatively naturalistic fashion with smooth tonal contrasts. It twists away apparently furtively and leans into the dark creature. The pink figure is generally considered to be Peggy.

④ BLACK FIGURE

Cut off at the edge of the painting, this dark, slender and sinister character is believed to be Ernst and the 'Antipope' of the title. Its dainty hands and a horse's head give it an unnerving appearance, and it seems to be pointing at the red figure on the left of the painting.

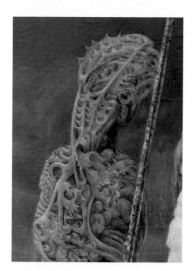

⑤ SPEAR

On the edge of a lagoon, turned three-quarters away from viewers, with its hands held behind its back, is yet another unsettling figure. Ernst conceded that this represented Peggy's daughter Pegeen. Behind her, a spear bisects the composition diagonally, which is thought to symbolize Leonora's irreconcilable separation from Ernst. He and Leonora never resumed their relationship.

⑥ TECHNIQUES

From 1925, in experiments to activate his unconscious through automatism, Ernst developed various techniques. He made pencil rubbings on textured surfaces, calling this 'frottage', and transferred paint from one surface to another, naming this 'decalcomania'. This work includes decalcomania as well as traditional painting techniques that he taught himself.

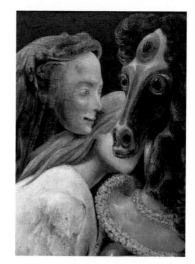

⑦ TWO HEADS

In front of the partially obscured face of the pink figure are two heads. One is the black horse's head that looks across the composition at the red figure. The other has a pale face shown in profile with long, green hair. This face looks intently at the horse's head and is attached to a column as if a totemic figure. Both are painted with contrasting tonal details and smooth, thin paint.

⑧ FEATHERS

Ernst's rejection of traditional painting techniques, styles, and imagery inspired younger artists, including the Abstract Expressionists. From 1930, he depicted himself as a birdlike creature, an alter ego he christened 'Loplop'. Here, he continues with the avian theme by creating a sense of the exotic with realistically rendered feathers. He delighted in combining the realistic with the fantastic.

Mermaids at Play, Arnold Böcklin, 1886, oil on canvas, 150.5 x 176.5 cm (59 ¼ x 69 ½ in.), Kunstmuseum Basel, Switzerland

A painter of mythological and fantastic scenes that are often linked with notions of death, the Swiss Symbolist artist Böcklin was unlike any other, although he was inspired by Romanticism and the Pre-Raphaelites. During the last years of the 19th century, his work was extremely sought after but it lost popularity until it was rediscovered in the 1920s by the Surrealists. It strongly influenced Ernst and Dalí, who admired his exploration of mythology, iconographic invention, mixture of genres and sense of morbidity. In this ambitious sea scene the tritons and naiads lack idealization, and symbolize the decadence of the bourgeoisie in contemporary society. It is part of a series of paintings of mythological subjects featuring large-eared heads that emerge from the water as here.

NIGHTHAWKS

EDWARD HOPPER

1942

oil on canvas
84 x 152.5 cm (33 ⅛ x 60 in.)
Art Institute of Chicago, Illinois, USA

EDWARD HOPPER (1882–1967) IS THE best-known painter of the urban United States in the 20th century. His depiction of feelings of isolation within the modern city, influenced many artists and filmmakers of the 1960s and 1970s.

Born near the Hudson River north of New York, Hopper studied commercial illustration and painting. Between 1906 and 1910, he visited Europe several times to study art. On his return to the United States, he worked as a commercial illustrator, while selling his watercolours and prints. He gained recognition with his second solo exhibition in 1924. He left his job and travelled to New England with his wife, painter Josephine 'Jo' Nivison (1883–1968) – who was his only female model. There he produced paintings of archetypal US urban architecture in a realistic, introspective style inspired by Chase, Manet, Degas and Gustave Courbet (1819–77). In the 1930s, he painted urban scenes of contemporary US life featuring solitary figures, bright lights and long shadows.

Nighthawks is his best-known work. With its solitary figures, long shadows and atmospheric light, it epitomizes the sense of loneliness that Hopper saw in the towns and cities around him and which he became famous for portraying.

The Winnowers, Gustave Courbet, 1854, oil on canvas, 131 x 167 cm (51 ⅝ x 65 ¾ in.), Musée des Beaux-Arts de Nantes, France

In 1906, Hopper saw a retrospective exhibition of French Realist Courbet at the Salon d'Automne in Paris. Courbet painted ordinary people experiencing the hardships of life. His work inspired Hopper, who continued to paint his own realistic scenes on his return to the United States.

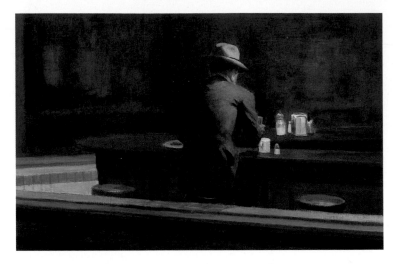

① LONELINESS

A powerful depiction of urban alienation, the four anonymous figures in the scene seem as separate and remote from each other as they are from viewers. There is no entrance, which emphasizes their detachment as viewers are separated from the interior scene by a wedge of glass.

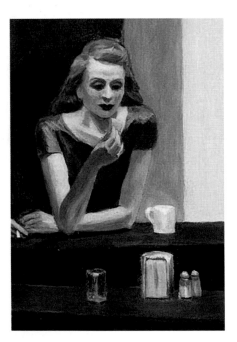

② FOCAL POINT

At the centre of the diner, this woman stands out with her flame-coloured hair and red dress. She seems to be lost in thought, interacting with neither of the male diners nor the waiter.

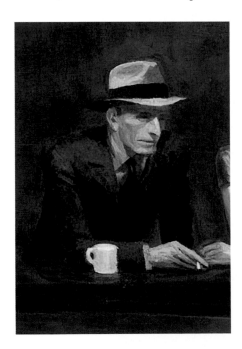

③ MALE DINER

Hopper painted this after he and Jo went to a restaurant on New York's Greenwich Avenue. Jo made notes: 'Man night hawk (beak) in dark suit, steel grey hat, black band, blue shirt (clean) holding cigarette.'

④ LIGHTING

Hopper took advantage of fluorescent lighting, which came into use in the early 1940s. This emits an eerie glow. The plate-glass windows enable the unnatural light to spill out on to the pavement.

Hopper used thin, fluid paint, long brushstrokes and smooth tonal contrasts to create subtle spatial relationships between and around his figures and objects. They are bathed in evocative, atmospheric light.

⑤ SHADOWS

The bright lights of the diner throw shadows into the street outside, which are cast around the pavement at different angles, suggesting more than one light source inside. Across the street, the line of shadow caused by the upper edge of the diner window is visible near the top of the composition.

⑥ PERSPECTIVE AND LINE

The angled diner and road opposite are drawn in fairly dramatic perspective, creating a sense that viewers are watching from across the street. The contrast of dark shadows outside forces viewers to look inside the diner. Straight and angled lines create rectangular and wedge shapes, drawing the eyes into the image.

⑦ COMPOSITION

Most of the composition is filled with empty space. The asymmetrical composition draws the eye into the part of the image where there are figures. Yet there is no imbalance: the composition follows the classical rule of thirds while the figures occupy half of the canvas, which creates a sense of equilibrium.

A Friendly Call, **William Merritt Chase, 1895, oil on canvas, 76.5 x 122.5 cm (30 ⅛ x 48 ¼ in.), National Gallery of Art, Washington, DC, USA**

Leading US Impressionist Chase taught Hopper. While Chase captured people from the middle and upper classes, Hopper depicted those from all echelons of society. Set in Chase's summer house at Long Island, this painting shows two fashionably dressed women. Chase's wife Alice, in a yellow dress, entertains her visitor, who still wears her hat and gloves and carries a parasol. Chase's rendering of light and creation of shapes, patterns and reflections in his compositions were valuable lessons from which Hopper learned.

BROADWAY BOOGIE WOOGIE

PIET MONDRIAN

1942–43

oil on canvas
127 x 127 cm (50 x 50 in.)
Museum of Modern Art, New York, USA

PIET MONDRIAN (1872–1944) WAS an innovator of abstract art and one of the founders of the Dutch modern movement De Stijl, which means 'The Style'. He also had an interest in the principles of theosophy, a form of religious mysticism based on Brahmin and Buddhist teachings. In reducing all elements of his paintings, he aimed to express the spiritual order of the world. His abridged visual vocabulary became highly influential on art, design and architecture.

Mondrian grew up in Amersfoort in the Netherlands, in a household where art and music were encouraged. His father was an enthusiastic amateur artist who encouraged his son to draw, while his uncle, Frits Mondriaan (1853–1932), was an accomplished artist who taught his nephew to paint. After studying painting at the Royal Academy of Fine Arts in Amsterdam, he began painting landscapes reflecting several styles, including that of The Hague School, and facets of Symbolism, Impressionism and Neo-Impressionism. In 1903, he travelled to Spain, then Belgium, and his paintings became brighter, blending aspects of Pointillism, Fauvism and Cubism.

In 1911, he moved to Paris but returned to the Netherlands during World War I. There he started reducing elements in his work, until he was only painting straight lines and pure colours. In 1917, with Van Doesburg, the architects J. J. P. Oud and Jan Wils collaborated on a journal, *De Stijl*, which expounded their ideas. They then formed a group of the same name along with several other artists and designers. Mondrian wrote of his theories on art that were based on his theosophical beliefs. On his return to Paris in 1919, Mondrian began expressing his belief that art reflects the spirituality of the universe, by reducing all the elements of his paintings to the most basic elements of straight vertical and horizontal lines, plus primary colours, white, black and grey. He called this Neo-Plasticism.

To escape World War II, Mondrian moved to New York in 1940, and immediately fell in love with the city; for its architecture and also the boogie-woogie music he heard on his first evening there. This painting expresses all Mondrian's philosophies, from theosophy to De Stijl and Neo-Plasticism, as well as the place and music that he loved.

Dance music

Boogie-woogie developed in African-American communities in the 1870s. By the late 1920s, it had became a popular musical genre. Mondrian was extremely musical and frequented jazz clubs in Europe. When he arrived in New York and experienced boogie-woogie and the music of composers such as George Gershwin, he was delighted and went out dancing as often as he could. *Broadway Boogie Woogie* represents the tempo of his favourite music as well as the lively dynamism of the streets around him in New York. By the time he painted it in the 1940s, boogie-woogie was an impromptu dance performed to strongly rhythmical music. Couples interpreted it with acrobatic elements and Mondrian's interpretation involved moves from the Charleston, tango and foxtrot, which were his specialities.

<div style="writing-mode: vertical">IN DETAIL</div>

② PURITY

Mondrian's search for purity in art was bold and innovative at the time. Here, he aimed to capture harmony, rhythm and as pure a vision of his subject as possible without being totally abstract.

③ VITALITY

Mondrian wanted to convey the order underlying the natural world through abstract forms on a flat picture plane. The patches of colours on the grid evoke a sense of New York's vitality.

④ THE CITY

The yellow squares were inspired by New York's yellow cabs. The other seemingly pulsating coloured squares imply figures or cars walking or driving around the streets and its grid layout.

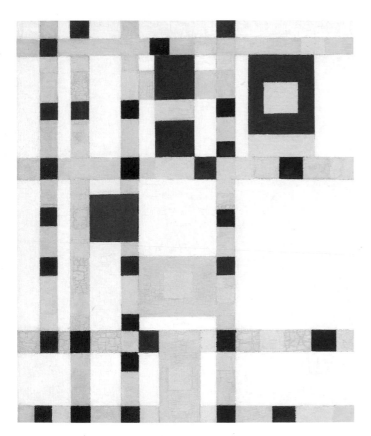

① RHYTHM

With its unexpected syncopation of rhythm, boogie-woogie music is expressed here. Exhilarated by music and dancing, Mondrian had shocked some of his acquaintances in Europe by dancing the new, risqué tango over the more sedate waltz. He named two paintings *Fox Trot B* (1929) and *Fox Trot A* (1930) after the US dance that had recently been introduced into Europe.

Mondrian began his career painting in a Dutch naturalistic tradition, but refined his style until he eliminated all surplus or excess elements. He still painted in a fluid manner, and on close inspection his lines are not as precise as they may initially appear.

⑤ PREPARATION

Mondrian began painting this work in Paris in 1937 and changed it as he continued it in New York. He coated his finely woven linen canvas with an even layer of commercially bought size – a gluelike preparation that smoothed the canvas. Over this, he painted a further smoothing layer of white paint and then drew his grid of straight lines.

⑥ COLOUR

Unlike many of Mondrian's paintings, this does not include any black, and the grid lines are multicoloured, creating a pulsing rhythm like an optical vibration or syncopated rhythm. Colours for Mondrian were symbolic. Red represented the body, yellow the mind and blue the spirit. His palette here comprised flake white, cadmium yellow, cadmium red and French ultramarine.

⑦ OPPOSITES

This composition is concerned with harmony and balance, positivity and negativity, and vibrancy and movement. Influenced by the philosophies of M. H. J. Schoenmaekers and the teachings of theosophy, Mondrian's sense of balance creates visual tension. He aimed for 'construction through the continuous opposition of pure means – dynamic rhythm'.

New York in the 1940s

When Mondrian moved to New York in September 1940, in comparison with war-torn Europe, it was a buzzing, exciting metropolis. With the Jazz Age in full swing, celebrities who congregated there included singer Ella Fitzgerald, dancer Martha Graham, writer Dorothy Parker and sports hero Babe Ruth. Prohibition was over and the city was known for its interpretation of Art Deco design and its dramatic skyscrapers, including the Chrysler and Empire State buildings. Harlem, with its sustained civil-rights activism, had become the political capital of black America. The Harlem Renaissance brought worldwide attention to African-American artists, musicians, novelists, poets and playwrights. At the same time, Abstract Expressionist artists were gaining recognition. New York soon became the centre of the art world, taking over from Paris.

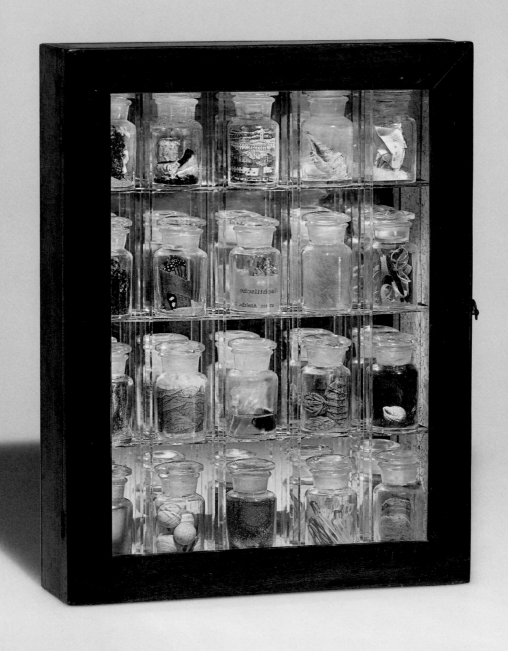

PHARMACY

JOSEPH CORNELL

1943

mixed media
38.5 x 30.5 x 8 cm (15 ¼ x 12 x 3 ⅛ in.)
private collection

AMERICAN ARTIST AND SCULPTOR Joseph Cornell (1903–72) is famed for his glass-fronted boxes containing items such as shells, cutout magazine pictures, photographs, novelties and other found objects. Known as 'shadow boxes', 'memory boxes' and 'poetic theatres', they elicit memories, suggest associations, imply connections and inspire ideas.

Cornell was born in Nyack, New York, the eldest child of four. The family enjoyed music, ballet, theatre and literature, and Cornell's father often came home from work with gifts of sweets, magazines, sheet music or small trinkets for the children. Cornell's brother Robert was born with cerebral palsy, and Cornell became his main carer. After Cornell senior's death in 1917, the family moved to Long Island. Cornell was shy and devoted to his brother. He left school early and began working as a salesman, but lost the job during the Great Depression. Meanwhile, he read widely, taught himself to paint and became a follower of Christian Science. When he was twenty-six years old, the family moved to Queens, where he lived for the rest of his life. Eventually, he worked as a textile designer, and by 1932, he was selling his artwork. At New York's Julien Levy Gallery, Cornell met several Surrealist poets and painters, exhibited with them and designed the catalogue cover for the 'Surrealisme' show of 1932 that launched Surrealism in the United States.

Cornell collected Japanese prints and while hunting for prints in an Asian shop in Manhattan, he found a box that inspired him. Already making collages with photocopied or cutout images from books and magazines, he began making small wooden boxes and filled them with items that evoked his memories. In 1936, he had one box *Untitled (Soap Bubble Set)* in the Museum of Modern Art's exhibition 'Fantastic Art, Dada, Surrealism'. After that, he exhibited regularly and sold his work, while freelancing as a designer on glossy magazines such as *Vogue*. Cornell created six versions of *Pharmacy* over ten years. It reflects his beliefs as a Christian Scientist, in which traditional medicine was prohibited. Instead, the miniature apothecary includes medicine for the imagination and the soul, it is filled with nostalgia and dreams.

Madonna and Child, **Filippino Lippi, *c.* 1485, tempera, oil and gold on wood, 81.5 x 59.5 cm (32 x 23 ½ in.) Metropolitan Museum of Art, New York, USA**

Among Cornell's many influences were Renaissance paintings. In his vial containing gold-painted cork, brilliant blue pieces and a white feather, he alludes to paintings such as this. Filippino Lippi (*c.* 1457–1504) used lapis lazuli and gold to enrich his detailed work. This is decorated with the emblems (three crescents) of the patron of the painting, Filippo Strozzi, whereas the landscape suggests the countryside around the Strozzi villa near Florence. It features the two most expensive pigments of the Renaissance: gold and ultramarine blue.

① GOLD

Consisting of four rows of five glass jars set against a mirrored back, this emulates a miniature apothecary, but each vial has been filled with something significant to Cornell. This scrunched pink foil suggests a sweet or chocolate, whereas the white feather, brilliant blue pieces and gold-painted cork evoke the Renaissance art that Cornell admired. The white feather represents a white dove to symbolize the Holy Spirit, whereas gold and lapis lazuli were the costliest pigments, used only in the most important paintings.

② ARCHITECTURE

Cornell collected objects for his boxes and organized them in folders labelled 'Dürer' or 'Dried Pigments' or 'Watch Parts', for example. Here, he cut out printed pictures of buildings and assembled them to resemble a 19th-century diorama – miniature paper models that were often shown in glass cases in museums. Shells are often collected in their own right, but here in the glass jar, this delicate shell is singled out for special attention.

③ HEALING

Cornell's adherence to Christian Science meant that the taking of traditional medicines was forbidden, yet the concept of healing is an important part of the work and an essential aspect of his life. The religious movement helped him with mental-health problems and at times of difficulty when looking after his brother. These symbols reflect Cornell's spiritual beliefs.

4 PIET MONDRIAN

Cornell was an acquaintance of Mondrian. He organized this work in a gridlike, abstract manner that recalls Mondrian's Neo-Plasticism. The grid simplifies the elements contained here. Fascinated with the rigour of symmetry, in 1946, recording his thoughts about a box, Cornell wrote: 'Mondrian feeling strong. Feeling of progress and satisfaction. Placed all of cubes before inserting into box....'

In 1941, Cornell organized a studio space at his family home in Flushing, Queens, enabling him to work on a larger scale than he had been and to store his collections. His magazine design work gave him skills in precision and balance.

5 SKETCHBOXES

Studying, organizing, combining and displaying his collections was the main aspect of Cornell's creative process. His gathering, storing and considering of items was akin to painters making sketches, and he kept folders and what he called 'sketchboxes' full of things, arranged in his classification system.

6 AUTOMATISM

Although Cornell carefully planned this box, and he sometimes called his studio his 'laboratory', some of it was made using intuition: sorting, selecting and arranging with the Surrealist method of automatism. He described this as his 'creative filing / creative arranging' and his 'joyous creation'.

7 SURREALISM

With his use of intuition, dreams, memories and his subconscious, Cornell continued to be associated with the Surrealists, although he always dismissed this connection. However, in 1939, Dalí described Cornell's art as 'the only truly Surrealist work to be found in America'.

POST
WORLD
WAR II

AS THE 20TH CENTURY PROGRESSED, overshadowed by the two world wars, artistic expression often became inward-looking, angry or even violent. Of great significance was the shift after World War II, when for the first time some major art movements originated in the United States. Unlike Europe, the United States was largely unscathed by the war. While Europe was recovering from the conflict, the United States experienced a rising economy and the influence of many European avant-garde artists who had fled there. Initially, New York emerged as a centre of artistic activity and then California. The first art movements that developed in the United States were Abstract Expressionism in the late 1940s and 1950s, followed by Pop art and then Minimalism, while various other art styles soon also began emerging on both sides of the Atlantic.

THE SQUARE II

ALBERTO GIACOMETTI

1947–48

bronze
23 x 63.5 x 43.5 cm (9 x 25 x 17 ⅛ in.)
Museum Berggruen, Berlin, Germany

FAMED FOR HIS SPINDLY figurative sculptures, Alberto Giacometti (1901–66) worked as a Surrealist in the 1930s and as an existentialist after World War II. He created a style of sculpture that summed up the philosophy's interests in perception, alienation and anxiety.

Born in Switzerland to a family of artists, Giacometti grew up in Stampa. From 1919 to 1920, he studied in Geneva, learning painting at the École des Beaux-Arts and sculpture and drawing at the École des Arts et Métiers. Next, he travelled to Italy, where he admired the paintings of Giotto and Tintoretto (c. 1518–94), as well as the works of Russian sculptor Alexander Archipenko (1887–1964) and Cézanne at the Venice Biennale. He also became fascinated by African and Egyptian art. In 1922, he moved to Paris to study under French sculptor Antoine Bourdelle (1861–1929). Four years later, he moved into a studio with his brother, designer Diego Giacometti (1902–85), and exhibited his sculpture at the Salon des Tuileries. In 1927, he had his first show in Switzerland, exhibiting with his father, painter Giovanni Giacometti (1868–1933), in Zurich. After meeting French artist and stage designer André Masson (1896–1987), he began creating fantastic images from his unconscious. When World War II ended, he renewed his friendships with French author Simone de Beauvoir, Picasso and French philosopher and writer Jean-Paul Sartre, and his work began to exemplify existentialism.

The Square II, with its elongated figures walking across an imaginary piazza, powerfully expresses Giacometti's interest in existentialism. He made five different casts of this work, with every figure placed in slightly different positions.

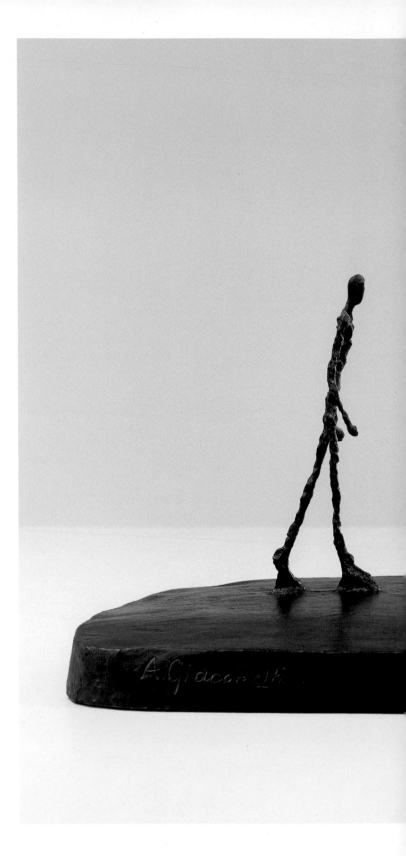

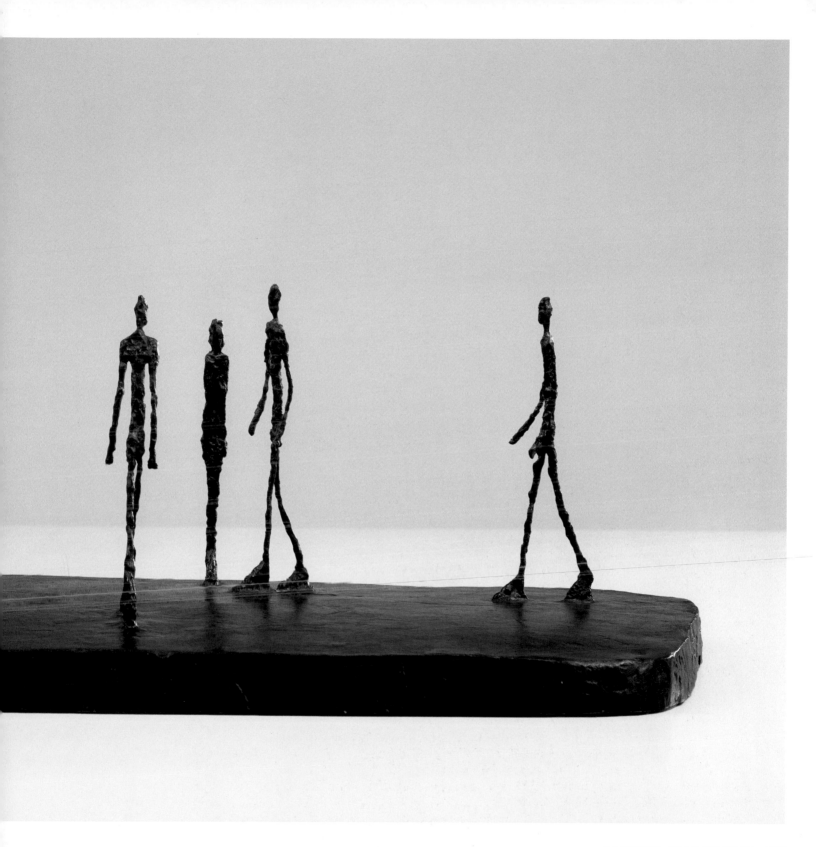

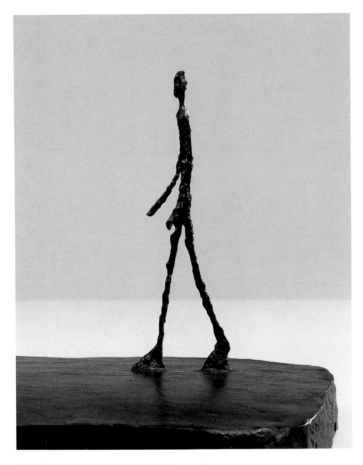

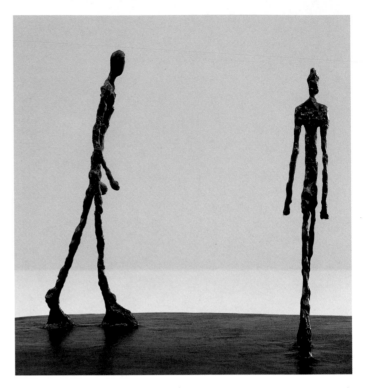

② MALE FIGURES

Four thin figures of this work are men. Although they are in close proximity with each other, they do not connect nor communicate, much the same as the figures in Grosz's painting *Metropolis* (see p. 94) and Hopper's *Nighthawks* (see p. 162). Giacometti's figures are featureless and appear to be self-absorbed. His brother Diego was one of his favourite models and is believed to have modelled for all four of these male figures.

③ FEMALE FIGURE

A single woman stands isolated and motionless near the centre of this work. Giacometti explained: 'In the street, people astound and interest me more than any sculpture or painting… They unceasingly form and re-form living compositions in unbelievable complexity… four men direct their steps more or less towards the spot where the woman is standing….'

① EXISTENTIALISM

The philosophy of existentialism focuses on finding truths about individuals and the meaning of life through free will, choice and personal responsibility. Giacometti was fascinated by it. During World War II, he worked on this group of bronze figures that Jean-Paul Sartre believed expressed the existential problems of alienation and loneliness.

In 1935, Giacometti changed his style. Initially, he created tiny sculptures, but gradually his figures developed with textured surfaces, long limbs and small heads. All his attenuated figures personify the themes of disconnection and of being alone in a crowd.

❹ ISOLATION

Heavy-looking, weighted feet emphasize the sense of each figure's isolation and anonymity. Giacometti was attempting to depict universal feelings of detachment and vulnerability. Some have perceived this work as representing the resilience of the human spirit and that the figures are survivors of World War II.

❺ SPACE

Intrigued by spatial relationships and in creating a sense of dynamism, Giacometti positioned his figures so that the negative spaces – the shapes between the figures – create an impression of motion when seen from any angle. The heavy flat bronze base that suggests a piazza is the antithesis of the wiry figures.

❻ METHOD

Giacometti altered the traditions of sculpture, abolishing volume and deforming his figures. Additionally, rather than creating smooth, polished surfaces, the textured bronze bears Giacometti's handprints and fingerprints. The impressions are from the original clay models used to make the bronze sculptures.

❼ LINE

Comparable to the space that is harnessed and used to add impact to the entire work, the narrow vertical lines of each figure project a pattern. While the lines are thin and tall, and so do not take up much space, they nonetheless dominate. The pointed, expressive figures appear as graphically rendered as his own linear drawings.

Moai, c. 1400–1650, tuff, varying heights, Ahu Tongariki, Easter Island, Chile

Approximately 1,000 of these massive megaliths have been found at Easter Island. Made by the indigenous people, they are known as *moai*. They are made of tuff – a local material of compressed volcanic ash – and carved with stone tools. The statues are believed to have been made to honour tribal chieftains or other important individuals after their deaths. Placed on rectangular stone platforms, similar to the flat, rectangular platform of Giacometti's *The Square*, they project a sense of the isolation and separation of humans – the solitude that can be felt even when within a crowd.

RUMBLINGS OF THE EARTH

WIFREDO LAM

1950

oil on canvas
151.5 x 284.5 cm (59 ¾ x 112 in.)
Solomon R. Guggenheim Museum, New York, USA

CUBAN ARTIST WIFREDO LAM (1902–82) painted with a distinctive style and unique symbolism. He was born to a mother of Spanish and African heritage and a Chinese father. Although he had a Catholic background, his godmother was a Santería healer and sorceress, and this contact with African spiritual practices became important to his work.

After studying law in Havana, he enrolled at the School of Fine Arts. In 1924, he left Cuba for Madrid where he studied drawing and painting. There he was inspired by the work of Bosch and Pieter Bruegel the Elder (c. 1525–69) that he saw in the Museo del Prado, and explored the primitivism that so many European painters had exploited.

In 1931, his wife and their son died of tuberculosis, and his themes became darker. After fighting on the Republican side in the Spanish Civil War, however, he escaped to Paris where he became involved with artists including Picasso, Léger, Matisse, Braque and Miró. With the outbreak of World War II and the invasion of Paris by the Germans, Lam returned to Cuba in 1942, where he remained for ten years. This was painted there and is a synthesis of many influences including Surrealism, Cubism, African art, Picasso and Miró.

The Triumph of Death, Pieter Bruegel the Elder, c. 1562–63, oil on canvas, 117 x 162 cm (46 x 63 ¾ in.), Museo del Prado, Madrid, Spain

Between 1923 and 1938, Lam lived in Madrid where he was inspired by the work of Bruegel. This depicts death destroying the world of the living, which includes people of all ages and social classes. *The Dance of Death* was a common theme in Northern European art but this savage depiction was particularly harsh and intended to shock.

② HYBRID FIGURES

The hybrid figures appear to possess male and female genitalia. Lam expressed many of his life experiences in his work. Among these, he drew on his studies of tropical plants he had made in Havana's Botanical Gardens. With their sinuous and spiky fronds, aspects of these graphic symbols seem like plants.

① UNDERCURRENTS

This work addresses Lam's amalgamation of European artistic styles with his feelings of sadness over racial prejudice in Cuba, where people of mixed heritage were seen as second-class citizens even though racial discrimination was banned in Cuba from 1940. These strange creatures express his frustration and anger.

③ STYLIZED

By the time Lam created this, he had developed his mature painting style that included flattened composite figures reflecting the Cubist approach of avoiding a sense of depth. With their exaggerated proportions and stylized geometric features, these long faces with small, round eyes recall African masks.

④ SANTERÍA

The Santería religion originated with the Yoruba people. Lam integrated elements of it to connect his art to his African roots as did Ana Mendieta (1948–85; see p. 270). He used animal-like forms inspired by their deitics, such as the 'femme-cheval' (horse-headed woman).

⑤ WOMEN

Lam challenged attitudes regarding sexual exploitation of women. Inspired by indigenous American and African ritual themes, this creature suggests a magical metamorphosis. It derived from Picasso's *Les Demoiselles d'Avignon* (see p. 38). Lam said: 'Rather than an influence, we might call it a pervasion of the spirit. There was no question of imitation, but Picasso may easily have been present in my spirit… On the other hand, I derived my confidence in what I am doing from his approval.'

⑥ COLOUR

Once back in Cuba, Lam began using this sombre palette of blacks, greys and browns. As well as *Les Demoiselles*, he was also inspired directly by Picasso's *Guernica* (1937), but he replaced Picasso's central horse with this fantastic being wielding a large knife, that Lam described as 'the instrument of integrity'.

⑦ VIEWPOINTS AND AUTOMATISM

In flattening objects on the canvas and working from multiple viewpoints, as well as using the automatist method that blurred the differences between the real and the unconscious, Lam assimilated Cubism and Surrealism. He was powerfully affected by André Breton's insistence that painting should not copy nature.

WOMAN I

WILLEM DE KOONING

1950–52

oil, enamel and charcoal on canvas
192.5 x 147.5 cm (75 ⅞ x 58 in.)
Museum of Modern Art, New York, USA

ALONG WITH JACKSON POLLOCK (1912–56) and Mark Rothko (1903–70), Willem de Kooning (1904–97) is one of the most prominent and celebrated Abstract Expressionist painters. His bold and spontaneous brushwork embody the energetic style of the movement, while fusing elements of Cubism, Surrealism and Expressionism.

Growing up in Rotterdam in the Netherlands, de Kooning lived first with his father and then with his mother after they divorced when he was three years old. At the age of twelve, he left school and was apprenticed to a firm of commercial artists. He also took evening classes at the Academy of Fine Arts and Applied Sciences of Rotterdam. Initially fascinated by the flowing organic forms of Jugendstil, de Kooning then became inspired by the pure colours and straight lines of De Stijl. After living in Belgium, he returned to Rotterdam, and in 1926, he stowed away on a ship and sailed to the United States. He made his way from Virginia to Boston on a coal ship, then worked as a house decorator in New Jersey. By the following year, he reached Manhattan, where he was employed as a commercial artist, window dresser, decorator and carpenter.

Meanwhile, in his spare time, de Kooning painted. He socialized with other artists working in Manhattan, including Stuart Davis (1892–1964), Arshile Gorky (1904–48) and John Graham (1886–1961). He was particularly inspired by Gorky's blend of Cubism and Surrealism. From 1935 to 1937, he was employed in the Federal Art Project of the Works Progress Administration. He then worked full-time as an artist, producing paintings on commission and giving art lessons. In 1939, he was one of thirty-eight artists chosen to paint murals for the World's Fair in New York.

Although he painted both abstractly and figuratively, de Kooning is most famous for his early 1950s series of paintings of women, of which this was the first. Blending figuration with gestural abstraction, it is a result of multiple influences, from Picasso and Gorky, to prehistoric figurines, Renaissance madonnas and female models in contemporary advertisements. His experiences in commercial illustration and house painting contributed to his free, fluid and expressive style.

Hélène Fourment in her Wedding Dress, **Peter Paul Rubens, 1630–31, oil on panel, 163.5 x 137 cm (64 ⅜ × 53 ⅞ in.), Alte Pinakothek, Munich, Germany**

Like Rubens, de Kooning celebrated the female form with paint. Similar to *Woman I* is this voluptuous young woman. This is Rubens's second wife, sixteen-year-old Hélène Fourment in her wedding gown. By this time, Rubens could afford to clothe his wife expensively. She is sumptuously dressed in the latest fashion, sitting on a carved chair, her feet on an expensive oriental carpet, her head framed by a swathe of rich red velvet. Although more detailed than de Kooning's painting, this compares to *Woman I* in that both women are shown seated.

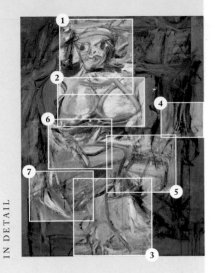

② UPPER BODY

The whole painting represents a parody of many male sexual preferences, with massive pillowlike breasts as one of the most obvious and stereotypical exaggerations. As well as the face, it is the most obvious focal point of the painting that explores clichéd and hackneyed imagery.

① HEAD

De Kooning developed *Woman I*'s lips after studying pouting female models in cigarette advertisements. He said: 'I used to cut out a lot of mouths [from magazine and newspaper advertisements] and then I painted those figures and then I put the mouth more or less in the place where it was supposed to be.' For this work however, he painted the mouth with long teeth.

③ LOWER BODY

De Kooning painted when abstract art was considered the most relevant, yet he chose to be figurative. The woman is portrayed in a colourful skirt with bare legs and ankle-strapped shoes. This was one of six paintings of single female figures that he painted between 1950 and 1953. It captures de Kooning's statement: 'Beauty becomes petulant to me. I like the grotesque.'

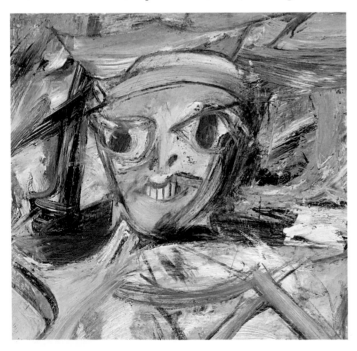

De Kooning was influenced by all types of visual material. To prepare for this work, he produced drawings and collages, and then painted the image numerous times, scraping away the figure repeatedly. His wife Elaine (1918–89), who was also a painter, estimated that some two hundred images preceded Woman I.

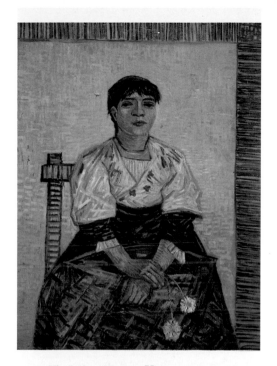

The Italian Woman, Vincent van Gogh, 1887, oil on canvas, 81.5 x 60.5 cm (32 ⅛ x 23 ⅞ in.), Musée d'Orsay, Paris, France

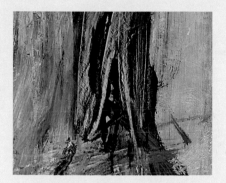

④ PAINT APPLICATION

De Kooning focused on creating a textural surface with impasto layers, even though he thinned his oil paint with water mixed with kerosene, benzene or safflower oil as binding agents. He applied, smeared and removed paint with spatulas and knives, working fast and energetically.

⑤ COLOUR

Colour is essential to this work. The clashing hues applied in thick, lustrous and layered marks create a dazzling impression of activity. De Kooning layered strokes of orange, blue, yellow and green in multiple directions, layer upon layer, yet never overblending or muddying the colours.

Another of de Kooning's influences, Van Gogh, created paintings using bright colours and juicy strokes of paint. As in *Woman I*, Van Gogh has portrayed a woman against a textured background. However, this is a portrait of an Italian artists' model, Agostina Segatori. Van Gogh followed contemporary scientific colour theories that were being expressed by the Neo-Impressionists. Although this work is more lifelike than de Kooning's, Van Gogh still applied his paint energetically, placing complementary colours next to each other in overlapping, layered marks. De Kooning's expressive approach can be compared with Van Gogh's loose painterly style, but de Kooning took his work further, creating a sense of violence through his vigorous paint application.

⑥ LINE

Outlined in thick and thin lines, the surface of the painting is built with angular strokes, streaks and slashes, all executed vigorously, to describe the woman's broad shoulders and ample bosom. The bright colours and angled lines create a flat appearance, so she is pressed against the picture plane.

⑦ SPONTANEITY

Despite the apparent spontaneity of the painting, de Kooning made many other works in exploration of and in preparation for it. So while this met his intentions, with its swathes of colour, slashing lines and anatomical distortions, it remains an exuberant and dynamic experiment.

HUDSON RIVER LANDSCAPE

DAVID SMITH

1951

welded painted steel and stainless steel
124 x 183 x 44 cm (48 ¾ x 72 ⅛ x 17 ⅜ in.)
Whitney Museum of American Art,
New York, USA

US SCULPTOR DAVID SMITH (1906–65) was one
of the first to work with welded metal and is best known
for his large steel abstract geometric sculptures. His
use of industrial processes also influenced Minimalism.
One of his most significant innovations was to abandon
the idea of a solid centre or core in sculpture, and instead
to 'draw in space', with thin wire to produce linear works
and later, large geometric forms that expressed the
vigorous gestures of Abstract Expressionism.

Smith was born in Indiana, but moved to Ohio
when he was fifteen years old. Four years later, he began
working at a car factory where he learned soldering and
spot-welding techniques that he later used in sculpture.
On moving to New York in his twenties, he enrolled
at the Art Students League, where he studied painting
and drawing for five years, and he created works in relief
that developed into sculptural objects. He befriended
other artists including John Graham (1886–1961) and
Arshile Gorky (1904–48).

In *c.* 1930, Graham showed him magazine pictures
of the welded metal sculptures of Picasso and Spanish
sculptor Julio González (1876–1942), and from that
moment, Smith realized he could use the industrial
techniques he had learned as a skilled labourer. He
rented a large workshop in Brooklyn, and in 1951 he
created *Hudson River Landscape*, transforming steel
agricultural tool fragments and foundry castoffs into an
expressive sculpture that loosely describes a landscape.

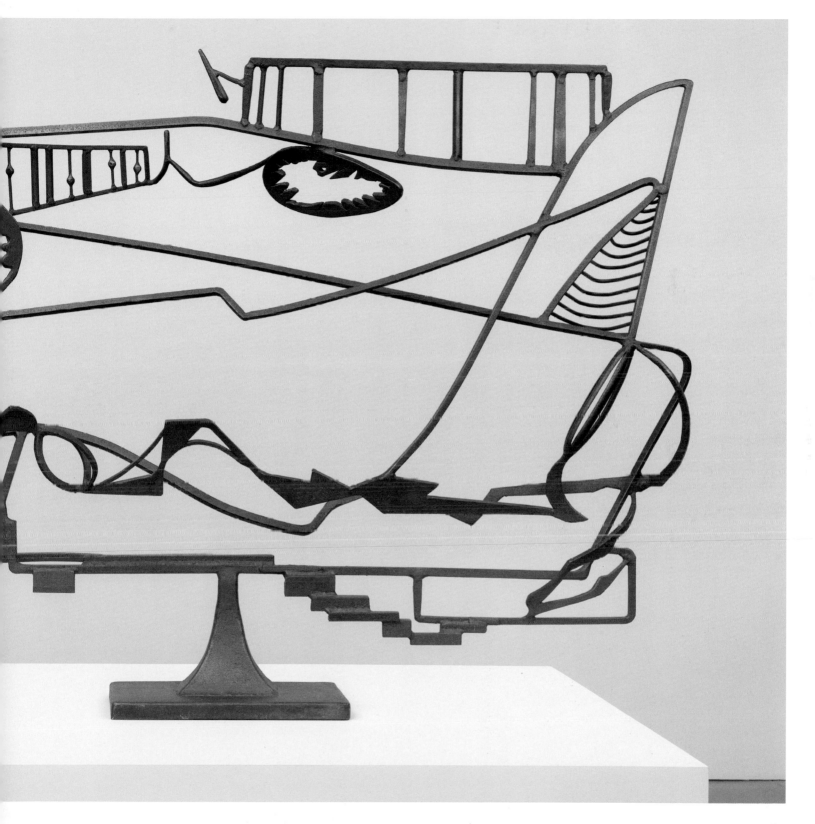

① DRAWING IN SPACE

Smith used welded steel to create what he called his 'drawings in space'. The sculpture, resembling a flat drawing, is a landscape, a synthesis of ten trips that he made over a 120-kilometre (75-mile) stretch of land between Albany and Poughkeepsie. He prepared by making 'dozens of drawings' on a train. The result, which can only be seen from the front like a drawing or painting, was the culmination of his efforts to unite painting and sculpture.

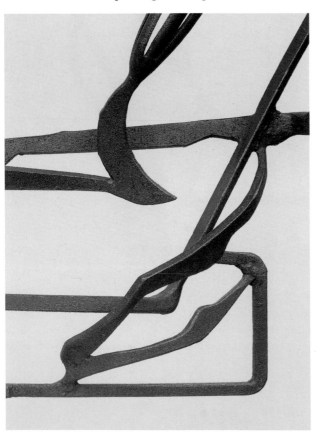

② SYMBOLIC

Smith explained how he made this: 'I shook a quart bottle of India ink. It flew over my hand, it looked like my landscape. I place my hand on the paper, and from the image this left, I travelled with the landscape to other landscapes and their objectives… The total is a unity of symbolized reality….'

③ PATTERN

In 1940, Smith and his wife, painter and sculptor Dorothy Dehner (1901–94), moved from Brooklyn to Bolton Landing on Lake George in the Adirondack Mountains, where he immersed himself in his surroundings. Nature and the environment became his primary subject. Although there are no specific elements of the scene he described this to be, patterns suggest the rugged mountainous landscape, sky, running water and man-made elements.

④ MATERIALS

Smith believed that more artists should embrace industrial materials and techniques. Discussing steel, he said: 'What it can do in arriving at form economically, no other material can do. The metal itself possesses little art history. What associations it possesses are those of this century: power, structure, movement, progress, suspension, destruction and brutality.' He stated that because he had worked in factories and made parts of cars and had worked on telephone lines, he 'saw a chance to make sculpture in a tradition I was already rooted in'.

⑤ CLOUDS AND A RAILWAY

Despite the forms being abstracted, these can be recognized as clouds and a train track. The angled lines suggest higher ground. They demonstrate the influence of Cubist art that he studied at the Art Students League.

⑥ ABSTRACT EXPRESSIONISM

As a close friend of US painter and printmaker Robert Motherwell (1915–91), Smith appreciated the concerns of his fellow Abstract Expressionist painters and interpreted them as sculpture. This is his translation of the energetic Action Painting of much Abstract Expressionism in sculptural form.

⑦ INNOVATIONS

While a great deal of traditional sculpture features figures, this is unusual in being a landscape. It also contradicts tradition with no solid centre and by being made with industrial materials. Furthermore, despite being made of heavy welded steel, its open construction makes it appear light and airy.

Totem poles

Smith was inspired by many things. By European modernism, by his industrial knowledge of cars, by totem poles made by indigenous people, by Abstract Expressionist paintings and by his mother, who was a strict Methodist who sang in the church choir. During World War II, Smith refined his welding and riveting techniques while working for the American Locomotive Company, assembling trains and tanks. In 1945, he created a totem pole called *Pillar of Sunday* in red painted steel, inspired by the native totem poles he had seen, his mother and his childhood memories. Just as many totem poles are difficult for others to interpret, so Smith's abstract symbols are also frequently hard to decipher.

BLUE POLES

JACKSON POLLOCK

1952

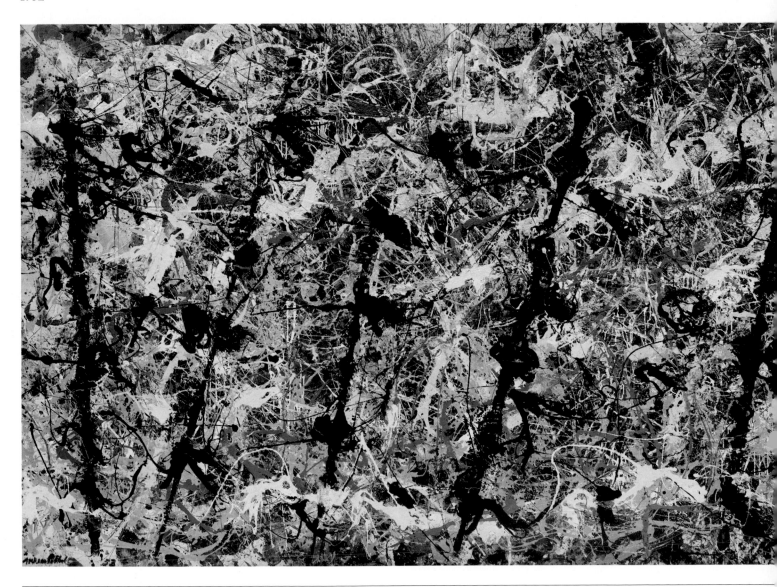

THE CREATOR OF ONE of the most radical abstract styles in modern art, Jackson Pollock (1912–56) redefined painting with his original methods. He became the leading figure in the Abstract Expressionist movement that occurred in the United States during the 1940s and 1950s.

Pollock grew up in Wyoming, California and Arizona. At school in Los Angeles, he became interested in theosophy, and while living in Phoenix he discovered and became intrigued by Native American art. In 1930, he moved to New York and enrolled at the Art Students League, taught by the regionalist painter Thomas Hart Benton (1889–1975). He became fascinated by the work of the Mexican muralists after meeting José Clemente Orozco (1883–1949), spending a summer watching Rivera paint murals at the New Workers School and joining the Experimental Workshop of David Alfaro Siqueiros (1896–1974). From 1935, he worked at the

enamel and aluminium paint with glass on canvas
212 x 489 cm (83 ½ x 192 ½ in.)
National Gallery of Australia, Canberra, Australia

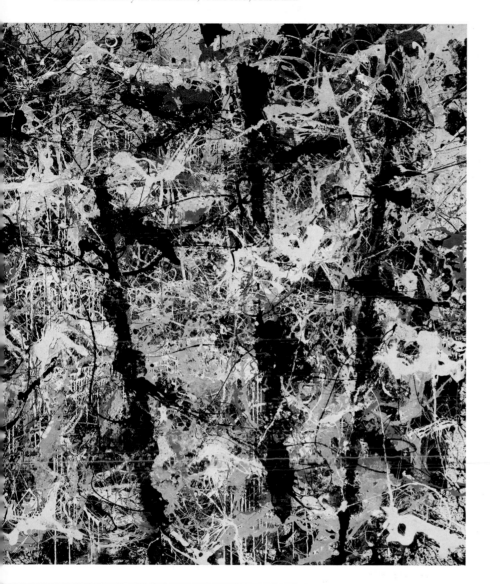

Fractals and art

Fractals are complex repeating patterns that echo each other and have been identified in *Blue Poles*. They can be split into parts and occur in different scales. The term 'fractal' was coined by the mathematician Benoit Mandelbrot in 1975 from the Latin word *'fractus'* meaning broken. He defined a fractal as a fragmented geometric shape that can be split into parts, each of which is a reduced sized copy of the whole. Fractal patterns occur in nature; for example in flowers and shells and. Fractal art (below) developed from the mid 1980s.

Works Progress Administration's (WPA) Federal Art Project that had been set up to employ out-of-work artists, first at the mural division and then the easel division. Although he painted figuratively at the time, when the WPA project ended in 1942 he began producing drip paintings by throwing, flicking and pouring paint on to large canvases on the floor, inspired by Surrealist automatism and Ernst's oscillation technique. *Blue Poles* is one of his most famous paintings.

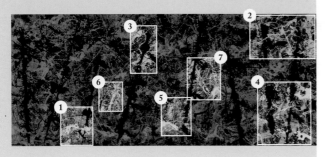

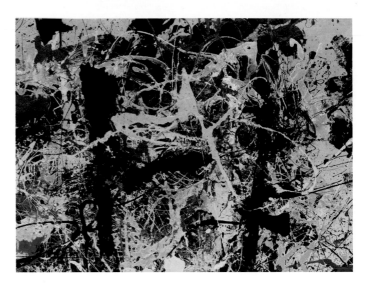

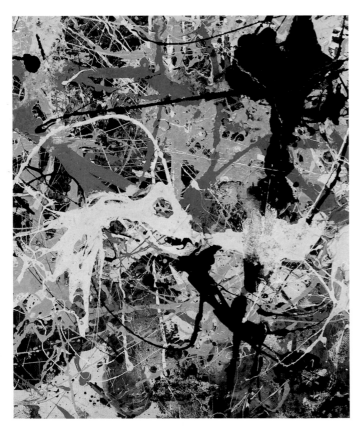

❶ ACTION

At the time of the painting's creation, Pollock preferred to assign numbers to his works, rather than names, and the original title of the painting was simply *Number 11* or *No. 11, 1952*. In 1954, he used the title *Blue Poles* at an exhibition. He painted it through a form of automatism, allowing his subconscious thoughts and intuition to take over. Both the action itself and the resulting painting suggest energy, but the work also expresses feelings of being ensnared in the mind, body or the modern world.

❷ FOOTPRINTS

At the top right of the painting a bare footprint is visible and there are other footprints around the edge of the work – evidence that this was painted on the floor. Pollock often stood on the edge of the canvas leaning in, occasionally stretching with his foot right into the centre of the canvas, in order to control his paint distribution.

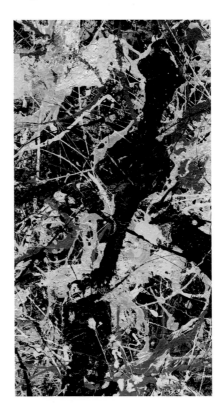

❸ BLUE POLES

After Pollock had left the canvas for a while and the paint beneath was dry, he added eight blue lines resembling poles at different angles To make the pole marks, he used a length of timber that he painted dark blue, and pressed them randomly across the work. They have been described as totems or swaying masts of tall ships, but they are not representative of anything from the visual world. He blurred their edges with further swathes and skeins of white, black and blue paint.

Pollock threw, splattered and dribbled paint on to the surfaces of his large canvases that he laid across the floor of his studio rather than stretching them and using an easel in the traditional way. As the canvas was on the floor, Pollock could walk around it and apply paint from all directions.

④ MATERIALS

Pollock laid down black enamel and then splattered white, cadmium orange, yellow and silver paint before adding the blue poles. Green emerged through the yellow mixing with the black. Glass shards are stuck in the paint from the syringes he used to apply it that later broke.

⑤ FRACTALS

Richard Taylor, director of the Materials Science Institute at the University of Oregon analysed *Blue Poles* and found that it contains fractals. He asserts viewers derive pleasure from the work because it features nature's patterns, which meet their subconscious preferences.

⑥ EXPRESSION

To achieve his effects, Pollock worked spontaneously. His paintings express his feelings and thoughts. He said of his approach: '…the modern painter cannot express this age, the airplane, the atom bomb, the radio, in the old forms of the Renaissance or of any other past culture.'

⑦ METHOD

Pollock allowed his subconscious to take over using automatism. His brushes rarely touched the canvas, as he flicked, poured and spattered paint from a distance. His method was influenced by the theories of psychoanalyst Carl Jung about the unconsciousness.

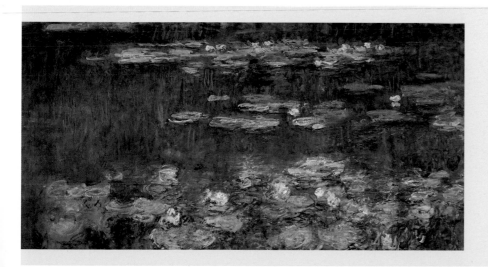

Detail from *Water Lilies, Green Reflections*, Claude Monet, 1915–26, oil on canvas, 200 x 850 cm (78 ¾ x 334 ⅝ in.), Musée l'Orangerie, Paris, France

Inspired by his water-lily pond in Giverny, France, Monet worked on 'Grandes Decorations' from 1915 until his death in 1926. This is one of eight monumental panels, created as a series to capture hours passing over a day. Breaking new ground, Monet painted no horizon, no foreground or background and no perspective, simply the water, sky and flowers, creating a rhythm through colours and gestural paintmarks. It is often debated whether Monet's ideas and style influenced Pollock, but directly or indirectly, comparisons can be drawn.

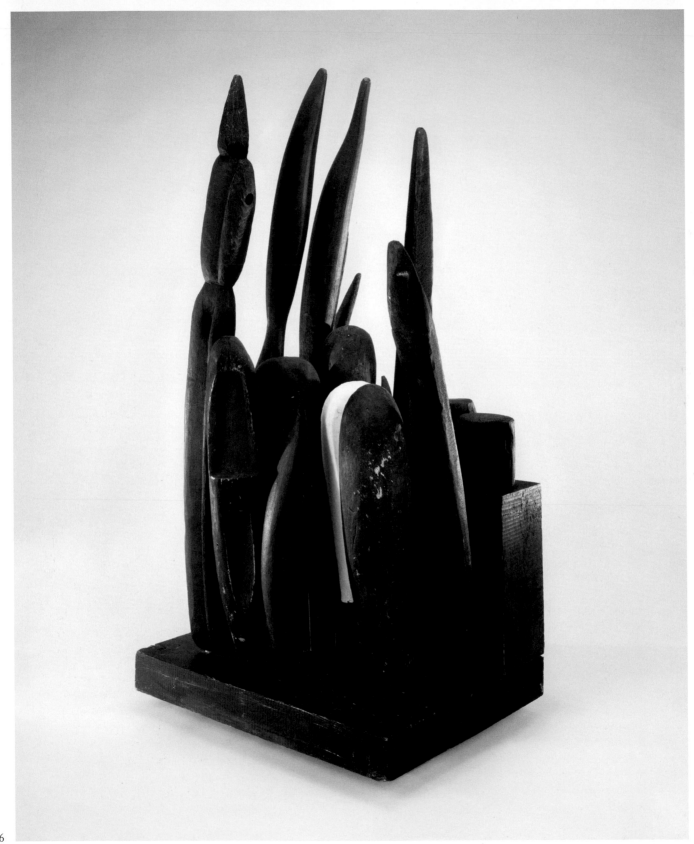

FORÊT (NIGHT GARDEN)

LOUISE BOURGEOIS

1953

painted wood
94 x 48 x 37 cm (37 x 18 ⅞ x 14 ⅝ in.)
private collection

WITH A CAREER THAT spanned much of the 20th century
and the first decade of the 21st, Louise Bourgeois (1911–2010)
created three-dimensional art that was often sexually explicit
or strongly informed by her childhood experiences, and
especially her father's infidelity to her mother. In 1912, the
Bourgeois family rented a house in Choisy-le-Roi outside
of Paris at 4 Avenue de Villeneuve-St-Georges. They lived
there until 1917 in a large house built in the mid 19th century.
Behind the house was a two-story atelier for the tapestry
workers. From a young age, Bourgeois created designs for the
worn or missing sections of the tapestries and also washed and
mended them, all in the company of her mother Josephine,
with whom she was extremely close. However, tensions arose
in the family because her live-in tutor was her father's mistress.

After the death of her mother in 1932, Bourgeois left her
mathematics course to study art. She enrolled at several
schools and ateliers between 1933 and 1938, including the
École du Louvre, the Académie Ranson, the Académie Julian,
the Académie de la Grande-Chaumière and the École des
Beaux-Arts in Paris. She also worked as an assistant to Léger
before emigrating to New York in 1938 with her husband,
US art historian and critic Robert Goldwater.

In the United States she began to produce sculpture, often
stylized, vaguely sexual figures. She started experimenting
with materials – latex, resin, plaster, aluminium – in the 1960s,
but up until then the materials she used for her sculptures
were rather traditional, primarily wood and paint. She stayed
at the forefront of artistic developments, working as a teacher
and being politically active as a socialist and feminist. In her
art practice she explored painting, printmaking, sculpture,
installation and performance. During the 1970s, she made
more overtly feminist works.

From 1947, she exhibited her *Personages* (1946–55) series
of carved and stacked columns of wood and plaster. Initially,
they had no bases and were displayed directly on the floor
creating an environment viewers could enter and walk through.
Later, she added bases to some of them. *Forêt (Night Garden)*
is one of the last works in the series.

Rendezvous in the Forest, **Henri Rousseau, 1889, oil on
canvas, 92 x 73 cm (36 ¼ x 28 ¾ in.), National Gallery
of Art, Washington, DC, USA**

French painter Henri Rousseau (1844–1910) visited the
zoo and botanical gardens in the Jardin des Plantes in
Paris regularly. He studied illustrated books on botanical
subjects, as well as a 200-page illustrated album entitled
Bêtes Sauvages (*Wild Beasts*). He explained: 'When
I go into the glass houses and I see the strange plants
of exotic lands, it seems to me that I enter into a dream.'
As with Bourgeois's work, here the forest dominates, and
Rousseau makes links with sexuality as a couple share
a kiss in the foliage. He used the dense vegetation as
decorative motif, creating patterns verging on abstraction.

② ORGANIC

When this was shown at the Peridot Gallery, New York in 1953, a reviewer wrote: 'Fruitlike, podlike, seedlike, slowly twisting, round, flat, incised or smooth, these forms constitute the vocabulary of a sensibility. They speak a private poem of restraint and seclusion.'

③ PLANT FORMS

The shapes suggest plant forms. They show the influence of Minimalism and the work of Romanian artist Constantin Brancusi, whom Bourgeois had met three years prior to producing this. Unlike his smooth sculptures, or the hard edges of many Minimalist works, these forms are twisted and distorted.

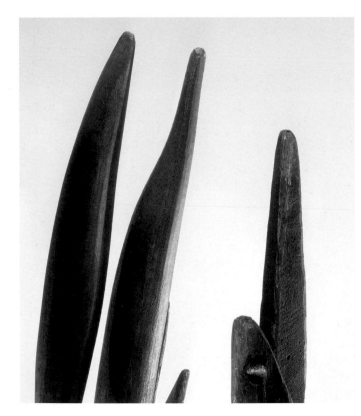

① NATURE

Suggestive of the shadowy shapes that appear in gardens at night, this evokes what Bourgeois described as 'the darkness that surrounds those plants near the ground [that] has always seemed to me attractive and frightening....' She was recalling memories of walking in gardens at night in France and the United States.

Soon after Bourgeois moved to the United States in 1938, she made efforts to work through her feelings of loneliness and alienation in a new country by creating sculptures using oddments she found in junk yards and driftwood that she carved and then painted. Her Personages *sculptures—assembled constructions of painted wood—represent missed family and friends.*

④ SPACE

The twenty objects on their small base are in relatively close proximity to one another. Depending on where the viewer stands, the small spaces between them appear and disappear. These spaces help to create a sense of intimacy.

⑤ UNREFINED

Bourgeois carved, assembled and painted this work from found wood in a fairly unrefined manner. The rough, quick execution adds to the sense the garden consists of dense, overgrown foliage, rather than it being a neatly trimmed space.

⑥ SHAPES

The seemingly random, sensuous shapes express the range of feelings Bourgeois experienced regarding her separation from France and all she had known, despite having lived in the United States for fifteen years. These included loneliness, vulnerability and aggression, and thoughts about family, sexuality and identity.

⑦ SHARED BASE

Few of Bourgeois's works can be interpreted in only one way and this is no exception. Attaching her *Personages* sculptures to a single base made these later works independent of their environment, suggesting the forms were organic rather than architectural. Placed together on their common base, these disparate forms suggest plant and human forms, huddling together or standing aloof from one other. Additionally, this form seems to be excluded from the rest.

EMPIRE OF LIGHT

RENÉ MAGRITTE

1953–54

oil on canvas
195.5 x 131 cm (77 x 51 ⅝ in.)
Solomon R. Guggenheim Museum, New York, USA

WITH HIS NATURALISTIC STYLE and smooth paint application that confuses illusion with reality, Belgian painter René Magritte (1898–1967) was a leading Surrealist. He admired De Chirico, and his years working as a commercial artist, producing advertising and book designs, also had a big effect on his art. Preferring a quiet middle-class existence in Brussels, and often painting an anonymous bowler-hatted clerk as his alter ego, Magritte contrasted dramatically with the flamboyant personalities of many other Surrealists.

Although little is known about his early life, when Magritte was twelve years old, his mother committed suicide by drowning. As many of his later paintings feature white cloths covering human faces, it is often suggested that he saw his mother's body when it was recovered from the river, with her nightdress obscuring her face, but this has never been verified. From 1916 to 1918, he studied at the Académie des Beaux-Arts in Brussels. He then began his career as a wallpaper designer and commercial artist, while producing paintings in his spare time that were influenced by Impressionism, Futurism and Cubism. After discovering the paintings of De Chirico in 1920, his painting style changed and in 1926 he co-founded the Belgian Surrealist group. When he showed his work in Brussels in 1927 he was highly criticized, so he moved to Paris where he became friends with André Breton and other Surrealists. He remained in Paris for three years, painting intriguing pictures of ordinary things, in unexpected scales and juxtapositions, challenging reality and raising questions about the mysteries of existence, for instance in his 1929 painting of a pipe in *The Treachery of Images*, with its inscription: '*Ceci n'est pas une pipe*' ('This is not a pipe'). He then returned to Brussels, and worked in advertising, although he occasionally stayed in London with the Surrealist patron, poet Edward James.

During the German occupation of Belgium in World War II, Magritte remained in Brussels, and broke with Breton in Paris. His style changed briefly but by 1948 he returned to his pre-war Surrealist art. Representing a house illuminated as if at night in front of a daytime sky, this is one of those later paintings and a theme he explored several times.

'*The Walrus and the Carpenter*', *Through the Looking-Glass*, **John Tenniel, 1871, wood engraving on India paper**

Magritte's paradoxical image of a nighttime street beneath a daytime sky directly echoes the lines in the poem '*The Walrus and the Carpenter*' by Lewis Carroll for his novel *Through the Looking-Glass, and What Alice Found There* (1871), illustrated by political cartoonist and illustrator John Tenniel (1820–1914):

> The sun was shining on the sea,
> Shining with all his might:
> He did his very best to make
> The billows smooth and bright –
> And this was odd, because it was
> The middle of the night.

The title *Empire of Light* was suggested to Magritte by the Belgian poet Paul Nougé, who helped to establish Surrealism in Belgium.

② SKY

High above the darkened house is this blue, light-filled sky with fluffy cumulus clouds. Seen alone, it appears normal, but combined with the paradoxical night scene below, Magritte upsets viewers' preconceptions of reality. The daylight adds to the eeriness of the image for its oddity and becomes disconcerting. Magritte said: 'We must not fear daylight just because it almost always illuminates a miserable world.'

① STREET LAMP

An ordinary street lamp illuminates a white house with green shutters. Dusk has fallen and the warm glow of the lamp suggests peace and tranquillity. The scene is at once familiar and eerily unsettling. The lamp and the green shutters provide the focal point of the image.

③ RECOGNITION

This gives viewers conundrums to solve. While all the elements of the image are recognizable, some are illogical and ambiguous. The scene looks real, but it also looks impossible; it contradicts viewers' expectations, questioning their concept of time and of what they see and understand to be real.

Magritte used his background in commercial art to create a smooth, realistic-looking finish in his paintings, using fine, almost imperceptible brushmarks. It also helped him create effective compositions.

④ APPLICATION

Magritte tried to make the subject important rather than his painting technique. He wrote: 'I work rather like the sort of writer who tries to find the simplest tone, who eschews all stylistic effects, so that the only thing the reader is able to see in his work is the idea he was trying to express.'

⑥ COLOUR

After 1926, when he had become a Surrealist, Magritte used a soft, bright palette that rarely changed for the rest of his life. It included flake white, zinc white, lemon yellow, cadmium yellow, vermilion, madder, red ochre, viridian, cerulean blue, Prussian blue, ultramarine, cobalt violet and black.

⑤ COMPOSITION

The house and dark trees form approximately one third of the canvas. The glowing street lamp is in the centre of that and is the focal point of the painting. The angle of these trees on the right lead the eye into the image, while the sky showing through the tall tree invites further investigation.

⑦ ILLUSION

Several versions of this theme exist, each varying slightly, but all are created with Magritte's impersonal style. Perspective is precise and accurate, and shadows and reflections are rendered carefully. The strong, dark shadows obscure spaces helping to create the sense of foreboding.

Surrealist manifestos

Two Surrealist manifestos were written and issued by André Breton, in 1924 and 1929. The first was published as a booklet (right). It defined Surrealism as: 'Psychic automatism in its pure state, by which one proposes to express – verbally, by means of the written word, or in any other manner – the actual functioning of thought. Dictated by thought, in the absence of any control exercised by reason, exempt from any aesthetic or moral concern.' It continues with explanations and examples of ways in which Surrealism can be applied to any circumstance or situation of life, not only within the arts. Dreams and their importance are also mentioned and the absurdity of Dadaism was alluded to. Generally, Magritte included, Surrealists did not interpret their dreams, but simply expanded upon them.

CONSTRUCTED HEAD NO. 2

NAUM GABO

1953–57

phosphor bronze on wood base
44.5 x 43.5 x 43.5 cm (17 ½ x 17 ¼ x 17 ¼ in.)
Israel Museum, Jerusalem, Israel

A PIONEERING CONSTRUCTIVIST SCULPTOR who used unusual materials including glass, plastic and steel that expressed the structure of his objects, Naum Gabo (1890–1977) trained as an engineer. His real surname was 'Pevsner', but he changed it in 1915 to avoid confusion with his older brother, artist Antoine Pevsner (1884–1962). Over his career, Gabo became associated with several styles and movements as well as Constructivism, including Cubism, Futurism, Bauhaus, Abstraction-Création and the St Ives School.

Born in the provincial Russian town of Bryansk, where his father owned a metalwork factory. In 1910, he left for Germany, where he began studying medicine at Munich University although soon after, he changed to natural sciences while concurrently attending art history lectures by Swiss art historian Heinrich Wölfflin. Two years later, he transferred again, this time to an engineering school in Munich, where he met Kandinsky who introduced him to abstract art. In 1913 to 1914, he walked from Munich to Florence and Venice on his way to Paris to join Antoine, who by then was an established painter. In Paris, he discovered the latest developments in Cubism and saw the glass and paper assemblages of fellow Russian sculptor Archipenko.

Just before World War I broke out, he escaped Paris and went to Copenhagen and then Christiania (now Oslo). His constructions made at that time were figurative, in nontraditional materials including plywood and cardboard. He soon began working with galvanized iron, a material more associated with industrial construction than the fine arts. One of his most notable works of that period is *Head No. 2*, which he first made in cardboard in 1916. With its intersecting planes, it was an experiment in depicting volume, shape and appearance without bulk. His engineering training helped him in the constructions of such works. The following year, he and Antoine returned to Russia where his method of sculpting initiated the term 'Constructivism'. He made several copies of *Head No. 2*. This phosphor-bronze copy was made thirty years after the first, in the same scale as the original. A decade later, he made four large steel versions of the same head.

Escape to Copenhagen, Denmark

After the outbreak of World War I, in August 1914, Gabo fled from Germany with his younger brother Alexei. They crossed the Danish border in the early hours of 2 August 1914. As they had fled in haste, when the brothers reached Copenhagen (above), they could only afford to rent a small attic room with one bed. Their family was Jewish, yet they had not been raised in the Jewish faith. They did not speak Yiddish, the main language of Eastern European Jews, nor had they ever attended a synagogue. However, on arrival in Copenhagen, they went to a Jewish organization there, to ask for financial assistance until money arrived from their family in Russia. Eventually, they received funds from their father and they moved to more comfortable lodgings. They stayed in Copenhagen for eight weeks before moving to Oslo, where Gabo became friends with various artists and intellectuals. Their older brother Antoine joined them there early in 1916.

② CUBIST INFLUENCE

Although he later criticized Cubism and Futurism for not embracing abstract art enough, Gabo created this work heavily inspired by the Cubism he had seen in Paris. Like Cubism, this shows the structure of the head, using planes that could be seen to show different angles.

① MATERIALS

First made in cardboard in 1916, this version of Gabo's head, made forty years later, is constructed with phosphor bronze and is the same size as his original work. Gabo used bronze for greater permanence and as a link with sculpture traditions, and believed this to be his greatest masterpiece.

③ CONSTRUCTIVISM

In 1920, Gabo and Antoine distributed their *Realistic Manifesto* on the streets of Moscow. It asserted art had a value and function and set forth the ideals of Constructivism. From 1922, living in Berlin, Gabo worked with artists of the Bauhaus. He followed Tatlin's Constructivist principles, but his work focused on its use of modern technology and industrial materials rather than politics.

④ NEGATIVE SHAPES

This head consists of several primarily oval-shaped geometric planes. However, it originated as a charcoal drawing Gabo did of a woman in a hat and veil, and the sculpture focuses as much on negative shapes as the solid part of the head. Gabo's description of space rather than mass was central to his oeuvre. The face and head seem to turn as viewers move around it.

⑤ 'STEREOMETRIC CONSTRUCTION'

In 1920, Gabo declared: '…we take four planes and we construct with them the same volume as of 4 tons of mass.' He called his method 'stereometric construction' and used a system of open construction derived from mathematicians' three-dimensional models.

⑥ SPATIAL FREEDOM

Like Cubism, this combines several aspects of one image so that when viewed from different angles the structure can still be discerned. Yet for Gabo, this was about creating spatial freedom, not following theories.

⑦ HANDS

The whole figure is of a person leaning forward in a hunched position with her hands clasped and resting in front of her. While these hands are formed purely of lines and angles, or three angled, horizontal shapes that fit into a rectangle, they are readily understood as hands by any onlooker.

JUST WHAT IS IT THAT MAKES TODAY'S HOMES SO DIFFERENT, SO APPEALING?

RICHARD HAMILTON

1956

collage
26 x 25 cm (10 ¼ x 9 ¾ in.)
Kunsthalle Tübingen, Baden-Württemberg, Germany

THE LOLLIPOP IN THIS collage gave an entire art movement its name. The maker of the collage, Richard Hamilton (1922–2011), is accepted as the founder of Pop art, one of the first artists to capture the rising energy of advertising and television in the 1950s.

Hamilton was born into a working-class family in London. After leaving school, he worked as a studio assistant at Reimann Studios, a Bauhaus-like art school and commercial design company. He helped in the display department and had permission to use the school life class. He left in 1938 to become a student at the Royal Academy Schools. In 1940, he studied engineering draughtsmanship at a Government Training Centre, but within months, it closed because of World War II. After the war, he returned to the Royal Academy, but after a few months he was expelled for 'not profiting from the instruction being given.' As a result of this expulsion he was conscripted into eighteen months' military service. In 1948, Hamilton met photographer Nigel Henderson (1917–85) at an art gallery in Bond Street, who suggested he apply to the Slade School. He was interviewed by William Coldstream (1908–87) and enrolled as a student. Henderson introduced him to the Independent Group and to D'Arcy Wentworth Thompson's book *On Growth and Form* (1917), which had been republished in 1942. In 1951, Hamilton held an exhibition called 'Growth and Form' at the Institute for Contemporary Arts in London. He continued to organize and show at various exhibitions and took several teaching posts, including at the Central School of Art and Design, London and King's College, Newcastle.

Hamilton was instrumental in planning the Independent Group's exhibition 'This Is Tomorrow' (1956) at London's Whitechapel Gallery that is now perceived as the start of the British Pop art movement. He produced this collage parodying US materialism and the postwar consumer boom for its poster and catalogue. A year later, he defined his interpretation of Pop art as: 'Popular, transient, expendable, low cost, mass produced, young, witty, sexy, gimmicky, glamorous, big business.'

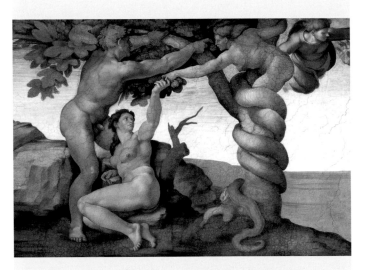

Detail from *The Fall and Expulsion from the Garden of Eden*, Michelangelo, 1509–10, fresco, 280 x 570 cm (110 ¼ x 224 ½ in.), Apostolic Palace, Vatican City

In part of Michelangelo's Sistine Chapel fresco (1508–12), Eve is taking the forbidden fruit from the Serpent's hand, while Adam also picks some for himself from the Tree of Life. This moment is known as The Fall, when Adam and Eve fall from God's grace. Michelangelo's interpretation of the story shows Eve grasping the apple boldly and Adam taking his greedily. Michelangelo's figures are strong and muscular with smooth skin; two perfect examples of humanity. Adam and Eve have been depicted as two ideal figures, following images of gods, goddesses and athletes in Greco-Roman art. Continuing that tradition, Hamilton, in his parody of his own era has echoed Michelangelo's perfectly formed, ideal male and female figures. The notion of temptation that dominates this biblical story is echoed in Hamilton's collage.

② LIVING ROOM

A decade after the war ended, Britain was struggling economically and consumer goods were exciting. The main elements of this room come from an advertisement in a 1955 edition of *Ladies' Home Journal* for linoleum. The advertisement stated: 'Just what is it that makes today's homes so different, so appealing? Open planning of course – and a bold use of colour.'

① BODYBUILDER

This is the bodybuilder Irvin 'Zabo' Koszewski from a photograph taken from *Tomorrow's Man* magazine in September 1954; he had won third prize at the 'Mr America' competition. Semi-naked, he is a contemporary classical male, corresponding to previous artistic interpretations of male figures such as Adam.

③ RECLINING WOMAN

Like a modern-day Eve, this female temptress reclines on the sofa. The US painter Jo Baer (b.1929), who posed for erotic magazines when she was a struggling artist, has said that she is the model. Fig-leaf nipple tassels have been painted on and the lampshade has been cut out and glued on her head.

4 LOLLIPOP

The giant lollipop, wrapped in red cellophane with its brand name 'Tootsie POP' in yellow, arguably gave the movement its name. It acts as a fig-leaf substitute and overtly demonstrates the range of boldly packaged consumer goods that were appearing in Britain from the United States.

5 CEILING

Made up of photographs taken from a height of 100 miles (161 km), this ceiling is an image of the Earth from the September 1955 issue of *Life* magazine. It references the Space Race between the Soviet Union and the United States, and recalls a 16th- or 17th-century *vanitas* painting.

6 WINDOW VIEW

This is a black and white photograph of the outside of the Warner Cinema on Broadway, New York advertising the premiere of the early talkie film *The Jazz Singer* (1927) starring Al Jolson. Although this photograph was taken nearly thirty years previously, the notion of cinema adds to the theme of entertainment that Hamilton emphasized throughout the image.

7 STEREOMETRIC CONSTRUCTION

Cut from an advertisement for a vacuum cleaner made by Hoover called Constellation, this part of the collage is also from the June 1955 edition of the *Ladies' Home Journal*. The woman in red vacuuming the stairs could be a maid or a domestic cleaner.

8 POSTER AND PORTRAIT

This picture of the cover of the first pictorial romantic-escapist comic *Young Romance* was from an advertisement for the magazine in November 1950. Hamilton's use of it anticipates the paintings of Roy Lichtenstein (1923–97). On the same wall, the Victorian portrait references traditional works of art.

STRINGED FIGURE (CURLEW) VERSION I

BARBARA HEPWORTH

1956

brass and cotton string on wooden base
46.5 x 56 x 34.5 cm (18 ¼ x 22 x 13 ⅝ in.)
private collection

EXEMPLIFYING MODERNISM, BARBARA HEPWORTH (1903–75) was one of the most distinctive abstract sculptors of the 20th century. Especially connected with the landscape, she exploited the natural world with work that ranged from small and intimate to grand and monumental, and the idea of solidity and space with smoothly honed, rounded forms.

She grew up in the West Riding of Yorkshire, England, the eldest child in a fairly comfortable family. After winning prizes for music at school, she was awarded a scholarship to Leeds School of Art in 1920 at the age of sixteen, where she met British sculptor Henry Moore who became both a friend and rival. A year later, she won a place at the Royal College of Art in London where she studied for three years. She said she knew she wanted to be a sculptor when she was a child and this led her to take up carving, which was an unusual activity for a woman at the time. She went to Italy where she learned how to carve marble. There she met her future husband, British sculptor and painter John Skeaping (1901–80).

Hepworth practised direct carving, whereby she worked without preliminary models or preparatory sketches. Over her career, her sleekly curving forms became more abstract. However, it was not until the 1930s when she was married to her second husband, British artist Ben Nicholson (1894–1982), that some of her work became completely abstract. In 1931, she became one of the pioneering artists to introduce holes into sculpture when she made a piece from pink alabaster, and pierced her work for the first time. She said of the technique that became integral to her practice: 'I had felt the most intense pleasure in piercing the stone in order to make an abstract form and space; quite a different sensation from that of doing it for the purpose of realism.'

In 1939, she and her family moved from London to Cornwall. There she became a member of the St Ives school of artists and started to work in metal as well as stone. Her sculpture *Stringed Figure (Curlew) Version I* is one in a series of editions in different sizes. Resembling an ancient Greek lyre, it also suggests the flight of the wading bird, the curlew.

Lyre guitar

The lyre guitar (above) was a type of guitar shaped like a lyre, almost certainly invented in the late 18th century. It was extremely popular, particularly in Paris for about fifty years; apparently even the French queen Marie Antoinette played one, as did a number of the most respected guitarists of the period. Looking exactly as its name suggests, the lyre guitar was a prominent influence on Hepworth's sculpture, showing how music featured in her thinking. After the lyre waned in popularity, its image became used often as a symbol of classicist ideals, and it featured in many allegorical paintings that aimed to evoke a sense of ancient Greece or Rome.

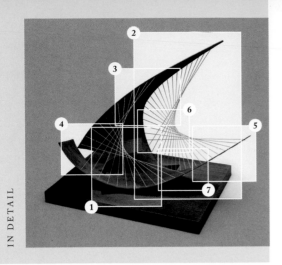

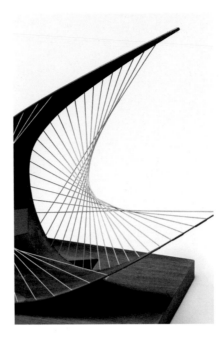

② THEME

The first part of this work's title, *Stringed Figure*, connects the work with Hepworth's musical talents. Deliberately resembling a musical instrument, especially the lyre of the ancient mythical hero Orpheus, this also recalls the shape of a curlew, a large wading bird. Hepworth was fascinated with birds, and the soaring arched forms suggesting the curlew in flight.

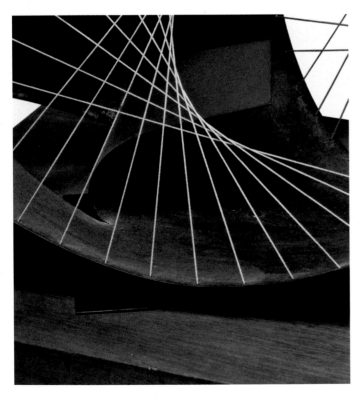

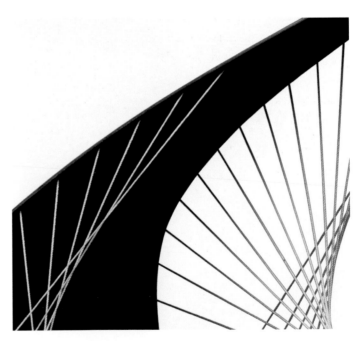

① SHAPE

This is one of several versions of the sculpture with its curving, dramatic and pointing shape. Hepworth formed her piece from a sheet of metal, shaped into a triangle, with the acute corners forming the curving, enclosing wings. She made two cuts in the left side of the triangle and turned the central section inwardly, allowing her to curl the form even tighter.

③ INFLUENCES

This resembles elements of Naum Gabo's threaded sculpture, *Linear Construction in Space No. 1.* (1942–43), which uses nylon filament and Perspex. It may have been inspired by the painting *Sea-Bird Forms* (1951) by fellow Cornish artist John Wells (1907–2000). The curving asymmetrical shapes suggest the swooping flight of sea birds or powerful Cornish waves.

By 1956, Hepworth had become interested in working with metal. She moved away from her focus on direct carving to experiment with brass and copper, and explore new techniques in modelling while still exploiting natural themes.

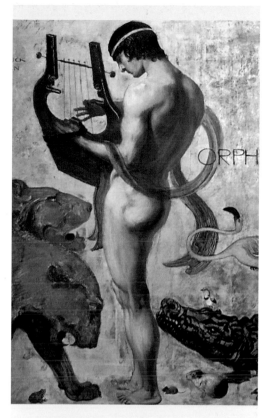

④ PREPARATION

This required quite extensive preparations. First, Hepworth made detailed drawings, then she cut out a cardboard template to determine the shape of the sculpture. The final work was made of brass sheeting and cotton fishermen's string. From 1956 to 1959, she created nine versions of this sculpture, each varying in size.

⑤ TENSION

The object appears open and lightweight, as if it could either be taken up and played, or could independently take flight. Using the thinnest sheet metal gave Hepworth freedom to produce delicate-looking shapes. The open, curving planes are kept in place through the tension of the weblike string.

Detail from *Orpheus*, Franz von Stuck, 1891, oil on wood and gold ground, 55 x 47 cm (21 ⅝ x 18 ½ in.), Museum Villa Stuck, Munich, Germany

The ancient Greco-Roman god Orpheus was the son of Calliope, the muse of epic poetry and inspiration for Homer's *Iliad* (*c.* 1260–1180 BC), and of Apollo, leader of the gods. Orpheus sang and played his lyre with such beauty that on hearing him, everything was captivated. Wild beasts were tamed, trees swayed towards him and people reconciled arguments. Jason and the Argonauts asked him to accompany them as protection against the evil sirens who tried to lure the heroic crew to their deaths. It was this magical lyre that Hepworth envisaged when she created *Stringed Figure (Curlew)*.

⑥ STRING

Harmony is achieved with two types of stringing. At the back, the string is threaded around the whole form, with narrow intervals between thread holes, forming a parabola. The stringing at the front occupies the central section of the curved wings, with more varied and wider intervals between the holes.

⑦ PROCESS

Keeping the green patination on the inside of the brass, Hepworth curved the sheeting by cold rolling it by hand, then riveting holes around the asymmetrical curving wings. She used a flat brass plate to secure the work on to a wooden base and then threaded the strings through the rivets.

FOUR DARKS IN RED

FOUR DARKS IN RED

MARK ROTHKO

1958

oil on canvas
258.5 x 295.5 cm (101 ¾ x 116 ⅜ in.)
Whitney Museum of American Art, New York, USA

MARK ROTHKO (1903–70) IS THE best-known Colour Field painter. Inspired by his Russian-Jewish heritage, the philosophy of Friedrich Nietzsche and Greek mythology, Rothko's abstract paintings focus on colour, balance, depth and scale. They aim to inspire emotions on a subconscious level.

He was born in Dvinsk, Russia (now Latvia), but moved with his family to the United States when he was ten years old. At the age of eighteen, he won a scholarship to Yale University, but within two years entered Parsons School for Design in New York. His early paintings were Expressionist in style and in 1935, he co-founded The Ten group. He struggled financially and with depression, and began reading mythology and philosophy. Influenced by European Surrealism and the ideas of Swiss psychoanalyst Carl Jung, he moved away from figurative art and reduced the number of forms in his paintings, creating coloured shapes with blurred boundaries.

In 1958, he was commissioned to paint a series of paintings for the exclusive Four Seasons restaurant in the Seagram Building, New York. After painting them, however, he chose to donate them to the Tate in London instead. *Four Darks in Red* exemplifies his dark palette of the late 1950s.

Wolfgang Amadeus Mozart

Rothko said: 'I became a painter because I wanted to raise painting to the level of poignancy of music and poetry.' He was influenced by the music of composer Wolfgang Amadeus Mozart as his son Christopher explained: '[In] Mozart's compositions... [he] found the stylistic and formal principles and more especially the means of articulating ideas that influenced the development of his own artistic language.'

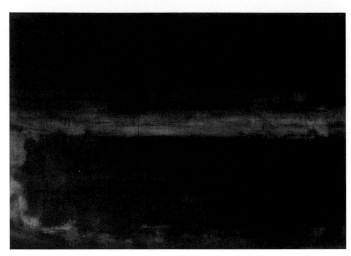

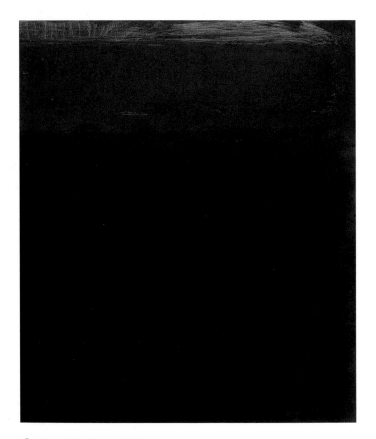

② FLOATING RECTANGLE

The lowest and narrowest lozenge in the painting, this deep red was painted over the lighter red background and marked with an indistinct white outline, creating the impression that it is floating. Along with the power of colour, Rothko believed in the expressive potential of his shapes, perceiving that they captured a spiritual presence.

① DARK PALETTE

In the late 1950s, Rothko began darkening his palette to discourage comments that his work was merely decorative. This palette of dark red, maroon, black and brownish tones expresses his belief in the power of dark colours to inspire uplifting feelings in viewers. Painted just before he received the Seagram commission, this can be seen as a prototype for those paintings.

③ SPIRITUALITY

Rothko once said that his paintings should be viewed from a distance of 45 cm (18 in.). He believed that if viewers were as close to the work as he was when painting it, they would have an equivalent spiritual experience: usually a feeling of contemplation and transcendence, but often even more powerful. In this way, he imagined a form of communion between himself and the viewer.

Rothko primed the canvas with a base coat of maroon paint made from powdered pigments and rabbit-skin glue. This created a matt surface to which he added a second coat that he subsequently scraped away, leaving just a thin coating of colour.

④ PAINT APPLICATION

Once Rothko's base red paint had dried on his canvas, he used a large commercial decorator's brush to apply black paint using fast, broken brushstrokes and broad sweeping gestures to build up the shape of the rectangle. He softened the edges of this to create a slight sense of movement and depth.

⑤ LAYERING

The rectangles simultaneously emerge and recede into the luminous red ground. To create his subtle variations of colour, tone and texture, Rothko applied layers of paint, changing his brushwork to create delicate or strong modulations. This method of layering emits an impression of depth and luminosity.

⑥ TRAGEDY, ECSTASY AND DOOM

The heaviest, darkest colour is near the top of the canvas, while the softer, lighter hue is at the bottom, which suggests the antithesis of the gravitational pull. Rothko believed that in creating visual enigmas such as this reversed gravity. Along with the strong colours, his paintings evoked intense visual sensations, or what he called 'the basic human emotions – tragedy, ecstasy and doom'.

⑦ CONTRASTS AND MOVEMENT

Veils of colour in contrasts of warm and cool, and light and dark convey what Rothko perceived to be the problems of modern life. Additionally, the painting projects an impression of slight movement and vibration. Although on initial confrontation, the dark colours may seem depressing, when the painting is contemplated quietly, they have an edifying effect.

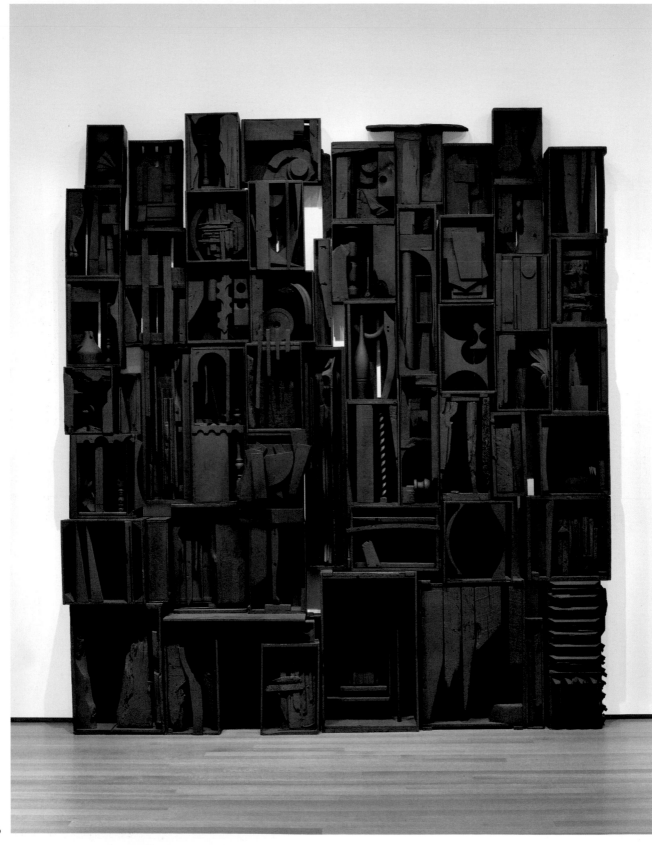

SKY CATHEDRAL

LOUISE NEVELSON

1958

painted wood
344 x 305.5 x 45.5 cm (135 ½ x 120 ¼ x 18 in.)
Museum of Modern Art, New York, USA

CONSIDERED AN ABSTRACT EXPRESSIONIST, sculptor Louise Nevelson (1899–1988) was the daughter of a Jewish timber merchant, born in Perislav in the Poltava Governorate of the Russian Empire (now Ukraine) as Leah Berliawsky. Growing up playing with wood in her father's timber yard had an effect on her later most iconic works. She also recalled deciding to be an artist from the age of nine.

Because of the Tsarist regime's hatred of Jews, when she was six years old, the family emigrated from Russia to the east coast of the United States. As a young woman in Maine, she worked as a stenographer while studying. She met Bernard Nevelson, who owned a shipping business with his brother Charles. In 1920, she and Charles married and moved to New York, where she studied painting, drawing, singing, acting and dancing as she had longed to do. In 1922, she had a son, and in 1924, the family moved out of the city. She drew and painted at home but felt cut off from the artistic community. In 1928, she began travelling into the city to study at the Art Students League, despite discouragement from her husband's family. At the end of 1931, she left Charles and their son, and travelled to Munich to study under painter Hans Hofmann (1880–1966) at his School of Fine Arts. When Hofmann emigrated to New York a year later to escape the political tension in Germany, Nevelson returned too and enrolled again at the Art Students League where she studied painting, sculpture and modern dance, taught by, among others, Grosz. During that period she became involved with Kahlo and Rivera. She began working with the Works Progress Administration (WPA) through the Federal Art Project, while participating in group exhibitions. In 1935, she taught mural painting at the Madison Square Boys and Girls Club in Brooklyn as part of the WPA.

Featuring found objects, her sculpture first gained attention in the early 1940s. Increasing in scale, it evolved into monumental walls, often made of discarded scraps of wood. Writing that she sought 'the in-between places, the dawns and dusk, the objective world, the heavenly spheres, the places between the land and the sea,' she created *Sky Cathedral* as a response to Abstract Expressionist paintings.

The Art Students League in the 1930s

Founded by a group of artists during the years after the American Civil War, the Art Students League of New York began as it continues, providing high-quality art instruction with independent studios run by individual instructors who have complete autonomy and creative control in the classroom, without being dictated to by bureaucracy. Many of the students who studied during the Depression years when Nevelson attended, went on to become Abstract Expressionists. After World War I, numerous young European artists and young Americans who had studied in Europe were employed as teachers there, including Hofmann and US painters Stuart Davis (1892–1964) and John Sloan (1871–1951). Rothko and Pollock numbered among Nevelson's fellow students.

IN DETAIL

② INFLUENCES

Nevelson was influenced by the Mayan ruins she encountered on her travels in Mexico and Central America in the 1940s and 1950s. She described it as a 'world of geometry and magic'. This reflects her interest in ideas about the emotive relationship between the artistic environment and the viewer. Her process of gathering objects from rubbish to create this was inspired by Duchamp's sculptures made from found objects and ready-mades.

③ STORIES AND BELIEFS

Like a montage of stories, this work is the result of Nevelson's experiences, including her earliest years in Russia, childhood in the United States as an immigrant, training in New York and Germany, decision to focus on her career instead of motherhood and difficulties in the male-dominated art world. Although she was raised in the Jewish faith, she studied a variety of religions and some of these compartments reflect her various beliefs.

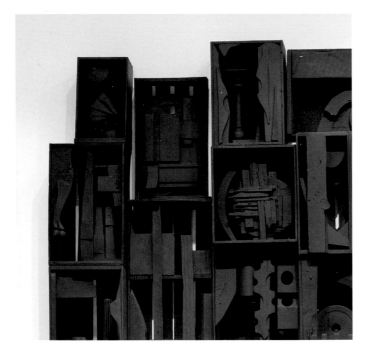

① BOXES

A series of tall, thin boxes joined together form the wall-like structure of *Sky Cathedral*. Each box contains found wooden objects, all painted black, which unified the disparate components and disguised their provenance and original purposes. The scraps of wood used in each box emerge from Nevelson's earliest memories. Some are purely abstract, some have Cubist or primitive motifs, and some are more figurative.

④ FORMS AND SHAPES

The work is made from pieces of wood that Nevelson salvaged from old buildings. She nailed and glued the pieces into boxes. She then arranged them using a rectangular plane informed by Cubism and curving forms of spindles, finials and architectural mouldings, reflecting the variety of architecture in New York at the time.

⑤ BLACK

Nevelson painted the entire sculpture black to suggest what she described as the 'silhouette, or essence, of the universe'. For her, black represented everything as it contains all colours. She also believed that black paint gave the work a sense of grandeur: '…black… wasn't a negation of colour. It was an acceptance. Because black encompasses all colours. Black is the most aristocratic colour of all.'

⑥ SHADOWS

Because this is a tall, narrow rectangular structure that must be viewed from the front, *Sky Cathedral* has the pictorial quality of a painting, rather than a work of sculpture. Unlike most sculpture, it does not reveal new insights when viewed from alternative angles. Yet it does have a layered depth. Overlaps and spaces, and variegated straight and curved lines, can be seen mainly as shadows.

⑦ SPIRITUALITY

Nevelson used wooden forms that evoke the celestial realm and the architecture of the urban environment around her. So while the design might appear to be random, the lines, shapes and scale suggest spirituality. The title gives the hint: *Sky Cathedral* purposely suggests the idea of a shrine or a place of devotion.

UNTITLED
(IDYLLIC LANDSCAPE WITH CHILDREN)

HENRY DARGER

mid 20th century

HENRY DARGER (1892–1973) WAS a writer and artist who worked in a hospital in Chicago. Posthumously, a manuscript was discovered that he created during his life; a 15,145-page, thirteen-volume fantasy entitled *The Story of the Vivian Girls, in What is Known as the Realms of the Unreal, of the Glandeco-Angelinian War Storm, Caused by the Child Slave Rebellion*. Along with the manuscript were nearly 300 drawings, watercolours and mixed-media works to illustrate the story. Categorized as Outsider art, Darger's work includes illustrations of either neatly dressed or naked children in daintily decorated Edwardian rooms and softly coloured landscapes, and shocking scenes of the massacre or torture of young children.

Darger lived in Chicago for most of his life. When he was four years old, his mother died after giving birth to a daughter who was then given up for adoption. Darger remained with his father until he was eight years old, when he was placed in a Catholic boys' home. His father was taken to St Augustine's

Catholic Mission home, where he died five years later. By now with numerous mental problems, Darger was placed in the Illinois Asylum for Feeble-Minded Children in Lincoln, from where he escaped when he was sixteen years old, and found work in a Catholic hospital. Apart from a short period in the army during World War I, the shabbily dressed Darger went to Mass up to five times a day, collected rubbish he found in the streets and lived alone.

Darger spent most of his adult life writing and illustrating his story. He also included elements of his own traumatic childhood in the narrative, and featured himself as the children's protector. A self-taught artist, he developed a unique style and copied pictures from catalogues, comics, magazines, newspapers and colouring books, which he collected. He displayed nearly one hundred artworks on the walls and doors of his rented, one-room apartment in Chicago, pinned on the walls, hanging from string or pasted with glue directly on to various surfaces.

watercolour, pencil, carbon tracing and collage on pieced paper (double-sided)
61 x 270.5 cm (24 x 106 ½ in.)
American Folk Art Museum, New York, USA

***The Ugly Duckling**, from *Hans Andersen's Fairy Tales*, Mabel Lucie Attwell, 1913,
pen and brown ink, watercolour and bodycolour, dimensions unknown, private collection*

British illustrator Mabel Lucie Attwell (1879–1964) studied art at Heatherley's and
St Martin's School of Art, but unhappy with the emphasis on classical drawing and
painting, she left college before finishing her course. Initially illustrating for magazines,
she soon embarked on a career in book illustration. From *c.* 1900, she developed her
style featuring plump, cherubic-looking little children and animals. In 1908, she married
painter and illustrator Harold Cecil Earnshaw (1886–1937) and had a daughter, Marjorie
(the 'Peggy' on whom her drawings of little girls are based), and two sons. By the time
she drew this illustration in 1913, Attwell's style was fully formed. During the 1920s
and 1930s her work was in demand, printed in greetings cards, on postcards, calendars,
chinaware and other merchandise as well as in books. Darger, as a reclusive, self-taught
artist, created his imaginary world through studying, copying, photocopying and cutting
out pictures by Attwell and other illustrators of the period. He drew and painted direct
copies, photocopied and cut them out, or cut them out directly and pasted them on
to his watercolour paintings.

① LITTLE GIRLS

Young girls feature prominently in Darger's epic story. The Vivian Girls are heroic figures who are either fighting or enslaved by the evil adult Glandelinians, who abduct children and gruesomely torture and massacre them.

② BOUNTIFUL NATURE

Around the girls, abundant flowers, plants and trees grow, a little red-roofed cottage nestles between the trees and soft, fluffy clouds float in the cobalt blue sky. This idyllic landscape is an important aspect of Darger's story that shows that ultimately, good will always triumph over evil.

③ FRIEZE

The heroines of Darger's tale are the seven little girls, known as the Vivian Girls; here they are, blonde-haired and all wearing identical spotted dresses. Darger placed them more or less in the centre of this long, frieze-like composition and included an extra girl, even though in the story there are only seven. He often drew far more than he described.

④ AMERICAN CIVIL WAR

Darger began to work on his manuscript when he was aged nineteen, three years before World War I. The story corresponds to events in the American Civil War that had ended forty-six years before he began the work. He was fascinated by the Civil War and collected memorabilia that he catalogued in journals.

⑤ BAKING

Three children with red bows in their hair are baking, another is surrounded by varyingly sized flowers, including yellow roses that have been copied precisely, petal by petal. An older girl in blue – curling horns emerging from her head, plaits and wings like a butterfly – stands at a pink podium.

⑥ RAMS' HORNS AND COWBOY HATS

Behind the flowers, two girls are talking. One has curly horns. Further along in the landscape, three girls wear or brandish cowboy hats. Even though Darger's imagery illustrates his story, it remains open to many interpretations. He wrote of children's right 'to play, to be happy, and to dream, the right to normal sleep of the night's season, the right to an education….'

⑦ STYLE

Darger's drawing style is light and delicate. He drew with light pencil lines to render precise, accurate shapes. With smaller elements in the background, there is some attempt at perspective, but also some ambiguously mixed proportions. The light, bright colours are applied with translucent watercolour and no attempt at tonal modelling.

ANTHROPOMÉTRIE DE L'ÉPOQUE BLEUE [ANTHROPOMETRY OF THE BLUE PERIOD] (ANT 82)

YVES KLEIN

1960

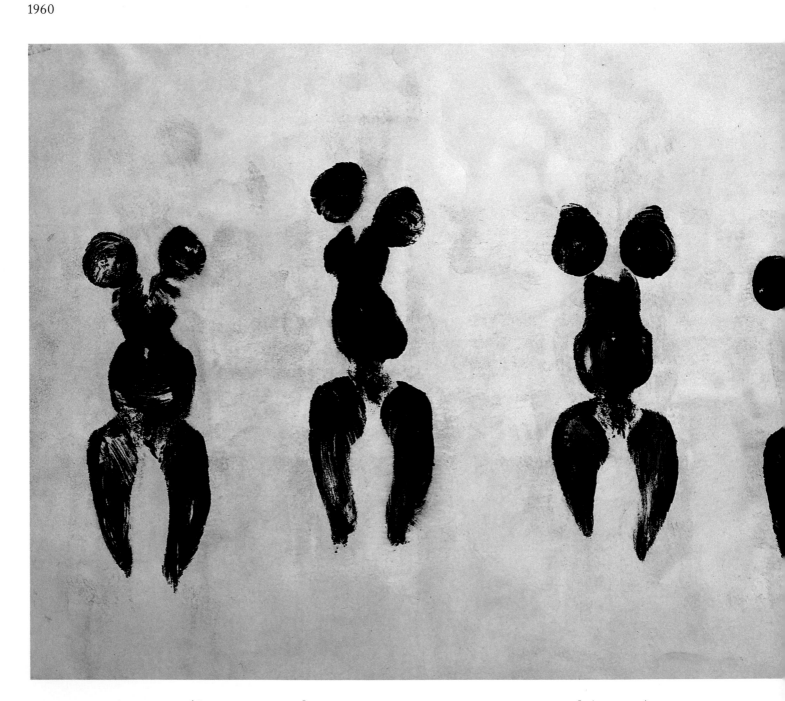

dry pigment and synthetic resin on paper mounted on canvas
156.5 x 282.5 cm (61 ⅝ x 111 ¼ in.), Musée National d'Art Moderne,
Centre Georges Pompidou, Paris, France

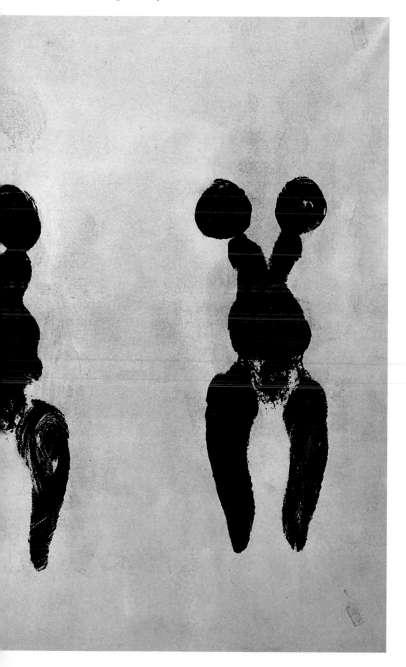

YVES KLEIN (1928–62) WAS one of the most controversial French artists to emerge during the 1950s. His art descended from the single colour paintings of Malevich, and anticipated Conceptual and Performance art and Minimalism. Fascinated by the spirituality of the Zen philosophy that he discovered in Japan, Klein described his work as 'the void'.

Born in Nice, he lived in Paris and Cagnes-sur-Mer – a town on the French Riviera – from the age of two. His mother, née Marie Raymond (1908–88), was a prominent artist in the French Tachisme movement, and his father Fred Klein (1898–1990) was a Dutch-born figurative painter of dreamlike, colourful landscapes. Despite Yves's parents being artists, he received no artistic training. From the age of fourteen, he studied in Paris for two years at National Schools for the Merchant Navy and Oriental Languages.

He began practising judo, which was his first experience with 'spiritual' space. In 1952, he went to Japan, where he registered at the country's most prestigious judo centre, the Kodokan Institute in Tokyo. After fifteen months he received a 4th Dan black belt; this was an impressive achievement and rare for a westerner. In 1954, he published a treatise on judo, *Les Fondements du Judo (The Foundations of Judo)*.

As well as Japan, he visited Italy, Britain and Spain. He then settled in Paris and in 1957, mounted an exhibition of monochrome paintings, 'Yves: Propositions Monochromes'. He believed his monochrome paintings could evoke sensations and emotions purely through colour, describing them as an 'open window to freedom, as the possibility of being immersed in the immeasurable existence of colour.'

Continuing the monochrome concept and assisted by a chemical technician, Klein created a matt ultramarine paint, International Klein Blue (IKB). It was the perfect colour for him to express his belief in spiritual powers, cosmological ideas of infinite space and the immaterial. After producing several monochrome works using IKB, he created his *Anthropometries* (*c.*1960) series, which includes *Anthropométrie de l'époque bleue* [*Anthropometry of the Blue Period*] *(ANT 82)*. He covered nude females in IKB and guided them to press, drag and lay themselves across canvases to create bodily impressions.

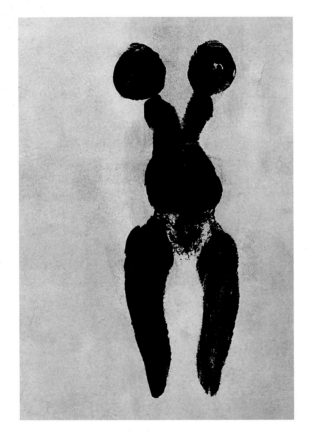

② LIVING BRUSHES

In front of a public audience, Klein gave instructions to his models. Later, they were described as 'living brushes' and 'human paintbrushes'. Although the model made the marks, he essentially created the picture, but he did regard them as co-creators of the works. Klein wore a suit and bow-tie as musicians played his *Monotone Silence Symphony*, which was a single note played for twenty minutes, followed by twenty minutes of silence. Klein said that the painting 'transcends personal presence'.

① PURE ESSENTIALS

Not just a painting, this was a live performance in front of an audience as Klein used naked women instead of paintbrushes to make the *Anthropometries* series. An orchestra played the *Monotone Silence Symphony* (1947) and Klein gave a signal to a model to first undress and then to cover her body in his blue paint. Under his supervision, she pressed herself against a sheet of paper fixed to the wall, reducing the female form to pure essentials.

③ VOID

An apocryphal account is often told to explain how Klein arrived at his main ideas for art. In 1947, he was on a beach with his friends poet Claude Pascal and artist Arman (1928–2005), and they discussed dividing the universe between themselves. Arman got the land and its riches, Pascal got the air, and Klein got the blue sky and its infiniteness. Soon after, he began seeking ways of showing the 'immaterial' and the 'invisible', which for him were essential aspects of art.

While living in London from 1949 to 1950, Klein learned gilding and basic painting techniques using raw pigments. In Tokyo in 1953, he was awarded the 4th Dan, one of the highest grades in judo. He said that monochrome paintings were an 'open window to freedom'.

The Virgin in Prayer, Sassoferrato, 1640–50, oil on canvas, 73 x 57.5 cm (28 ¾ x 22 ¾ in.), National Gallery, London, UK

④ BLUE

Ultramarine is used extensively in Islamic and Christian art. It evokes the infinity of sky. For Klein, blue was a spiritual force: 'All colours arouse associative specific ideas… while blue suggests at most the sea and the sky; and they, after all, are in actual, visible nature, what is most abstract.'

⑤ SENSATION

Klein was determined to inspire powerful sensations and feelings in viewers, without the use of line, rendered objects or abstracted symbols. He believed that his single, intense, pure pigment released his painting from reality, or of the sense of belonging to the world.

Emphasizing the softly draping white veil and brilliant blue cloak, Italian Baroque painter Sassoferrato (1609–85) shows the influence of Pietro Perugino (*c.* 1450–1523) and Raphael. The Virgin's face is largely in shadow, her eyes downcast, her hands joined in prayer. While devotional, the painting was also supremely expensive. The ultramarine blue of her cloak was derived from lapis lazuli, a pigment considered more precious than gold. For centuries, the only source for it was a strip of mountains in northern Afghanistan and the process for obtaining it was specialized and time-consuming. Few artists could afford to use it. Many artists, from the ancient Egyptians to Kandinsky and Klein believed in the spiritual properties of blue and its symbolic power.

⑥ INSPIRATION

Klein was inspired by photographs of body-shaped burn marks on the earth after the atomic explosions at Hiroshima and Nagasaki fifteen years before he created this work. He was also motivated by his love of judo, and the marks left on judo mats by practitioners when they fall.

⑦ DISTANCE

Klein's models smeared themselves with his IKB paint and then he orchestrated where they should place themselves and how they should move. In this way, he distanced himself from his subject matter and the artistic process. Nonetheless, his method meant he retained control.

CAMPBELL'S SOUP CANS

ANDY WARHOL

1962

BEFORE HE BECAME A POP ARTIST, Andy Warhol (1928–87) was the most successful and highly paid commercial illustrator in New York. As an artist, screen-printed images of film stars, packaging and sensational newspaper stories helped to change beliefs about art, materials, techniques and traditions, and about the boundaries between high and low art.

Born in Pittsburgh, Pennsylvania as Andrew Warhola, he was the fourth child of Czechoslovakian parents and studied pictorial design at the Carnegie Institute of Technology. He moved to New York in 1949 and worked as a commercial artist illustrating magazines and advertisements, creating window displays and designing album covers. In the 1960s, he began creating images using the silk-screen printmaking process, which had not been used in fine art before. Using other commercial art processes, he created prints, photography and three-dimensional work, allowing chance mistakes and imperfections to become part of the art. His unique and astute ways of using these processes and images from the media propelled him to prominence in the Pop art movement.

In July 1962, in a solo exhibition in Los Angeles, he showed thirty-two paintings of Campbell's soup cans. Reactions to them were of horror and mirth, and sales were appalling. Ultimately the paintings launched his career as an artist, and introduced Pop art to the US West Coast.

Screen-printing

The screen-printing process first appeared in China during the Song dynasty (960–1279). Originally silk was used. Eventually, it became a method of printing packaging and advertisements with polyester mesh, stencils, ink and a squeegee. Warhol was the first to use the process in fine art as it suited his requirements for repeated imagery.

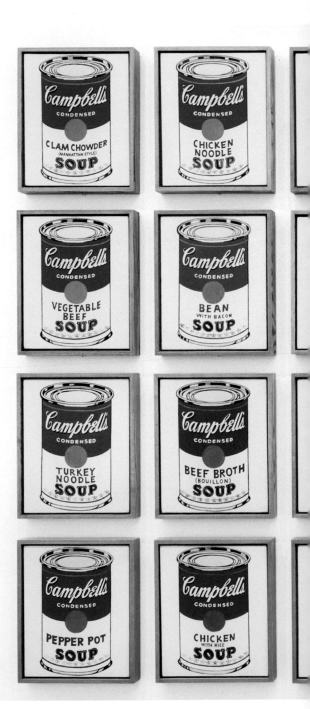

synthetic polymer paint on thirty-two canvases
each canvas 51 x 40.5 cm (20 x 16 in.)
Museum of Modern Art, New York, USA

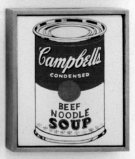

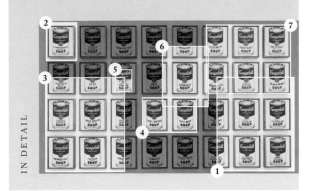

① VARIETIES

At the time Warhol made these prints, the Campbell's Soup Company sold thirty-two soup varieties, and each canvas corresponds to a different flavour. Warhol said of Campbell's Soup: 'I used to drink it. I used to have the same lunch every day for twenty years.' As he had given no instructions about how the canvases should be displayed, the Ferus Gallery in Los Angeles lined them along shelves, like products in a grocery shop.

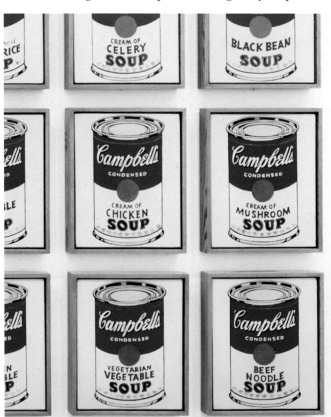

② IDEA

Warhol was one of several artists in New York in the 1960s who decided it was time to move on from Abstract Expressionism and reintroduce imagery to art. He talked over the notion with gallery owner Muriel Latow, who suggested that he painted things that people use everyday like soup cans and dollar bills. He paid her $50 for the idea.

③ REPETITION

Emulating the repetition and uniformity of advertising, Warhol reproduced the same image on each canvas. Describing his production of repeated images, he said: 'The more you look at the same exact thing, the more the meaning goes away, and the better and emptier you feel.'

④ PROCESS

Warhol bought every variety of Campbell's soups and projected the image of each can on to a small canvas, drew the outlines with a pencil, and then painted within the lines to imitate the appearance of the original offset lithographic labels. He painted with no tonal contrasts, following the appearance of mechanical reproduction. After he had painted this first series of thirty-two canvases, he began using the silk-screen process.

⑤ ADVERTISING AND PACKAGING

Although Latow had suggested the idea of soup cans, it was Warhol's interpretation that caused a sensation. At first ridiculed and criticized, it nonetheless was noticed and discussed. Rather than create a painterly or three-dimensional image, Warhol produced a flattened, detached group of images. It was not only irreverent, it also caused offence for being exhibited as art. Yet Warhol captured his own culture, expressing it in a way that few people initially understood.

⑥ ARTIFICIALITY

The colours follow the minimal hues of Campbell's soup labels, and highlight the artificiality of the work, distancing it from anything that had been seen in a gallery before. The choice of subject and direct copying of such a commercial item was perceived as an insult to the techniques and philosophies of Abstract Expressionism that had been important in the United States for almost twenty years. The paintings initiated debates about art and artists' motives.

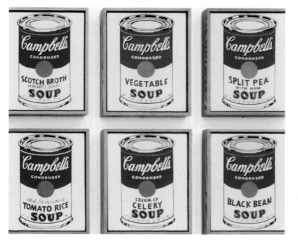

⑦ DADA

Six of the thirty-two paintings sold at the show but the director of the gallery, Irving Blum, bought them back to keep as a group. He recognized that they presented an optimistic view of modern culture. They are also linked to notions of Dada; the cans had been designed for another purpose, but were now art.

Every day 27 million

A well-known US press campaign of 1951, this advertisement ran in several different versions. The headline remained the same with each advert but depending on where it appeared, the images changed. All showed happy, wholesome families enjoying Campbell's soup. Throughout his career, Warhol continued to be captivated by Campbell's soup packaging, admiring its boldness, clarity and immediacy. After his initial painting of all varieties, he frequently experimented with different ways of featuring the label. As well as admiring the packaging, he said that along with Coca-Cola, Campbell's soup was the quintessential US product and that everyone was united through it. He pointed out: 'What's great about this country is that America started the tradition where the richest consumers buy essentially the same things as the poorest.'

THREE STUDIES FOR A CRUCIFIXION

FRANCIS BACON

1962

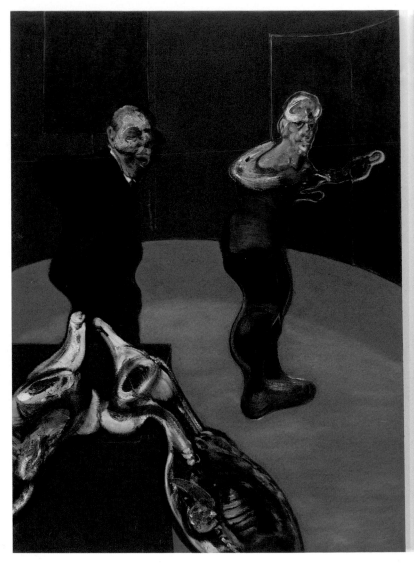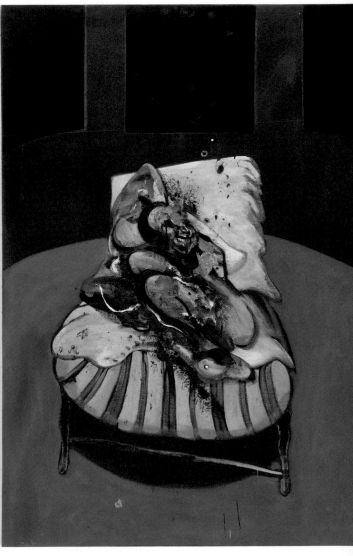

INSPIRED BY SURREALISM, Picasso, Van Gogh, Velázquez, Michelangelo, Rembrandt, Cimabue (*c.* 1240–*c.* 1302), film and photography, Dublin-born Francis Bacon (1909–92) produced figurative, expressive paintings, usually representing violently distorted, tormented souls. Named after his famous ancestor, the English philosopher and scientist, Bacon grew up one of five children, and moved between Ireland and England as his father served in the army.

When he was aged seventeen, Bacon's father threw him out of the family home after finding him wearing his mother's clothes. He travelled around Berlin and Paris before settling in London and working as an interior and furniture designer. After seeing work by Picasso and the Surrealists in Paris, he painted in a semi-Cubist and Surrealistic style despite having no formal art training. He painted sporadically and in 1944, he destroyed many of his paintings to date. That year, he

oil with sand on canvas
three panels, 198 x 145 cm (78 x 57 in.) each
Solomon R. Guggenheim Museum, New York, USA

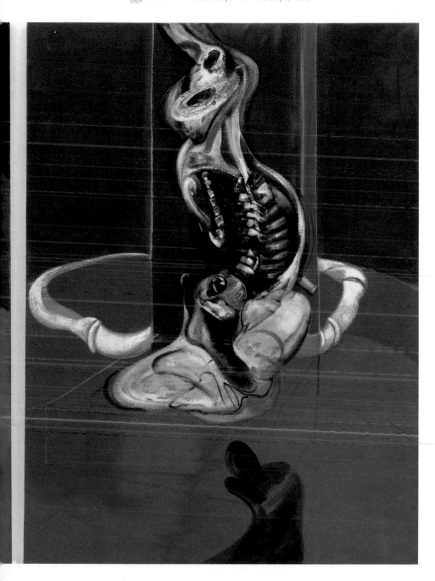

Crucifix, Cimabue, *c.* 1265–68, tempera
and gold on wood, 336 x 267 cm
(132 ¼ x 105 ⅛ in.), Church of San
Domenico, Arezzo, Italy

One of two large crucifixes attributed
to Italian artist Cimabue, this is an
amalgamation of medieval and Byzantine
styles with embryonic Renaissance ideas. The
contorted figure and facial features portray
a sense of suffering. Bacon kept a copy of the
painting in his study, although he displayed it
upside down as he was not looking to copy
it, but to garner the elements of expression
from it. It inspired his *Three Studies for
a Crucifixion*. Cimabue painted another
Crucifixion in Florence that was damaged by
a flood in 1966. The day after the flood, Bacon
made a large donation for its renovation.

painted *Three Studies for Figures at the Base of a Crucifixion*,
a triptych expressing the horrors of World War II, the biblical
Crucifixion, and some Greek mythology. From then on,
he often painted disturbing figures, including disembodied,
semi-faceless portraits; writhing, distorted bodies; screaming,
trapped figures and grotesque interpretations of the
Crucifixion. He painted this triptych of a crucifixion
in 1962, making connections with a slaughterhouse.

 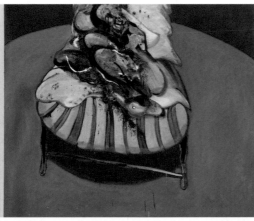

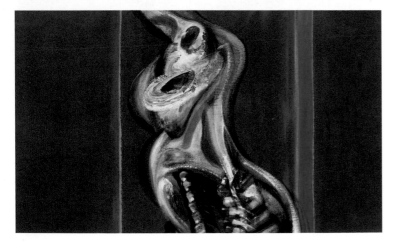

① TRIPTYCH

After his first triptych in 1944, Bacon used the format many times over the next thirty years. Triptychs have religious and historical connotations, but Bacon saw them as a way of creating artwork for the cinematic age. He said: 'Triptychs are the thing I like doing the most, and I think this may be related to the thought I've sometimes had of making a film. I like the juxtaposition of the images separated on three different canvases. So far as my work has any quality, I often feel perhaps the triptychs have the most quality.'

② THE CRUCIFIXION

The Crucifixion is one of the most commonly depicted subjects in Western art. Artists including Gauguin and Picasso represented the theme to express universal human suffering and individual pain. Bacon used the Crucifixion to convey 'all types of feeling and sensation'. His fascination with the notion of Christ's Passion was part of his interest in melancholy subjects.

③ ART OF THE PAST

Bacon believed artists should study past masters. He surrounded himself with piles of books, hundreds of torn pages, stained photographs and press cuttings in his investigations into other artists' work and ideas. He amalgamated many different techniques and concepts in his endeavour to create his own art.

Most of the time Bacon painted directly on to unprimed canvases. He had not trained in the traditional methods of painting in oils and did no underpainting or priming, preferring to see the texture of the canvas through his paint. Yet this is an unforgiving method. Paint applied to raw canvases leaves stains that cannot be wiped away, so he could not make mistakes — or if he did, they remained.

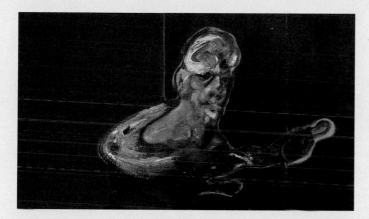

④ DISTORTION

Distortion is an essential element of Bacon's art. He started painting because he was inspired by Picasso's anthropomorphic figures, and Van Gogh and Rembrandt's impasto paint. The various thicknesses of his paint add to the contorted appearance.

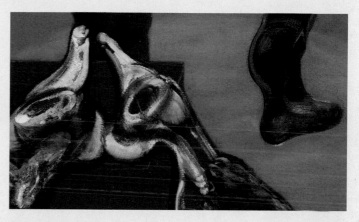

⑤ SPACE

Two men are in a butcher's shop near a counter displaying haunches of meat. The negative space around the objects helps viewers see the similarities between the shapes of the men's legs and the carcasses.

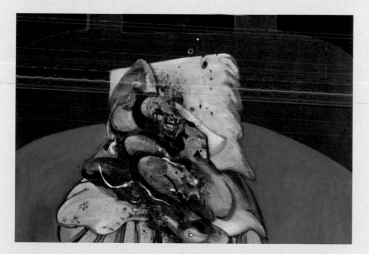

⑥ SYMBOLISM

A mutilated body smeared with blood lies on a bed, writhing in pain. Believing that animals in slaughterhouses anticipate their fate, Bacon drew parallels with some forms of human suffering, particularly the Crucifixion that has symbolized martyrdom for thousands of years.

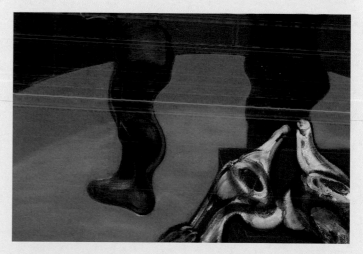

⑦ METAPHOR

A combination of one of the carcasses in the left panel of the triptych and Cimabue's Christ in his *Crucifix* at Arezzo, this figure slithering down from its vertical position is a metaphor for death. In describing Cimabue's Crucifixion, Bacon said: 'I always think of that as an image — a worm crawling down the cross.'

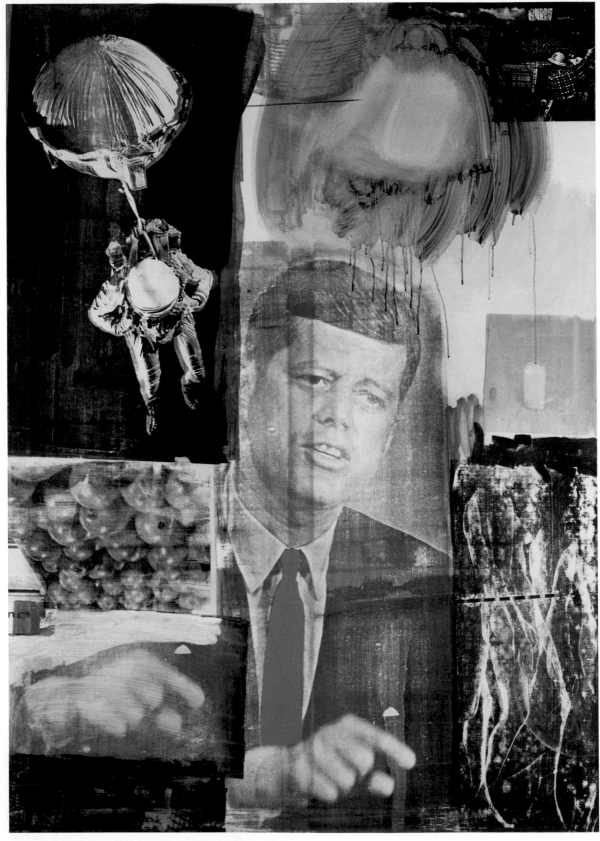

RETROACTIVE I

ROBERT RAUSCHENBERG

1963–64

oil and silk-screen ink on canvas
213.4 x 152.4 cm (84 × 60 in.)
Wadsworth Atheneum, Connecticut, USA *Gift of Susan Morse Hilles*

IN HIS RADICAL MIXING OF materials and methods, Robert Rauschenberg (1925–2008) opened up channels of exploration for future artists. Moving away from the seriousness of Abstract Expressionism, he innovated many techniques and used unconventional art materials, including incorporating items into his work that he found on the streets.

Rauschenberg was born in Texas to devout Christian parents; his mother made the family's clothes from scratch. Although this embarrassed Rauschenberg as he grew up, he later built on this idea, creating assemblages and collages from found elements. He was conscripted in World War II and assigned as a medical technician in the Navy Hospital Corps in San Diego. After the war, he enrolled at the Kansas City Art Institute and then travelled to Paris to study at the Académie Julian. In 1948, he returned to the United States and studied at Black Mountain College in North Carolina, he was taught by German-born artist Josef Albers (1888–1976), one of the founders of the Bauhaus. Albers's course, in which students investigated the line, texture and colour of everyday materials influenced Rauschenberg's assemblages. From 1949 to 1952, he studied in New York at the Art Students League and had his first solo exhibition. He then travelled to Europe and North Africa with US painter, sculptor and photographer Cy Twombly (1928–2011), whom he had met at the Art Students League. During his travels, Rauschenberg worked on collages, hanging assemblages and boxes filled with junk he found in the Italian countryside. After he went back to the United States, he included objects in the surface of his paintings, calling them 'Combines', because they combined paint and objects on canvas. Divorced and recently split up from his relationship with Twombly, Rauschenberg met Jasper Johns (b.1930) in 1953. The two became romantic and artistic partners, and explored the boundaries of art through their exchange of ideas.

Retroactive I is one of a series of silk-screen paintings that Rauschenberg made between 1963 and 1964. It features his own photographs and images from the press. He had intended to discard the work, but when President John F. Kennedy was assassinated soon after, he reworked it as a memorial.

Christ the Merciful, 1100–50, glass and stone mosaic, 61 x 30 cm (24 x 11 ¾ in.), Bode Museum, Berlin, Germany

Mosaics for Christian iconography were made extensively during the Byzantine period and later also in Eastern Orthodox art. This theme is often called 'Christ in Majesty', with Jesus holding an embellished prayer book. Rauschenberg aspired to become a preacher as a child but when he realized the Church of Christ to which his family belonged prohibited dancing, he abandoned the idea. However, familiar visions of religion, such as icons and mosaics, continued to influence his art.

② COMPOSITION

The composition has been created with the traditional rule of thirds, and the overlapping colours and shapes convey a sense of a series of collaged screenshots. Viewers are drawn to the large, bright blue portrait of Kennedy, which contrasts with the duller surrounding colours. Next, the eye is drawn to the black and white image of the astronaut. Separate irregular sections show the images in order of importance, comparable to the hierarchy of scale in ancient Egyptian art.

③ CURRENT AFFAIRS

Rauschenberg's subject matter and commercial means of reproduction for this work led critics to link him to the Pop art movement, although he was later described as a Neo-Dadaist. The astronaut and parachute highlight the Space Race to land on the moon, which Kennedy had particularly wanted to achieve. The black cloud above Kennedy's head suggests the Cold War and the Cuban Missile Crisis of 1962. The work reflects life in 1960s America, with its bombardment of imagery.

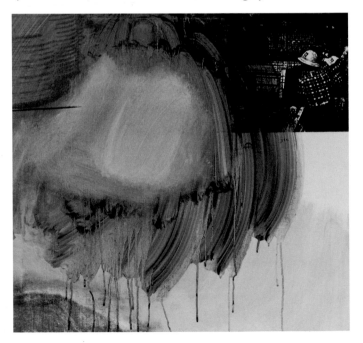

① PRESIDENT JOHN F. KENNEDY

The largest and most central image is that of President John F. Kennedy set against blue and wearing a green tie. As the main focus, he originally reflected the reassuring promise of hope for the future of the United States. However, after his assassination in 1963, his image worked as a memorial in the painting. His placement against blue recalls religious icons or martyrs.

4 THE UNITED STATES

This collage-derived silk-screen painting reflects contemporary life in the United States. Rauschenberg said: 'I was bombarded with TV sets and magazines, by the refuse, by the excess of the world… I thought that if I could paint or make an honest work, it should contain all of these elements, which were and are a reality.'

5 MASS MEDIA

Imagery taken from mass-media sources and amalgamated with the grainy, flickering quality of Rauschenberg's painting deliberately resembles a grainy television documentary. Rauschenberg wanted to capture on canvas something comparable to the experience of flicking between television channels.

6 MARCEL DUCHAMP

This is an enlargement of a photograph by Gjon Mili (1904–84) from *Life* magazine. With successive frames of a figure moving, it emulated Duchamp's *Nude Descending a Staircase, No. 2* (1912). Rauschenberg distorted the image to resemble Adam and Eve in Masaccio's 15th-century Florentine frescoes.

John Cage and chance music

US composer John Cage (below) was a major influence on Rauschenberg. During the 1950s, Cage pioneered the idea of 'aleatory music', from the Latin *alea* meaning 'dice'. Aiming to unite the sounds of the ordinary world with traditional music, Cage created compositions that were affected by whatever noises happened at the time of their performance. The best-known example is *4'33"* (1952) in which the conductor and musicians remain silent for that length of time. Cage wanted his audience to listen with a heightened sense of perception to the noises of the world around them. Rauschenberg modelled *Retroactive I* on such experiments. Instead of aleatory music, he proposed aleatory painting–pictures in which all sorts of images might seem to have been put together randomly.

M – MAYBE

ROY LICHTENSTEIN

1965

oil and acrylic on canvas
152 x 152 cm (59 ⅞ x 59 ⅞ in.)
Museum Ludwig, Cologne, Germany

ROY LICHTENSTEIN (1923–97) WAS admired and denounced for his comic-strip style paintings. Yet he was one of the first US Pop artists to achieve widespread recognition.

He was born in New York to a middle-class family. When he was aged sixteen, he took summer classes at the Art Students League. In 1940, he began studying fine art at Ohio State University (OSU), but was conscripted to the army in 1943 and sent to Europe for the rest of World War II. He then returned to OSU to study for three years. One of his teachers, Hoyt L. Sherman (1903–81), taught theories about connections between vision and perception, which were a significant influence on his later work. After completing his studies, he taught at OSU before moving to Cleveland, where he worked as a window dresser, industrial designer and commercial art instructor. His painting style at the time was inspired by the work of Klee, Abstract Expressionism and biomorphic Surrealism.

During the early 1950s, he started to incorporate cartoon figures into his compositions. While teaching at Rutgers University in 1960, he met painter Allan Kaprow (1927–2006) who introduced him to other artists, including Claes Oldenburg (b.1929) and Robert Whitman (b.1935), who were part of the Happenings art scene. Lichtenstein was interested in their explorations into cartoon imagery. In 1961, he painted *Look Mickey* using Ben-Day dots, a commercial printing method used in comic-book illustrations. Ben-Day dots are small, closely spaced, coloured spots that when combined, create different colours and tones. He made many works using this technique, often adapting images from DC Comics, and it came to define his style. He built an easel that rotated his canvases 360 degrees to enable him to paint with precision. He said: 'I paint my own pictures upside down or sideways. I often don't even remember what most of them are about… The subjects aren't what hold my interest.'

In 1965, he created *M – Maybe*. Although the painting caused an outrage, it helped establish him at the forefront of Pop art.

The Allegory of Vanity, Titian, *c.* 1515, oil on canvas, 97 x 81 cm (38 ¼ x 32 in.), Alte Pinakothek, Munich, Germany

Lichtenstein was following established artistic practice in *M – Maybe*. The Venetian master Titian is known for his paintings of idealized females, and this allegorical work depicts one of his favourite models relaxing, contented with her beauty. However, Titian's model holds a mirror in which viewers can see the reflections of jewelry, money and a maid. Similar to a *vanitas*, this painting suggests the transience of beauty and futility of vanity. Although Lichtenstein was not presenting an allegory in the same way, he was nonetheless calling attention to the idealization of women in art and the media.

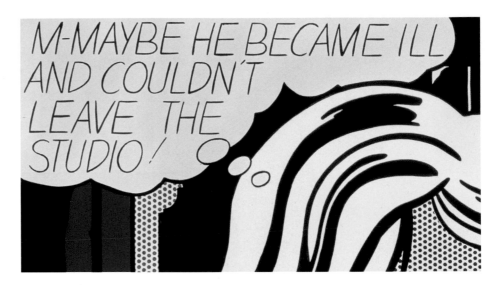

① WORDS

'M – Maybe he became ill and couldn't leave the studio' expresses a private, anxious thought, like many expressed in comics, that insinuate certain fears and concerns, personalizing the perpetrator and setting the scene. But while this was expected in comics, in fine art it was a complete departure, and one not welcomed by many critics of the time.

② GLOVE

The gloved hand shows that the woman is probably middle class and fashionable. In the 1960s, manners dictated that women wore gloves and a hat when out of the home. The impeccable, stark white glove contrasts with the brilliant yellow hair. The gesture of her hand holding her hair conveys her anguish.

③ FACE

Comprising nearly the entire surface of the painting, the blonde girl with windswept hair holds her gloved hand to her face in worry, yet her face displays a hopeful expression. In a vaguely urban setting, she awaits a man. Along with the text, her expression captures her concern, anxiety and anticipation.

④ NARRATIVE

The image is not part of a continuing narrative as usual in a cartoon strip, so there is no previous or ensuing reference for guidance. In this way, Lichtenstein invites speculation regarding identification of the individuals involved and of events, creating a tale akin to that in Victorian narrative paintings.

Once Lichtenstein had decided to produce paintings in this comic style, he continued throughout his career, adapting the approach for various subjects and themes. Completely contrasting with Abstract Expressionism that had predominated the art world in the United States since the 1940s, this artificial-looking, precise, flat style exemplified Pop art.

⑤ SCALE

Lichtenstein scaled up the source image for this by projecting it on to his canvas and hand-tracing the image. Detachment emerges from the mechanical execution and over-sizing. He was attracted by ways in which emotive subject matter could be depicted in an impersonal manner, leaving viewers to decipher meanings.

⑥ BEN-DAY DOTS

After tracing the image on to his canvas, Lichtenstein stencilled Ben-Day dots on the woman's face and in reflections on the background windows through a screen of cutout circles, creating pink and pale blue areas. Like Mondrian, his reduced palette consisted of the three primary colours, plus black and white.

⑦ LINES

Heavy black outlines in differing widths and lengths describe the contours of the girl, the buildings behind her and the steps. The black lines also help to express a sense of flatness. The image is cropped extremely closely, so that the girl's hair flows beyond the edges of the canvas and most of the background is only suggested.

The idealization of women

During the 1950s and 1960s, a new phenomenon arose that expanded upon the idealization of women. For the rapidly developing world of film and television, the starlet evolved; typically a young woman styled by the predominantly male directors and producers of films to look provocative. The women had to conform to criteria that included a slender waist, large bust and shapely legs and hips. Eyes and lips were accentuated along with an abundant head of hair. Although this was a continuation of the artistic tradition that began during the Renaissance with artists such as Botticelli and prevailed with later artists such as Rubens, it established a strict conformity of appearance and spread to other areas of the media, including tabloid newspapers, magazines and comics. A typical example of this type of idealized woman is Ursula Andress (right), a Swiss actress who appeared in several films at the time Lichtenstein made *M–Maybe*.

LATE 20TH CENTURY

ALTHOUGH PRIMARILY INSPIRED BY Duchamp's ideas and more generally by Dada, Surrealism and Abstract Expressionism, Conceptual art did not develop as a movement until the late 1960s. Conceptualism is any art where the idea is more important than material and technical concerns, and can take almost any form. This breadth of scope with materials and methods set a precedent for a vast amount of art produced from that time. A related development that originated with Dada and from Happenings, was Performance art or Actionism. Out of them, the Fluxus movement evolved that promoted 'living and anti-art'. It continued the notions of breaking down distinctions between high and low art that had started in earnest during the 1960s.

ACCESSION II

EVA HESSE

1968

galvanized steel and vinyl
78 x 78 x 78 cm (30 ¾ x 30 ¾ x 30 ¾ in.)
Detroit Institute of Arts, Michigan, USA

ALTHOUGH HER FIRST ARTWORKS were Abstract
Expressionist paintings, Eva Hesse (1936–70) became
most famous for her Minimalist objects made of a variety
of materials, including fibreglass, latex, cloth and plastics.

With a childhood marred by harrowing events, Hesse
eventually trained as an abstract painter and commercial
designer in the United States. She was born in Nazi Germany
to a Jewish family, two years before the horrific attacks on
thousands of Jews across Germany that became known as
'*Kristallnacht*'. Soon after, Hesse and her sister were sent to a
children's home in the Netherlands and six months later, with
their parents, they escaped first to England and then to New
York. A few years later, Hesse's parents divorced. Her father
remarried and her mother, who had a history of depression,
committed suicide. At ten years old, Hesse was traumatized.

When Hesse was aged eighteen, she began studying
painting at the Cooper Union, and painted her first Abstract
Expressionist works. She worked as an intern at the magazine
Seventeen, and was featured in an article in which she
explained: 'For me, being an artist means to see, to observe,
to investigate. It means trying to understand and portray
people, their emotions, their strengths and faults. I paint what
I see and feel to express life in all its reality and movement.'

She took classes at the Art Students League and the Pratt
Institute. From 1957, she studied at the Yale School of Art
and Architecture where she was taught by Albers who was
spreading modernist ideas from his native Germany to
Americans. After graduating Hesse worked as a textile
designer, while producing Abstract Expressionist paintings.
During her short-lived marriage from 1962 to 1966, Hesse
worked in Dusseldorf, where she began creating sculptures
with 'found' materials, such as rope, string, wire and rubber,
creating organic-looking forms that conveyed the vulnerability
of the human body, psychological moods and sexual
innuendoes. After exhibiting in 'Eccentric Abstraction' at
the Fischbach Gallery in New York in 1966, she became well
known and produced her 'Accession' series in 1967 and 1968.
This work was one of her first forays into working with metal.

Kristallnacht

From 1933, when Adolf Hitler, the leader of the Nazi
Party became chancellor of Germany, German Jews
were subjected to increasingly oppressive policies.
In November 1938, when Hesse was two years old,
SA paramilitary forces and German civilians torched
synagogues, vandalized Jewish homes, schools and
businesses (above), and killed at least ninety-one Jews.
Additionally, 30,000 Jewish men were arrested and
sent to Nazi concentration camps. The event became
known as *Kristallnacht* (Crystal Night), referring to
the broken glass that littered the streets after the
pogrom. In efforts to help, the British organized
the *Kindertransport* (Children's Transport); a series
of rescue efforts for Jewish children. Hesse's parents
managed to send their young daughters via the scheme
to the Netherlands to escape the persecution. Aspects
of these formative experiences remained with Hesse
throughout her life.

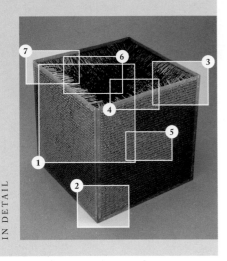

② SERIES

Much of Hesse's work is concerned with geometry and repetition. This piece is the second in a series of five open boxes or cubes made for her. Every box was drilled with thousands of holes, which she threaded with either rubber or plastic tubing. Each cube is a different size and some are in different materials.

① CONCEPT

Often classified as a Post-Minimalist, Hesse shared the Minimalists' interest in abstraction and materiality, but her work was more expressive. The expressiveness was spontaneous, evolving from her early Abstract Expressionist work and following the advice of her friend Sol LeWitt (1928–2007) who told her: 'Stop [thinking] and just do!'

③ FEMINISM

Hesse wrote: 'I cannot even be myself, nor know what I am.' While she did not perceive herself as a feminist, her work had a powerful influence on the perception of women and their rights in a male-dominated world. This work references the 'masculine'–the rigid geometric box – and the 'feminine'–the flexible, soft tubing.

After producing soft, biomorphic works, Hesse created art made from industrial materials that featured rigid, repetitive elements and geometric forms. Unlike Minimalist artists, she added unexpected elements that required hands-on processes and suggest complexities of human experience.

④ MATERIALS

Particularly influenced by both Abstract Expressionism and Albers, Hesse combined emotion with Minimalist aesthetics. The main part of this box was machine-made of galvanized steel, then drilled with thousands of holes that give a meshed effect and that were subsequently hand-threaded with clear vinyl tubing.

⑤ WEAVING

Hesse explored notions regarding the natural order of things. She threaded the flexible vinyl tubing through the perforations in the hard metal walls of the cube. The labour-intensive method and the result of the weaving evokes ideas of stereotypical female pursuits that oppose the rigid masculinity of the metal box.

⑥ INTERIOR

The cube resembles an industrial container, but the hollow interior with its bristling and sensuous texture has been compared to aspects of the human body, waving plantlike fronds or the soft tendrils of a sea creature. They have been likened to porcupine quills, with the bendy projections conveying a sense of unease.

⑦ CONTRASTS

Intentionally full of contradictions and suggestive of the diversity of life, the box comprises soft and hard textures, flexibility and rigidity, evoking a sense of comfort and of menace. Hesse said her aim was to create both nothing and something. The work's duality can be seen to symbolize Hesse's disparate life experiences.

THE SLED

JOSEPH BEUYS

1969

sled of wood and metal with felt, cloth straps,
flashlight, wax and cord
35 x 90.5 x 34.5 cm (13 ⅞ x 35 ⅝ x 13 ⅝ in.)
Museum of Modern Art, New York, USA

FAMOUS FOR MIXING SOCIAL commentary with political activism, Joseph Beuys (1921–86) is one of the most influential artists of the late 20th century. His disparate body of work encompasses drawing, painting, sculpture, performances and installations, as well as artistic theory.

Born in north-west Germany, from a young age he demonstrated an aptitude for art, music, history, mythology and the sciences. At fifteen, he volunteered for the Hitler Youth and five years later, for the Luftwaffe. After three years of fighting, in 1944 his plane crashed in the Crimea. He later told how he was rescued by nomadic Tatar tribesmen who wrapped him in animal fat and felt for warmth. Fat and felt subsequently played an important role in much of his art.

After World War II, he studied sculpture and began his artistic career. Haunted by wartime memories, he produced thousands of drawings, taught sculpture and associated with artists affiliated with the Fluxus group. Fluxus stressed the importance of applying oneself to a broad range of media. Developing from this, Beuys produced powerful, original expressions of myth and obsession.

Aeroplane crash and rescue

In 1941, Beuys volunteered for the Luftwaffe. In March 1944, he was serving as a rear gunner in a Stuka dive-bomber (left) when his aeroplane crashed on the Crimean Front. For the rest of his life, he perpetuated the myth that he was rescued by Tatar nomads.

❷ UNCONVENTIONAL MATERIALS

This work comprised a sledge, cord, straps, a flashlight and fat (now wax). Beuys said: 'The most direct kind of movement over the earth is the sliding of the iron runners of the sleds… This relationship between feet and earth is made in many sculptures… Each sled carries its own survival kit: the flashlight represents the sense of orientation, then felt for protection and fat is food.'

❶ EXPERIENCE

Beuys was known for circulating fantasy stories and his experience of being rescued by nomads during World War II is questionable. Apparent eyewitnesses claimed that he was recovered by a German search commando and there were no Tatars in the village at that time. Truth or fiction, it aided Beuys's imagination and the myth – if it is – becomes part of the work.

❸ EXPEDITION

This sledge is set up ready for an arduous exploration, initiating further questions in viewers' minds. Where is it going, who is taking it on the journey and why? The flashlight, felt and fat could imply it is an emergency expedition. It could also suggest this is a still life of survival, evoking a 17th-century Dutch *vanitas*, which symbolizes the transience of life.

4 SURVIVAL

Overall, Beuys's tale of being saved by nomads when he was stranded in deep snow expressed his optimistic belief that by caring for each other, humans can be stronger together. This work contains the basics needed for individual survival. As Beuys believed that art had the power to shape a better society, the work is also a metaphor for the survival of the human race.

5 ATMOSPHERE

As much as the physical objects and their connections and connotations, the mystery created by Beuys is important, too. His negative recollections of World War II and of his part in it, his weaving of myths and stories about his life and his ultimate optimism, were also part of the work and his exploration of how art could exert healing effects on both artists and viewers.

6 NONART

Materials that were not usually used in art were part of Beuys's approach. While this practice of using nonart materials descended from Duchamp, it was also original. He frequently blurred the lines between art and life, as well as fact and fiction, by his suggestions that artists' and viewers' beliefs about reality matters more than actual reality.

Performance art

Beuys maintained: 'To be a teacher is my greatest work of art.' He taught for over twenty years at the Dusseldorf Academy of Art. Charismatic and inspiring, he was loved by his students, but intensely disliked by the academy's authorities, and in 1972, they dismissed him without notice. He and many of his students protested (above), which turned into an action resembling Performance art.

SPIRAL JETTY

ROBERT SMITHSON

1970

mud, precipitated salt crystals, rocks, water coil,
457 x 4.5 m (1,500 x 15 ft)
Rozel Point, Great Salt Lake, Utah, USA

AN ARTIST, WRITER AND CRITIC, Robert Smithson (1938–73) used his broad range of interests, including religion, geology and science fiction to inform his work. Despite his short life, he became one of the most influential artists of the post-Pop art period.

Born in New Jersey, he studied drawing and painting at the Art Students League, and at the Brooklyn Museum School. After seeing his paintings and collages in 1959, the art dealer Virginia Dwan helped him to organize his first solo show in New York. Initially, his work drew heavily on Abstract Expressionism, but after meeting artists at the forefront of the new Minimalist art movement his artwork changed. By 1964, he was producing sculpture that resembled Minimalist installations, often mixing incongruous dimensions or using mirrors or lighting effects to confuse viewers' perceptions. At the same time, he visited quarries and industrial wastelands in New Jersey, exploring deserts and tracts of land that appear to be untouched by human intervention. He began creating art in the landscape, and in 1970 he produced the Earthwork or Land art for which he is best known: *Spiral Jetty*, a coil of rock created off the shore of the Great Salt Lake in Utah.

Spiral, c. 3200 BC, Newgrange, County Meath, Ireland

Megaliths or large stones were used extensively to create prehistoric monuments, mainly during the Neolithic era. Spiral designs were an important feature of megalithic art. In *Spiral Jetty*, Smithson was recalling examples such as Newgrange that had an affinity with their surroundings as well as a simplicity and spirituality.

❷ DECAY AND RENEWAL

Fascinated by the concept of entropy, Smithson made some crystalline structures. Believing that entropy was the second law of thermodynamics, and that eventually the universe will burn out and everything will become the same, he explored ideas of decay and renewal, and chaos and order. He believed that entropy was a way in which society and culture could transform.

❶ LOCATION

Smithson's first Earthworks were simply preliminary sketches on paper. Through his interest in thermodynamics, he became increasingly fascinated with industrial areas and the human neglect that leads to wastelands. After a great deal of searching, he bought a remote plot of land on the northern shore of the Great Salt Lake in Utah.

❸ SPIRAL

The spiral shape is a reference to a mythical whirlpool at the bottom of the lake, as well as to the circulation of blood around the body, and the ways in which flowers, trees and shells are formed naturally. The coiling structure was also inspired by the growth patterns of crystals and various primeval symbols seen on ancient megalithic structures.

4 CHEMICAL REACTIONS

Constructed from rocks, earth and salt, this work changes through chemical reactions that naturally occur. The lake waters are sometimes a red-violet colour because of the reactions created by the mixture of high concentrations of beta-carotene in the green algae *Dunaliella salina*. For several years, *Spiral Jetty* was submerged by rising lake waters, but eventually it re-emerged.

5 MATERIALS

Smithson chose the site at Rozel Point for *Spiral Jetty* because it had been cut off from fresh water supplies in 1959 when a nearby causeway was constructed. Using more than 5,443 tonnes (5,357 t) of black basalt rocks, precipitated salt crystals and 6,032 tonnes (5,937 t) of earth, he formed his giant coil, winding anti-clockwise off the shore and into the water.

6 HARMONY

Smithson wanted to maintain harmony and integrity with the natural environment that surrounded *Spiral Jetty*. He aimed to create a massive work of art that appeared to be a natural part of the landscape, and contrasted with the damage that industry and urbanization was doing to the Earth. It highlighted a new direction for art and for environmental concerns.

7 CONTRASTS

Smithson intended saline crystals to form on top of the black basalt rock surface to create a white coiled line on top of the spiral, which has happened. He enjoyed the contrasts of mainly static ground and flowing, moving water, the local, natural materials and his man-made efforts, and the changes that naturally occur and transform the environment.

TV CELLO

NAM JUNE PAIK

1971

video tubes, TV chassis, Plexiglas boxes, electronics, wiring, wood base, fan, stool, photograph
dimensions variable
Walker Art Center, Minneapolis, USA

NAM JUNE PAIK (1932–2006) WAS A pioneer in performance and technology-based art. In 1963, he was the first artist to show abstract forms on a television, using a magnet to distort the image, and in 1965, the first artist to use a small portable video camera. He became internationally recognized as the 'Father of Video Art', creating a large body of work including video sculptures, installations, performances, videotapes and television productions.

Paik was born in Seoul to a wealthy industrial family. When he was eighteen, the outbreak of the Korean War (1950–53) forced his family to flee to Hong Kong. They soon moved to Japan, where Paik studied art and music history at the University of Tokyo, writing his thesis on Austrian composer Arnold Schoenberg. He then relocated to Germany to study at the University of Munich. In the late 1950s, while working at a radio studio in Cologne, he met US composer John Cage, whose ideas inspired him. Simultaneously, he became involved with the group Fluxus. For his exhibition 'Exposition of Music-Electronic Television' at the Galerie Parnass in Wuppertal in 1963, he scattered televisions everywhere and used magnets to alter or distort their images. It was first time that anyone had used video as an artistic medium. Two years later, he immigrated to New York, where he collaborated with cellist and Performance artist Charlotte Moorman (1933–91) combining his video, music and performance. However, they were both arrested in 1967 for public indecency, when Moorman played Paik's *Cello Sonata No. 1 for Adults Only* (1965) while topless at the opening of his *Opéra Sextronique*. Two years later, they performed *TV Bra for Living Sculpture* in which Moorman wore a bra fitted with small TV screens.

In 1971, Paik created *TV Cello* for Moorman. He stacked three televisions on top of each other, so that they formed the shape of a cello, and attached some cello strings. Moorman sat on a stool at the structure as if playing the cello, and drew her bow across it while images of her and other cellists playing appeared on the television screens.

② STOOL

A four-legged wooden stool was put behind the televisions, to suggest a musician or performance, and for the time in which Moorman played, to actually seat the musician herself. She sat on the stool and simulated playing, using the cello's bow that rests on top of the stool. While she pretended to play, the screens showed her and other musicians playing real cellos.

① WIRES

The confused, trailing wires snake across the floor and around the work, deliberately evoke images of a common late 20th-century problem: the increasing amounts of electrical equipment in the home and the messy wires attached to them. The wires here also serve as ways in which the various elements of the installation are connected.

③ LARGE TELEVISION

Associated with the international conceptual movement Fluxus, Paik regularly collaborated with other Fluxus artists such as Beuys. This large, base television has been removed from its set, so that its inner workings can be seen all around. It has been placed in a box made of transparent synthetic polymer resin with a tailpiece and cello bridge attached to the screen. An end piece is fixed to the base.

④ MIDDLE TELEVISION

The smallest screen is stacked between two other television sets. This section mirrors the C-rib and sound holes of a cello, with strings pulled tautly across it. The work represents a light-hearted sense of improvisation and experimentation. It looks crudely put together but that is intentional and comparable with spontaneous brushmarks in a Fauvist painting. Like them, this structure is the result of experience and careful planning.

⑤ TOP TELEVISION

The medium-sized television was stacked on top of the other two. It represents the shoulder of the stringed instrument and the strings continue as if they are on a fingerboard. The connection with a cello was deliberately obvious. Paik was making links with the modern world and reflecting it back to viewers. The concept aligns with Pop art principles by emphasizing the contrast between popular and high culture.

⑥ NECK

The neck of the faux cello is formed loosely with the use of coiled wire and strings. This encourages comparisons between televisions and musical instruments: electronics usually need little involvement to work whereas strings require human intervention to function as part of an instrument.

⑦ CASES

The original television cases are stacked up, discarded by the side of the display. This is a critique of the ephemeral, expendable and disposable nature of late 20th-century society, while also conveying manipulation and synthesis, particularly in relation to performance and installation. In 1971, the silent film *TV Cello Premiere* was made documenting Moorman's performance with this work at the Bonino Gallery in New York.

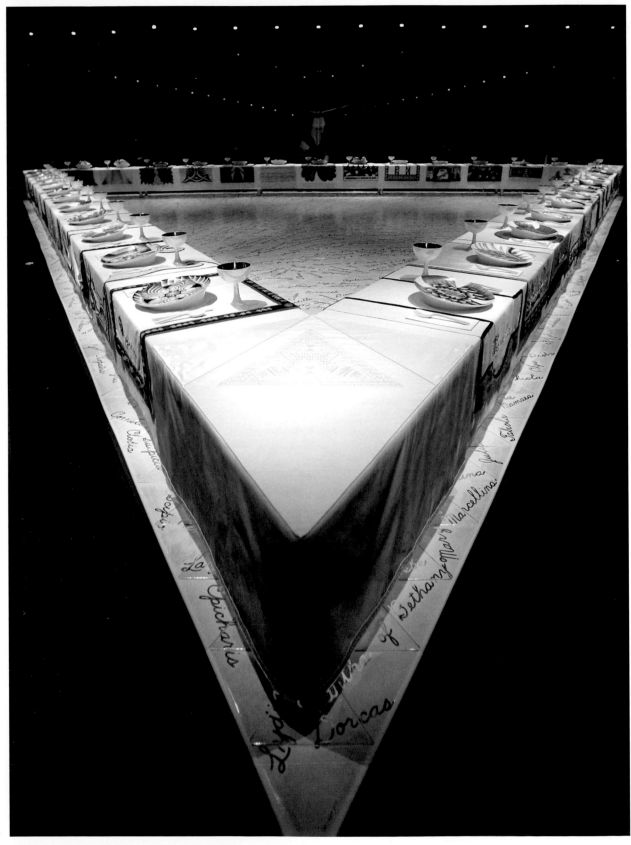

THE DINNER PARTY

JUDY CHICAGO

1974–79

ceramic, porcelain, textile
14.65 x 14.65 m (48 x 48 ft)
Brooklyn Museum, New York, USA

IN THE 1970S JUDY CHICAGO (b.1939) helped to pioneer Feminist art, a movement that aimed to reflect women's lives and improve female artists' prominence and experiences. Incorporating stereotypical female skills such as needlework, alongside typical male pursuits such as welding and pyrotechnics, she creates art that focuses on female themes. She did this most famously in her work *The Dinner Party*, which celebrates the achievements of women throughout history, and shocked audiences with its imagery of vaginas.

Born in Chicago as Judith Cohen, she changed her surname in 1969 as a way of detaching herself from patriarchal convention. Chicago's intellectual parents both worked and frequently discussed their left-wing politics with their children. In 1947, she studied at the Art Institute of Chicago and then went to UCLA, completing her master's degree in painting and sculpture in 1964. Grief over the tragically early deaths of her father and her first husband emerged in her early paintings that overtly explored female sexuality in a male-dominated society. During the 1960s, however, she turned to sculpture, creating Minimalist, geometric type works.

From the mid to late 1960s, her work was dominated by feminist themes. In 1970, she ran a women-only art course at California State University with Canadian-born artist Miriam Schapiro (1923–2015), and then at the California Institute of Arts. The course focused on female identity and independence, and combined object-making, installation and performance. From this, the Womanhouse art space evolved, which Chicago and her students used as a forum for teaching, performance, exhibition, discussion and expression. In 1974, she began her most significant and controversial work. Using techniques that are traditionally dismissed as mere feminine crafts, including ceramic decoration and embroidery, she collaborated with artisans to create an installation that honoured women from history whom she felt had been forgotten or marginalized. *The Dinner Party* presents a ceremonial banquet at a monumental thirty-nine place dinner table, originally presented in a triangular form. Plates – many decorated with symbolic vaginas – mark the guests' places.

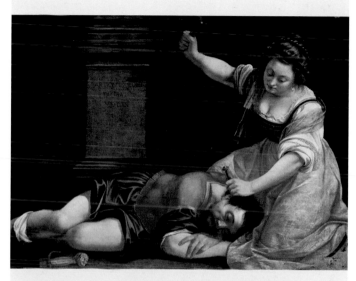

Jael and Sisera, Artemisia Gentileschi, 1620, oil on canvas, 86 x 125 cm (33 ⅞ x 49 ¼ in.), Szepmuveszeti Museum, Budapest, Hungary

Portraying assertive and strong women, Artemisia Gentileschi (1593–c. 1652) was the only female 'Caravaggisti' or close follower of Caravaggio (1571–1610) in the 17th century. This is one of her biblical images of a woman slaying an aggressor. Sisera was a cruel Canaanite leader who ruled the Israelites for twenty years, until Jael kills him as he sleeps. Inspired by her life events, Gentileschi's innovative compositions and female focus on biblical heroines set her apart from her male contemporaries. She earned the support and patronage of the Medici duke, Cosimo II, and was the first woman to be accepted into the Florentine Academy of Fine Arts. Unusually, when she separated from her husband, she led an independent life. After her death she fell into obscurity and Chicago featured her in *The Dinner Party* in an effort to help redress this.

❶ CONCEPT

The concept for this work is to honour the richness of women's heritage and celebrate traditionally feminine crafts. Thirty-nine women are featured and arranged in three groups of thirteen, which represents the number of people present at the biblical Last Supper, who were all men. When first exhibited in March 1979 at the San Francisco Museum, *The Dinner Party* attracted more than 5,000 visitors.

❷ 1,038 WOMEN

Embroidered runners, gold chalices and utensils, and painted porcelain plates are set at a triangular table. Each place setting commemorates an important woman from history; each runner is embroidered, and each plate is painted in a style that complements the particular woman honoured. The names of another 999 women are inscribed in gold on the white tiled floor. In total 1,038 women are commemorated in the installation.

Over six years, more than 400 people contributed to the creation of the work, most of them volunteers. The thirty-nine plates are flat at the start, and the later plates are in relief. The first side of the triangular table refers to the goddesses of prehistory up to the time of the Roman Empire. The second side covers the rise of Christianity and ends with the Reformation period. The third side represents the Age of Revolution and ends with British writer Virginia Woolf and US artist O'Keeffe.

3 ISABELLA D'ESTE

Renaissance patron of the arts Isabella d'Este was married to the Marquis of Mantua. Her plate echoes the colour motifs of ceramics from Urbino and illustrates Renaissance artistic innovations, including the application of linear perspective.

4 HATSHEPSUT

The fifth pharaoh of the Eighteenth Dynasty of Egypt was Hatshepsut. The curving shapes in the plate recall Egyptian hairstyles, headdresses and pharaonic collars. Hieroglyphs praising Hatshepsut's reign are embroidered on the runner.

5 ELEANOR OF AQUITAINE

Queen of France and England in the 12th century, Eleanor of Aquitaine has a runner embroidered with a fleur-de-lys and an illuminated letter 'E'. The plate symbolizes her imprisonment by her second husband, Henry II, from 1173 to 1189.

6 ARTEMISIA GENTILESCHI

Gentileschi's place setting depicts a paintbrush and palette. Velvet and gold represent elements in her work. A butterfly image on her plate uses the chiaroscuro technique that Caravaggio made famous and which she emulated.

7 GEORGIA O'KEEFFE

O'Keeffe's place setting is the last in the composition. Her plate features imagery from her flower paintings, such as *Black Iris* (1926). A piece of Belgian linen is attached to cherry-wood stretcher bars, representing an artist's canvas and easel.

CORAZÓN DE ROCA CON SANGRE (ROCK HEART WITH BLOOD)

ANA MENDIETA

1975

Super-8mm film transferred to high-definition digital media,
3:14 minutes
at various locations

ANA MENDIETA (1948–85) WAS born in Havana in Cuba.
At twelve years old, she moved to the United States with her
sister as part of the government-sponsored Operation Pedro
Pan, which helped children flee from the dictatorship of Fidel
Castro. The sisters were put in refugee camps in Florida and
finally in foster homes in Iowa. Five years later, they were
reunited with their mother and younger brother, and then in
1979, with their father after he was released from internment
in Cuba as a political prisoner.

Mendieta studied French and art at the University of Iowa
where she was introduced to Conceptual and body-oriented
practices by German-American artist Hans Breder (1935–2017).
She began using her body as a medium, assimilating aspects of
religious rituals and exploring themes including gender, cultural
conflict and violence. She experimented with changing her
appearance, aiming to manipulate perceptions of female identity,
but most of all, she focused on her body in the environment.
This work is 'a dialogue between the landscape and the female
body'. It is part of her *Silueta Series* (*Silhouette Series*, 1973–80)
series, in which she either laid on the ground and merged with
the surroundings, or made imprints with her body in the land.

**Detail from *Book of the Dead, Papyrus
of Ani*, c. 1250 BC, paint on papyrus,
42 x 67 cm (16 ½ x 26 ⅜ in.), British
Museum, London, UK**

According to ancient Egyptian myth,
a dead person's heart would be weighed
against a feather. If the heart balanced against
the feather, the deceased was admitted to the
afterlife. If it was heavy with wrongdoings,
a monster ate it and the person ceased to
exist. Fascinated by such ancient beliefs,
Mendieta also focused on the heart.

Mendieta began her *Silueta Series* in Mexico on a trip with Breder, and then continued in Iowa. The works register the trace of the body on the environment. A study in displacement, this work evolved from the pain she felt as a child separating from her mother and home. The themes are autobiographical, including feminism, life, identity, place and belonging. In 1981 she wrote: 'I have been carrying out a dialogue between the landscape and the female body (based on my own silhouette). I believe this has been a direct result of my having been torn from my homeland (Cuba) during my adolescence. I am overwhelmed by the feeling of having been cast from the womb (nature). My art is the way I re-establish the bonds that unite me to the universe. It is a return to the maternal source.'

② HEART AND BLOOD

Like other works in the *Silueta Series*, this is shot in a documentary style. Resembling a primitive ritual, Mendieta kneels, naked, next to an impression of her body that has been cut into a soft, muddy riverbank. She places a rock in the centre of this bodily hollow and covers the rock with what appears to be blood – a vivid red against the monochrome landscape. The presence of her living body records human impact on the natural world, while the heart and blood on the earth suggest death. It is a fusion of Performance art and Land art which Mendieta called 'earth-body work' and 'earth-body sculptures'. She wrote: 'Through my earth/body sculptures I become one with the earth… I become an extension of nature and nature becomes an extension of my body.'

③ ART MOVEMENTS

Mendieta aimed to provoke an acceptance that people are essentially the same. She was a key figure in the Body art movement that emerged from Performance art. She was also associated with the Feminist art movement, and her focus on the natural environment made her an important contributor to Land art.

④ SANTERÍA

Mendieta places herself face down on the heart-rock in the cutout body shape, recalling a ritual. Her portrayal of the earth and body as one suggests a physical and spiritual connection. Passionate about religious rituals, like Lam (see p. 181) she was especially inspired by Santería; an Afro-Caribbean religion that developed in Cuba, based on Yoruba beliefs with Roman Catholic elements.

After the Bath, Woman Wiping her Left Foot, Edgar Degas, 1886, pastel on cardboard, 54.5 x 52.4 cm (21 ⅜ x 20 ⅝ in.), Musée d'Orsay, Paris, France

Women washing, drying, brushing their hair and generally preparing themselves is a common theme with Degas, but his intimacy was not appreciated by many at the time; it was considered too private and personal, not a subject for art and his motives were questioned. But, like Mendieta, he was fascinated with the body. In many ways, he was also considering how women are perceived in a male-dominated society, although of course, his view was affected by his background and era. As with Mendieta's work, the woman's face is not seen; luxuriant hair falls over her face as the personality of the sitter was deliberately avoided by both artists. Gestures and actions appealed to Degas rather than facial features, and the composition, following his interest in Japanese art, is uncluttered and features few colours. Again, similarities are apparent in Mendieta's work: she features the female body in almost monochrome surroundings. The brutal honesty of Degas's art of women at their toilette was harshly criticized, while Mendieta, being both the model and artist, and working in a different era, is praised as a pioneer of Feminist art.

NAKED PORTRAIT WITH REFLECTION

LUCIAN FREUD

1980

oil on canvas
91 x 91 cm (35 ⅞ x 35 ⅞ in.)
private collection

RENOWNED FOR HIS FIGURATIVE PAINTINGS,
Lucian Freud (1922–2011) worked for more than six decades.
His early style incorporated smooth paint, cool colours and
crisply rendered outlines, whereas his later work became
more gestural with expressively applied impasto paint.

The grandson of the founder of psychoanalysis Sigmund
Freud and the son of architect Ernst Freud, Lucian was born
in Berlin to an artistic middle-class Jewish family. In 1933,
he and his family left Berlin to escape the rise of Nazism
and settled in London. In 1938, a drawing he did when he was
eight years old was selected for a children's art exhibition at
Peggy Guggenheim's London gallery. He studied briefly
at the Central School of Art in London and in 1939 entered
the East Anglian School of Painting and Drawing in Essex.
During World War II, he served as a merchant seaman from
1941 but was invalided out of service after a year. He then
entered Goldsmiths' College, London.

By 1943, he had started to paint seriously, and three years
later, travelled to Paris and then to Greece. While in Paris, he
became friends with Picasso and Giacometti, and on his return
to London he taught at the Slade School of Art and exhibited
his paintings in London galleries. The paintings he showed
were mainly portraits, with enlarged eyes, smooth outlines
and muted colours. From those early days and for the rest of
his career, Freud produced portraits and figure paintings, in
contrast to contemporaries who focused on more abstract or
Conceptual art. He preferred to paint standing, so often his
images are from aerial viewpoints. Gradually, his style evolved.
In order to create variegated colours in flesh, he cleaned his
brushes after every stroke. By 1960, he used freer brushmarks,
heavier paint density and more layers. He painted nudes that
were severe, unflattering and, in some areas, exaggerated. His
aim was to explore 'the insides and undersides of things'.

In *Naked Portrait with Reflection*, his standing position
means viewers look down on the subject as she reclines on
a torn sofa. The image appears raw and closely scrutinized.

Reclining Woman, Gustave Courbet, *c.* 1865–66,
oil on canvas, 77 x 128 cm (30 ⅜ x 50 ⅜ in.),
Hermitage Museum, St Petersburg, Russia

After seeing paintings by Gustave Courbet on trips to
France in 1960 and 1961, Freud wrote: 'I looked at the
Courbets… a lot… I like Courbet.' Inspired by Courbet's
portrayals of the female nude, Freud continued his
frank methods of non-idealization, employing visible
brushmarks, strong tonal contrasts and creating a sense
of immediacy. While this work conforms to academic
conventions, in her languid pose and alabaster skin
draped with a cloth, Courbet emphasized the woman's
earthy sensuality. She is not a cool, depersonalized
goddess as was expected in art of the time, but a woman
with warm, soft flesh, rosy cheeks, and reddened fingers
and knees. Almost a century later, Freud painted his
similarly posed nude figure, adding more varied flesh
colours in patchy, impasto paint, exaggerating her curves
and interpreting his model in a more starkly analytical
manner. Nonetheless, Courbet's influence is evident.

② PALETTE AND PAINT

Using hog's hair brushes and a restricted, mainly warm palette of cremnitz white, yellow ochre, raw and burnt umber, raw and burnt sienna, red lake, viridian and ultramarine, Freud describes the skin with patches and layers. Using fairly agitated brushstrokes, he built up the volume of paint to almost shape the contours of the skin. He said: 'I want the paint to feel like flesh.'

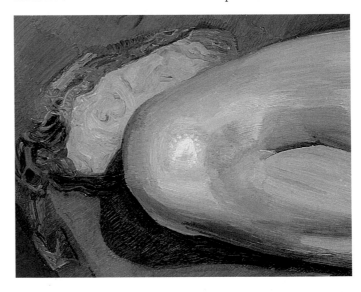

① THE FACE

Her eyelids down, the model gazes away from the artist. Freud applies paint in thick, directional layers to describe the shape and structure of the face, including the slight sagging where she relaxes into the sofa. The dramatic highlights and shadows are marked in warm yellows, ochres, pinks and salmons. Freud once noted: 'I like skin, it's so unpredictable.'

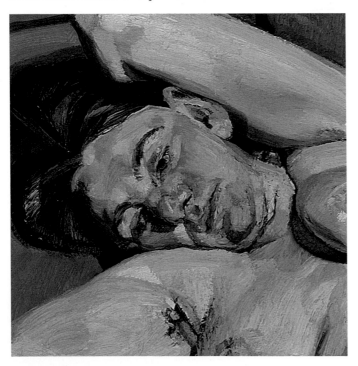

③ CURVING SHAPES

The model posed for long hours and many sessions. Freud painted her from his usual standing position, towering over her and looking down. Her skin contrasts and blends with the tatty sofa. Freud's paint was thicker and richer on the earlier layers, and drier and thinner on the top layers. The curving shape of the woman's waist and hips echoes that of the back of the sofa.

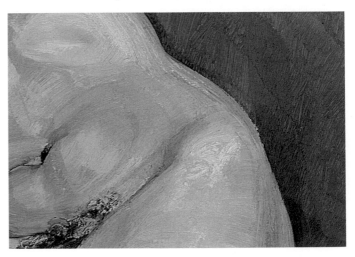

④ LIGHT AND SHADOW

Using white paint, Freud built up a balance of light and shadow. The figure is brightly illuminated from the top, which throws cast shadows on to the sofa. The shape of the knee, its shadow and the hole in the fabric are all similarly shaped and in accordant muted hues. Highlights and dark areas are emphasized, while the heaviness of the figure's breasts is exaggerated.

⑤ TECHNIQUE

Freud's approach had evolved from close study of the Old Masters, including Courbet, Titian, Rembrandt, Rubens and Ingres, although he abandoned any sense of idealization. The painting took him months to complete as he built up the surface of paint with a multitude of expressive brushmarks and allowed each layer to dry before applying the next.

⑥ REFLECTION

Freud created a heightened tension with the presence of a male, fully-clothed in the top right corner of the painting. The title of the work tells viewers that the image is a reflection, and it is assumed that the feet belong to Freud standing at his easel. This presence generates a uneasy sense that viewers have intruded upon an intimate moment between artist and sitter.

⑦ FLESH

Swirls and slashes of paint capture the woman's curves and flaws. The brushmarks follow the contours of the flesh, emphasizing undulations. The image is unnerving as Freud has not attempted to portray beauty but rather to project a sense of mystery and even disquiet. He said: 'Living people interest me far more than anything else. I'm really interested in them as animals.'

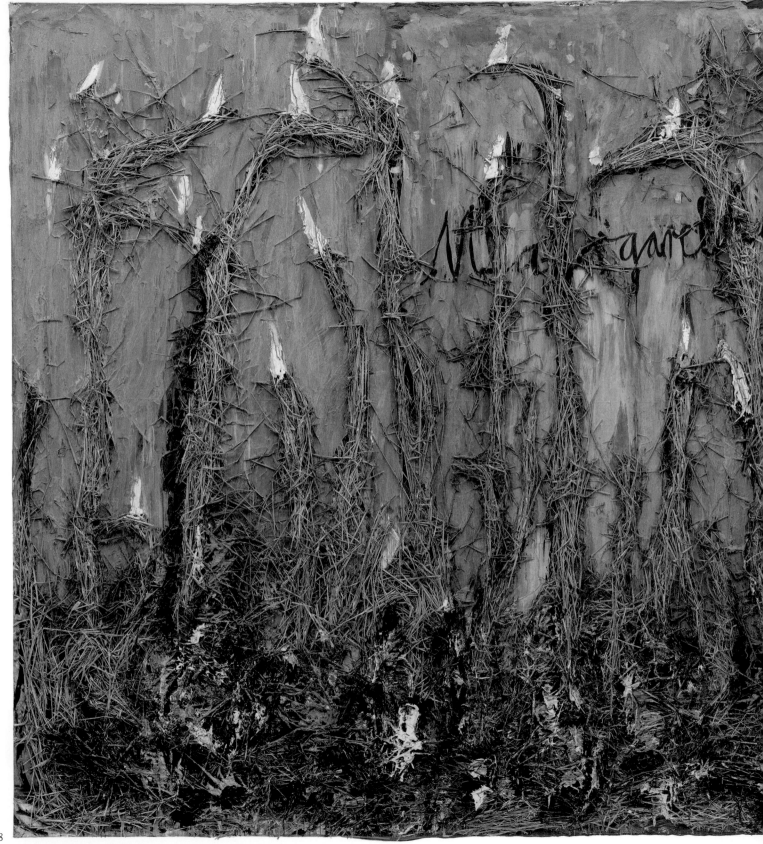

MARGARETHE

ANSELM KIEFER

1981

oil, acrylic, emulsion and straw on canvas
290 cm x 400.5 cm (114 ¼ x 157 ¾ in.)
San Francisco Museum of Modern Art, California, USA

GERMAN ARTIST ANSELM KIEFER (b.1945) produced monumental paintings at a time when painting was not perceived as pioneering. Much of it focuses on German history and myth, and incorporates heavy impasto and materials such as lead, shards of glass, dried flowers and hay.

Classed as a Neo-Expressionist, Kiefer studied law and languages at Freiburg University, Germany. From 1966, he trained in painting with Peter Dreher (b.1932). He attended the School of Fine Arts at Freiburg im Breisgau then the Art Academy in Karlsruhe. He began his career confronting controversial issues, especially of German national identity, which have remained frequent themes in his oeuvre. The spiritual concepts of Kabbalah and the poetry of Romanian-born poet Paul Celan, along with Kiefer's Catholic upbringing, have influenced his work. Celan's parents both died in Nazi concentration camps, while he was in a work camp. *Margarethe* [*sic*] is one of a series of paintings inspired by Celan's poem, '*Todesfuge*' ('*Death Fugue*', *c.* 1945).

Extract from '*Death Fugue*', Paul Celan

He calls out more sweetly play death death is a master from Germany
he calls out more darkly now stroke your strings then as smoke you will rise into air
then a grave you will have in the clouds there one lies unconfined

Black milk of daybreak we drink you at night
we drink you at noon death is a master from Germany
we drink you at sundown and in the morning we drink and we drink you
death is a master from Germany his eyes are blue
he strikes you with leaden bullets his aim is true
a man lives in the house your golden hair Margarete
he sets his pack on to us he grants us a grave in the air
He plays with the serpents and daydreams death is a master from Germany
your golden hair Margarete
your ashen hair Shulamith

② YELLOW STRAW

The golden-haired German heroine Margarethe is denoted by wheat waving in the wind. In Johann Wolfgang von Goethe's play *Faust* (1808–32) an innocent woman, Margarete, kills her baby, and lays on a bed of straw while Faust kills her brother. Kiefer alludes to her by using the yellow straw.

③ HOLOCAUST

A German-speaking Jew, Celan was the only member of his family to survive imprisonment during the Holocaust. Celan's memories are expressed in the poem, which tells of Jewish prisoners in a concentration camp who suffer under the watch of a blue-eyed, blond haired German. Kiefer suggests that Germany and the Holocaust will always be inextricably linked.

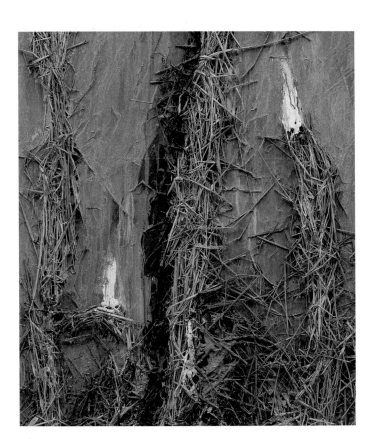

① DEATH FUGUE

From 1979, for approximately ten years, Kiefer created works he called *Margarethe* or *Shulamith,* after the two women in Celan's poem set in a Nazi death camp where Jewish prisoners are forced to dig their own graves to dance music. The women are Margarete with blonde Aryan hair, and Shulamith, Jewish with ashen black hair from the Nazi crematorium. Shulamith was also King Solomon's dark-haired love in the biblical *The Song of Songs.*

4 MATERIALS

Creating his own symbolic language, here Kiefer used mixed media, which comprises an unusual combination of oil paint, acrylic, emulsion and straw. The textural effects that rise above the picture plane create sculptural forms, shaping a relief, not just a two-dimensional painting. This was the first time he utilized straw in his work.

5 MARGARETHE

In black ink, the name 'Margarethe' is scrawled across the surface of the painting like graffiti, intentionally irreverent, sullying the field of golden straw. The tops of the straw appear like candle flames, suggesting death-camp chimneys, and the cremation of bodies. The meaning, however, is intentionally ambiguous and the flames could also imply resurrection or prayer.

6 CHARRED REMAINS

The soil from which the straw grows is charred and black, while black skeins of further impasto paint the shorn hair of those incarcerated or burned in concentration camps. This is emphasized in the poem's description of Shulamith's 'ashen hair', which evokes the presence of Shulamith and the implication that she has been thrown into a burning pit or oven.

7 METHOD

Using a limited palette and layers of paint to create textures and patterns, Kiefer evokes a sense of desolation, innocence and suffering. Although the painting is named *Margarethe* and refers to the woman's blonde hair, it also suggests a strong presence of the other woman, especially in the tangled black lines of paint that imply Shulamith, whose fate is unknown.

ABSTRACT PAINTING

GERHARD RICHTER

1986

oil on canvas
70.5 x 100 cm (27 ¾ x 39 ⅜ in.)
private collection

IN HIS PAINTINGS AND PHOTOGRAPHS, Gerhard Richter (b.1932) explores notions of chance and the balance between realism and abstraction.

Born in Dresden, he trained in the former East Germany in a Social Realist painting style that supported the propaganda of the Communist state. After World War II, he was apprenticed to a theatre-set painter and later studied at Dresden's Academy of Fine Arts, where he painted murals and political banners. Restrictions imposed on art by the state, however, limited his ability to express himself. In 1959, while on a trip to 'Documenta II' in West Germany, he discovered Pollock's expressive use of paint and the work of Italian painter Lucio Fontana (1899–1968), who is known as the founder of Spatialism and for his ties to Arte Povera. Two years later, immediately before the completion of the Berlin Wall, he moved to Dusseldorf and enrolled at the local art academy, where he worked in a less inhibited way. He created some paintings from photographs, which he projected on to canvases and traced, but he distorted the images so they were only just recognizable. He also commenced blurring, scraping and painting in layers, sometimes applying paint with thick brushstrokes or rollers. In 1971, he was appointed a professor at the Dusseldorf Art Academy. At the same time, he made colour-chart paintings, where he systematically applied patches of colour to large canvases.

During the 1980s and 1990s, he was celebrated for the series of abstract paintings he had been producing since the early 1960s. They appear to continue the tradition of Abstract Expressionism, but they are not about the artist's feelings – rather they are explorations of the process of production. *Abstract Painting* is one of these paintings in which he created a sense of dynamism by intervening with the paint surface through the use of a hard-edged implement. The image appears to shift, as he disassembled and reassembled the layers. He said: '[The] first, smooth, soft-edged paint surface is like a finished picture; but after a while I decide that I understand it or have seen enough of it, and in the next stage of painting I partly destroy it, partly add to it; and so it goes on at intervals.'

❷ ENERGETIC AND EXPRESSIVE

Richter aimed for energetic and expressive colour using various techniques to achieve a rich, textural surface. These included brushing, scraping and skimming layers of paint to create many focal points. He used squeegees to cover and uncover paintmarks that he could not achieve with a brush alone.

❶ CHANCE

Focusing on the results of chance through random movements and paint application, Richter created areas of concentrated colour and textures in a detached manner. He has explained that he considers his most successful works to be 'incomprehensible' or unable to be deciphered or read in any one particular way. Interpretations of art are always individual and personal.

❸ COLOUR

Rich colours in veils and splashes appear in different parts of this painting. Acid yellow, brilliant red and intense blue combine to create radiant greens and oranges, through sweeping strokes, loose trailing skeins and spattering of paint. He used the three primary colours and his blending created secondary colours naturally.

④ MECHANICAL

Sceptical of the lofty sentiments of many art styles, Richter was exploring mechanical processes, investigating ways of applying pigments in layers, which he then scraped in an automated manner. He said: 'A picture like this is painted in different layers, separated by intervals of time. The first layer represents the background....'

⑤ LAYERS

The effect that Richter sought was achieved by applying several layers of paint, and then scraping away at them, moving in sweeping movements to uncover and cover layers of colour, in ridges, blobs and splatters of thick impasto paint that conceal and reveal further layers.

⑥ PAINT APPLICATION

A thoughtful artist, Richter challenges traditions of painting by focusing on the paint itself. This work is completely abstract and Richter's application of paint and then his scraping off, blurring, wiping and smudging of it questions our expectations and experiences of art, but does not pretend to be anything else.

⑦ SPONTANEITY

This painting's jewel-like colours and luscious use of paint is comparable to the exuberant colour in paintings by Klimt, Monet, Seurat, Gauguin or the Pre-Raphaelites. Yet Richter was not concerning himself with theories of simultaneous contrast. He has explained: 'It is a highly planned kind of spontaneity.'

UNTITLED #213

CINDY SHERMAN

1989

chromogenic print
108 x 84 cm (42 ½ x 33 in.)
San Francisco Museum of Modern Art, California, USA

BEST KNOWN FOR HER CONCEPTUAL PORTRAITS,
photographer and film director Cindy Sherman (b.1954) is a
key figure in the so-called 'Pictures Generation' of US artists
who received critical recognition during the early 1980s.
Initially painting in a Superrealist style while at art school,
Sherman later turned to photography. Constantly questioning
outside influences on individual and collective identities, she
creates extensive series of works, often incorporating herself
in role-playing situations. Her photographs draw attention
to unsettling, undesirable and even amusing stereotypes
by creating illusions that challenge the traditional view
of women's roles in art and society.

Soon after she was born in New Jersey, the Sherman family
moved to Long Island. From 1972 to 1976, she studied art
at State University College at Buffalo, New York. Although
she began painting, she found the medium restricting and
so she turned to photography. In 1974, with fellow artists
Robert Longo (b.1953), Charles Clough (b.1951) and Nancy
Dwyer (b.1954), she created the Hallwalls centre that aimed
to accommodate artists from diverse backgrounds. At the same
time, she was inspired by the photography-based Conceptual
works of Hannah Wilke (1940–93), Eleanor Antin (b.1935)
and Adrian Piper (b.1948).

After graduating, Sherman moved to New York where she
embarked on creating a series of black and white photographs
of herself, dressing up and posing with props to epitomize
the characters of numerous female stereotypes, including a
starlet, housewife and prostitute. This was the start of her series
Untitled Film Stills (1977–80). Assuming the roles of director,
make-up artist, hairstylist, wardrobe mistress and model,
she shoots her images by herself in her studio.

She created the series *History Portraits* (1988–90) while
living in Rome, drawing inspiration from some of art history's
most famous paintings. She produced thirty-five portraits that
explore the relationship between painter and model and modes
of representation, including parodies of Raphael's *La Fornarina*
(1518–19), Caravaggio's *Sick Bacchus* (c. 1593) and Holbein's
Portrait of Sir Thomas More (1527), pictured here.

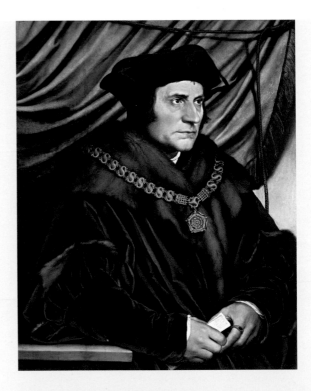

Portrait of Sir Thomas More, **Hans Holbein the Younger,
1527, oil on oak panel, 75 x 60.5 cm (29 ½ x 23 ¾ in.),
Frick Collection, New York, USA**

Painted while Holbein was living in London, this depicts
Henry VIII's diplomatic envoy and Privy Councillor,
Thomas More. Two years after it was painted, More
became Lord Chancellor, but he was later executed for
disagreeing with the annulment of the king's marriage to
Catherine of Aragon. Here, More wears a chain of office
that indicates his service to the king. In Sherman's image,
she reflects on More's prominent status before his demise
and the ways in which high-powered men of the period
attired themselves ostentatiously to demonstrate their
control of almost every aspect of life.

① CARICATURE

While the image can be translated as a cynical view of social customs and male conceit through the ages, it can also be viewed as a caricature. Sherman said: 'The images are little more than smug parodies of classical art portraiture and make no emotional connection, or provoke any inner exploration by the viewer.'

② GENERIC PORTRAIT

Sherman avoids titling her works and identifies them merely with numbers, which helps leave interpretations open to viewers. This image relates to a generic portrait of a successful man of the 16th century. It is based loosely on Holbein's *Portrait of Sir Thomas More* as well as his portrait *Thomas Cromwell* (1532–33). Sherman said she derived inspiration from secondary rather than primary sources: '…when I was doing those history pictures, I was living in Rome but never went to the churches and museums there. I worked out of books, with reproductions. It's an aspect of photography I appreciate conceptually: the idea that images can be reproduced and seen anytime, anywhere, by anyone.'

③ EYEBROWS

Sherman's painting alludes to the familiar style of Holbein. She uses exaggeration so draw an incongruous comparison. The theatricality of Sherman's costume looks disproportionate and even farcical. Props, especially the long shaggy hair, protruding forehead and monobrow give the sitter a clownish appearance that contrasts with the sombre dignity of Holbein's subjects.

Sherman is categorized as part of the Appropriation art movement that began with Duchamp's ready-mades and reached prominence during the 1980s in the United States. The movement followed Pop art in its imitation of masterpieces and mass-media images but reworked them to arouse a sense of uneuse and encourage viewers to re-evaluate them.

④ EXPRESSION

Sherman's unfathomable expression provokes questions about identity and the relationship between the artist and viewers. She has said: 'When I prepare each character, I have to consider what I'm working against; that people are going to look under the make-up and wigs for that common denominator, the recognizable… I am trying to make other people recognize something of themselves rather than me.'

⑤ CONTRAST

Not a copy of any one particular painting, this photograph is meant to evoke a sense of Holbein's paintings. Sherman has dismantled and confused the original concept by being artist and model, and a female dressed as a male. In highlighting the contrasts and differences, it offers viewers a way of reconsidering their understanding of the original painting and its messages with a modern outlook as well as to question representation itself.

⑥ PROPS

Sherman frequented flea markets to find props and costumes for her projects. The make-up, costumes and props recreate the look of 16th-century portraits that also overlap with and differ from its prototype. In Holbein's portrait of More, the subject wears fur and a chain of office, but he holds a piece of paper, not a piece of fruit. Sherman included a mangosteen to refer to Holbein's use of props as symbols to describe the lives of his sitters.

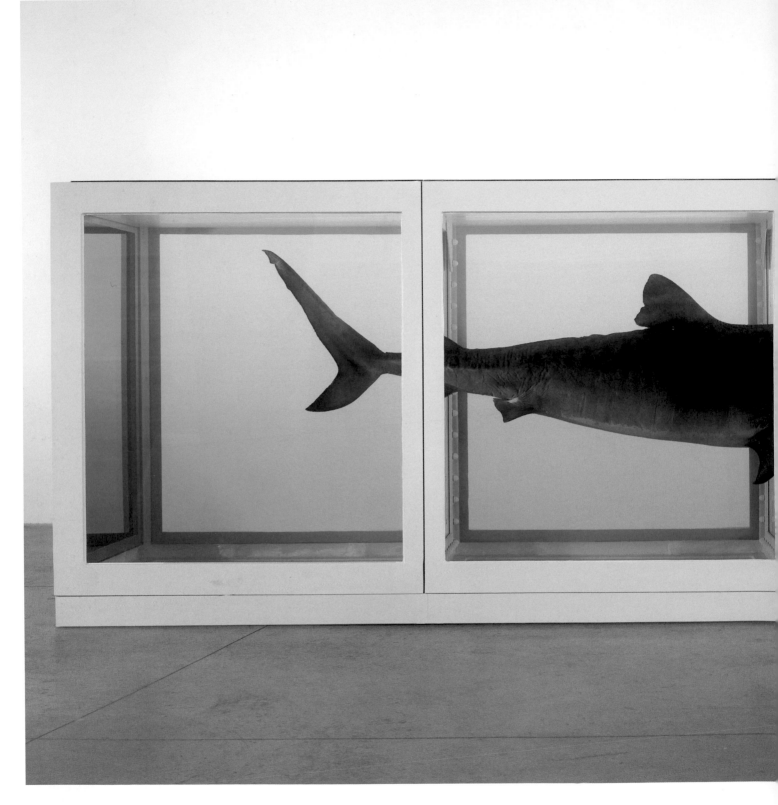

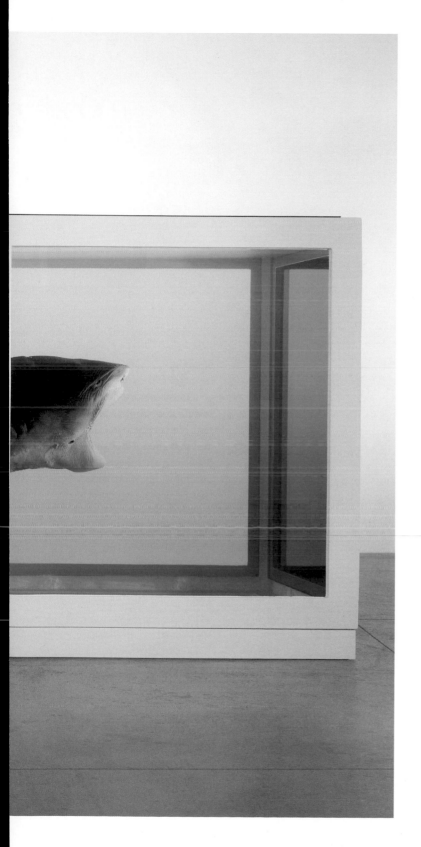

THE PHYSICAL IMPOSSIBILITY OF DEATH IN THE MIND OF SOMEONE LIVING

DAMIEN HIRST

1991

tiger shark, formaldehyde solution, glass, painted steel
217 x 542 x 180 cm (85 ½ x 213 ⅜ x 71 in.)
private collection

SYNONYMOUS WITH THE PROVOCATIVE art movement of the 1990s, the Young British Artists or YBAs, Damien Hirst (b.1965) was propelled to fame when British art collector and advertising tycoon Charles Saatchi backed him and he produced this installation of a dead shark suspended in a tank of formaldehyde.

Hirst was born in Bristol but grew up in Leeds. A difficult schoolboy, he achieved an 'E' grade in his art A-level. After taking the Foundation Diploma course at the Jacob Kramer School of Art (now Leeds College of Art), he moved to London in the early 1980s, and studied at Goldsmiths from 1986 to 1989. While he was there he curated a show, 'Freeze' (1988), which showcased his work and that of fellow students from Goldsmiths, who later became known collectively as the 'YBAs'. Among several other influential visitors, Saatchi attended the exhibition, and decided that Hirst's work was worthy of investment.

Death has often been a central theme in Hirst's work, reflecting his interest in mortality and humanity's reluctance to confront it. After shocking viewers with an installation including a maggot-infested carcass, *A Thousand Years* (1990), he continued the theme with *The Physical Impossibility of Death in the Mind of Someone Living*, and further installations featuring dead animals, such as dissected cows, pigs and sheep.

IN DETAIL

② DEATH

The tiger shark represents life and death. Death in actuality, but also in the realization that in another situation, such close proximity with this predator could result in the death of the viewer. Being in such close proximity to a silent and ghostly 4-metre (13-ft) long tiger shark is something most people will never experience. It encourages viewers to confront fears about death.

① MEMENTO MORI

Funded by Saatchi, this work brought Hirst international renown. Despite its shock value, it draws parallels with the *memento mori* and *vanitas* artistic traditions that served as stark reminders of mortality and the transience of life. On the meaning of the work, Hirst commented that the concept 'came from a fear of everything in life being so fragile.'

③ VITRINE

The dead fishy predator is preserved in formaldehyde and encased in a vitrine like an exhibit in a museum of natural history. The installation emphasizes that life is ephemeral, and that even the strongest life forms are inherently assailable. Hirst explained that he wanted 'to make a sculpture where the fragility was encased. Where it exists in its own space.'

④ SHARK

Hirst paid a fisherman £6,000 to kill a shark, asking for something 'big enough to eat you'. It was caught off Queensland, Australia but the specimen deteriorated and was replaced in 2006. There is a debate whether the sculpture with the replacement is the same artwork. Hirst has said: 'I come from a Conceptual art background, so I think it should be the intention. It's the same piece.'

⑤ HORROR

The vast, gaping mouth appears frightening and dangerous, augmented by the viewers' understanding of sharks' behaviour. The shark's eyes stare back at viewers, with a lidless, unnerving gaze. Although the creature is dead and cannot harm viewers, it still has the power to provoke their fear in the same way that a horror film evokes such feelings. In some ways, this installation is comparable to more traditional art of the past as it captures a moment, paused and immortalized in time.

⑥ STATIC

By using a shark and immersing it in turquoise-green liquid, the installation suggests movement in its natural habitat, the sea. Standing away from the case, viewers can imagine that the creature is alive and swimming. Yet in close up or on longer consideration, it can be seen that this is a completely static composition. The shark is in an unnatural environment, preserved in a glass tank and trapped forever. The creature's stillness projects an eerie, unsettling quality.

The Severed Heads, Théodore Géricault, 1818, oil on canvas, 50 x 61 cm (19 ⅝ x 24 in.), Nationalmuseum, Stockholm, Sweden

After training in the Neoclassical painting style, Théodore Géricault (1791–1824) was inspired by the work of Rubens, Titian, Velázquez and Rembrandt. Their exuberant paintings stimulated him to create his own style, which distinguished him as a precursor of Romanticism. He made studies of horse anatomy and movement, and like Hirst, he was interested in death as a theme in his work. He was fascinated by human body parts and made studies in morgues in Paris and at public executions of political prisoners while in Rome from 1816 to 1817. He painted these repeatedly over two weeks to record colour changes in the rotting flesh. Famously, he expressed many of these findings in his over life-sized *The Raft of the Medusa* (1818–19), which he painted a few months after these severed heads.

SELF-PORTRAIT

CHUCK CLOSE

1997

oil on canvas
259 x 213.4 cm (102 x 84 in.)
Museum of Modern Art, New York, USA

RENOWNED FOR HIS ORIGINAL methods of monumental portrait painting, Charles 'Chuck' Close (b.1940) has maintained his position as a leading figure in contemporary art since the 1970s. His struggle with dyslexia, prosopagnosia (the inability to remember faces) and partial paralysis, have not detracted from his determined and intuitive methods of painting.

Although his family had financial constraints, while growing up to the north-east of Seattle, Close's parents hired a tutor to give him art lessons. He struggled academically because of his dyslexia but his creative abilities were always advanced. Yet through his artistic talents, while at the University of Washington in Seattle, he won a scholarship to the Yale Summer School of Music and Art. In 1962, he was accepted on the Yale Master of Fine Arts course. He also worked as a studio assistant to Hungarian printmaker Gabor Peterdi (1915–2001) and just before leaving Yale, he won a Fulbright scholarship, which gave him the opportunity to study art in Europe.

In 1965, after completing his travels abroad, Close began teaching art at the University of Massachusetts Amherst. Initially, he painted in an Abstract Expressionist style but he soon began painting large nudes from photographs. Changing his direction slightly, but still working along similar lines, he produced *Big Self-Portrait* in 1968, which initiated his huge 'Heads' series, all painted in massive close-up from photographs. All in black and white, the portraits highlight rather than hide their photographic roots. Although he achieved success with his black and white portraits, Close began to use colour once again, initially emulating the photographic dye-transfer process, in applying separate layers of cyan, magenta and yellow. Painted on top of each other, the colours appear to mix and create full-colour images for viewers. Next, Close began working with grids, sizing up facial features. Then in December 1988, Close suffered a seizure that led to complete paralysis below the neck. Eventually he regained enough movement and control in his upper body to be able to resume painting, and he made this large self-portrait nine years after what he calls 'The Event'.

Detail from *Oceanus and Tethys*, artist unknown, 4th century, mosaic, 272 x 269 cm (107 x 106 in.), Hatay Archaeology Museum, Antioch, Turkey

Close's work is influenced by ancient Greek and Roman mosaics, the Action painting of Pollock and photography. He has developed several methods, including the tessellated patterns on his *Self-Portrait* of 1997. Like this ancient mosaic from the Greco-Roman city of Antioch, Close's self-portrait has been created from small facets, resulting in a dazzling whole image. Unlike this mosaic, however, his *Self-Portrait* is a highly abstract and systematic composition of individual parts, and a finely rendered likeness of the subject.

② MARKS

Through his complex combinations of colour and mark-making, Close has developed an almost abstract approach to portraiture. Across the image, he has created small shapes in paint that includes circles, triangles, squares and ovals. He calls his preoccupation with achieving unity of surface as 'all-overness'.

① ILLUSION

While some have described Close's work as Photorealist, he has never liked the term, and maintains that his work has always dealt as much with illusion and artificiality as it has with realism. So while this is an illusion of his face, he has stated: 'I'm as interested in the distribution of marks on a flat surface… as I am with the thing that ultimately gets depicted….'

③ WOVEN PATTERNS

Recalling tapestries, mosaics and pixelated images, this work appears in close-up like a woven pattern and from a distance, as a unified, detailed and lifelike portrait. Close has developed a realistic image of a face through drawings of simple shapes created across a large chequerboard pattern with every small square as significant as every other.

Since The Event when Close suffered a spinal artery collapse that left him paralysed from the neck down, he has relied on a wheelchair. He now paints with a brush taped to his wrist, and creates his large portraits with the aid of a special easel and an assistant. His meticulous working method means he was able to produce this precise and realistic portrait despite his inability to remember faces.

④ SYSTEM

To create this work, Close overlaid a grid on a Polaroid photograph that divided the image into sections, which he scaled up and painted on to his canvas, cell by cell. He compares his methodical row-by-row system of painting with knitting.

⑤ COMPOSITION

All areas of the composition are given equal emphasis. Larger than life, highly focused and in extreme close-up – with the face taking up almost the whole surface and even being cut off the edges – it creates an immediate impact.

⑥ PROCESS

Close begins by applying a background colour to each cell. Unlike most artists, he does not step back to view his work from afar but continues to paint at a close distance. The work is effective in its entirety because he studies the hue and lightness of all colours on the photograph first, and matches them closely in paint.

⑦ COLOUR

Close creates strong contrasts between light and dark hues, matching them with the colours in his photograph. He fills each cell of his grid with four or five colours in the correct tone. Each of these becomes an abstract colour study but from a distance, they appear to mix and create a certain colour and tone.

21ST CENTURY

THE 21ST CENTURY HAS been called the Information Age. Since its introduction in the 1990s, the World Wide Web made knowledge and information more accessible to everyone, and artists became even more interdisciplinary, using a wider variety of materials, sometimes cheap and easily accessed, or sometimes priceless or extremely technical. Figurative or abstract, large or small, enduring or ephemeral, art continues to erase old boundaries and traditions. Globalization has seen artistic influences change drastically, as human interaction and communication occur at greater speed. Yet while the artists' views on identity, gender, class, relationships and social and political meanings and values may be entirely different from many artists of previous centuries, surprisingly, some artistic approaches and attitudes have altered little.

HOW TO BLOW UP TWO HEADS AT ONCE (LADIES)

YINKA SHONIBARE MBE

2006

two fibreglass mannequins, two prop guns, Dutch wax-printed
cotton, shoes, leather riding boots, plinth
dimensions variable; plinth 160 x 245 x 122 cm (63 x 96 ½ x 48 in.);
each figure 160 x 155 x 122 cm (63 x 61 x 48 in.)
Davis Museum at Wellesley College, Massachusetts, USA

YINKA SHONIBARE MBE (B.1962) is a British-Nigerian
artist who paints, sculpts, photographs and produces films,
often exploring issues of race, class, culture and identity.
Frequently using brightly coloured and patterned fabrics, he
creates life-sized sculptural tableaux that contrast European
and West African traditions.

Although he was born in London, when he was three
years old, Shonibare moved with his family to Lagos in
Nigeria, where his father practised law. At the age of sixteen,
he returned to school in London and later studied Fine Art,
first at Byam Shaw School of Art and then at Goldsmiths
College, where he attained a Master of Fine Arts. During that
time, he contracted transverse myelitis, an inflammation of
the spinal cord that resulted in a long-term physical disability
where one side of his body is paralyzed. Resolute that he
would continue as an artist, he has since directed assistants
to make much of his artwork. He said: 'I was determined
that the scope of my creativity should not be restricted purely
by my physicality. It would be like an architect choosing to
build only what could be physically built by hand.'

Initially he also worked as a development officer for an
organization that makes art accessible to disabled people,
and he began exhibiting at leading international museums and
exhibitions, including the Venice Biennale. In 2002, he was
commissioned by the Nigerian curator Okwui Enwezor to
create *Gallantry and Criminal Conversation*, a work that
brought him international renown. In 2004, he was shortlisted
for the Turner Prize and was made a Member of the Most
Excellent Order of the British Empire.

The life-sized sculptural arrangement *How to Blow Up
Two Heads at Once (Ladies)* is one of several works featuring
headless figures in elaborate period garments. The mannequins
wear reconstructed 18th-century costumes and wield guns, and
the artwork was inspired by the revenge killings of aristocrats
during the French Revolution (1789–99).

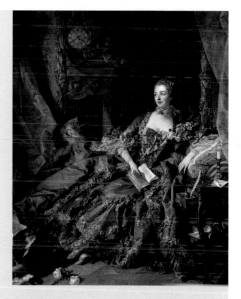

**Detail from *Marquise de Pompadour*,
François Boucher, 1756, oil on canvas,
201 x 157 cm (79 ⅛ x 61 ¾ in.),
Alte Pinakothek, Munich, Germany**

This is one of several portraits French
Rococo artist François Boucher
(1703–70) painted of the mistress of
Louis XV, Madame de Pompadour, or
Jeanne de Poisson. The portraits were
part of her strategy for power, and she
used them to secure royal patronage
for Boucher. With their ruffles,
ribbons, frills and flounces, the frothy
fashions appealed to Shonibare's
interest in Rococo art and its approach
towards women and history.

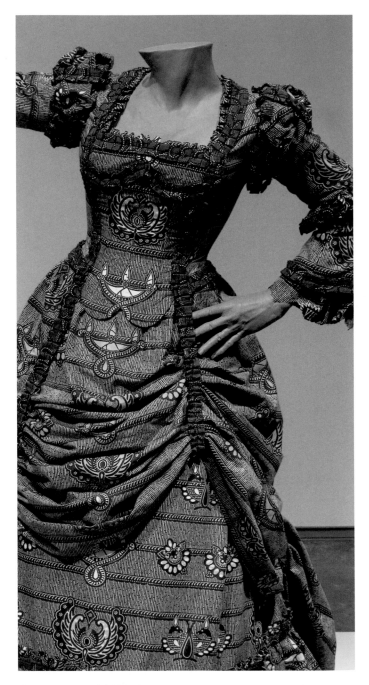

❶ FABRIC

Since 1994, Shonibare has worked brightly coloured fabrics that he buys from London's Brixton market. They blend African-style patterns with Indonesian design and Dutch mass production. He explained: '[The fabrics] have a crossbred cultural background quite of their own. And it's the fallacy of that signification that I like. It's the way I view culture – it's an artificial construct.'

❷ DECAPITATION

Shonibare has frequently produced art featuring headless mannequins, representing moments in history and from art history. Although his underlying considerations are serious, he expresses them with humour. The decapitated heads here are not gory – just missing, so viewers do not consider their facial features or hairstyles, but the meanings behind the outward appearance.

3 PISTOLS

Each pointing at what would be the other woman's face, these are percussion-cap duelling pistols, introduced in the early 19th century and able to be fired in all weathers. The pistols were not used much until after 1840, but Shonibare was not interested in being historically accurate. The fabrics he employed have a multilayered history and the artwork has multilayered meanings; it is a critique of colonialism and empire, and exploration of individual and political power.

4 CULTURAL CONFUSION

By dressing these figures in lavish European Rococo styles and in materials that are generally perceived as being African, Shonibare questions established beliefs and myths that so often complicate the integration of cultures. Shonibare experienced this strongly as he grew up: he was educated in English, but spoke Yoruba at home.

5 CLASS BARRIERS

In the late 18th century, printed cotton was expensive and worn only by the upper classes. By the early 19th century however, advances had been made in textile technology that resulted in printed cotton becoming more affordable for the middle and lower classes. So these women could be of any social class and the cause of the fierce tension between them is open to conjecture.

DOTS OBSESSION – INFINITY MIRRORED ROOM

YAYOI KUSAMA

2008

eleven balloons, vinyl dots, mirrors, lighting
dimensions variable
installation at various locations

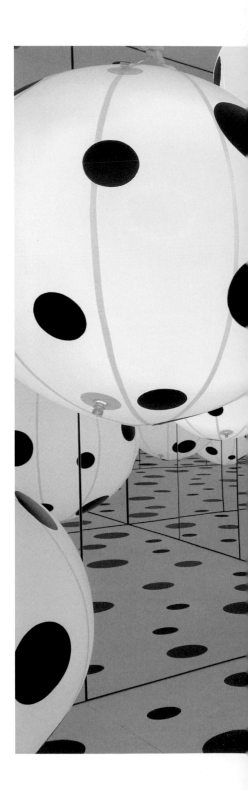

SINCE THE 1950S, JAPANESE artist Yayoi Kusama (b.1929) has been creating repeating patterns. Expressing her ideas with unusual materials and bright colours, she paints and produces installations, filling large spaces to generate the most impact.

Born in Matsumoto City in 1929, she studied the formal style of *nihonga* painting in Kyoto before moving to New York in the late 1950s. There she mixed with artists including Warhol, Cornell and Oldenburg. She experimented with sculpture and installation, exploring her identity as a female artist in a male-dominated society and as a Japanese artist in the Western art world. She came to attention when she organized a series of Happenings in which naked people were painted with brightly coloured polka dots. Since returning to Japan in 1973, she has been involved with film, printmaking, fashion and product design. Although she is classed as a Conceptual artist, she insists that her work cannot be labelled.

Since childhood, she has suffered with anxieties, depressive episodes and suicidal thoughts. One of many similar explorations, *Dots Obsession* expresses her ideas about floating, being closed in, and childhood memories.

Bridge at Courbevoie, Georges Seurat, 1886–87, oil on canvas, 71 x 81 cm (28 x 31 ⅞ in.), Courtauld Gallery, London, UK

Kusama is not the first artist obsessed by dots. In the 19th century, Seurat painted using the pointillist technique of tiny dots of pure colour. This is his view of a suburb near Paris.

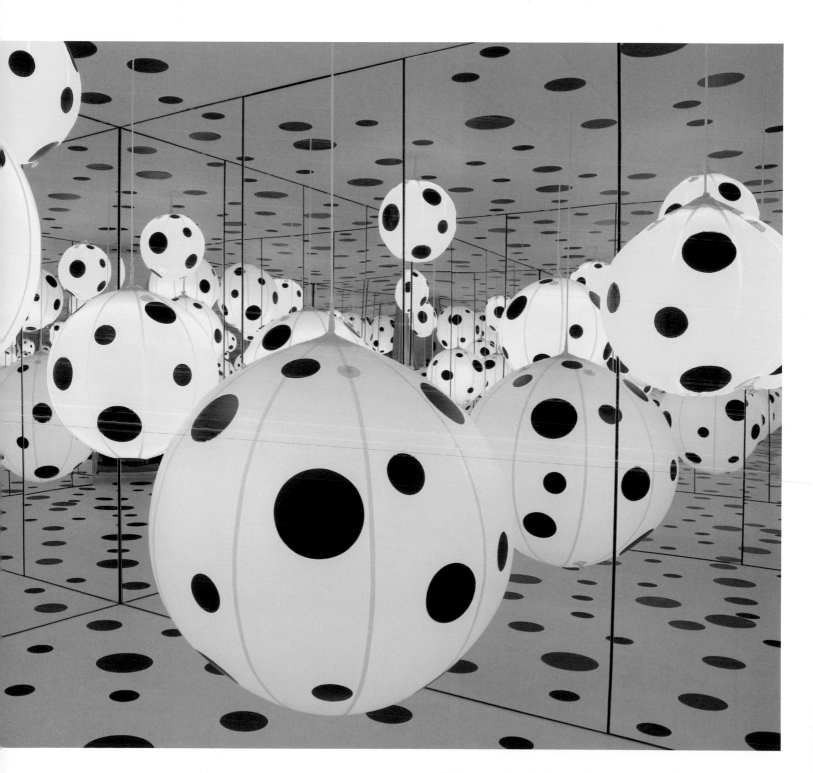

② SPACE, COLOUR AND LIGHT

Despite the seemingly haphazard arrangement, Kusama paid careful attention to the construction of space here through colour and form, and to the play of light and perspective with the aid of strategically placed mirrors. Bright colours have been a feature of her work since the 1960s.

③ ILLUSIONS

Illusions are created through the mirrors. The shapes and forms, dots, colour and light are disorientating. Simultaneously unlimited and immeasurable, the shapes are large and close, but the reflections are small and distant. These and other conflicting sensations caused by the scale of the balloons, the dots and the mirrors create an illusion of a never-ending space.

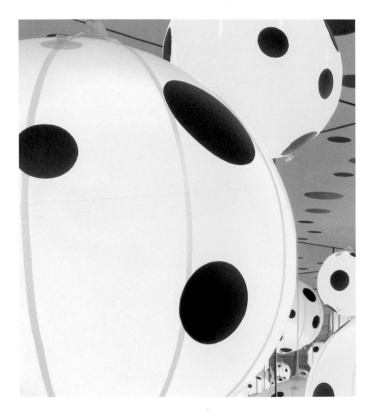

① DOTS

Kusama has incorporated dots in her art since 1939, when she drew her mother wearing a dot-patterned kimono. She has described her use of dots as 'self-obliteration'. Here, she employs giant polka-dot-covered balloons to invite viewers to step in and share her experience. The negative spaces around and between the dots are as vital as the dots.

④ INFINITY

Kusama investigates ideas of infinity. The spheres hanging at varying heights, mirrors and repeated dots and colours create a continuous space. It is unclear where this work begins or ends, and this encourages viewers to experience feelings of claustrophobia or even floating.

⑤ ENCLOSED AREA

This dotted interior with its large, hovering balloon shapes evolved from Kusama's idea that on entering the installation, viewers – or participants – are immediately affected by the cocoonlike surroundings. The overall effect is one of bombardment of the senses.

⑥ REFLECTIONS

Kusama has made extensive use of reflections in this installation, which are presented in two ways. First, in the many balloons and their common pattern of dots, plus the continuation of the pattern on the floor and ceiling. Secondly, in the floor-to-ceiling mirrors.

⑦ HALLUCINATIONS

Kusama has said her work emerged from hallucinatory visions that she has experienced since childhood. The relentless patterns, with their obsessional repetition of dots, are derived from her subconscious, in which the world is covered with proliferating forms. She explained: 'I translate the hallucinations and obsessional images that plague me into sculptures and paintings.'

Flowers of the Twelve Months, Watanabe Seitei, *c.* 1900, ink and colour on paper, 174 x 60 cm (68 ½ x 23 ⅝ in.), Ashmolean Museum, University of Oxford, UK

This is one of a pair of folding screens painted by *nihonga* artist Watanabe Seitei (1851–1919) representing the months of the year in the traditional style in which Kusama trained. *Nihonga* paintings do not seek to appear lifelike and they contain no shadows. They have calligraphic outlines, soft colours and simple compositions. Kusama's art absorbed some of the style's disciplines, and her productions retain apparent simplicity.

KAPANCIK

MONA HATOUM

2012

mild steel and handblown glass
64 x 34 x 34 cm (25 ¼ x 13 ½ x 13 ½ in.)
installation at various locations

MONA HATOUM (B.1952), WHO lives and works in London, was born into a Palestinian family in Beirut. She has produced videos, performances, photography, sculpture and installations, often exploring themes of war, exile and violence.

Because of opposition from her family to study art, Hatoum chose to study graphic design at Beirut University College as a compromise. In 1975, she travelled to London but while she was there civil war broke out in Lebanon and she could not return. Instead, she studied art at the Byam Shaw School of Art and the Slade School of Fine Art until 1981. Since then, she has held several artist's residencies in Britain, Canada, the United States, France, Germany and Sweden. She has also taught in London and Maastricht as well as at the Cardiff Institute of Higher Education and the École des Beaux-Arts in Paris.

Hatoum's earliest work was Performance Art that spoke of torture, separation, powerlessness and oppression. Since 1989, she has concentrated on producing sculptures and large-scale installations using everyday materials and domestic objects. Her work can be evaluated as suggesting the contrasts within her life: her Middle Eastern roots and the time spent in England and then more recently, Berlin. It can also be interpreted as an exploration of space. She often addresses individual vulnerability with installations that initially appear innocent, but on closer inspection offer more sinister translations that seek to engage viewers with contradictory emotions. In 1994, she had a solo exhibition at the Centre Georges Pompidou in Paris and the following year, she was short-listed for the prestigious Turner Prize in the UK.

KAPANCIK evolved from a series of works in which Hatoum sought to convey notions about boundaries, restrictions, contrasts and entrapment. Metal grids have been a recurring theme in her installations, alluding to violence and imprisonment. In 2016 she told The Guardian newspaper: 'I am focusing on the materials, on the aesthetic. In fact, I sometimes spend time trying to remove the content, the better to arrive at abstraction. The tension is between the work's reduced form and the intensity of the possible associations.'

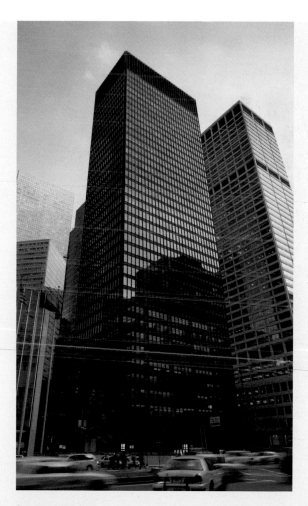

Seagram Building

New York's Seagram Building was designed in 1958 by Ludwig Mies van der Rohe. Its minimalist grid of windows and glass and bronze exterior adhere to the International Style of architecture that features simple rectilinear forms and the use of reinforced concrete, glass and steel. Hatoum's KAPANCIK takes inspiration from it.

① CAGE

This structure is like a cage with no entrance or exit. It combines industrial materials and the reduced forms of Minimalism, along with handblown glass that can be seen as a reference to Hatoum's body. It suggests notions of entrapment or of being confined. This grew out of her experiences early on when she wanted to pursue a career in art but was discouraged, and later when she could not return to Lebanon from England because civil war broke out.

② CONTRASTS

Contrasting with the hard, solid gridlike geometric structure of the cage, this cherry red form appears soft, organic and translucent. The materials contrast with each other too: one is tough metal and the other is fragile glass. This can be compared with the Chinese philosophy of yin and yang as it features opposing forces: colourless and colour, dark and light, male and female.

③ RED

Inside the cage, this reflective red form bulges around and between the bars. It resembles an internal body organ, perhaps a heart or a piece of raw meat, and presses against the hard, heavy metal bars. Blown glass such as this is usually associated with a delicate ornament or vase chosen to bring cheer to the home, but here it seems heavy and deflated, evoking sadness.

④ STEEL

This sculpture is made from mild steel (and handblown glass), using an interlaced technique that has been employed since the medieval period to make window grills. The geometric lines of the steel cage appear strong and immobile, which conveys a sense of confinement or isolation, or contrastingly, the spaces between could imply energy or hope. As an alloy, steel is versatile, strong and relatively accessible, with a high tensile strength and low cost, and so is used widely in industry.

⑤ MATERIALS

During the late 1960s and 1970s, a radical Italian art movement, Arte Povera, developed. The artists involved explored a range of unconventional processes and nontraditional, ordinary materials that can be seen in Hatoum's work. However, while many Arte Povera artists were critical of the consumer society and the commercial values of the gallery system, Hatoum focuses on other aspects of life including personal freedom and the human condition. She told *The Guardian* in 2015: 'Each person is free to understand what I do in the light of who they are and where they stand.'

Detail from *War. The Exile and the Rock Limpet*, J. M. W. Turner, exh. 1842, oil on canvas, 79.5 × 79.5 cm (31 ¼ x 31 ¼ in.), Tate Britain, London, UK

Like Hatoum, English painter Turner was greatly affected by conflict and his work was often inspired by the Napoleonic Wars (1803–15). The wars had a huge effect on all Europeans and for Turner one of the greatest difficulties was that it prevented travel across the Continent. He painted this in the year Napoleon Bonaparte's ashes were returned to France. It shows Napoleon in exile, standing alone against the sunset on the island of St Helena. In verses that Turner wrote to accompany the paintings, he described the sunset as a 'sea of blood', referring to the pain and suffering of war.

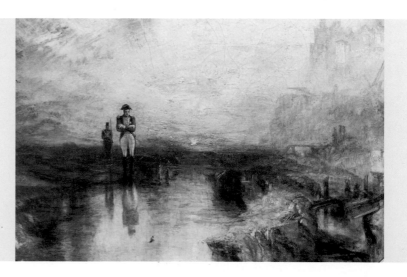

MARTYRS (EARTH, AIR, FIRE, WATER)

BILL VIOLA

2014

colour high-definition video polyptych on four vertical plasma displays, 7:15 minutes
executive producer: Kira Perov; performers: Norman Scott, Sarah Steben, Darrow Igus, John Hay
140 x 338 x 10 cm (55 x 133 x 4 in.)
on loan to St Paul's Cathedral, London, UK
gift to Tate by Bill Viola and Kira Perov, with support from donors

OFTEN DEMONSTRATING PHILOSOPHIES INSPIRED by Zen Buddhism, Sufism and Christianity, with specific references to medieval, Renaissance and Baroque art, Bill Viola (b.1951) produces installations and videos using various technologies to explore life experiences and metaphysical issues.

Born in New York, Viola studied fine art at Syracuse University and then made experimental electronic music until 1980. During that time, he also began creating video installations, but in 1980, he moved to Japan on an artist fellowship exchange and while there, studied Zen Buddhism, including ink painting and meditation, with the master Daien Tanaka. He maintained that the experience helped him to see 'the sense of an object.' He became the first Artist in Residence for Sony Corporation's Atsugi research laboratories. Since then, among a wide range of projects, he has collaborated with medical-imaging technologies, explored animal consciousness at San Diego Zoo, investigated fire-walking rituals in Hindu communities in Fiji, studied Native American rock-art sites and recorded nocturnal desert landscapes.

Frequently working in collaboration with his wife Kira Perov (b.1951), Viola explores and articulates universal themes and underlying truths. In 2003, he was commissioned to create an installation for London's St Paul's Cathedral. The work was installed in 2014. Soundless and in slow motion, it consists of four screens, each featuring a figure being martyred using one of the four cardinal elements: earth, air, fire and water. The four plasma screens are mounted in a row in the cathedral's south quire aisle. Placed near older and more familiar paintings and sculpture, the work does not seem out of place in the Anglican Baroque cathedral. It echoes a Renaissance altarpiece. Yet it also contrasts with tradition as it invites visitors of all faiths and nationalities to contemplate time, space, suffering and sacrifice, and what it might be like to die for one's beliefs.

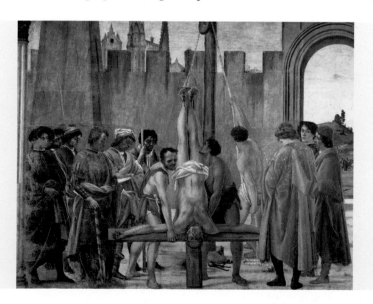

Detail from *Disputation with Simon Magus and Crucifixion of St Peter*, Filippino Lippi, 1481–82, fresco, 230 x 598 cm (90 ½ x 235 ½ in.), Cappella Brancacci, Santa Maria del Carmine, Florence, Italy

The Brancacci Chapel in the Church of Santa Maria del Carmine in Florence is renowned for its Renaissance painting cycle, primarily created by Masaccio and Masolino da Panicale (*c.* 1383–*c.* 1435). After Masaccio's death in 1428, Filippino Lippi, a Florentine painter who was taught by his father Fra Filippo Lippi (*c.* 1406–69) and Botticelli, completed the unfinished cycle. Inspired by his teachers, Filippino developed his style comprising animated lines and warm colouring. His depiction of the Crucifixion of St Peter is known to Viola, and it is clear that it had an influence on him in *Martyrs*, although he has stressed that he is not interested in recreating historical paintings.

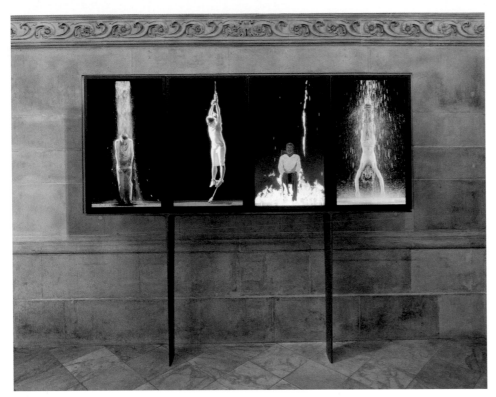

Martyrs is located in St Paul's Cathedral, London. A place of Christian worship for more than 1,000 years, first dedicated to Paul the Apostle in AD 604, the cathedral was built between 1675 and 1708 in a Baroque style by Christopher Wren to replace an earlier church on the site. Viola explained that he created *Martyrs* to symbolize 'some of the profound mysteries of human existence'. It is a quadriptych or tetraptych: a four-part arrangement of images that reflects the religious art he saw in Florence when he worked there from 1974 to 1976. It is intended to function as an aesthetic object of contemporary art and as a practical object of 'traditional contemplation and devotion.' Concerned with the nature of existence, he has said: 'This work deepens our perceptions by slowing them down... We each have been given the gift of being.'

2 EARTH

A fine spiral of earth is sucked upward by an unseen force. Resembling an earthquake survivor, this martyr emerges from beneath a heavy pile of earth. This may be a metaphor for the soul as it becomes transformed by an intense experience.

3 AIR

Bound at the wrists and ankles, a woman in white is suspended on a rope and appears buffeted by a storm. Viola explained that the martyrs 'exemplify the human capacity to bear pain, hardship and even death in order to remain faithful to their values...'

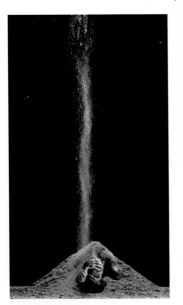

④ FIRE

A seated man is encircled by small flames that develop into an inferno, accepting his fate with dignity. The sequence was shot from different angles in multiple takes to construct a narrative. The man wakes and realises that a fire is burning around him; he begins to fight back and then calms down to eventually come through the experience. The emphasis here is on his fortitude, courage and spirituality. It challenges viewers to think of sacrifice. Viola has said of his video artwork: 'As the elements rage, each martyr's resolve remains unchanged. In their most violent assault, the elements represent the darkest hour of the martyr's passage through death into the light.' The video runs on a 7-minute cycle and viewers can watch it again and again. Each of the four narratives shares a rhythm over time to form the artwork.

⑤ WATER

In the water sequence, a man lying on the ground is hoisted into the air by his feet as water pours over him, adopting a pose reminiscent of a crucifixion upside down. Viola remains profoundly affected by an experience he had as a child when he almost drowned, remembering his sense of calm rather than panic, and seeing 'the most beautiful image I ever saw in my life' including reeds, a fish and light glinting through the water. For this reason, water remains a frequently occurring element in his work.

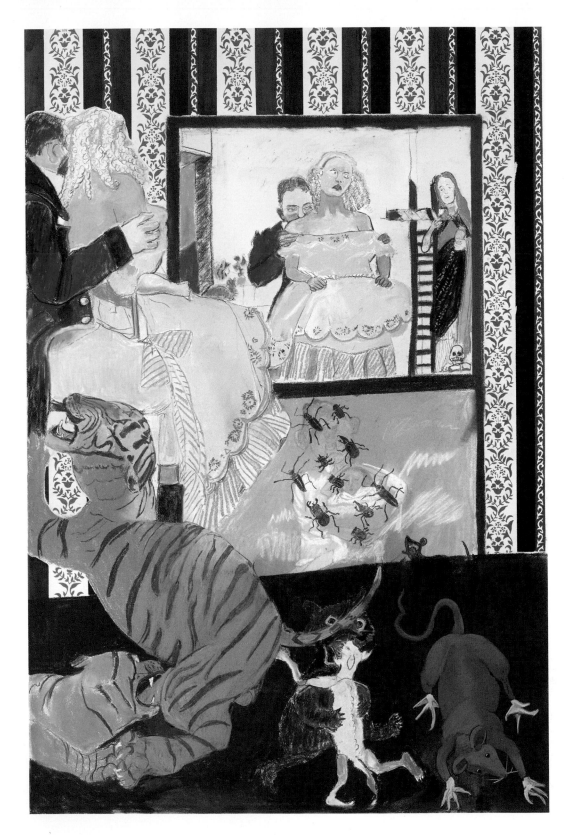

VISIONS

PAULA REGO

2015

pastel on paper
180 x 119 cm (71 ⅝ x 47 in.)
Marlborough Fine Art, London, UK

BORN IN LISBON, PAULA REGO (b.1935) was sent to a finishing school in England when she was sixteen-years-old but a year later, she transferred to study at the Slade School of Fine Art in London. There she met fellow art student Victor Willing (1928–88), and in 1957, she and Willing moved to Ericeira in Portugal, marrying two years later after Willing's divorce from his first wife. From 1962, the couple spent their time in Portugal and London, and Rego began exhibiting with The London Group, an artists' organization established in 1913 by among others, Walter Sickert (1860–1942), Jacob Epstein (1880–1959) and Wyndham Lewis (1882–1957). Rego's career ascended rapidly and she exhibited in Portugal and Britain, and then internationally.

In 1966, Rego's father died and Willing was diagnosed with multiple sclerosis. Willing died in 1988, and in that same year, Rego was the subject of a retrospective exhibition at the Calouste Gulbenkian Foundation in Lisbon and the Serpentine Gallery in London. In 1990, she was invited to become the first artist in residence at the National Gallery in London. A prolific worker, Rego says she is fascinated by 'the beautiful grotesque' in life and art, and is renowned for her paintings, prints, drawings and collages based on fairy and folk tales, cartoons, religious texts, literature and autobiography, and her use of pastels over more traditional oils. Her early style was influenced by Surrealism, particularly the automatism of Miró, and was often quite abstract. Nevertheless, her work has always retained a strong narrative element; often comprising disconcerting, politically or sexually charged scenes with sinister or cruel undertones, exploring flawed, difficult relationships and social complications.

After 1990, Rego's work changed from a loose painterly style to firmer, more contoured forms. She gave up working with collage in the late 1970s, preferring the intense colours of acrylics. In 1994, she became captivated by the immediacy and vibrancy of pastels. This is one of seven pastel paintings that she produced in 2015 based on the highly regarded realist novel *O Primo Basílio* (*Cousin Bazilio*, 1878) by the eminent 19th-century Portuguese writer José Maria de Eça de Queirós in which Bazilio seduces his cousin Luiza, a married woman, whose husband is out of Lisbon on business.

Un chien andalou (*An Andalusian Dog*), **screenplay by Luis Buñuel and Salvador Dalí, 1929, silent film**

Dalí maintained that when he was five years old, he became fascinated by the sight of an insect that had been eaten by ants and of which nothing remained except the shell. From then, ants became one of several recurrent motifs in his work, famously in the Surrealist film he made with Spanish director Luis Buñuel, *An Andalusian Dog* (left), where they were used to symbolize death, decomposition, mortality, impermanence, decadence and most of all, acute sexual desire. Ants and beetles feature in Rego's painting for the same metaphorical reasons as Dalí's ants and also add to its portent as the insects did not live in the room, but came in from the outside by themselves.

② MARY MAGDALENE

This figure is Mary Magdalene, the patron saint of repentant sinners. In Christian imagery, she is often represented holding a jar, with either a book or a skull, representing her life of reflection and penitence. Rego has described herself as 'a sort of Catholic'. For this reason, and for the softness of this figure's depiction, Mary is probably included as a protective symbol.

① LUIZA AND BAZILIO

Rego engaged the Surrealist method of automatism in disconnecting her conscious mind to allow her unconscious mind to take over production. This is a mirror-reflection of Luiza, the married female protagonist, and Bazilio with whom she has an affair. In the opening pages of *Cousin Bazilio*, Queirós describes Luiza's innocent appearance: '…her slightly tousled blonde hair… coiled up on top of her small head with its pretty profile; her skin has the soft, milky whiteness of all fair-haired women….'

③ ANIMALS

Oversized rats, kissing cats and tigers performing sexual acts project the sleaziness of the affair. They convey Bazilio's perspective of it, rather than Luiza's false, romanticized notions. Rego has explained that frequently she uses animals to represent people: 'Because with animals, you can say anything, can't you?'

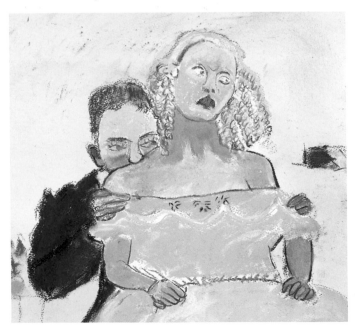

4 DEATH, HALLUCINATIONS AND LUST

The skull may relate to Mary Magdalene's role as a witness to Christ's crucifixion on Golgotha, the 'place of the skull'. The ants and beetles symbolize mortality and lust. These suggest the events of the novel, including the delirium and hallucinations of Luiza's later, guilt-induced illness and death, brought about through her affair with Bazilio and her blackmail by her greedy maid, Juliana.

5 MAN AND BABY

Beneath the mirror and under the ants and beetles, inside a pale blue case like an aquarium, a man holds a baby. Through Rego's use of automatism, this does not have a logical explanation, and as she continued the work, she began to erase the man and baby, and then added the insects over the top. Rego felt that this completed the picture, foreshadowing Luiza's downfall.

6 WALLPAPER

This is the apartment that Bazilio has rented in Lisbon in which to conduct the affair with Luiza. Blinded by her wish to see this as a romantic situation, Luiza calls the apartment 'Paradise' and Bazilio humours her. Yet in reality, with its overpowering, gaudy wallpaper that compares unfavourably with the tastefully decorated home she shares with her husband, this room is tawdry.

7 PASTELS

Enjoying the tactile rawness of pastels, Rego applies hard pastels first, sometimes creating indentations through pressure, then applies soft pastels over the top in layers, creating a sense of depth. She secures each layer with fixative and never smudges the pastels. Drawing directly from models, she explains: '…it's all layers, I never, ever rub.'

Glossary

Abstract art
Art that does not imitate real life but consists of forms, shapes and/or colours, independent of subject matter.

Abstract Expressionism
Post-World War II US art movement characterized by a desire for freedom of expression and the communication of strong emotions through the sensual quality of paint.

Abstraction-Création
An association of abstract artists set up in Paris in 1931, led by Auguste Herbin (1882–1960) and Georges Vantongerloo (1886–1965) aiming to promote abstract art through group exhibitions. Every major contemporary abstract painter took part.

Action painting
Technique in which paint is applied with gestural movements, often by pouring or splashing.

Aerial or Atmospheric perspective
To evoke illusions of distance, background objects are painted lighter, bluer and blurrier, with few details, emulating atmospheric effects.

Alla prima
Meaning 'at the first' or 'at once' in Italian, this is a style of painting completed quickly, usually in one session, while the paint is still wet. The French term is *au premier coup*.

Analytical Cubism
From approximately 1908 to 1912, Cubism was expressed in fragmentary, multiple viewpoints and overlapping planes. To differentiate that phase from the later stage of Cubism, in retrospect, art historians labelled it Analytical Cubism because of its structured dissection – or analysis – of the subject and simplified palette.

Armory Show
In 1913, an International Exhibition of Modern Art was held in New York at the 69th Regiment Armory. It later travelled to Chicago and Boston. The exhibition comprised approximately 1,300 paintings, sculptures and decorative works, including many avant-garde European examples, which were unfamiliar to US viewers. Reviewers criticized and ridiculed the exhibition, but it became a significant event in the history of US art, as from that time, many US artists began creating their own avant-garde art.

Art Deco
Taking its name from the '*Exposition Internationale des Arts Décoratifs et Industriels Modernes*' (International Exhibition of Modern Decorative and Industrial Arts) held in Paris in 1925, Art Deco spanned the 1920s and 1930s. It affected all forms of design, from the fine and decorative arts to fashion, film, photography, transport and product design. The style is characterized by rich colours, bold geometric shapes and gilded, angular ornamentation.

Arte Povera
Italian for 'Poor Art', the term was coined by Italian critic Germano Celant to describe art made using everyday materials such as newspapers, cement or old clothing rather than traditional materials such as oil paint. Predominantly created in the 1960s and 1970s by Italian artists.

Art Nouveau
From the early 1890s until the outbreak of World War I, a new international art, design and architectural style developed to express modern life. Emphasizing sinuous, organic lines, it emerged in painting, sculpture, jewelry, metalwork, glass, architecture, graphic arts and ceramics. Although mainly known as Art Nouveau, it was also known by several other names, including the Glasgow Style, Jugendstil, Stile Liberty, Modernisme and Stile Floreale.

Arts and Crafts Movement
Inspired by the writings and teachings of John Ruskin (1819–1900) and William Morris (1834–96), who hated the effects of industrialization and mass production on design, the Arts and Crafts Movement began in Britain in *c.* 1880 and then spread across Europe and to the United States and Japan. The movement advocated a return to a simpler way of life and a revival of traditional handicrafts, and became extremely influential.

Art Students League
Located in Manhattan, the Art Students League of New York was founded in 1875, specifically to offer reasonably priced art classes on a flexible schedule for students of all ages and abilities. Its informal attitude made it instantly appealing, while its reputation became established because of the calibre of its instructors and students, many of whom became significant artists.

Assemblage
An approach to art-making that was introduced by Picasso in *c.* 1912, assemblage is created through artists assembling various found or bought objects. Although the technique is usually three-dimensional, Schwitters created both 3D and 2D assemblages from 1918, using found oddments and calling the method '*merz*'.

Automatism
A method whereby the act of painting, writing or drawing is based on chance, free association, suppressed consciousness, dreams and states of trance. As a means of supposedly tapping into the subconscious mind, automatism was adopted with enthusiasm by the Surrealists and Abstract Expressionists.

Avant-garde
Term used to describe any new, innovative and radically different artistic approach.

Barbizon School
French landscape painters active from 1830 to 1870 and part of the Realist movement. The group took its name from the village of Barbizon, where the artists gathered to paint in the forest of Fontainebleau.

Baroque
Style of European architecture, painting and sculpture, produced from 1600 to 1750, Baroque is typically dynamic and theatrical and originally aimed to promote Catholicism during the Counter-Reformation. The best-known exponents were Caravaggio and Rubens.

Bauhaus
German school of art, design and architecture founded in 1919 by German architect Walter Gropius and closed by the Nazis in 1933. Artists such as Kandinsky and Klee worked there, and its trademark streamlined designs became influential worldwide, continuing to this day.

Baule sculpture or mask
More than two centuries ago, the Baule people moved to the Ivory Coast in Africa and adopted sculptural and mask-making carving traditions from their neighbours, the Guro, Senufo and Yaure peoples. Baule masks range from realistic to abstract; most feature human or animal attributes, and are worn only by men to contact Gu, the ruler of the world.

Ben-Day dots
Commercial printing style used for comic-book illustrations, in which small, closely spaced, coloured dots are combined to create contrasting colours and tonal contrasts.

Bete statue
The Bete people are mainly farmers, living in the south-western part of the Ivory Coast. Their religion promotes a harmonious relationship between nature and the spirits of their ancestors that inhabit the natural environment. As part of this religion, some perform in masks that feature exaggerated, distorted, often protruding features. The Bete also carve elegant statues influenced by their neighbours the Guro. Bete carvings are usually standing figures with an elongated torso and square shoulders.

Blaue Reiter, Der
German for 'The Blue Rider'. One of the two most important pioneering movements of German Expressionism, it had a particular emphasis on abstraction and the spiritual value of art. It was formed by a group of artists in Munich in 1911 to express their disaffection with the modern world.

Kandinsky and Marc were the leaders of the movement. The name refers to an important theme in Kandinsky's work; a horse and rider, which for him represented moving beyond realistic depictions. Horses were also prominent in Marc's work and for him animals symbolized rebirth.

Brücke, Die
German for 'The Bridge'. A group founded in Dresden in 1905 by four German Expressionists, who aimed to form a bridge with art of the future and oppose the established social order of Germany. The group, which had disbanded by 1913, espoused radical political views and sought to create a new style of painting to reflect modern life, although this was not complete abstraction. Noted for their landscapes, nudes, vivid colour and use of simple forms, the group which included Kirchner and Emil Nolde (1867–1956), had a major impact on the evolution of modern art, and especially on the development of Expressionism.

Byzantine
Term for orthodox religious art created during – or influenced by – the Byzantine (eastern Roman) Empire from AD 330 to 1453. Icons are a common feature in the art of this era, which is also typified by exquisite mosaic church interiors.

Camera obscura
Latin for 'dark chamber'. An optical device used to project an image via a hole or lens on to a wall or surface such as canvas opposite. The device was popular from the 15th century onwards among many artists including Canaletto (1697–1768), to help them to plan compositions with accurate perspective.

Chacmool figure
A particular form of pre-Columbian Mesoamerican sculpture depicting a reclining figure, leaning on its elbows with its head turning to the side, with a bowl or disk on its stomach, the Chacmool figure possibly represents dead warriors carrying offerings to the gods.

Chiaroscuro
Italian for 'light-dark'. A term used to describe the dramatic effects of strongly contrasting light and shade in paintings, popularized by Caravaggio.

Classicism
Term describing the use of the rules or styles of classical antiquity. Renaissance art incorporated many classical elements and artists working in other eras, such as the 18th century, have also looked to ancient Greece and Rome as inspiration. The term can also mean formal and restrained.

Cloisonnism
Technique used by some Post-Impressionists, such as Gauguin and Émile Bernard (1868–1941), whereby flat colours are surrounded by strong, dark outlines.

Cold rolling
Process by which sheet metal is compressed and flattened between rollers. The amount of pressure used determines the hardness and smoothness of the end product.

Collage
Style of picture-making in which materials (typically newspapers, magazines, photographs and so on) are pasted together on a flat surface. The technique first gained prominence in fine art through Picasso and Braque with Synthetic Cubism from 1912 to 1914.

Colour Field
Term originally used to describe the work of certain Abstract Expressionists such as Gorky, Hofmann and Rothko in the 1950s and Helen Frankenthaler (1928–2011) and Kenneth Noland (1924–2010) in the 1960s. Characteristic Colour Field works are recognized for their large areas of flat, single colours.

Composition
The arrangement of visual elements in a work of art.

Constructivism
Art movement founded in Russia c. 1914, spreading to the rest of Europe by the 1920s. Notable for its abstraction and use of industrial materials such as glass, metal and plastic.

Cremnitz white
A type of pure lead white oil paint with a dense, opaque and stringy consistency obtained partly through its inclusion of lead carbonate and absence of zinc oxide.

Cubism
Highly influential and revolutionary European art style invented by Picasso and Braque, and developed between 1907 and 1914. Cubists abandoned the idea of a fixed viewpoint, resulting in objects portrayed appearing fragmented. Cubism gave rise to a succession of other movements, including Constructivism and Futurism. See also Analytical Cubism and Synthetic Cubism.

Cubo-Futurism
Emerging in Russia during the early 20th century as a development from European Futurism and Cubism, the term 'Cubo-Futurism' was first used in 1913 to describe some contemporary poetry, but it became used far more for the visual arts. It describes a Russian style of painting that amalgamated elements of French Cubism and Italian Futurism, or specifically, fragmented forms blended with the depiction of movement.

Dada
Art movement that was started in 1916 in Switzerland by writer Hugo Ball as a reaction to the horrors of World War I. It aimed to overturn traditional values in art and became notable for its introduction of readymades as art and its rejection of the notion of craftsmanship. Main artists included Duchamp, Arp and Schwitters. See also Readymade.

Decalcomania
Most commonly associated with Ernst, decalcomania is a process of squashing paint between two surfaces, usually by applying paint on paper and then folding it, pressing it together and then opening it out to achieve a random mirrored pattern. Many artists who have used the technique have then built on the resulting patterns, using their imaginations to turn them into recognizable images. For this reason, decalcomania can be used as a form of automatism.

Degenerate art
Entartete Kunst, or Degenerate art in English, was the name Adolf Hitler and the German Nazi Party applied to art they did not approve of, which was nearly all modern art. Degenerate artists were dismissed from teaching positions and forbidden to exhibit or sell their art. The Nazis confiscated much Degenerate art and held an exhibition of it under the same title in 1937 in Munich, labelling the work with derisory captions. The exhibition subsequently travelled to other cities in Germany and Austria.

De Stijl
Dutch for 'The Style'. This is the title of a Dutch magazine produced from 1917 to 1932 and edited by Van Doesburg and used to champion the work of co-founder Mondrian and the ideas of Neo-Plasticism. The term is also applied to the ideas the magazine promoted, which had a significant influence on the Bauhaus movement and on commercial art in general.

Direct carving
Rather than following a preconceived model, some sculptors carve directly on to their materials, creating sculpture that is less planned than traditional sculpture. Although direct carving was an ancient method, it was reintroduced in c. 1906 by Brancusi, who focused on 'truth to materials'. Direct carving is typically performed on materials including marble, stone and wood. See also Truth to materials.

Divisionism
Painting theory and technique involving the application of small dots of paint to obtain colour effects optically rather than by mixing colours on a palette. Its most famous practitioners were Seurat and Signac. The technique is also called pointillism.

Drip painting
Painting technique in which paint is allowed to drip on to the canvas rather than being applied with a brush or spatula. Popularized by Pollock in the 1940s.

École des Arts Décoratifs
Aiming to improve the quality of manufactured goods in France, the École Royale Gratuite de Dessin (Royal Free School of Art) was founded in 1766. Students undertook a strict apprenticeship in the creative arts. After several changes of name, in 1877 the school became the École Nationale des Arts Décoratifs (National School of Decorative Arts). In 1927, the name changed again to the École Nationale Supérieure des Arts Décoratifs or ENSAD.

École des Beaux-Arts
Many of the most famous French artists trained at the École des Beaux-Arts in Paris, such as Degas, Delacroix, Monet and Seurat. It opened in 1648 as the Académie des Beaux-Arts, specifically to educate students in drawing, painting, sculpture, engraving and architecture. In 1863, Napoleon III granted the school independence from the government and later, the architectural school was separated from fine art. At the end of their course, art students could compete in the Prix de Rome for a prestigious scholarship to study in Rome.

Eight, The
A group of US painters formed in 1907 to protest against the powerful but conservative National Academy of Design.

Existentialism
During the 19th and 20th centuries, existentialism had the most influence on the arts of all philosophical theories. It centres on the analysis of human existence, and is mainly concerned with finding the self and the meaning of life through free will, choice, experiences, outlook and personal responsibility.

Expressionism
Term used to describe an early 20th-century art style that distorts colour, space, scale and form for emotional effect and is notable for its intense subject matter. Adopted particularly in Germany by artists such as Kandinsky, Marc and Kirchner.

Fauvism
Derived from the French word '*fauve*' meaning 'wild beast', this art movement emerged in 1905, lasting to 1910 and was characterized by wild brushwork, the use of bright colours, distorted representations and flat patterns. Fauvism is associated with artists such as Matisse and Derain.

Fluxus
Founded during the 1960s as an international avant-garde collective of artists and composers, Fluxus deliberately challenged accepted ideas about art. It had no one unifying style, but Fluxus artists used a range of materials and methods, often staging random performances, while collaborations were encouraged between artists and across art forms.

Folk art
Folk art describes art that falls outside fine art and that is created by people not formally trained in art. Its subject matter often involves family or community life and it encompasses painting, crafts, naive art and quilts.

Foreshortening
When objects are represented in proximity, they are dramatically shortened or certain aspects are enlarged and seemingly distorted.

Found object
Any natural or man-made object found and used in an artwork. Sometimes the object is bought by an artist to be used in a work of art. See also Readymade.

Fresco
A method of painting with water-based pigments on to freshly plastered walls or ceilings. There are two different fresco techniques. *Buon fresco*, also called 'true' fresco, is painted on to wet plaster. As the plaster dries, the fresco becomes integral to the surface. *Fresco secco* or 'dry' fresco is painted on to dry walls.

Frottage
From the French *frotter*, 'to rub', frottage is a creative method of rubbing that was developed for fine art by Ernst in 1925, when he used pencils, pastels and other dry drawing implements and made rubbings over rough surfaces to create the impression of texture. This was either left alone or used as the basis for further refinement. Ernst was initially inspired by the graining in an ancient wooden floor.

Futurism
Art movement launched by the Italian poet Filippo Tommaso Marinetti in 1909, Futurism was characterized by works that expressed the dynamism, energy and movement of modern life and celebrated machines, violence and the future. Integral artists included Boccioni and Balla.

Genre painting
Paintings of scenes from daily life. The style was particularly popular in the Netherlands in the 17th century. This type of art is also sometimes called narrative. The term 'genre' is also used to describe categories of painting, such as portrait or history.

Glaze
A thin, transparent layer of paint applied over dry, opaque layers or washes that adjusts the colour and tone of the underlying wash.

Gothic
European style of art and architecture produced from 1150 to *c*. 1499. Gothic art is characterized by an elegant, dark, sombre style and by a greater naturalism than in the earlier Romanesque period.

Gouache
Also known as body colour, gouache is a type of water-soluble opaque paint. Because of its matt finish, it is fairly flat and has never been as popular with artists as oils or watercolours. Some watercolourists use white gouache for highlights in watercolour paintings, while others use it to create opacity.

Graffiti art
A phenomenon that emerged in the mid 1970s in New York. It was inspired by the graffiti that teenagers sprayed on to subway trains using aerosol paint.

Ground
Also called priming, the ground of a painting is a coating on a support – or surface – before the art is started. A ground helps to seal and protect the support and provides a good surface for painting, often with a bit of tooth so the paint adheres well. Different supports require different grounds; for instance, canvas expands and contracts and so requires a flexible ground.

Happening
The first examples of Performance art occurring during the 1950s were called Happenings. The artists encouraged direct involvement from viewers. Although there was no single style or approach to Happenings, all the artists involved aimed to bring art into everyday life. With viewer participation, chance and change played a large part. Overall, Happenings were a reaction against the dominance of Abstract Expressionism and they reflected social changes occurring at that time. See also Performance art.

Hyperrealism
Used to describe a resurgence of exacting realism in painting and sculpture that followed Photorealism or Superrealism, which began in the 1970s. While the earlier movement was detached and photographically accurate, Hyperrealism incorporates elements of narration or emotion.

Iconography
Derived from '*eikon*' in Greek, meaning 'image', iconography means the use of imagery in art. More specifically, an icon is a picture or sculpture of a holy person used as an object of devotion. In art, the word has also come to be used to describe any object or image with a special meaning attached to it.

Impasto
Technique whereby paint is thickly applied using a brush or palette knife, so that the strokes or marks remain visible and in some cases raised from the surface to provide texture.

Impressionism
Revolutionary approach to painting landscape and scenes of everyday life, pioneered in France by Monet

and others from the 1860s, Impressionism was later adopted internationally. Impressionist paintings were often executed outdoors (*en plein air*) and are notable for the use of light, colour and loose brushwork. The first group exhibition held in 1874 was mainly ridiculed by critics, particularly Monet's painting *Impression, Sunrise* (1872), which gave the movement its name.

International Style
A radical international architectural style that began in Europe during the late 1920s, but was named at a 1932 exhibition in New York's Museum of Modern Art. The style reflects the ideas of the Bauhaus, featuring an abandonment of ornament, use of glass, steel, reinforced concrete and chrome, rectilinear forms, open interior spaces, flat roofs, ribbon windows and a sense of volume rather than mass.

Japonism or Japonisme
After 220 years of isolation, in 1858, Japan began trading with the West. Japanese art – particularly *ukiyo-e* woodblock prints – caught the imagination of artists across Europe and parts of North America. The Impressionists and Art Nouveau artists and designers were influenced by it. See also Ukiyo-e.

Jugendstil
See Art Nouveau.

Kinetic art
The word 'kinetic' relates to motion. From *c.* 1930, Calder began making mobiles to incorporate movement into art, exploring motion, time and expressing the development of technology in the 20th century. Some artists, such as Gabo, created art that moved mechanically with motors, whereas Calder exploited the effects of air movement, and in the 1950s and 1960s, Op artists painted static works that optically suggest movement.

Law of Simultaneous Contrast
Identified by the French chemist Michel-Eugène Chevreul, and written about in his book *De la loi du contraste simultanée des couleurs* (1839, *The Law of Simultaneous Contrast of Colours*), this describes the effects of two different colours in proximity, especially the brightening effects created by the juxtaposition of complementary colours.

Linear perspective
The attempt to convincingly depict three dimensions and depth on two-dimensional surfaces, perfected during the Renaissance, using a system of lines and vanishing points.

Lubok
The term 'lubok' (plural: lubki) describes coloured prints, usually simplistic pictures with explanatory texts, popular with the Russian upper classes and peasants from the early 17th century onwards. Most luboks depicted saints and biblical scenes, although they also portrayed folktales and satires.

Magic Realism
Part of a reaction against modern art, Magic Realism developed after World War I. The term, invented in 1925, described paintings depicting fantasy or dreamlike subjects. Artists who have been called Magic Realists include De Chirico and O'Keeffe.

Memento mori
Latin term that loosely translates as 'remember you will die'. It was a popular theme in medieval and Renaissance art and describes paintings or sculptures that are intended to move viewers to contemplate their mortality.

Mexican Muralism
Beginning as a government-funded form of public art after the Mexican Revolution of 1910 to 1920, Mexican Muralism portrayed an official history of Mexico to educate citizens. Although many artists were employed, the three main Mexican Muralists were Orozco, Rivera and Siqueiros.

Minimalism
Style of abstract art characterized by a spare, uncluttered approach and lack of emotive expression or conventional composition. It arose in the mid 20th century and flourished in the 1960s and 1970s.

Mobile
A term coined by Duchamp to describe particular sculptures by Calder exhibited in 1932 that consisted of flat metal shapes suspended from wires and which were moved by an air current.

Moderne Bund, Der
German for 'the Modern Alliance'. Founded in 1911 in Switzerland by Arp and others, *Der Moderne Bund* is seen as the first Swiss artistic association to make avant-garde art more accessible to a wider public, and to encourage its reception and development.

Modernism
A broad term used to describe Western artistic, literary, architectural, musical and political movements beginning in the late 19th century and continuing through much of the 20th century. The term is applied to innovative, experimental art and design, and works that reject the old or traditional to be in keeping with the modern age.

Naturalism
In its broadest sense, a term used to describe art in which the artist attempts to portray objects and people as observed rather than in a conceptual or contrived manner. More generally, it can also be used to suggest that a work is representational rather than abstract.

Neoclassicism
A prominent late 18th and early 19th-century movement in European art and architecture, motivated by the impulse to revive styles of ancient Greek and Roman art and architecture. The term has also been applied to a similar revival of interest in classical styles during the 1920s and 1930s.

Neo-Expressionism
An international movement in painting that started in the 1970s, influenced by raw personal emotion and bold mark-making first seen in Expressionism. Neo-Expressionist paintings are often figurative and typified by their large scale and use of mixed media on the surface. Artists include Kiefer and Georg Baselitz (b.1938).

Neo-Impressionism
In 1886, French art critic Félix Fénéon used the phrase Neo-Impressionism to describe a French movement in painting started by Seurat and Signac that aimed to take a scientific approach to creating illusions of light and colour using Divisionism or pointillism.

Neo-Plasticism
Term invented by Dutch painter Mondrian in 1914 to describe his theory that art should be non-representational in order to find and express a 'universal harmony'. Mondrian's paintings are characterized by their restricted palettes and use of horizontal and vertical lines.

Neue Sachlichkeit, Die
German for 'The New Objectivity', *Neue Sachlichkeit* was a German art movement of the 1920s that lasted until 1933. It opposed Expressionism and is noted for its unsentimental style and use of satire. Artists include Dix and Grosz.

Nihonga painting
'Japanese-style paintings' or *nihonga* follow Japanese artistic traditions and techniques. The term was first used during the Meiji period of 1868 to 1912, when Japan moved from being an isolated feudal society to a more international one, in order to distinguish traditional Japanese painting from Western-style art.

Orphism
Abstract art movement originated by French painter Jacques Villon (1875–1963) and characterized by its use of bright colour. The term was first used in 1912 by the French poet Guillaume Apollinaire to describe the paintings of Robert Delaunay, which he related to Orpheus, the poet and singer in Greek mythology.

Patination
The tarnish or sheen that forms on the surface of copper, bronze and other similar metals through oxidation or other chemical processes. Patination also describes a sheen formed by wear, rubbing or ageing on surfaces such as wood or stone.

Performance art
Art form in which artists become participants in their own work of art, often combining elements of music, theatre and visual arts. Popularized in the 1960s.

Photorealism
Emerging in Europe and the United States in the late 1960s, Photorealism is characterized by meticulous detail, precision and sharp clarity, making images look photographic. It developed among artists who aimed for emotional detachment and to emphasize the artist's technical skill.

Piercing
In 1931, Hepworth was one of the first artists to make piercings in sculpture an essential part of her work. Commonly used in ceramics, piercing adds a weightless quality.

Pittura Metafisica
Italian for 'Metaphysical Painting'. A painting style that developed from the art of De Chirico, which includes disconcerting images of reality and the everyday.

Plein air
See Impressionism.

Pointillism
See Divisionism.

Pop art
Term coined by British critic Lawrence Alloway for an Anglo-American art movement that lasted from the 1950s to the 1970s, notable for its use of imagery taken from popular cultural forms such as advertising, comics and mass-produced packaging. Practitioners included Warhol and Lichtenstein.

Post-Impressionism
Term used to describe the developments in art and works of various artists created after Impressionism. The phrase was invented by the British art critic and painter Roger Fry for his group exhibition 'Manet and the Post-Impressionists' in London in 1910 – by which time all the artists involved, including Cézanne, Gauguin and Van Gogh, had died.

Postmodernism
Term that describes the reaction to the dominance of modernism in the arts, architecture and politics, which came into use in the 1970s

Pre-Raphaelite Brotherhood
A British society of painters founded in London in 1848 that championed the work of artists who were active before the Renaissance master Raphael. The work is characterized by its precise, realistic style, bright colours, close attention to detail, and engagement with social problems and religious and literary themes.

Priming
See Ground.

Primitivism
Art inspired by the so-called 'primitive' art that fascinated many early modern European artists. It included tribal art from Africa and the South Pacific, as well as European folk art.

Rayonism
An early form of abstract art that was influenced by Cubism, Futurism and Orphism, it emerged as a Russian avant-garde art movement from 1910 to 1920.

Readymade
First used by Duchamp to describe the works of art he made from manufactured objects, the term 'readymade' became applied to many other works of art created from previously manufactured objects by other artists. Readymades are often also modified by artists. See also Found object.

Realism
Realism describes a 19th-century art movement, characterized by subject matter that depicts ordinary working-class life, exemplified by Courbet. Additionally, realism is used to describe painting that appears photographic in its representational accuracy, irrespective of subject matter.

Regionalism
In response to the Great Depression, Regionalism was an US realist art movement that developed in the 1930s to 1940s. Regionalists had no single style, but all the art was relatively conservative, which appealed to US sensibilities and contrasted with many avant-garde movements in Europe at the time.

Renaissance
French for 'rebirth'. Term used to describe the revival of art from 1300, largely influenced (in Italy) by the rediscovery of classical art and culture. The Renaissance reached its peak – the High Renaissance – from 1500 to 1530, with artists such as Michelangelo, Leonardo da Vinci (1452–1519) and Raphael, while the Northern Renaissance featured meticulously painted and sculpted art.

Romanticism
Artistic movement that developed during the late 18th and early 19th centuries. Broadly characterized by an emphasis on the experience of instinct over rationality, and the concept of the sublime, such as in the paintings of Turner, Delacroix and Géricault.

Rule of thirds
A simplification of the golden ratio that has been used by artists for thousands of years, the rule of thirds is a way of creating compositions to attain balance in two-dimensional art.

Salon
Annual spring exhibitions held by the French Royal Academy of Painting and Sculpture, later the Academy of Fine Arts, in Paris from 1667 to 1881 were called the Paris Salon or the Salon. Named for the Salon Carré in the Louvre, where the exhibitions were held regularly from 1737 onwards, the Salon was highly prestigious, and if selected to exhibit there, most artists attracted patronage.

Salon d'Automne
Established as an alternative to the conservative official Salon in Paris in 1903 by a group of artists and poets, the Salon d'Automne was an annual exhibition that aimed to show innovative art. The group chose the jury for selecting exhibitors by drawing straws. The Salon d'Automne was held in the autumn as most other Paris shows occurred in the spring and summer.

Salon des Indépendants
The annual art exhibition of the Societé des Artistes Indépendants, the Salon des Indépendants has been held in Paris since 1884. It began as a protest against the staid and strict official Salon, aiming to exhibit avant-garde art that was never chosen for the official Salon. Opposing the rigid jury selection process, the Salon des Indépendants had no selection jury and any artist could exhibit after paying a fee.

Screen-printing
A process that originated in China during the Song dynasty (960–1279) and spread across Asia, screen-prints are created by forcing coloured ink through a thin screen that is partially blocked by a stencil. It was initially called silk-screen printing because silk was used as the screen. The process was eventually used in Europe to print packaging and advertisements, and now incorporates polyester mesh, stencils, ink and squeegees.

Secession
Secessionists were two groups of artists in Germany and Austria in the 1890s who 'seceded' from art institutions that the artists deemed conservative. Klimt led the Vienna Secession.

Simultanism
Robert Delaunay first used the term 'Simultanism' to describe the abstract painting approach that he developed with his wife Sonia from c. 1910. Their painting method derived from the theories of French chemist Michel-Eugène Chevreul who identified the phenomenon of colours appearing different depending on those colours near to them. See also Orphism.

Stretching
To create an oil painting on canvas, the canvas is usually first stretched over 'stretcher bars', or wooden supports, and stapled to them before being placed in a frame. Pollock was one of the first artists to use unstretched canvases.

Sturm, Der
German for 'The Storm'. *Der Sturm* was an influential German art and literary magazine published in Berlin between 1910 and 1932, promoting several avant-garde movements. To celebrate its 100th edition, the Galerie Der Sturm was opened in 1912. Exhibiting art by Munch, Picasso, Delaunay, Klee, Kandinsky and many more, the Galerie Der Sturm also became known for its touring exhibitions across Germany and in other major European cities.

Suprematism
Russian abstract art movement. Its chief proponent was Malevich, who invented the term in 1913. Suprematist paintings are characterized by a limited colour palette and the use of simple geometric forms such as squares, circles and crosses.

Surrealism
Movement in art and literature launched in Paris in 1924 by French poet André Breton with his publication of the 'Manifesto of Surrealism', the movement then flourished between World Wars I and II. Surrealism was characterized by a fascination with the bizarre, the illogical and the dreamlike. The Surrealist emphasis on chance and gestures informed by impulse rather than conscious thought was highly influential on subsequent artistic movements such as Abstract Expressionism. See also Automatism.

Symbolism
In 1886, French critic Jean Moréas described the poetry of Stéphane Mallarmé and Paul Verlaine as Symbolist. Applied to art, Symbolism describes the use of mythological, religious and literary subject matter, and art that features emotional and psychological content, with an interest in the erotic, perverse and mystical. Prominent Symbolist painters included Pierre Puvis de Chavannes (1824–98), Gustave Moreau (1826–98), Redon and Gauguin.

Synesthesia
The union of senses, for instance the sense of tasting or hearing colours, is a condition experienced by many, including for instance, Kandinsky, who 'saw' colour in his mind when he heard sounds or read words. Generally, synesthetes appreciate sounds, colours or words with two or more senses simultaneously. The term is a combination of the Greek words '*syn*' meaning together and '*aisthesis*' meaning sensation.

Synthetic Cubism
Generally considered to have been practised from about 1912 to 1914, Synthetic Cubism features simpler shapes and brighter colours than Analytical Cubist paintings, but also features further textures, including collage elements. It focused on flattening images and abandoning all allusions of three dimensions. See also Analytical Cubism and Cubism.

Synthetism
Term used by Gauguin, Bernard and their circle at Pont-Aven in Brittany in the 1880s to describe the synthesis of subject matter with the emotions of the artist, rather than with observed reality.

Taches
Monet and the Impressionists were among the first to stop oil painting in the traditional manner by applying thin glazes, instead applying thick paint in short, flat strokes and dabs, which became called '*taches*', French for 'blots' or 'stains'. *Taches* became the basis of the Impressionist painting technique, made possible by the invention of the circular metal ferrule – or clamp – which held hairs on to wooden paintbrush handles and could be flattened, creating flat bristle brushes instead of only rounded brushes.

Tehuana costume
The elaborate, traditional costume worn by the Tehuana, or women from the Isthmus of Tehuantepec in the south of Mexico.

Tempera
Derived from the Latin '*temperare*', meaning 'to mix in proportion', tempera is paint made with powdered pigments, egg yolk, or only yolks or whites, and water. Quick-drying and long-lasting, tempera reached its peak during the Renaissance period before oil paints were adopted.

Theosophy
Late 19th-century spiritual theory. Artists involved with theosophy attempted to produce art that had a higher purpose than merely representing nature.

Triptych
Three hinged panels featuring paintings or carvings, often in an altarpiece.

Truth to materials
Belief that the form of an artwork should be inseparably related to the material from which it is made. The phrase became popular in aesthetic discussions during the 1930s and is particularly associated with Moore and Brancusi.

Ukiyo-e
Japanese for 'pictures of the floating world'. Style of Japanese paintings and woodblock prints that were created from the 17th to the 19th centuries. Noted for their apparent flatness, bright colours and decorativeness, they often feature animals, figures, landscapes and theatre scenes. *Ukiyo-e* prints were especially influential on late 19th-century European art and design.

Underdrawing
A sketch made by a painter as a preliminary outline for a finished painting, usually on a primed support and subsequently covered with paint.

Underpainting
Usually a neutrally coloured thin paint, applied to establish the darkest values before a painting is started, underpainting has been used in different forms since before the Renaissance. There are several types of underpainting, including *verdaccio*, a green-grey underpainting and *imprimatura*, a transparent stain.

Vanitas
A genre of art, often still life, in which symbolic objects, such as skulls, broken instruments or rotting fruit, imply the transience of life and the inevitability of death.

Wet-in-wet
Painting technique in which wet paint is applied to a wet or damp support. The results are soft and often undefined, with blurred edges.

Wiener Werkstätte
German for 'Vienna's Workshops'. Established in 1903 by the Austrian artist Koloman Moser (1868–1918) and the Austrian designer and architect Josef Hoffmann (1870–1956), the Wiener Werkstätte was a company of artists, designers and architects in Vienna, who aimed to produce good design in ceramics, fashion, silver, furniture and the graphic arts. They opposed low-quality mass production, and upheld the Vienna Secession's idea of a '*Gesamtkunstwerk*', or total work of art, especially concentrating on reduced surface ornament and geometric symmetry.

Woodblock printing
Made by cutting away areas from a block of wood, woodblock printing originated in China for printing on textiles and then later printing on paper. The earliest surviving examples from China were made before AD 220. Woodblock printing remained the most common East Asian method of printing text and images until the 19th century, and *ukiyo-e* is the best-known type of Japanese woodblock art print.

Works Progress Administration Federal Art Project
In the mid-1930s, the United States remained at the centre of the Great Depression. As part of his New Deal to provide economic relief to artists, President Franklin D. Roosevelt established the Works Progress Administration (WPA) and from that, the WPA Federal Art Project (FAP) developed. The project hired hundreds of artists, who created more than 100,000 paintings, murals and works of sculpture.

YBAs
The Young British Artists, or YBAs, is the name given to visual artists who first began exhibiting together at the 'Freeze' show in London in 1988, organized by Hirst. Many of the artists graduated from the Bachelor of Arts Fine Art course at Goldsmiths in the late 1980s. Their work is hugely diverse, but often involved installations and shocking subject matter.

Index of artworks

Index

Picture credits

All works are courtesy of the museums, galleries or collections listed in the individual captions.

Key: t = top; l = left; c = centre; r = right; b = bottom; tr = top right; bl = bottom left; br = bottom right

2 akg-images **4 l** Musée d'Orsay, Paris, France / Bridgeman Images **4 c** © Succession Picasso / DACS, London 2017. Digital image, The Museum of Modern Art, New York / Scala, Florence **4 r** © The Pollock-Krasner Foundation ARS, NY and DACS, London 2017. National Gallery of Australia, Canberra / Purchased 1973 / Bridgeman Images **5 l** © Anselm Kiefer. The San Francisco Museum of Modern Art, The Doris and Donald Fisher Collection, Photograph: Katherine Du Tiel **5 r** Copyright Paula Rego, Courtesy Marlborough Fine Art **10-11** Musée d'Orsay, Paris, France / Bridgeman Images **12** Musée d'Orsay, Paris, France / Bridgeman Images **13** Wikimedia Commons: URL: https://commons.wikimedia.org/wiki/File:Van_Gogh_-_Die_Kirche_von_Nuenen_mit_Kirchgängern.jpeg **15 tr** Rijksmuseum **16–17** Museum of Fine Arts, Boston, Massachusetts, USA / Tompkins Collection / Bridgeman Images **19 br** Album / Prisma / Album / Superstock **20** The Print Collector / Getty Images **24–25** © Succession Picasso / DACS, London 2017. Digital image, The Museum of Modern Art, New York / Scala, Florence **26–27** Philadelphia Museum of Art, Pennsylvania, PA, USA / The George W. Elkins Collection / Bridgeman Images **27** PAINTING / Alamy Stock Photo **29 br** INTERFOTO / Alamy Stock Photo **30** akg-images **31** Photo Scala, Florence **33 br** Private Collection / Photo © Christie's Images / Bridgeman Images **34** © Succession H. Matisse / DACS 2017. Photo © SMK Photo **35** classicpaintings / Alamy Stock Photo **37** Pictures from History / akg-images **38** Gift of Evelyn K. Kossak / Brooklyn Museum **39** © Succession Picasso / DACS, London 2017. Digital image, The Museum of Modern Art, New York / Scala, Florence **41 br** The Barnes Foundation, Philadelphia, Pennsylvania, USA / Bridgeman Images **42** ACME Imagery / ACME Imagery / Superstock **42–43** Erich Lessing / akg-images **45 br** Private Collection / Bridgeman Images **46** © ADAGP, Paris and DACS, London 2017. Kunstmuseum, Basel, Switzerland / Artothek / Bridgeman Images **47** Collection of Mr. and Mrs. Paul Mellon / National Gallery of Art, Washington DC **50** © ADAGP, Paris and DACS, London 2017. Kunstmuseum, Basel, Switzerland / Peter Willi / Bridgeman Images **51** Wikimedia Commons: URL: https://commons.wikimedia.org/wiki/File:Auguste_Renoir_-_Dance_at_Le_Moulin_de_la_Galette_-_Musée_d%27Orsay_RF_2739_(derivative_work_-_AutoContrast_edit_in_LCH_space).jpg **53 br** Dennis van de Water / Shutterstock.com **54–55** akg-images **55** ART Collection / Alamy Stock Photo **57 br** Musée d'Orsay, Paris, France / Bridgeman Images **58** DeAgostini / DeAgostini / Superstock **59** Heritage Image Partnership Ltd. / Alamy Stock Photo **61 tr** © Les Arts Décoratifs, Paris / akg-images **62** Photo Fine Art Images / Heritage Images / Scala, Florence **63** Christie's Images, London / Scala, Florence **66–67** © Fondation Oskar Kokoschka / DACS 2017. akg-images **67** PAINTING / Alamy Stock Photo **69 br** Antiquarian Images / Alamy Stock Photo **70** Art Collection 2 / Alamy Stock Photo **71** © Pracusa 2017634 **73 br** © ADAGP, Paris and DACS, London 2017. Peter Horree / Alamy Stock Photo **74** © DACS 2017. Private Collection / De Agostini Picture Library G. Nimatallah / Bridgeman Images **75** DeAgostini / Getty Images **78** FineArt / Alamy Stock Photo **79** akg-images **80 br** Public domain **82–83** Chagall ® / © ADAGP, Paris and DACS, London 2017. Digital image, The Museum of Modern Art, New York / Scala, Florence **83** Art Museum of Kaluga, Russia / Bridgeman Images **85 r** De Agostini Picture Library / Bridgeman Images **86** De Agostini / G. Nimatallah / akg-images **87** Digital Image © Tate, London 2015 **89 br** Chicago History Museum / Getty Images **90** © DACS 2017. Photo © Musées d'art et d'histoire, Ville de Genève, n° inv. 1982-0013, Hans Arp, Configuration. Portrait de Tristan Tzara. Photo: Bettina Jacot-Descombes **91** © 2017 Kunsthaus Zürich **93 br** National Gallery of Australia, Canberra / Bridgeman Images **94** Private Collection / Bridgeman Images **95** © Estate of George Grosz, Princeton, N.J. / DACS 2017. Museo Thyssen-Bornemisza, Madrid, Spain / De Agostini Picture Library / G. Nimatallah / Bridgeman Images **98–99** Egon Schiele: Egon Schiele, Reclining Woman with Green Stockings, 1917. Private collection, courtesy Galerie St. Etienne, New York **101 br** Archivart / Alamy Stock Photo **102** Norton Simon Collection, Pasadena, CA, USA / Bridgeman Images **103** Josse Christophel / Alamy Stock Photo **105 br** Mondadori Portfolio / Sergio Anelli / akg-images **106** © DACS 2017. akg-images **107** © DACS 2017. Prixpics / Alamy Stock Photo **109 r** André Held / akg-images **110** ullstein bild / ullstein bild via Getty Images **111** © DACS 2017. Erich Lessing / akg-images **114** Sovfoto / UIG via Getty Images **115** Library of Congress, Washington DC **117 r** Fine Art Images / Fine Art Images / Superstock **118** The Berggruen Klee Collection, 1984 / The Metropolitan Museum of Art, New York **119** The Solomon R. Guggenheim Foundation / Art Resource, NY / Scala, Florence **121 b** Keute / ullstein bild via Getty Images **122** © Succession Brancusi - All rights reserved. ADAGP, Paris and DACS, London 2017. Photo: The Metropolitan Museum of Art / Art Resource / Scala, Florence **123** Jean-Louis Nou / akg-images **125 r** Yale University Art Gallery **126** Peter Horree / Alamy Stock Photo **126–127** © Successió Miró / ADAGP, Paris and DACS London 2017. The Solomon R. Guggenheim Foundation / Art Resource, NY / Scala, Florence **130** © DACS 2017. Peter Willi / Superstock **131** Wikimedia Commons: URL: https://en.wikipedia.org wiki/File:The_Garden_of_Earthly_Delights_by_Bosch_High_Resolution.jpg **134–135** © The Henry Moore Foundation. All Rights Reserved, DACS 2017 / www.henry-moore.org / Bridgeman Images **137 tr** Peter Horree / Alamy Stock Photo **138** Alte Pinakothek, Munich, Germany / Bridgeman Images **139** The Art Institute of Chicago, IL, USA / Friends of American Art Collection / Bridgeman Images **141 br** Peter Willi / Superstock **142–143** © Salvador Dalí, Fundació Gala-Salvador Dalí, DACS 2017. Digital image, The Museum of Modern Art, New York / Scala, Florence **146** © Georgia O'Keeffe Museum / DACS 2017. Heritage Image Partnership Ltd. / Alamy Stock Photo **147** The Phillips Collection, Washington, D.C., USA / Acquired 1926 / Bridgeman Images **149 b** Library of Congress, Washington, D.C. **150** Everett Collection Historical / Alamy Stock Photo **151** © Banco de México Diego Rivera Frida Kahlo Museums. Museo de Arte Moderno, Mexico City, Mexico / De Agostini Picture Library / G. Dagli Orti / Bridgeman Images **153 br** Iberfoto / Superstock **154** © 2017 Calder Foundation, New York / DACS London. Digital image © 2017. The Solomon R. Guggenheim Foundation / Art Resource, NY / Scala, Florence **155** Rogers Fund, 1914 / The Metropolitan Museum of Art, New York **157 b** Detroit Institute of Arts, USA / Gift of Ralph Harman Booth / Bridgeman Images **158** © ADAGP, Paris and DACS, London 2017. Digital image © 2017. The Solomon R. Guggenheim Foundation / Art Resource, NY / Scala, Florence **159** The Artchives / Alamy Stock Photo **161 br** DEA PICTURE LIBRARY / De Agostini / Getty Images **162-163** The Art Institute of Chicago, IL, USA / Friends of American Art Collection / Bridgeman Images **165 b** Chester Dale Collection / National Gallery of Art, Washington DC **166** Bettmann / Getty Images **167** ©2017 ES Mondrian / Holtzman Trust. Digital image, The Museum of Modern Art, New York / Scala, Florence **169 r** Brooklyn Museum Collection **170** © The Joseph and Robert Cornell Memorial Foundation / VAGA, NY / DACS, London 2017. Private

Collection/Bridgeman Images **171** The Jules Bache Collection, 1949/The Metropolitan Museum of Art, New York **174-175** © The Pollock-Krasner Foundation ARS, NY and DACS, London 2017. National Gallery of Australia, Canberra/Purchased 1973/Bridgeman Images **176–177** © The Estate of Alberto Giacometti (Fondation Annette et Alberto Giacometti, Paris and ADAGP, Paris), licensed in the UK by ACS and DACS, London 2017. Photo: Jens Ziehe. bpk, Bildagentur fuer Kunst, Kultur und Geschichte, Berlin/Scala, Florence **179 b** Bryan Busovicki/Shutterstock **180–181** © ADAGP, Paris and DACS, London 2017. The Solomon R. Guggenheim Foundation/Art Resource, NY/Scala, Florence **181** Wikimedia Commons: URL: https://commons.wikimedia.org/wiki/File:Thetriumphofdeath.jpg **184** © The Willem de Kooning Foundation / Artists Rights Society (ARS), New York and DACS, London 2017. Digital image, The Museum of Modern Art, New York/Scala, Florence **185** bpk, Bildagentur fuer Kunst, Kultur und Geschichte, Berlin/Photo Scala, Florence **187 tr** Photo Scala, Florence **188–189** © Estate of David Smith/DACS, London/VAGA, New York 2017. Digital Image © Whitney Museum, N.Y. **191 r** Pixabay **192–193** © The Pollock-Krasner Foundation ARS, NY and DACS, London 2017. National Gallery of Australia, Canberra/Purchased 1973/Bridgeman Images **193** Pixabay **195 b** Fine Art Images/Heritage Images/Getty Images **196** © The Easton Foundation/VAGA, New York/DACS, London 2017. Collection The Easton Foundation/Photo: Christopher Burke **197** Gift of the W. Averell Harriman Foundation in memory of Marie N. Harrima/National Gallery of Art, Washington DC **200** Old Paper Studios/Alamy Stock Photo **201** © ADAGP, Paris and DACS, London 2017. The Solomon R. Guggenheim Foundation. Peggy Guggenheim Collection, Venice, 1976 (76.2553.102) © 2017. The Solomon R. Guggenheim Foundation/Art Resource, NY/ Scala, Florence **203 br** Private Collection/Archives Charmet/Bridgeman Images **204** The Work of Naum Gabo © Nina & Graham Williams. The Israel Museum, Jerusalem, Israel/Bequest of Miriam Gabo, lent by Mrs. Miriam Gabo, London/Bridgeman Images **205** Granger Historical Picture Archive/Alamy Stock Photo **208** Vatican Museums and Galleries, Vatican City/Bridgeman Images **209** © R. Hamilton. All Rights Reserved, DACS 2017.Kunsthalle, Tubingen, Germany/Bridgeman Images **212** Nigel Osbourne/Redferns/Getty Images **213** Works by Barbara Hepworth © Bowness. Private Collection/Photo © Christie's Images/Bridgeman Images **215 tr** Wikimedia Commons: URL: https://commons.wikimedia.org/wiki/File:Orpheus_Franz_von_Stuck_1891.jpg **216–217** © 1998 Kate Rothko Prizel & Christopher Rothko ARS, NY and DACS, London. Digital Image © Whitney Museum, N.Y. **217** Imagno/Getty Images **220** © ARS, NY and DACS, London 2017. Digital image, The Museum of Modern Art, New York/Scala, Florence **221** Keystone-France/Gamma-Keystone via Getty Images **224–225** © ARS, NY and DACS, London 2017. Museum purchase with funds generously provided by John and Margaret Robson © Kiyoko Lerner. Photo: James Prinz. Photo Credit: American Folk Art Museum/Art Resource, NY **225 b** Private Collection/Bridgeman Images **228–229** © The Estate of Yves Klein c/o DACS, London 2017. BI, ADAGP, Paris/Scala, Florence **231 tr** Sergio Anelli/Electa/Mondadori Portfolio via Getty Images **232** Cultura Creative (RF)/Alamy Stock Photo **232–233** © 2017 The Andy Warhol Foundation for the Visual Arts, Inc./Artists Rights Society (ARS), New York and DACS, London. Martin Shields/Alamy Stock Photo **235 r** Image Courtesy of The Advertising Archives **236–237** © The Estate of Francis Bacon. All rights reserved. DACS 2017. The Solomon R. Guggenheim Foundation/Art Resource, NY/Scala, Florence **237** Photo Scala, Florence **240** © Robert Rauschenberg Foundation/DACS, London/VAGA, New York 2017. Wadsworth Atheneum Museum of Art, Hartford, CT. Gift of Susan Morse Hilles, 1964.30. Photography: Allen Phillips/Wadsworth Atheneum **241** Azoor Photo/Alamy Stock Photo **243 r** Rowland Scherman/Getty Images **244** Interfoto/Superstock **245** © Estate of Roy Lichtenstein/DACS 2017. akg-images **247 b** Sunset Boulevard/Corbis via Getty Images **248–249** © Anselm Kiefer. The San Francisco Museum of Modern Art, The Doris and Donald Fisher Collection, Photograph: Katherine Du Tiel **250** © The Estate of Eva Hesse. Courtesy Hauser & Wirth. Detroit Institute of Arts, USA/Bridgeman Images **251** © Bettmann/CORBIS/Bettmann Archive/Getty Images **254** Granger Historical Picture Archive/Alamy Stock Photo **254–255** © DACS 2017. Christie's Images Ltd./Superstock **257 br** dpa picture alliance/Alamy Stock Photo **258–259** © Estate of Robert Smithson/DACS, London/VAGA, New York 2017. Robert Smithson, Spiral Jetty, 1970. © Holt-Smithson Foundation. Photo: George Steinmetz. Courtesy Dia Art Foundation, New York **259** DeAgostini/Getty Images **262–263** © Nam June Paik Estate. Collection Walker Art Center, Minneapolis. Formerly the collection of Otto Piene and Elizabeth Goldring, Massachusetts. Collection Walker Art Center, T. B. Walker Acquisition Fund, 1992 **266** © Judy Chicago. ARS, NY and DACS, London 2017. Stan Honda/AFP/Getty Images **267** Sergio Anelli/Electa/Mondadori Portfolio via Getty Images **269** © Judy Chicago. ARS, NY and DACS, London 2017. Photo: © Donald Woodman **270** British Museum, London, UK/Bridgeman Images **271** © The Estate of Ana Mendieta Collection, L.L.C. Courtesy Galerie Lelong & Co. **273 r** Christophel Fine Art/UIG via Getty Images **274** Masterpics/Alamy Stock Photo **275** © Lucian Freud Archive Bridgeman Images. Digital image Christie's Images, London/Scala, Florence **278-279** © Anselm Kiefer. The San Francisco Museum of Modern Art, The Doris and Donald Fisher Collection, Photograph: Katherine Du Tiel **282–283** © Gerhard Richter 2017 (0099). Private Collection/Bridgeman Images **286** Artepics/Alamy Stock Photo **287** Courtesy of the artist and Metro Pictures, New York **290–291** © Damien Hirst and Science Ltd. All rights reserved, DACS 2017. Photo: Prudence Cuming Associates Ltd. **293 b** PRISMA ARCHIVO/Alamy Stock Photo **294** Photograph by Ellen Page Wilson, courtesy Pace Gallery. Museum of Modern Art, New York. © the artist **295** GM Photo Images/Alamy Stock Photo **298–299** Copyright Paula Rego, Courtesy Marlborough Fine Art **300–301** © Yinka Shonibare MBE. All Rights Reserved, DACS 2017. Davis Museum and Cultural Center, Wellesley College, MA, USA/Museum purchase with funds provided by Wellesley College Friends of Art/Bridgeman Images **301** classicpaintings/Alamy Stock Photo **304** Samuel Courtauld Trust, The Courtauld Gallery, London, UK/Bridgeman Images **304–305** Courtesy YAYOI KUSAMA Inc., Ota Fine Arts, Tokyo/Singapore and Victoria Miro, London (PhotographyAlexander Atwater). © Yayoi Kusama **307 br** Ashmolean Museum, University of Oxford, UK/Bridgeman Images **308** © the artist **309** Philip Scalia/Alamy Stock Photo **311 b** Steve Vidler/Alamy Stock Photo **312** © Bill Viola. Photo: Peter Mallet, courtesy Blain|Southern, London **313** Fondo Edifici di Culto - Min. dell'Interno/Photo Scala, Florence **314 t** © Bill Viola. Photo: Peter Mallet, courtesy Blain|Southern, London **314 b** © Bill Viola. Photo: Kira Perov, courtesy Bill Viola Studio **315** © Bill Viola. Photo: Kira Perov, courtesy Bill Viola Studio **316** Copyright Paula Rego, Courtesy Marlborough Fine Art **317** Moviestore collection Ltd./Alamy Stock Photo

First published in the United Kingdom in 2017 by
Thames & Hudson Ltd, 181A High Holborn,
London WC1V 7QX

www.thamesandhudson.com

First published in 2017 in the United States of America by
Thames & Hudson Inc., 500 Fifth Avenue,
New York, New York 10110

www.thamesandhudsonusa.com

© 2017 Quintessence Editions Ltd.

This book was designed and produced by
Quintessence Editions Ltd.
The Old Brewery
6 Blundell Street
London N7 9BH

Project Editor	Carol King
Senior Designer	Isabel Eeles
Design Assistance	Thomas Keenes
Picture Researcher	Jen Veall
Design Concept	gradedesign.com
Production Manager	Anna Pauletti
Editorial Director	Ruth Patrick
Publisher	Philip Cooper

All Rights Reserved. No part of this publication may be reproduced
or transmitted in any form or by any means, electronic or mechanical,
including photocopy, recording or any other information storage
and retrieval system, without prior permission in writing from
the publisher.

British Library Cataloguing-in-Publication Data
A catalogue record for this book is available from the British Library

Library of Congress Control Number 2017934856

ISBN 978-0-500-23976-6

Printed in China